ILLUSTRATORS 44

THE SOCIETY OF ILLUSTRATORS 44TH
ANNUAL OF AMERICAN ILLUSTRATION

From the exhibition held in the galleries of the
Society of Illustrators Museum of American Illustration
128 East 63rd Street, New York City
February 6 - May 4, 2002

Society of Illustrators, Inc.
128 East 63rd Street, New York, NY 10021-7303
www.societyillustrators.org

First published in 2003 by:
HDI, an imprint of HarperCollins Publishers
10 East 53rd Street
New York, NY 10022

ISBN 0-06-052994-6
Library of Congress Catalog Card Number 59-10849

Distributed throughout the world by:
HarperCollins International
10 East 53rd Street
New York, NY 10022

Editor, Jill Bossert
Book and jacket designed by Bernadette Evangelist
Jacket cover illustration by Noah Woods

Printed in Hong Kong

Photo Credits: © Sue Coe, Courtesy Galerie St. Etienne, New York, NY; Peter de Sève by Randall de Sève;
Milton Glaser by Stephen Green; Rafal Olbinski, Mark Summers and SI Gala by George Kanatous; David Small by Helen Handelsman;
Dan Yaccarino by Greg Miller. Portrait of Anita Kunz by John Collier.

ILLUSTRATORS 44

THE SOCIETY OF ILLUSTRATORS 44TH ANNUAL OF AMERICAN ILLUSTRATION

CHAIRMAN'S MESSAGE

One of the true highlights of my years as an art student in New York City was attending the Society's Annual exhibits, so it was a real honor for me to act as the chairman of the Annual.

My thanks to Nancy Stahl for the extraordinary job she did last year and for selecting me to be her assistant chair. Thanks also to Tim Bower for his wonderful Call for Entries poster art and to Patrick Flynn for his design. Many thanks to Steve Brodner for his efforts and support as my assistant chair and for planting the seed that developed into the Sequential category. This long overlooked segment of our field will grow and prove to be a very exciting addition to the show in years to come.

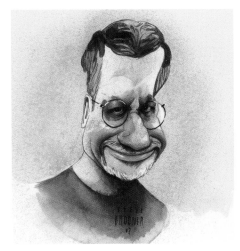

Thank you to the exceptional jurors who generously assembled for over five days to view the nearly 5,000 entries. Thanks to the Society's staff whose tireless efforts were invaluable and, of course, thanks to the hanging committee for mounting the show.

Finally, I'd like to especially thank the entrants who, despite the tragedy of September 11th and the uncertain climate in our business, all participated to make this show a success. You have proven that the need to create images remains vital and that you will find a way to persevere.

Joe Ciardiello
Chairman
44rd Annual Exhibition

Portrait by Steve Brodner

THE SOCIETY OF ILLUSTRATORS
44TH ANNUAL OF AMERICAN ILLUSTRATION
AWARDS GALAS

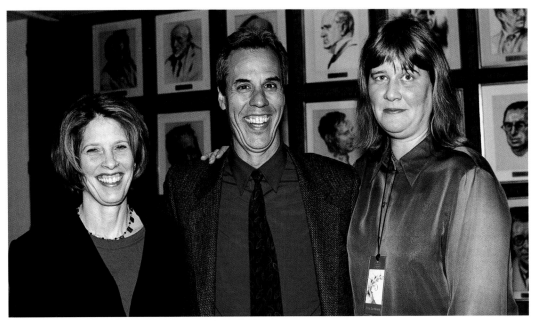

American Showcase and The Workbook were Co-Sponsors of the Awards Galas from the 44th Annual Exhibition. l. to r.: Ann Middlebrook, Executive Vice President, American Showcase; Bob Pastore, Director of Illustration Sales, The Workbook; and Erica Sturdevant, Director of Sales and Marketing, American Showcase.

american showcase

WORKBOOK
& COMPANY

THE ILLUSTRATORS HALL OF FAME

Since 1958, the Society of Illustrators has selected to its Hall of Fame artists recognized for their "distinguished achievement in the art of illustration." The list of previous winners is truly a "Who's Who" of illustration. Former presidents of the Society meet annually to elect those who will be so honored.

HALL OF FAME LAUREATES 2002

Milton Glaser
Daniel Schwartz
Elmer Simms Campbell*
Jean-Leon Huens*

HALL OF FAME COMMITTEE 2002

Chairman, Murray Tinkelman
Chairman Emeritus, Willis Pyle

Former Presidents
Vincent Di Fate
Diane Dillon
Peter Fiore
Al Lorenz
Charles McVicker
Wendell Minor
Howard Munce
Alvin J. Pimsler
Warren Rogers
Eileen Hedy Schultz
Shannon Stirnweis
Steve Stroud
John Witt

HALL OF FAME LAUREATES 1958-2001

1958	Norman Rockwell	1988	Robert T. McCall
1959	Dean Cornwell	1989	Erté
1959	Harold Von Schmidt	1989	John Held Jr.*
1960	Fred Cooper	1989	Arthur Ignatius Keller*
1961	Floyd Davis	1990	Burt Silverman
1962	Edward Wilson	1990	Robert Riggs*
1963	Walter Biggs	1990	Morton Roberts*
1964	Arthur William Brown	1991	Donald Teague
1965	Al Parker	1991	Jessie Willcox Smith*
1966	Al Dorne	1991	William A. Smith*
1967	Robert Fawcett	1992	Joe Bowler
1968	Peter Helck	1992	Edwin A. Georgi*
1969	Austin Briggs	1992	Dorothy Hood*
1970	Rube Goldberg	1993	Robert McGinnis
1971	Stevan Dohanos	1993	Thomas Nast*
1972	Ray Prohaska	1993	Coles Phillips*
1973	Jon Whitcomb	1994	Harry Anderson
1974	Tom Lovell	1994	Elizabeth Shippen Green*
1974	Charles Dana Gibson*	1994	Ben Shahn*
1974	N.C. Wyeth*	1995	James Avati
1975	Bernie Fuchs	1995	McClelland Barclay*
1975	Maxfield Parrish*	1995	Joseph Clement Coll*
1975	Howard Pyle*	1995	Frank E. Schoonover*
1976	John Falter	1996	Herb Tauss
1976	Winslow Homer*	1996	Anton Otto Fischer*
1976	Harvey Dunn*	1996	Winsor McCay*
1977	Robert Peak	1996	Violet Oakley*
1977	Wallace Morgan*	1996	Mead Schaeffer*
1977	J.C. Leyendecker*	1997	Diane and Leo Dillon
1978	Coby Whitmore	1997	Frank McCarthy
1978	Norman Price*	1997	Chesley Bonestell*
1978	Frederic Remington*	1997	Joe DeMers*
1979	Ben Stahl	1997	Maynard Dixon*
1979	Edwin Austin Abbey*	1997	Harrison Fisher*
1979	Lorraine Fox*	1998	Robert M. Cunningham
1980	Saul Tepper	1998	Frank Frazetta
1980	Howard Chandler Christy*	1998	Boris Artzybasheff *
1980	James Montgomery Flagg*	1998	Kerr Eby*
1981	Stan Galli	1998	Edward Penfield*
1981	Frederic R. Gruger*	1998	Martha Sawyers*
1981	John Gannam*	1999	Mitchell Hooks
1982	John Clymer	1999	Stanley Meltzoff
1982	Henry P. Raleigh*	1999	Andrew Loomis*
1982	Eric (Carl Erickson)*	1999	Antonio Lopez*
1983	Mark English	1999	Thomas Moran*
1983	Noel Sickles*	1999	Rose O'Neill*
1983	Franklin Booth*	1999	Adolph Treidler*
1984	Neysa Moran McMein*	2000	James Bama
1984	John La Gatta*	2000	Alice and Martin* Provensen
1984	James Williamson*	2000	Nell Brinkley*
1985	Charles Marion Russell*	2000	Charles Livingston Bull*
1985	Arthur Burdett Frost*	2000	David Stone Martin*
1985	Robert Weaver	2000	J. Allen St. John*
1986	Rockwell Kent*	2001	Howard Brodie
1986	Al Hirschfeld	2001	Franklin McMahon
1987	Haddon Sundblom*	2001	John James Audubon*
1987	Maurice Sendak	2001	William H. Bradley*
1988	René Bouché*	2001	Felix Octavius Carr Darley*
1988	Pruett Carter*	2001	Charles R. Knight*

*Presented posthumously

MILTON GLASER

(b. 1929)

Milton Glaser is not just an illustrator. However, if he were just an illustrator his contribution to late twentieth century applied arts and popular culture would be no less monumental. Yet because he has not been limited to one mode of expression his impact is even more extraordinary. Glaser is a designer whose graphic language includes narrative, conceptual, and decorative illustration, but decades ago he developed a holistic practice that wed type design to editorial illustration, magazine design to poster conception, interior design to book jackets and covers, and created a world in which art and design were completely intertwined. You see, Glaser ignores boundaries.

It is natural to cite Glaser's most iconic work as the reason for his induction in the Society of Illustrators Hall of Fame. The "Dylan" poster, "I ♥ NY" logo, and the post-9/11 "I ♥ NY More Than Ever" cover of the New York Daily News, to name a few of the memorable ones, are as recognizable today as were the most celebrated Norman Rockwell Saturday Evening Post covers. Yet for this writer Glaser's renown also derives from what he did not make himself but rather what he has influenced and inspired.

To this day when Victor Moscoso, one of the progenitors of the San Francisco psychedelic poster style, lists his influences he credits Glaser's sinuous, curvilinear drawing and vibrant color palette as a benchmark for psychedelia. And this approach further inspired Heinz Edelman's animated drawings—the color, line, and whimsy—for the now classic feature film Sgt. Pepper's Lonely Heart's Club Band. Back in the late sixties it was common to hear Glaser's name associated with the Blue Meanies, the sublimely comic villains of this Beatles film, even though he had nothing to do with them, because Glaser's hand was spiritually present.

When I was a teenager Glaser's eye-catching rainbow-colored posters for WNEW FM, America's first progressive rock 'n' roll radio station (which were ubiquitous in New York City), defined the epoch and helped launch the sixties

youth culture illustrative style. Likewise, his brightly colored, linear portrait of an American Indian published as a cover for Life magazine provided such a boost in the mainstream to this new period aesthetic, that I found myself copying the forms and colors in much of my own art school assignments. It is a tribute to Glaser's vision that his collected work became synonymous with the late sixties, while it is evidence of his genius that it also transcended the fashion of the times.

Glaser's designs are not artifacts of a single decade but epitomize the eclectic visual culture of the second half of the twentieth century, which Glaser (and his partner in Push Pin Studio, Seymour Chwast) helped foment. Prior to Push Pin's rise during the late fifties and sixties as a hot house of contemporary illustration and design practice, traditional drawing and painting had been marginalized by photographic and other mechanical media, which were more "of their time." Modernism rejected both representational and stylized illustrative techniques, calling them passé or anti-Modern. Glaser thought such prescriptions ridiculous and refused to accept dicta that art must be entirely of the moment. He proved that vintage styles, including Art Nouveau and Art Deco, could be resurrected and hybridized to be more than nostalgic pastiche but rather dialects within a universal design language. Doing so, he expanded

graphic communications and enlivened what had become an increasingly stolid practice. In the bargain he also presaged postmodernism, which eventually cast a large aesthetic shadow on design from the seventies through the nineties.

Whether labeled postmodern or eclectic Glaser has routinely embraced twentieth century design traditions while remaining contemporary. And yet it is curious that as styles predictably shift through the passage of years (sometimes months and even days), some of Glaser's formal inventions and re-inventions have been rejected as passé. Of course, such are the vicissitudes of fashion and the myopia of the young. Whatever the surface manifestations (and some of his are admittedly locked in time), Glaser's work is based on the sturdiest of foundations. "I was always personally interested in that idea that you could draw, you could design, you could do three-dimensional work, and so on," he notes in his career-defining book, Art is Work (Overlook Press, 2000). So to view his oeuvre—from the posters to the textiles to the restaurants to the jewelry (he's done it all)—it becomes crystal clear that drawing is indeed the lingua franca of visual communication, and that no amount of sophisticated computer programs can replace it.

Milton Glaser is not just an illustrator because illustration alone is too binding for his vast talents. He once said, "I'm never happier than when I'm making things or thinking about making things." And it is this passion for conception, regardless of whether the object is ephemeral or ageless, that keeps his mind fertile. It is this continued love affair with drawing, painting, printmaking, in short all the plastic arts through which he articulately converses with the public, that secures his pedestal in this Hall of Fame.

Steven Heller
Art Director of The New York Times Book Review and Co-chair of the MFA/Design program at the School of Visual Arts, New York

A GAY FANTASIA ON NATIONAL THEMES
ANGELS IN AMERICA

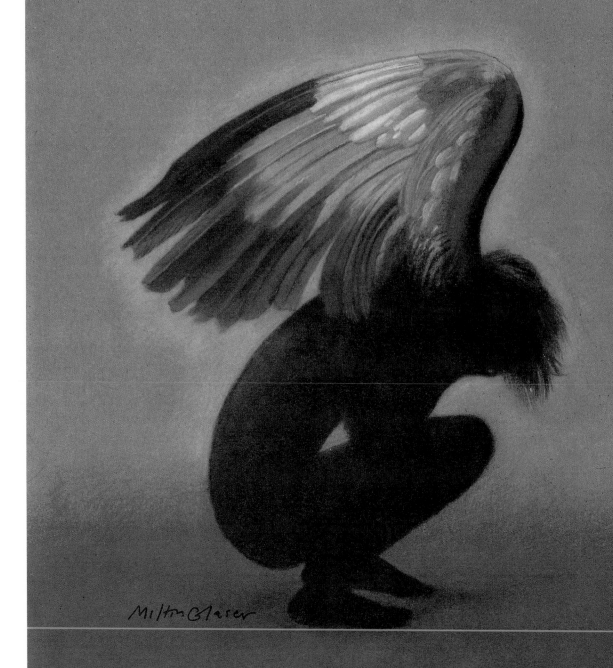

TONY KUSHNER

Illustration for the play *Angels in America Part One: Millennium Approaches* by Tony Kushner, 1993. Courtesy of the artist.

DANIEL BENNETT SCHWARTZ
(b. 1929)

By the time he was 12 years old, Daniel Bennett Schwartz already knew he would become an artist. Born in New York, he was raised in Queens and at the tender age of eight rode the elevated train to Manhattan for an art class every Saturday at The Little Red Schoolhouse. He was then accepted into the High School of Music and Art, which proved to be a significant turning point in his young life for he met remarkably talented kids from all over the city who would become lifelong friends and who themselves would have successful careers. "It was they," he says, "who introduced me to the classical tradition: Rembrandt, Goya, Ingres, Degas, Eakins, Homer, Kollwitz. My sights were set. I had gods."

After high school he won scholarships to the Art Students League, where he studied briefly with Yasuo Kuniyoshi, and to the Rhode Island School of Design in 1946. At RISD the emphasis was on the new aesthetic of Modern Art, but Schwartz was less interested in Cezanne or the Cubists than in Manet and Toulouse-Lautrec. Drawing from nature liberated him, and paradoxically, so did a growing fascination with postwar changes taking place in graphic design. He decided he was more suited to the field of illustration. After graduation in 1949, he returned to New York where, on the strength of his redesign of the RISD yearbook, Bradbury Thompson recommended him for an entry job in a small graphics firm. A few unhappy weeks in the bullpen convinced him that his efforts should be directed to trying his hand as a freelancer. He landed a commission for a book jacket and for the next several years he made a living depicting "nubile ladies in various stages of undress teetering on the brink of violation," while painting for himself at night.

By 1952 Schwartz had saved enough money for a trip to Europe where, he says, he saw "the mind-blowing old art at the heart of Western culture that only strengthened my conservatism." In 1954 he joined the Davis Galleries to show his paintings with like-minded realists. Schwartz's first one-man show in 1955 received good reviews and in 1956 he won the first of two Louis Comfort Tiffany Painting Grants, enabling him to return to Europe and live in France for an extended period of time.

Jerome Synder, the gifted art director of *Sports Illustrated*, was a longtime fan of the Davis Gallery artists and in 1959 he persuaded Schwartz to illustrate articles for the magazine. His involvement with athletes led to numerous paintings on the subject, which were exhibited at the Davis Gallery in a show called "On a Sports Theme." In 1960, *Esquire* offered Schwartz a commission for a series of illustrations which, added to several large, previously exhibited works, resulted in a major article. This impressive format generated excitement and led to similar assignments from *McCall's* and *Fortune*, then from *Redbook* and *Time*. The artist looks back on the sixties as a golden period for magazines, a time when brilliant editors wanted to do brilliant things, when Schwartz "saw the opportunity of making magazines a virtual gallery." For the next two decades, Schwartz's extraordinary and multi-faceted skills were utilized in cover portraits, annual reports, reportage for CBS and assignment as the Mobil Oil artist-in-residence in Southeast Asia. His work was recognized in many Society of Illustrators Annual Exhibitions, the coveted Gold Medal awarded to him eleven times. "The extraordinary illustration of Daniel Schwartz," wrote Gerald D. Bender in introducing a 1984 exhibition which included his work for the Academy Award-winning documentary *Genocide*, "has had a profound effect on his professional peers...Dan has extended his experience and training as a painter into the realm of the marketplace, which in turn has created an atmosphere that has helped broaden the range and ambitions of other illustrators."

The artist continues to show his paintings and his works are held in numerous public and private collections. He was elected to the Century Association in 1986 and to the National Academy of Design in 1997. Often been asked how he reconciles his painting and illustrating efforts, he replies, "Early on, I concentrated on learning my craft and in doing so, lost myself in that learning. I found I was unable to accept the aesthetic that the visual world—as a frame of reference—was at an end. So I go on painting in the way that makes me most happy, within a tradition that I can relate to. Though an illustration assignment brought with it its own tension, I found that working within that discipline under deadline pressure trained me to get to the point quickly and that the adventure and fun in the mix has made me a more well-rounded artist."

Walton Rawls

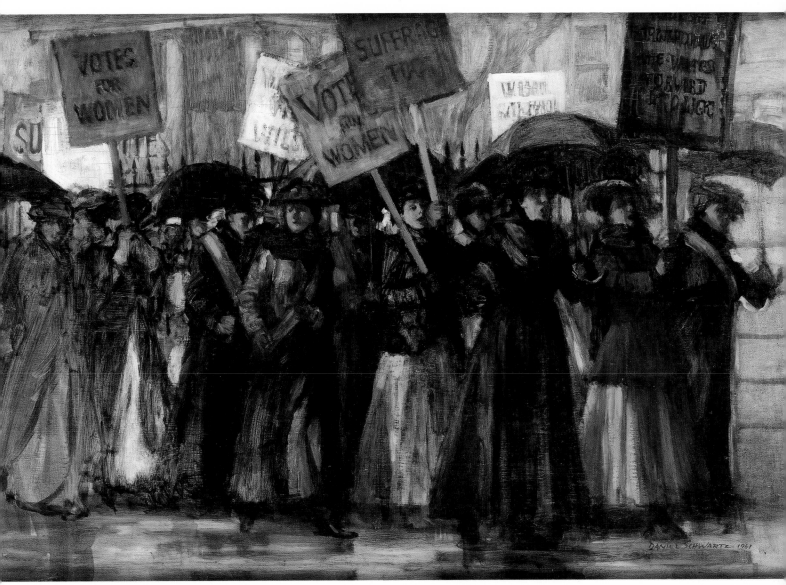

"When suffragists, calling themselves 'Silent Sentinels,' picketed the White House in 1917, President Woodrow Wilson invited them inside to get out of the cold, but they refused." Illustration for "Women's Suffrage" by Leonard Slater, *McCall's*, September 9, 1961. Courtesy of the Society of Illustrators Museum of American Illustration.

ELMER SIMMS CAMPBELL
(1906-1971)

Best known for his drawings of sumptuous women, Elmer Simms Campbell enjoyed success in both magazine illustration and newspaper cartooning. One of the first African American artists to have a long-term contract with a national magazine, he was hired by *Esquire* in 1933, and he created its mascot, Esky. From 1939 until his death in 1971, Campbell also had a syndicated cartoon panel for King Features titled "Cuties," an apt summary of its theme.

Elmer Simms Campbell was born in St. Louis, Missouri, on January 2, 1906. When he was four his father, a teacher and school administrator, died, and the boy was sent to Chicago to live with an aunt. He completed high school in Chicago and attended the University of Chicago before transferring to study briefly at the Chicago Art Institute. He returned to St. Louis and, despite being advised against pursuing an art career because of his race, he freelanced for several publications and supported himself by working as a waiter on a dining car. He worked for Triad Studios, a large commercial art firm, for 18 months before moving to New York City in 1929.

Famously hard working, Campbell drew advertisements, caricatures, cartoons, and sold gags to other artists. He enrolled at the Academy of Design and studied at the Art Students League, where he met other artists and became part of the New York art world as he began to make the round of magazine editors. The young artist moved to Harlem, and met singer Cab Calloway, who became a good friend. Campbell created a popular "Night-Club

Map of Harlem" which showed the locales of area hot spots. He was a handsome man who enjoyed partying until the wee hours, but he prided himself on never missing a deadline.

In 1932 Campbell illustrated a book of poetry by Sterling Brown titled *Southern Road*. The next year, he illustrated *Popo and Fina*, a gentle story set in Haiti written by Arna Bontemps and Langston Hughes. The beautifully crafted woodcut style of these book illustrations is an interesting departure from the fine brushwork of Campbell's cartoons and magazine illustrations.

Cartoonist Russell Patterson is said to have advised the young man to "specialize" in drawing beautiful women, with the comment that "you can always sell a pretty girl." Campbell took this advice and spent most of his career lampooning the world of upper-class white society with his art. Soon his work appeared in *Life*, *Judge*, *The Saturday Evening Post*, *The New Yorker*, *Collier's*, and, later on, *Playboy*. His syndicated feature,

which appeared nationally in 145 newspapers, was collected into two books, *Cuties* (1942) and *Cuties in Arms* (1943).

E. Simms Campbell worked at the time racial segregation was the norm in the United States. Because his work was primarily about the life of wealth and pleasure enjoyed by white people, and it appeared in mainstream publications, most of his admirers were unaware that Campbell was African American. Economic reality was the most likely motivation for the absence of African Americans in his art: until after the Civil Rights Movement, most American publications were not willing to feature nonstereotypical minority characters regularly.

Campbell's magazine and newspaper work had a fluid, painterly style. He was an expert in black and white, and his watercolor drawings have a spontaneity that sets them apart. Though his gags are humorous and entertaining, Campbell's watercolors fully engage and please the eye.

After *Esquire* redesigned its format in 1957, Campbell and his family moved to Switzerland where he lived and worked until 1970. Shortly after his return to the United States, he was diagnosed with cancer, and he died after a brief illness.

E. Simms Campbell received honorary degrees from Lincoln and Wilberforce universities. Regrettably, no public collections of his work are known.

Lucy Shelton Caswell
Professor and Curator
The Ohio State University
Cartoon Research Library

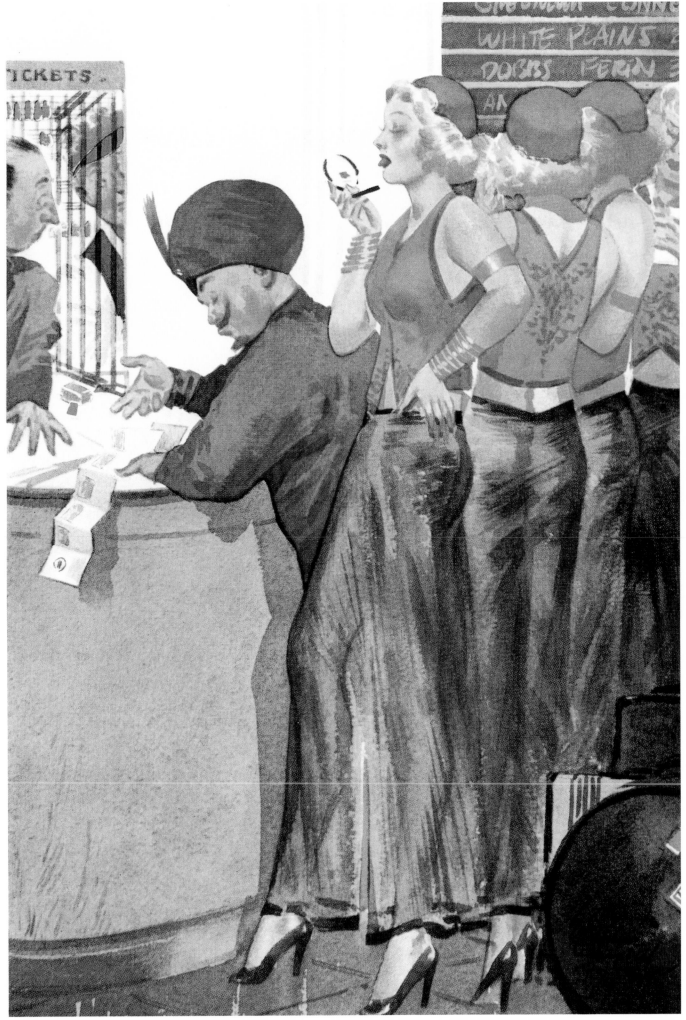

"Did you say A compartment, Sir?" Published in *Esquire*, March 1939. Courtesy of the Society of Illustrators Museum of American Illustration.

HALL OF FAME 2002

JEAN-LEON HUENS
(1921-1984)

The eyes of Gerardus Mercator, 16th-century Flemish cartographer, look into mine. The bearded old man is surrounded by maps and a globe, and holds in his hand a pair of dividers. His head is tipped slightly, and his eyebrows are raised, as if he has just posed a question about geography or mapmaking, and, like a patient professor, awaits my answer.

I found this portrait in an issue of *Penrose Annual* and wrote the author to see if the painting could be used in a map exhibit I was designing for the National Geographic Society. He forwarded my request to the artist in Belgium, and in a few days a small envelope arrived on my desk. In it was a postcard-size image of Mercator and a letter from Jean-Leon Huens telling me that this was the original painting and "May I ask you to guard this with your life." I was amazed that he would dispatch this exquisite little gem across the Atlantic, and to a perfect stranger!

Thus began a collaboration and a friendship that was to last for 17 years.

Generous in many ways, Jean-Leon Huens was most generous in the rich detail that he gave to every painting. Instead of using shortcuts and simplifications, he took great delight in recreating the wood grain in furniture, the texture of clothing, the brickwork of old buildings, the wrinkles of old age. And over all, a gentle Flemish light that unified all the elements of these miniature masterpieces.

Huens was a master not only of detail and of lighting, but also of perspective and composition. His panorama of Bethlehem at the time of Christ, painted for *Reader's Digest*, compels the eye to wander the streets, rooftops and plazas, and to end up back at the beginning, still wanting to mingle with the more than a hundred people going about their business. The panorama appeared in the book *Great People of the Bible and How They Lived* and also as the jacket design.

Huens painted many covers for *Reader's Digest* but they appeared in the magazine's international editions and were rarely seen in the United States. Reader's Digest also commissioned Huens to make more than a hundred paintings to illustrate Shakespeare's works. The book, unfortunately, was never published. Twenty-two of Huens' paintings were donated

to the Society of Illustrators.

Those works in the Society's collection are small, measuring but 5.25 by 7.25 inches. They are breathtakingly precise glimpses of scenes from *Julius Caesar*, *Hamlet*, and *Macbeth*: Calpurnia, on bended knee, begging Caesar not to leave; Macbeth hiring two wicked knaves to murder Banquo; Hamlet rejecting Ophelia with the line, "Get thee to a nunnery..."; Macduff holding Macbeth's severed head.

Had the book been published, these paintings would certainly have enriched the iconography of Shakespeare's work. But now they are stored in dark archives, seldom exhibited, because of the very light-sensitive nature of Huens' work.

Huens painted with what he called "watercolor pencils," which enabled him to render detail with great precision, later brushing a slight wash of clear water over the areas to blend the colors. He worked from photographs of models in various poses and costumes, often posing himself. His wife Monique—researcher, correspondent, translator, critic, and photographer—assisted him throughout his career.

Jean-Leon Huens was born December 1, 1921, in Melsbrock, Belgium. He attended the Institute of St. Luc and completed his studies at the Academy of La Cambre, in Brussels. At the end of World War II, while still in his twenties, Huens began illustrating children's books for publishers such as Casterman, Marabout, Désclee-DeBrouwer, and Durendal.

In 1946 Huens and his brother Etienne founded the Historia Society, with the aim of popularizing Belgian history through more than

400 paintings—village scenes, battle scenes, coronations, hangings, and portraits of heroes such as Gerardus Mercator. Huens' carefully researched paintings were lithographed in full color, each 3.75 × 5.75 inches, and were offered as premiums with packages of tea, chocolate, spices, and biscuits. Like nineteenth-century trade cards, the Historia Society cards are prized collectibles today.

As soon as I saw the Mercator portrait, I knew that Huens could enrich the pages of *National Geographic*, and in short order he was working on portraits of Copernicus, Kepler, Galileo, Newton, Herschel, Einstein, and Hubble, all of which appeared in the May 1974 issue. A year later, *National Geographic* published four Huens paintings in a story about Sir Francis Drake, including a heart-stopping view of the Golden Hind in the stormy seas of the Straits of Magellan. He later painted scenes of life in Thrace (ancient Bulgaria), and, for a major article on the Byzantine Empire, two large, fold-out paintings. One, a map of the Byzantine world, was painted as if it were a mosaic assemblage, a self-imposed challenge that he may have regretted, but one he finished flawlessly. The other, an aerial view of ancient Constantinople, is equally powerful.

Huens' Christmas cards throughout the years, painted in full color, showed Father Time in a wide variety of styles and situations, giving us a peek at Huens' overflowing wit and humor. This made him the perfect artist for a Time-Life Books series called The Enchanted World, a set of books about wizards, merlins, magic, and mystery. Huens completed but one painting, a promotional piece to help get the series marketed, before he died suddenly on May 24, 1982, in Benissa, Spain.

In his 60 years, Jean-Leon Huens had seen his work heralded throughout Europe, and had successfully expanded his audience to the United States. Now, 20 years after his death, the Society of Illustrators pays tribute to Jean-Leon Huens by inducting him into its Hall of Fame.

Howard E. Paine
Former Art Director
National Geographic

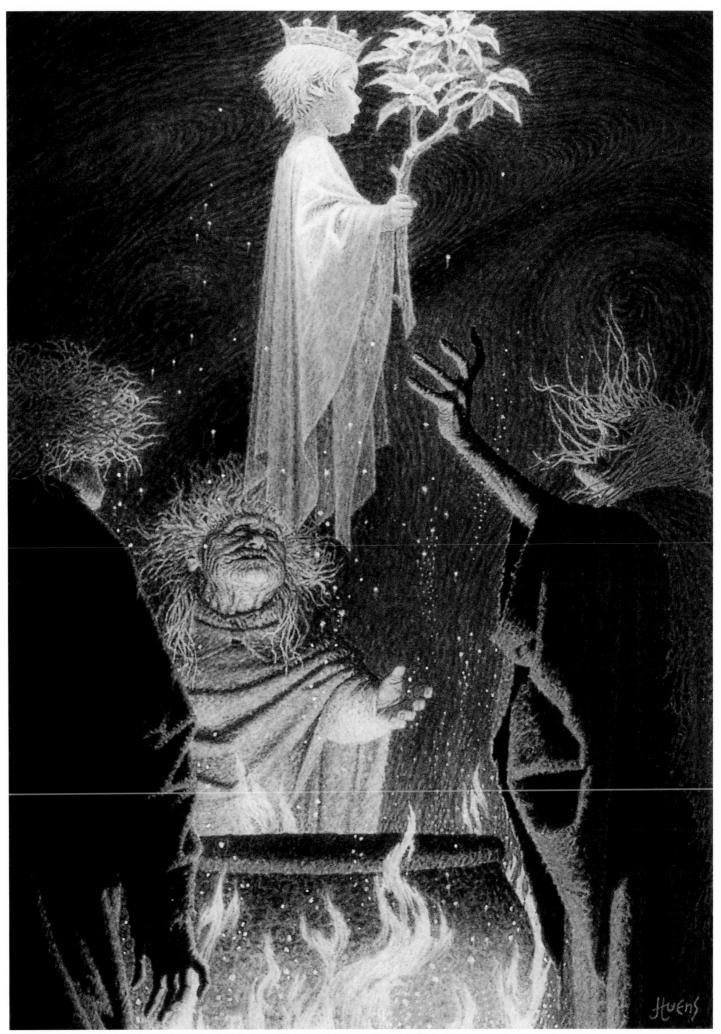

Illustration for *Macbeth*, Act IV, Scene I. Courtesy of the Society of Illustrators Museum of American Illustration.

HAMILTON KING AWARD 2002

PETER DE SÈVE

(b. 1959)

The Hamilton King Award, created by Mrs. Hamilton King in memory of her husband through a bequest, is presented annually for the best illustration of the year by a member of the Society. The selection is made by former recipients of this award and may be won only once.

Years ago, too many to count, I started bugging Peter to give me one of his originals. Any one of his originals. I recognized a future Hamilton King Award winner when I saw one. For form's sake, we arranged a trade, but I knew he was just humoring me. I could tell by the nervous tic in his face that he would have preferred cash. Now, many years later, as I study that very same original, I continue to marvel at its seamless marriage of natural wit and unnatural drawing ability.

As early a piece as it is, it still effectively demonstrates the signature de Sève "one-two." One: A small, excited man leans into his computer with the eager smile of one who has just snagged the muse. Over his head, and illuminating the room in which he works, is the light bulb of the "big idea." Two: Lost in the blue shadows at his feet are several discarded and broken light bulbs of former big ideas that didn't quite fly. Or, if viewed as a metaphor for our Mr. de Sève, they could represent the spent shells of a rapid fire and seemingly limitless reservoir of big ideas.

When I think of Pete, I see him leaning against a polished mahogany bar, with that famous de Sève half smile, swirling a martini, entertaining friends and strangers alike with his lightning quick sense of humor and easygoing charm. He is, it could be said, New York City personified. So what better artist to grace the cover of *The New Yorker* with his work than Mr. de Sève himself. For about ten years now, he's been doing just that, by supplying a steady stream of covers that have never failed to hit the

mark. Each one showcases an effective blend of humor and charm, brilliant execution, solid composition, mellowed color, and that unique, expressive line. Not unlike the perfect martini, they have a sophisticated depth, but, at the same time, are light, airy—a joy to behold.

But these are not his only triumphs. Not by a long shot. Though the world of editorial illustration has provided the perfect stage for his magic brew of multilayered concept, subtle wit and intimidating draftsmanship, de Sève has also conquered the more challenging worlds of advertising, book, and film. His character designs for the movie *Ice Age* broke new ground, not only in how well conceived they were, but, perhaps more importantly, in that he managed to ride herd on them all the way up and on to the big screen, safeguarding their integrity from the dumbing down of production limitations.

I won't attempt to describe his patented Old World technique of pencil, pen, and paint. At this point, there is no one who holds any interest in contemporary illustration left on the planet, who is not familiar with his work. Besides, he can be mysteriously elusive about his process. According to a somewhat incoherent article in the November/December '94 issue of

Step-By-Step magazine, Peter employs approximately 467 steps just to transfer a sketch onto watercolor paper. Any scheming newcomers with designs of hopping on board a good thing were so completely thrown off by that article, they left the field altogether.

When visiting his Brooklyn studio, which sits atop the grand old brownstone he shares with his lovely wife Randall, their equally lovely daughter Paulina, various cats, and a dog who claims to be from France, I always have to brace myself for the staggering amount of artwork Pete generates like a crazed machine with a broken throttle. Flat files, like tiered waterfalls, overflow with sketches and paintings, each one a rich piece that deserves the kind of close inspection Pete usually denies out of some bizarre sense that it doesn't measure up.

I'd like to cite some favorites, but where to begin? The piece represented here is one of a small collection of jewels created for the previously unpublished book, *A Murder, a Mystery, and a Marriage*, by Mark Twain. It's a fine example of Pete's best work, and demonstrates his deep understanding of true characterization. Not just of humans or animals, but of clouds, hot air balloons, wicker, rope, anything and everything. In other words, all the stuff of life.

I can't possibly touch on all of de Sève's accomplishments, but I will say he has never altered or compromised his dedication, his genuine reverence and love for the art, no matter who the client. I don't think he could. His work is a perfect extension of himself, and I'm really not sure where one leaves off and the other begins.

I'm honored to have been asked to write this, and let me add, there is nobody more deserving of the Hamilton King Award than you, Mr. Man. My heartfelt congratulations.

Carter Goodrich

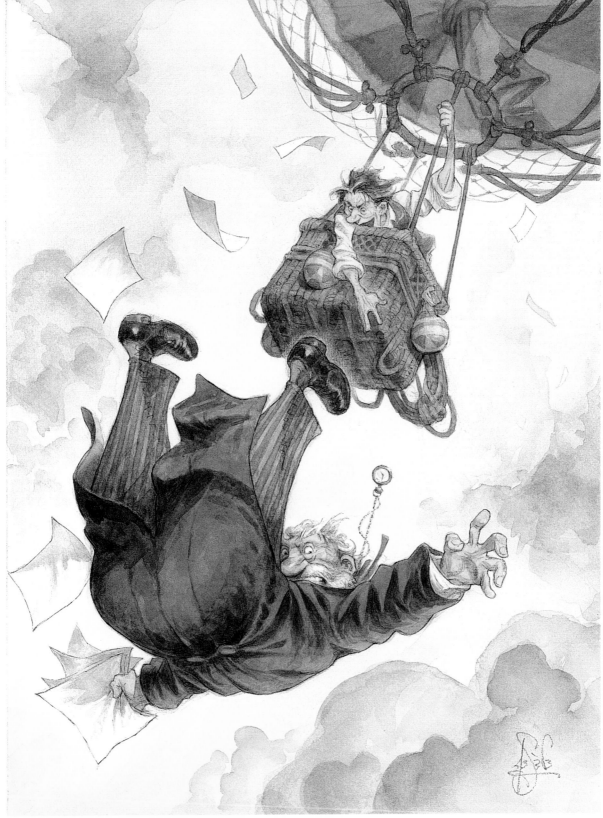

"I hove him out of the balloon!" from *A Murder, a Mystery and a Marriage* by Mark Twain, published by W.W. Norton, 2001.

HAMILTON KING AWARD 1965-2002

1965	Paul Calle	1977	Leo & Diane Dillon	1990	Edward Sorel
1966	Bernie Fuchs	1978	Daniel Schwartz	1991	Brad Holland
1967	Mark English	1979	William Teason	1992	Gary Kelley
1968	Robert Peak	1980	Wilson McLean	1993	Jerry Pinkney
1969	Alan E. Cober	1981	Gerald McConnell	1994	John Collier
1970	Ray Ameijide	1982	Robert Heindel	1995	C.F. Payne
1971	Miriam Schottland	1983	Robert M. Cunningham	1996	Etienne Delessert
1972	Charles Santore	1984	Braldt Bralds	1997	Marshall Arisman
1973	Dave Blossom	1985	Attila Hejja	1998	Jack Unruh
1974	Fred Otnes	1986	Doug Johnson	1999	Gregory Manchess
1975	Carol Anthony	1987	Kinuko Y. Craft	2000	Mark Summers
1976	Judith Jampel	1988	James McMullan	2001	James Bennett
		1989	Guy Billout	2002	Peter de Sève

SEQUENTIAL

JURY

Randy Enos, Chair
Illustrator

Joey Cavalieri
Editor
DC Comics

Genevieve Coté
Illustrator

Tomer Hanuka
Illustrator

Peter Kuper
Cartoonist/illustrator

Matthew Lenning
Deputy Art Director
GQ Magazine

Bill Plympton
Illustrator/animator

Bill Sienkiewicz
Comic book artist/author

SEQUENTIAL

I GOLD MEDAL
Artist: **Farel Dalrymple**
Publisher: Cryptic Press
Medium: Ink on 2 ply Bristol board (interiors), oil

"While not doing much in the way of commercial illustration work, I have been making my own comic books for about four years now. I helped found the popular comic book anthology *Meathaus* (www.meathaus.com), as well as editing the first five issues. With *Pop Gun War*, I was trying to make the sort of comic book I would like to read. The greatest compliment I can receive is being told that *Pop Gun War* inspired them to make their own comic book. *Pop Gun War* is currently being published quarterly from Absence of Ink Comic Press."

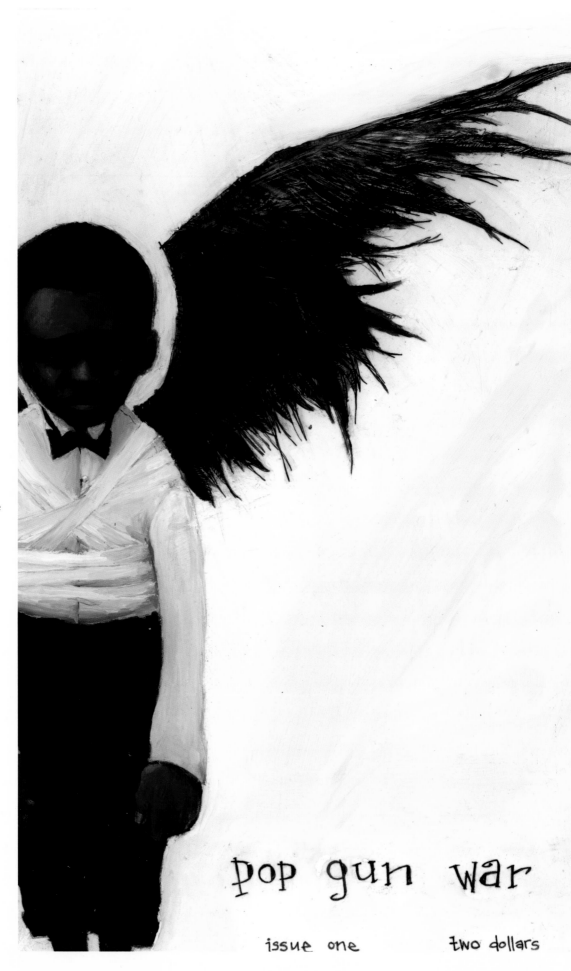

pop gun war

issue one two dollars

SEQUENTIAL

2 SILVER MEDAL
Artist: **Kevin C. Pyle**
Publisher: Autonomedia
Medium: Pen & ink

"While I was writing and illustrating this book, I often thought of it as a dream illustration gig—an extended history encompassing a century of ideas and imagery. I think there's a deep possibility for the illustrator to function as a journalist, to bear witness, in his or her imagination, to the increasingly restricted and unseen events of our time. For that reason, it is especially heartening and gratifying that the Society chose to distinguish this work."

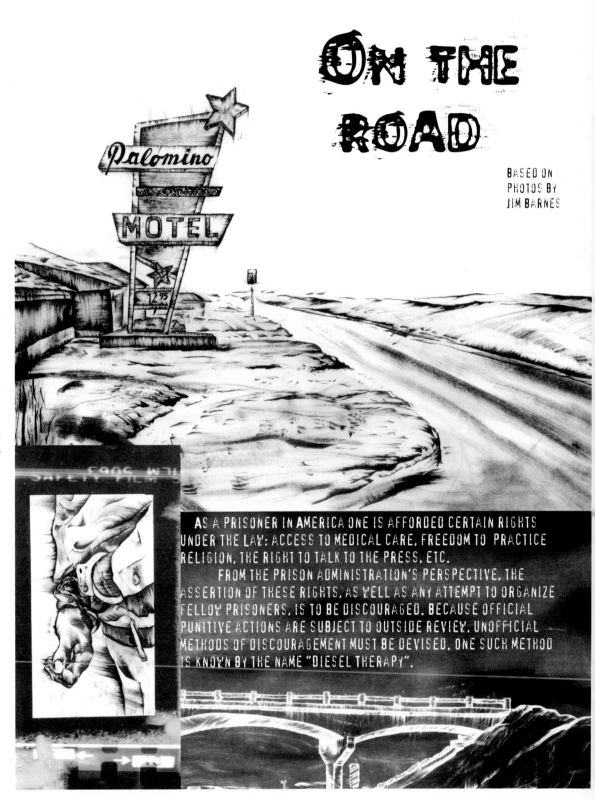

ON THE ROAD

BASED ON PHOTOS BY JIM BARNES

AS A PRISONER IN AMERICA ONE IS AFFORDED CERTAIN RIGHTS UNDER THE LAW: ACCESS TO MEDICAL CARE, FREEDOM TO PRACTICE RELIGION, THE RIGHT TO TALK TO THE PRESS, ETC.

FROM THE PRISON ADMINISTRATION'S PERSPECTIVE, THE ASSERTION OF THESE RIGHTS, AS WELL AS ANY ATTEMPT TO ORGANIZE FELLOW PRISONERS, IS TO BE DISCOURAGED. BECAUSE OFFICIAL PUNITIVE ACTIONS ARE SUBJECT TO OUTSIDE REVIEW, UNOFFICIAL METHODS OF DISCOURAGEMENT MUST BE DEVISED. ONE SUCH METHOD IS KNOWN BY THE NAME "DIESEL THERAPY".

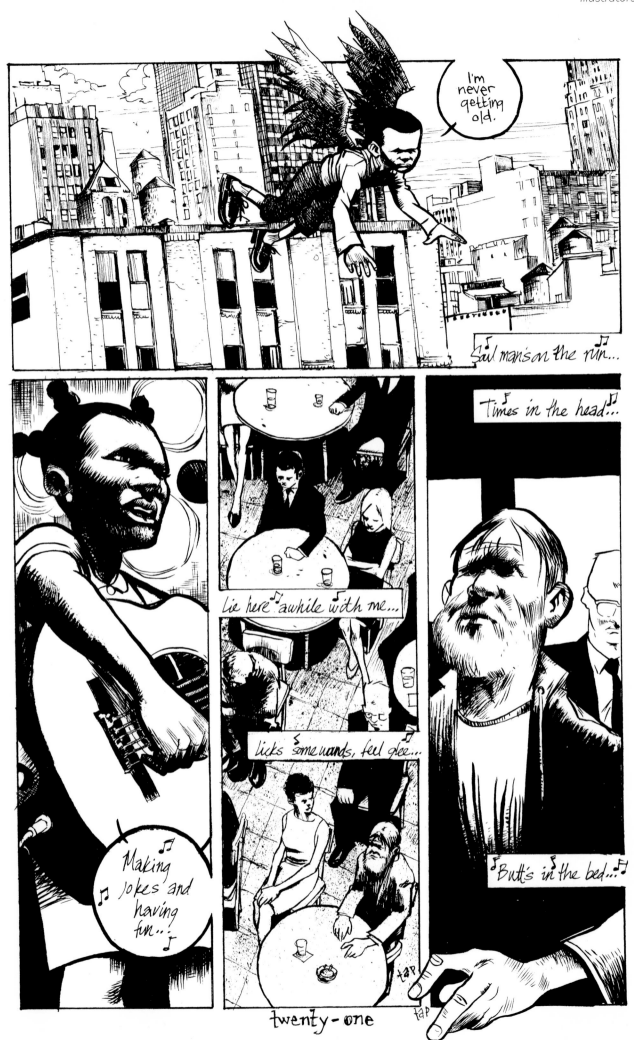

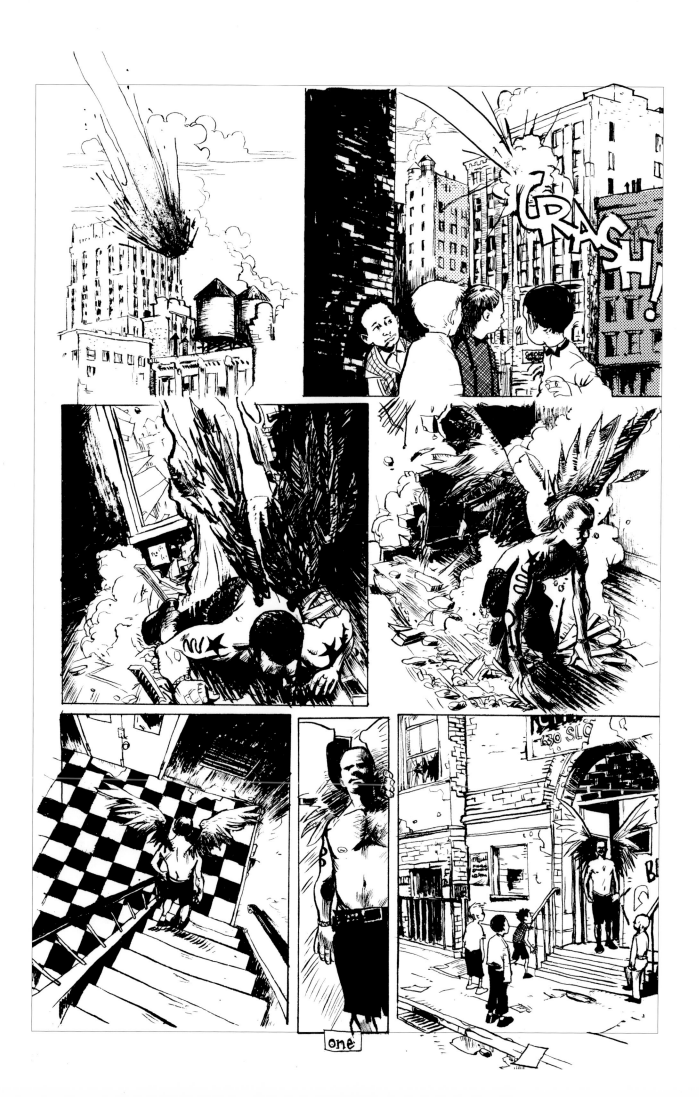

1962 In the early 1960s Dr. Austin R. Stough ran a blood donation and drug testing operation in the prison systems of Oklahoma, Arkansas, and Alabama. His program produced about a fourth of the plasma used to make the national supply of gamma globulin and conducted between 25 and 50 percent of the total experimental investigational drug studies from 1962 to 1969.[6]

1983 In the early 1980s Health Management Associates(HMA) provided health care to inmates in the Arkansas prison system. They also ran a blood donation program. Most of the blood was bought by a Canadian bloodbroker,Continental Pharma Cryosan,LTD. Cryosan had a shady reputation for selling blood from Russian cadavers relabeled as being from Swedish volunteers.[8]

The prisoners were paid $1.00 a day, greatly supplementing the $.50 they received every 3 weeks for incidental spending. An executive of one of Stough's most prominent clients, Cutter Labratories, descibed the conditions as "sloppy" and that gross contamination of the rooms with donors' plasma was evident.[7]

1962

Cummins Farm Prison in Arkansas paid prisoners $7.00 for a pint of blood that sold on the international blood market for $50.[9] It has since been revealed that HMA did no screening of donors even after the FDA issued special alerts about higher incidence of AIDS and hepatitis in prison. Several former inmates with H.I.V. and hepatitis charge that they were cross-contaminated with dirty needles.

3

Artist: **Daniel Zezelj**

Client: Clandestino Publications

Medium: Ink on paper

Size: 12" × 9"

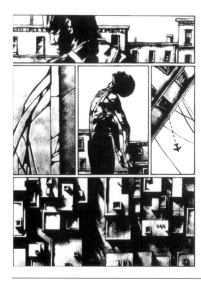
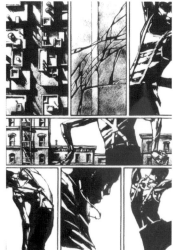
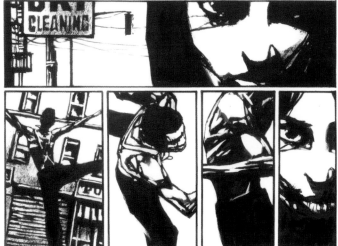

4

Artist: **Matt Dicke**

Publisher: Hard Left Press

Medium: Monotype, digital
on BFK paper

Size: 15" × 20"

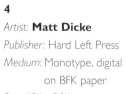
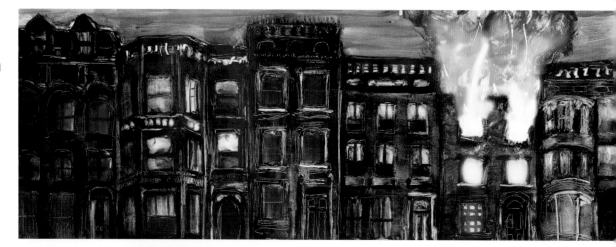
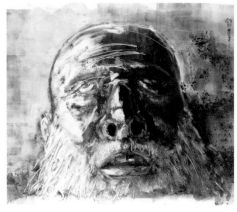
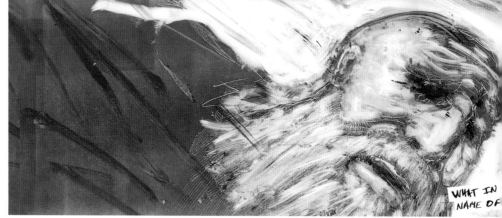

5

Artists: **Bill Sienkiewicz**

Jose Villarrubia

Art Directors: Mike Marts

Mike Raitch

Client: Marvel Enterprises, Inc.

Medium: Digital

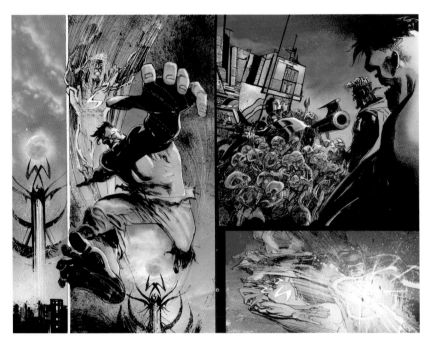

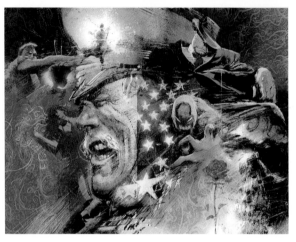

6

Artist: **Gareth Hinds**

Client: thecomic.com

Medium: Pen & ink, watercolor-dye wash, spattering, white charcoal on 100% cotton plate Bristol

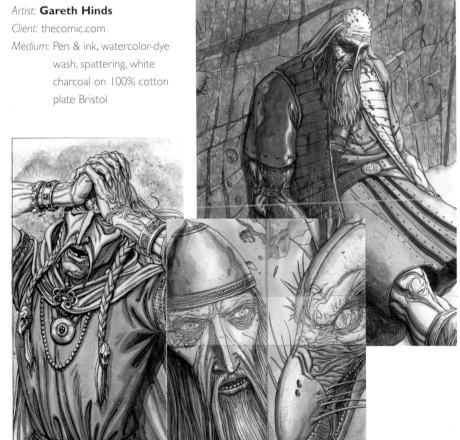

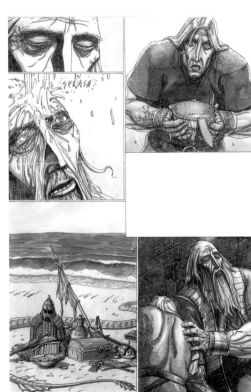

7

Artists: **Jae Lee**
 Jose Villarrubia

Art Directors: Nanci Dakesian
 Stuart Moore

Client: Marvel Enterprises, Inc.

Medium: Digital

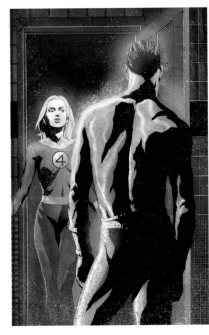
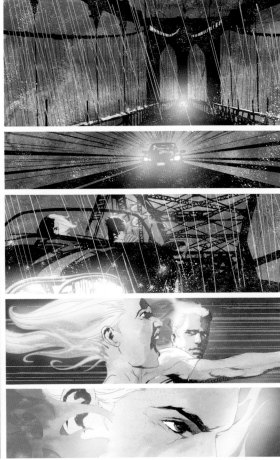

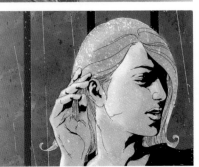
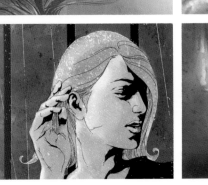

8

Artists: **Jae Lee**
 Jose Villarrubia

Art Directors: Nanci Dakesian
 Stuart Moore

Client: Marvel Enterprises, Inc.

Medium: Digital

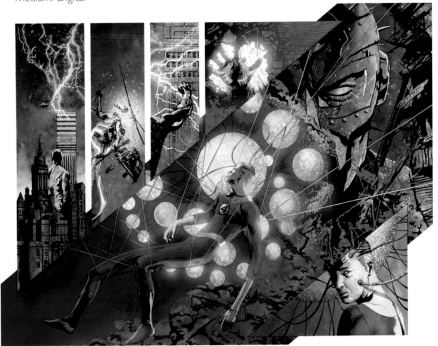

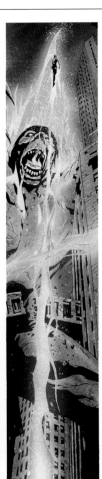

9

Artists: **Jae Lee**
Jose Villarrubia

Art Directors: Nanci Dakesian
Stuart Moore

Client: Marvel Enterprises, Inc.

Medium: Digital

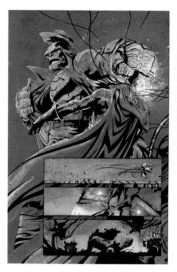

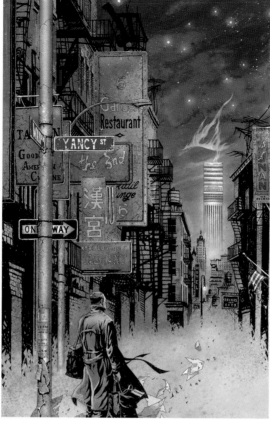

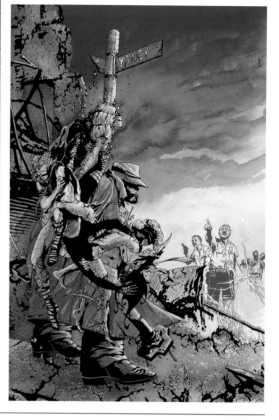

10

Artist: **Christopher Moeller**

Art Directors: Dan Raspler
Amie Brockway

Client: DC Comics

Medium: Acrylic on
illustration board

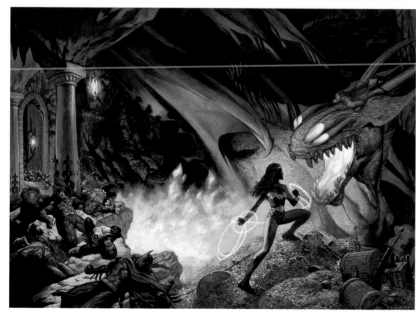

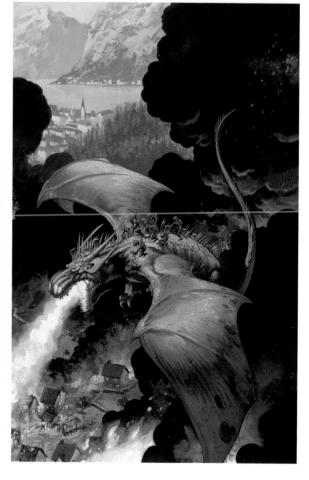

11

Artist: **Laura Levine**

Art Director: Monte Beauchamp

Client: Blab! Magazine

Medium: Acrylic, mixed on
found cupboard door

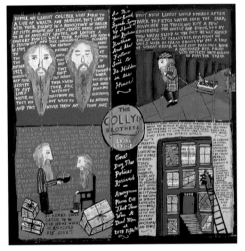

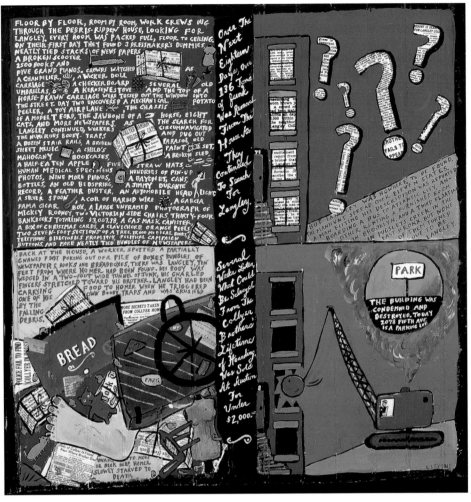

12

Artist: **Mark Alan Stamaty**

Art Director: Matthew Lenning

Client: Gentleman's
Quarterly

Medium: Pen & ink, pencil,
gouache, watercolor
on 2 ply Strathmore,
plate finish

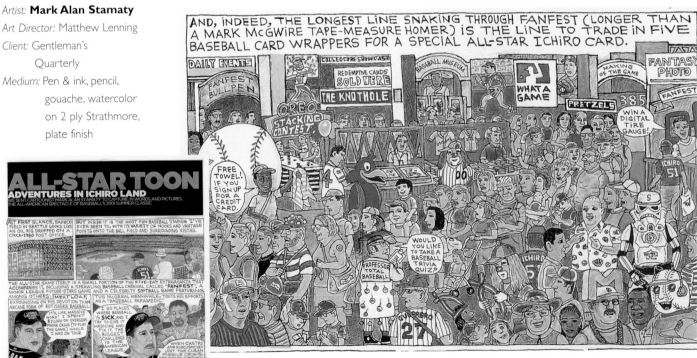

13

Artist: **Dave McKean**

Client: Allen Spiegel Fine Arts/
Kent Williams Publishing

Medium: Mixed

14

Artist: **Craig Frazier**

Art Director: Malcolm Frouman

Client: Business Week

Medium: Digital

Size: 22" x 16"

SEQUENTIAL

15

Artist: **Seymour Chwast**

Art Director: Oliver Prange

Client: Personlich Magazine

Medium: Mixed

16

Artist: **Gerard DuBois**

Art Director: Coleen McCudden

Client: Selling Power

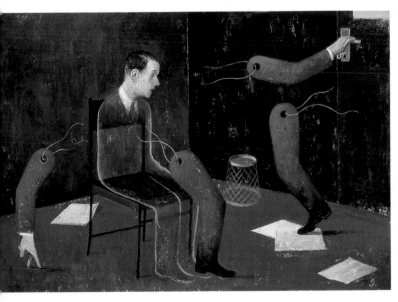

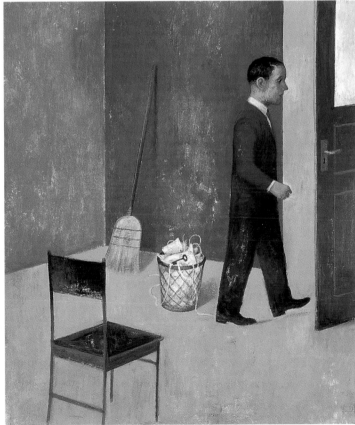

17
Artist: **Steve Brodner**
Art Director: Tim Baldwin
Client: Philadelphia Magazine

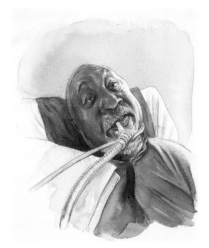

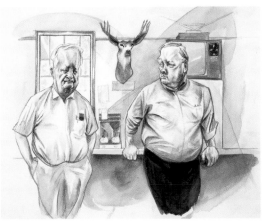

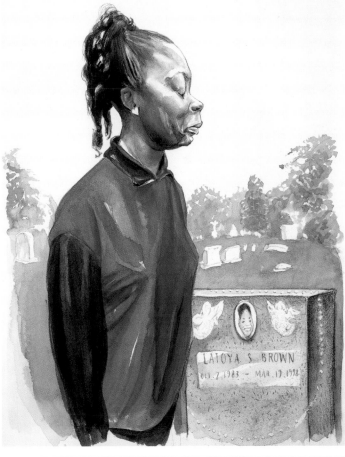

18
Artist: **Lynn Pauley**
Client: Dean & DeLuca
Medium: Acrylic, pencil on paper
Size: 12" × 16"

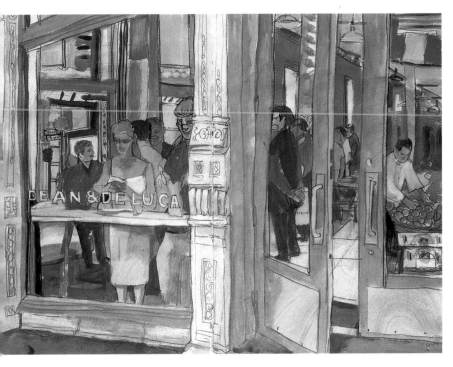

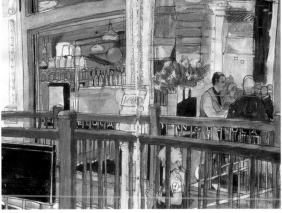

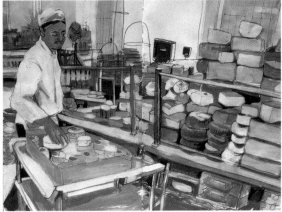

19

Artist: **Brian Cronin**

Art Director: Steve Ramos

Client: Forbes

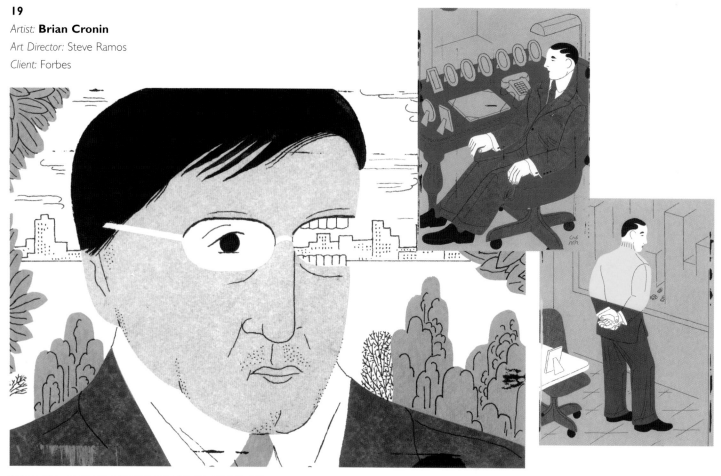

20

Artist: **Marcos Chin**

Art Director: Carole Rufiange

Client: ALDO

Medium: Digital

Size: 8" x 11"

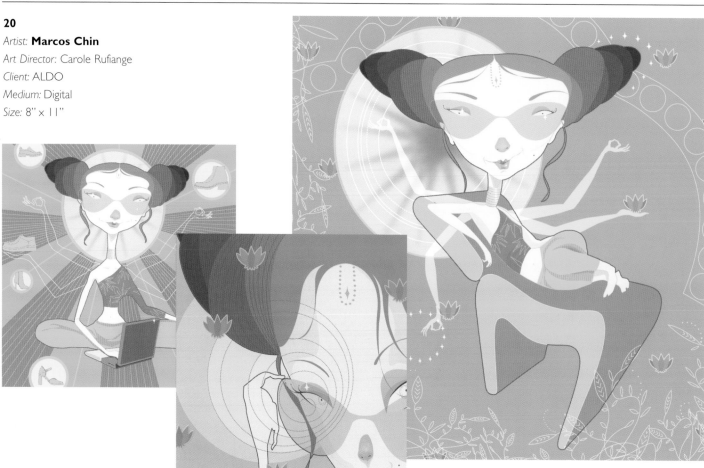

21

Artist: **Greg Clarke**

Art Director: Monte Beauchamp

Client: Fantagraphics Books

Medium: Pen & ink, watercolor

Size: 10" x 10"

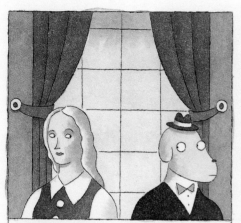

Calling on Thursdays was Jane, a professor of epistemology, who bore an uncanny resemblance to Raphael's "Lady of the Unicorn."

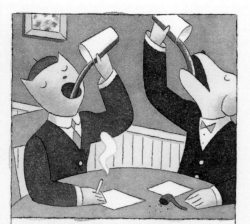

Every Saint Patrick's Day, he quaffed Guinness with Walter, famous for debunking the widely held belief that everything happens for a reason.

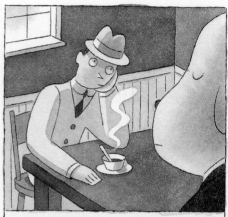

His crony Phil, an art dealer, lamented the tyranny of his own good taste and yearned to experience pleasure through mediocrity.

22

Artist: **Douglas Fraser**

Art Director: Monte Beauchamp

Client: Blab! Magazine

Medium: Alkyd, spray paint, pencil on paper

SEQUENTIAL

23
Artists: **Peter Hoey**
 Maria Hoey
Art Director: Monte Beauchamp
Client: Blab! Magazine
Medium: Digital
Size: 10" × 10"

24
Artist: **Steven Guarnaccia**
Art Director: Monte Beauchamp
Client: Blab! Magazine
Medium: Pen & ink, watercolor
 on watercolor paper

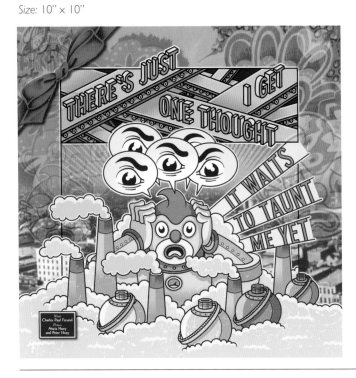

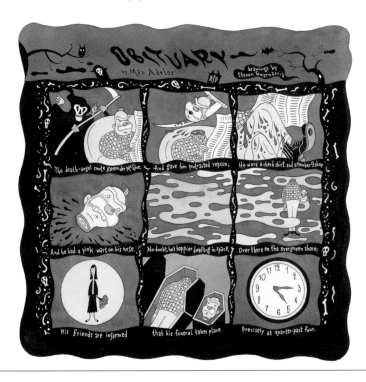

25
Artist: **Carter Goodrich**
Art Director: Mary Parsons
Client: The Atlantic Monthly
Medium: Colored pencil

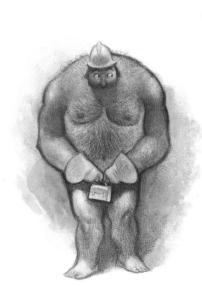

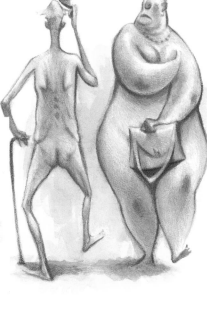

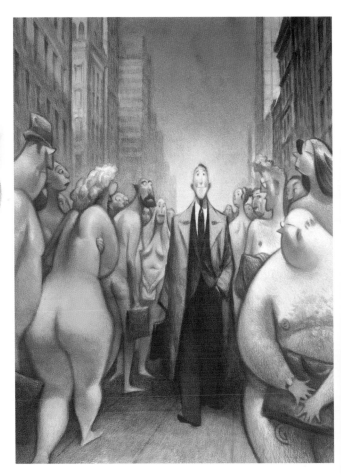

26

Artist: **Peter Kuper**

Art Director: Brett Warnock

Client: Top Shelf Productions

Medium: Mixed

Size: 15" x 10"

 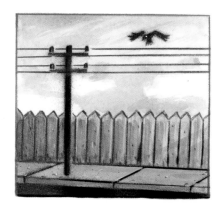 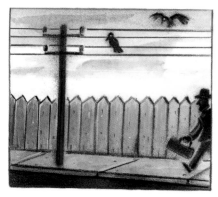

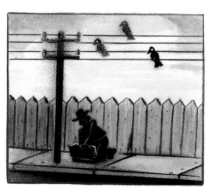 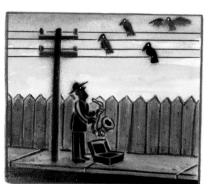

27

Artist: **Serge Bloch**

Art Director: Mary Ann Bean

Client: Iceland Air

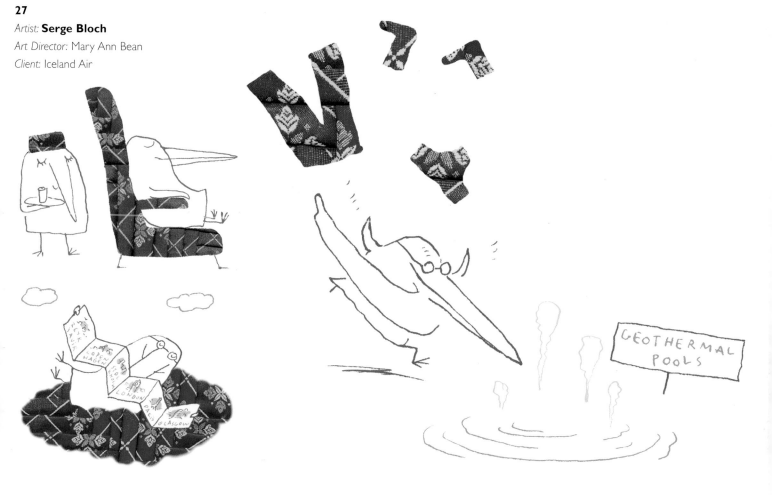

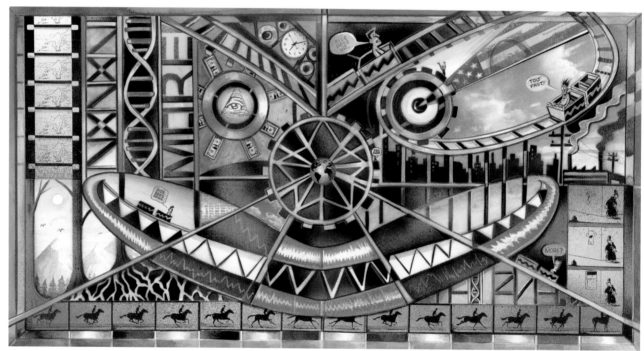

SEQUENTIAL

30

Artist: **Gary Baseman**

Client: Disney/ABC Television

Medium: Mixed

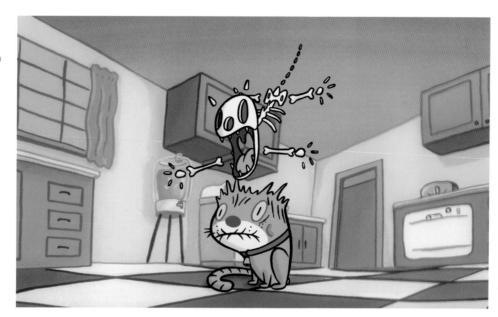

31

Artist: **Peter Kuper**

Art Director: Monte Beauchamp

Client: Blab! Magazine

Medium: Mixed

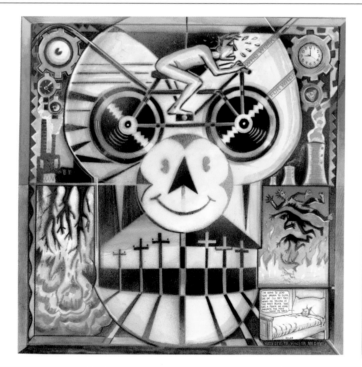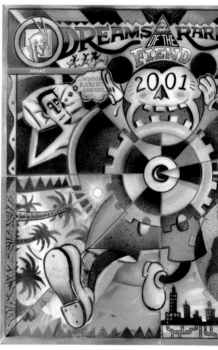

32

Artist: **Steven Guarnaccia**

Art Director: Chris Oliveros

Client: Drawn & Quarterly

Medium: Pen & ink,
watercolor on
watercolor paper

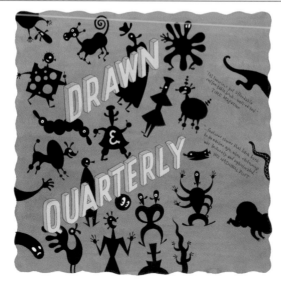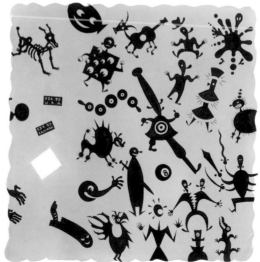

28

Artist: **Joe Thiel**

Art Director: Jon Ward

Client: Long Wind Publishing

Medium: Acrylic, pencil, digital on
 Xerox transparencies

29

Artist: **Daniel Lim**

Art Directors: Alex Gross
 Richard Keyes

Medium: Gouache, acrylic, ink

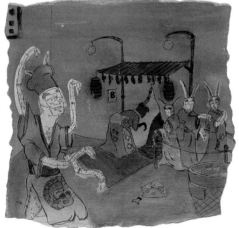

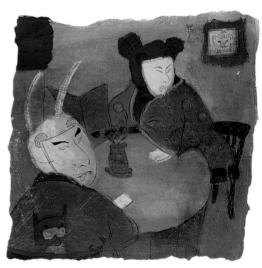

EDITORIAL

JURY

Guy Billout, Chair
Illustrator

Istvan Banyai
Illustrator

Teresa Fernandes
*Art director and principal
TFD Studio*

Louise Fili
*President
Louise Fili Ltd.*

Hollis King
*Vice President, Creative Services
The Verve Music Group*

Rick Meyerowitz
Illustrator/author

Neill Archer Roan
*Principal and CEO
The Roan Group*

Whitney Sherman
Illustrator

Kenneth Smith
*Art Director
TIME*

33 GOLD MEDAL
Artist: **Phil Hale**
Art Directors: Tom Staebler
 Kerig Pope
Client: Playboy
Medium: Oil on linen
Size: 40" × 56"

"*Playboy* has always been the main forum for many of my favorite illustrations, but my fear of designer Kerig Pope keeps me reasonable at some cost to the picture itself." "Hardcore Hate" paints a not too pretty picture of then-Governor George W. Bush's rehabilitation policies. Race is a key player in that violent environment.

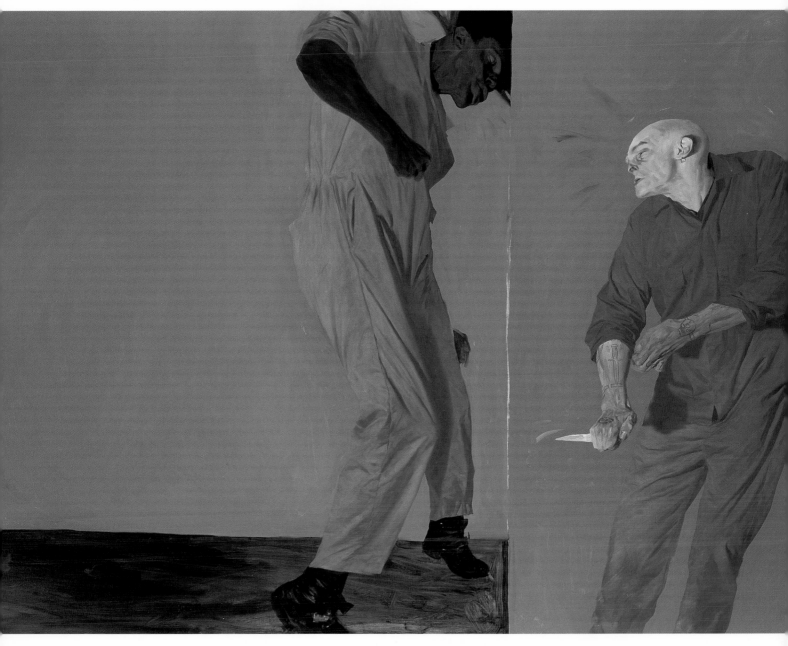

34 GOLD MEDAL
Artist: **Edel Rodriguez**
Art Director: Owen Phillips
Client: The New Yorker
Medium: Pastel, gouache, woodblock
 printing ink on colored paper
Size: 7" x 7"

Born in Havana, Cuba, in 1971, the artist moved to the U.S. when he was nine. He studied at Pratt Institute and has often worked for Owen Phillips at *The New Yorker*. "For this assignment, I was asked to do a portrait of the Senegalese musician Youssou N'Dour. It would run in the `Goings on About Town' section. For inspiration, I was given several of his CDs to listen to. The music had a dreamy, delicate quality with a definite African feel. The spareness of the composition and the colors grew out of the music's character."

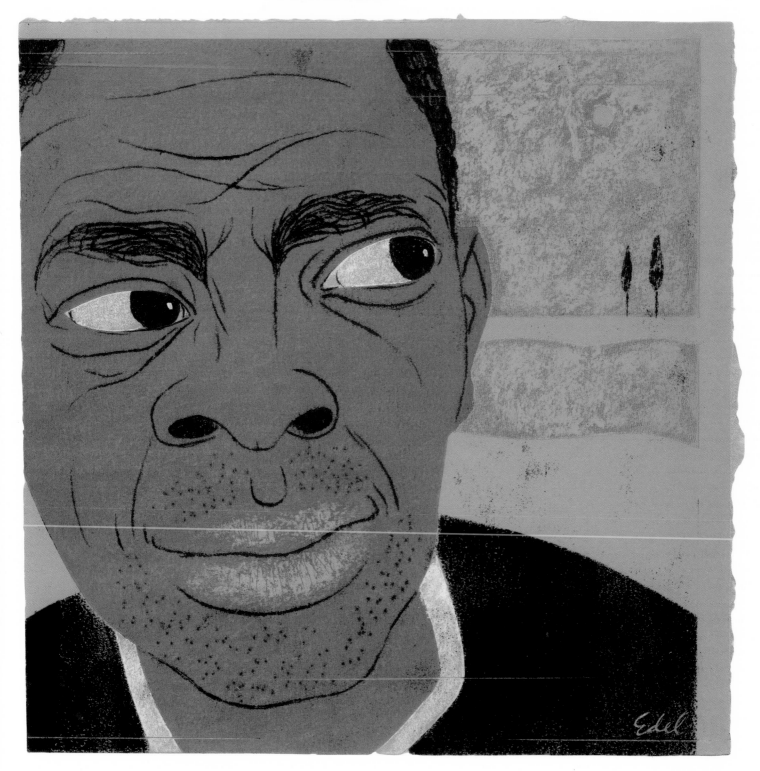

35 SILVER MEDAL
Artist: **Barry Blitt**
Art Director: Michael Lawton
Client: Men's Journal
Medium: Watercolor, ink
Size: 12" x 9"

A Montreal native schooled in Toronto, Barry Blitt has been in New York for twelve years. Blitt said that he came up with other varieties to add to this fowl flock after the job was complete. The thinking part and the first rough, loose sketch is the fun for him; the final ink and watercolor is the job.

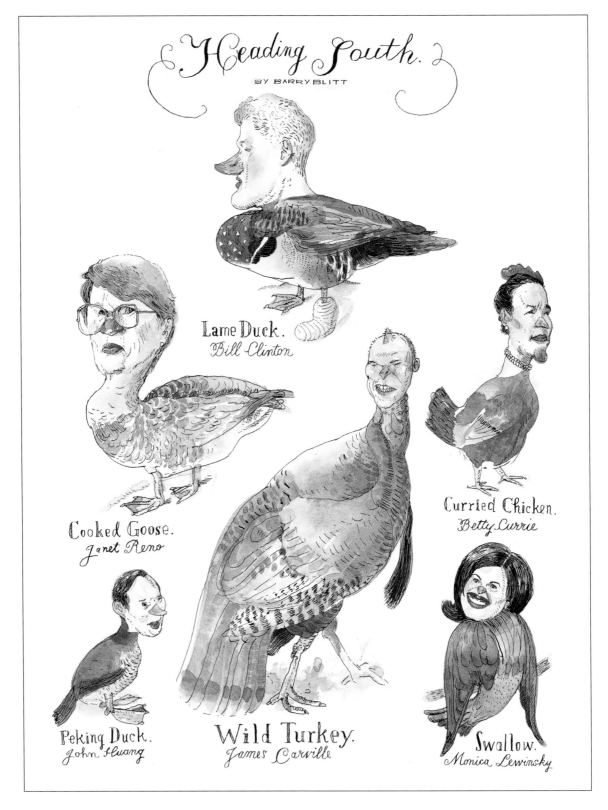

36 SILVER MEDAL
Artist: **Tim O'Brien**
Art Director: Mary Parsons
Client: The Atlantic Monthly
Medium: Oil on panel
Size: 14" x 12"

"Certain jobs just sound perfect during the first phone call. Mary Parsons, art director of *The Atlantic Monthly*, described an article and rough idea that I immediately envisioned close to the final result. I'm grateful for any job where the editors, art directors, or designers aim to use illustration to advance an idea or an article, not just decorate it. I not only thank the Annual jury for this award, but thank Mary Parsons, and all my clients who keep me busy. My wife Elizabeth, and son Cassius appreciate it."

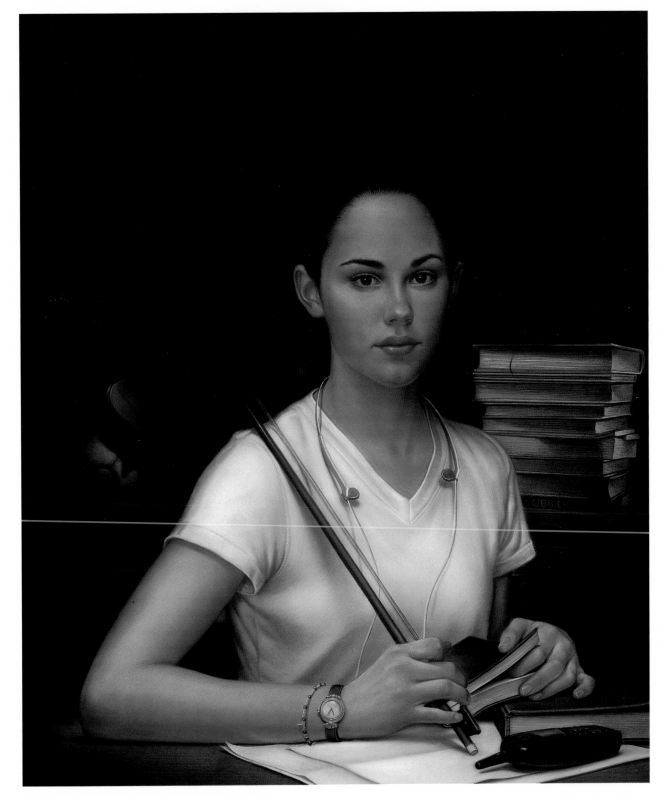

37 SILVER MEDAL

Artist: **C.F. Payne**

Art Director: Steven Heller

Client: The New York Times Book Review

Size: 14" x 11"

In three days, Chris Payne caught the youth and ire—the "darker side"—of Joe Dimaggio in watercolor, oils, acrylics, and inks. The artist says, "It's the drawing that counts," and, as quoted from the National Cartoonists Society newsletter, he gave this description of the field: "Illustration is art done under the circumstances."

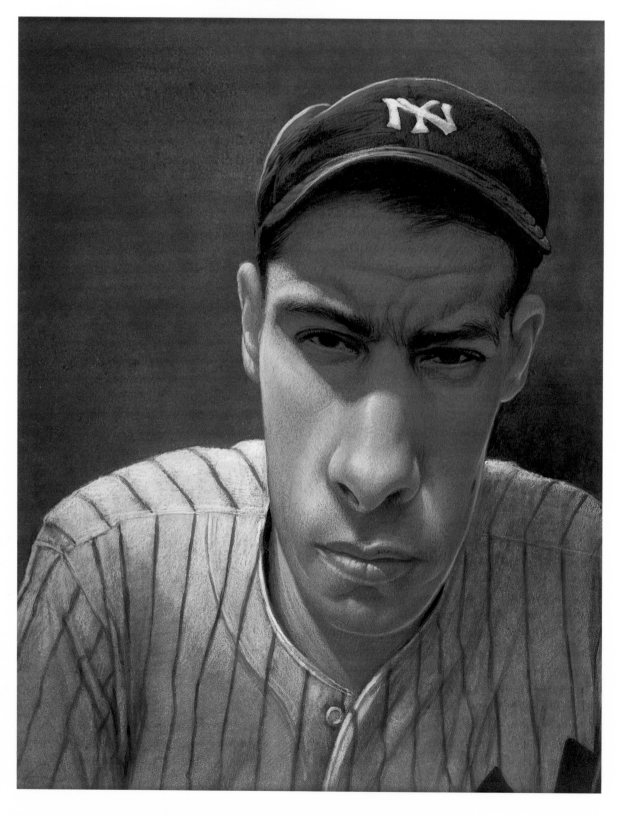

38 SILVER MEDAL

Artist: **Mark Ulriksen**

Art Director: Caroline Mailhot

Illustration Editor: Chris Curry

Client: The New Yorker

Medium: Acrylic on hot press board

Size: 11" × 12"

"'`Arafat's Gift' represents a wonderfully succinct example of art direction. Chris Curry of *The New Yorker* explained: `It's Sharon, Barak, and Arafat, the Western Wall, the Temple Mount, and Palestinians throwing rocks in the background. Emphasize Sharon. It's due in a week.' I've been a regular contributor to *The New Yorker* since 1994 when I became an illustrator full-time after a career as a magazine art director. This is the first time my work has been a Society award winner. Thanks."

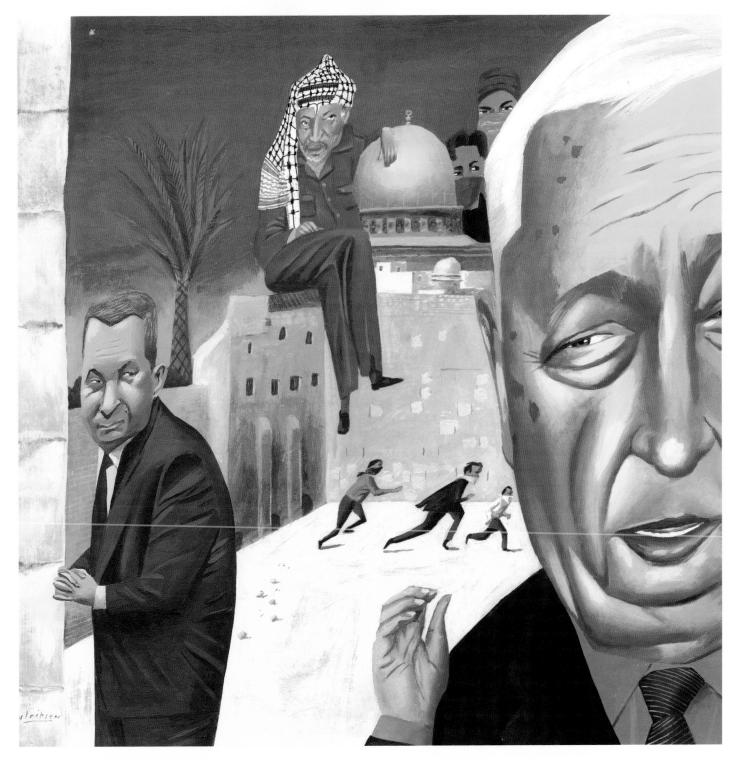

39

Artist: **Tim Bower**

Art Director: Geraldine Hessler

Client: Entertainment Weekly

Medium: Mixed

Size: 10" × 10"

40

Artist: **Tim Bower**

Art Director: Michael Picon

Client: New York Magazine

Medium: Mixed

Size: 13" × 11"

41

Artist: **Gerard DuBois**

Illustration Editor: Chris Curry

Client: The New Yorker

42

Artist: **Gerard DuBois**

Art Director: Hannu Laakso

Client: Reader's Digest

Size: 15" × 11"

43

Artist: **Gerard DuBois**

Art Director: Jocelyne Fournel

Client: L'Actualité

Size: 13" × 10"

39

40

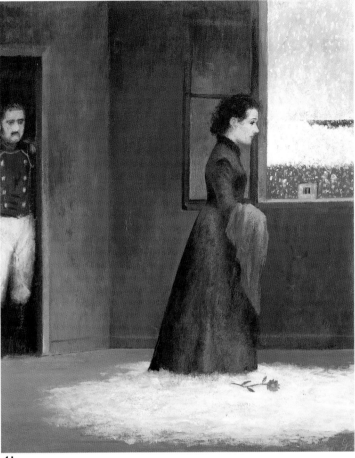

41

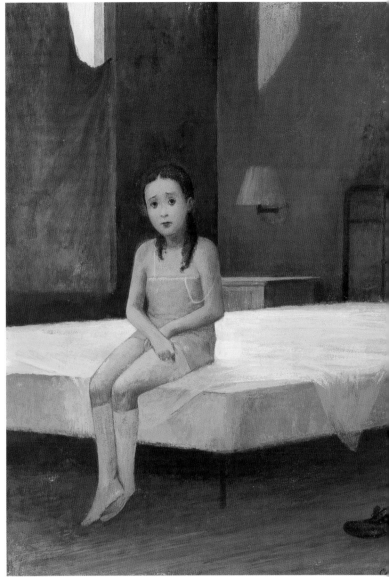

42

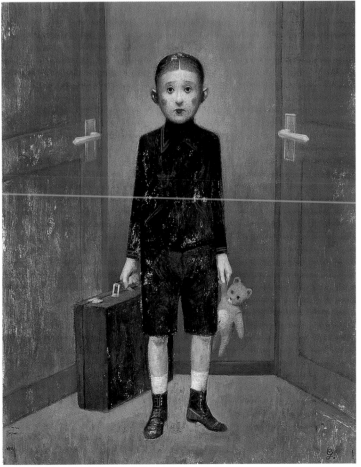

43

44
Artist: **Martin Jarrie**
Art Director: Jaimey Easler
Client: Hemispheres Magazine
Size: 23" x 16"

45
Artist: **Mirko Ilic**
Art Director: Gail Anderson
Client: Rolling Stone
Medium: Digital
Size: 13" x 10"

46
Artist: **Ross MacDonald**
Art Director: Gayle Grin
Client: The National Post
Medium: Watercolor, pencil crayon on paper
Size: 6" x 7"

47
Artist: **Sterling Hundley**
Art Director: Fred Woodward
Client: Rolling Stone
Medium: Pen & ink, pencil, oil washes on
 Bainbridge illustration board #80
Size: 14" x 8"

44

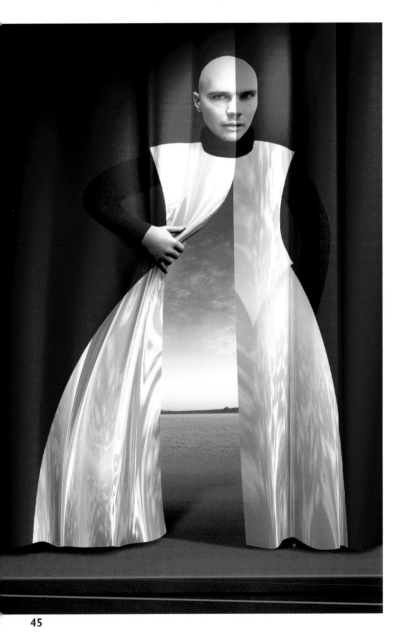

45

46

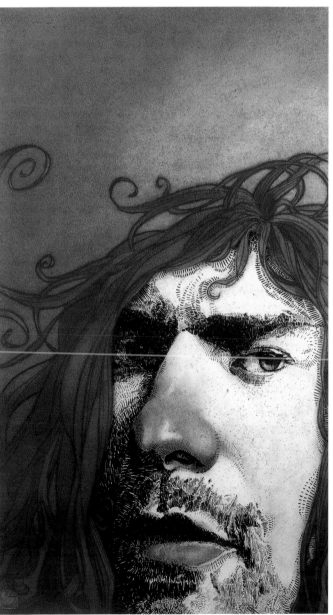

47

48
Artist: **James Bennett**
Art Directors: Leonard Loria
 Dave Nelson
Client: Yankee Magazine
Medium: Oil
Size: 13" x 9"

49
Artist: **James McMullan**
Art Director: Gail Anderson
Client: Rolling Stone
Medium: Watercolor, gouache on paper
Size: 9" x 6"

50
Artist: **Scott Laumann**
Art Director: Gail Anderson
Client: Rolling Stone
Medium: Acrylic on board
Size: 20" x 13"

51
Artist: **Randall Enos**
Art Director: Gail Anderson
Client: Rolling Stone
Medium: Linocut collage on board
Size: 17" x 11"

52
Artist: **Roberto Parada**
Art Director: Marti Golon
Client: TIME
Medium: Oil on canvas
Size: 13" x 10"

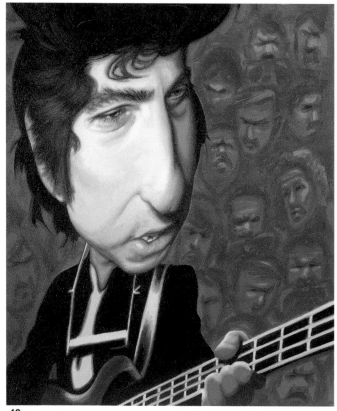

48

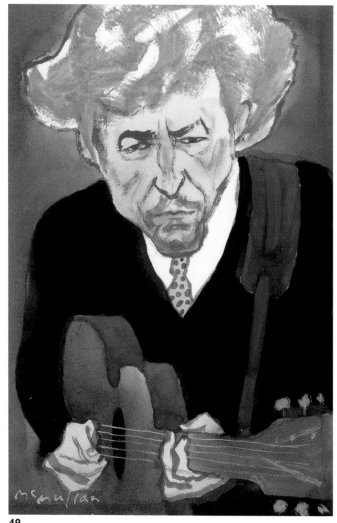

49

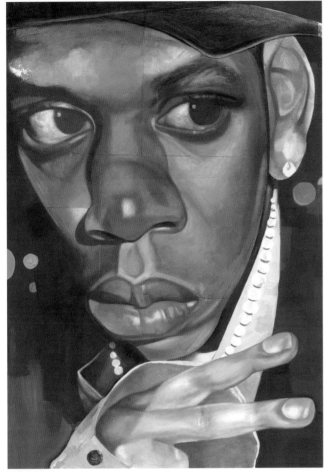

50

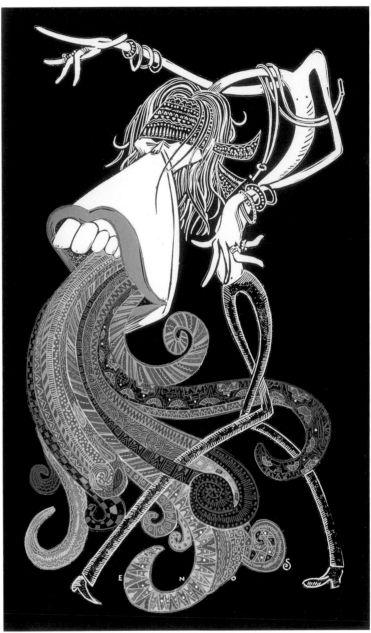

51

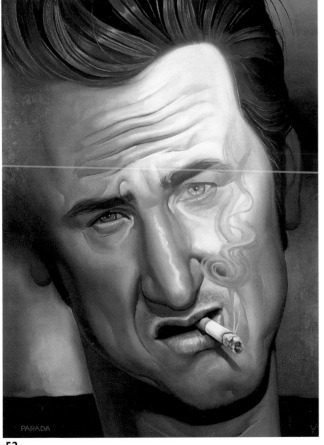

52

53
Artist: **Steve Brodner**
Art Director: Gail Anderson
Client: Rolling Stone
Size: 13" × 10"

54
Artist: **Peter de Sève**
Art Director: Francoise Mouly
Client: The New Yorker
Medium: Watercolor, ink
Size: 13" × 9"

55
Artist: **Ralph Steadman**
Illustration Editor: Chris Curry
Client: The New Yorker

56
Artist: **Anita Kunz**
Art Director: Francoise Mouly
Client: The New Yorker
Medium: Mixed
Size: 12" × 8"

57
Artist: **Edward Sorel**
Illustration Editor: Chris Curry
Client: The New Yorker
Medium: Watercolor, ink

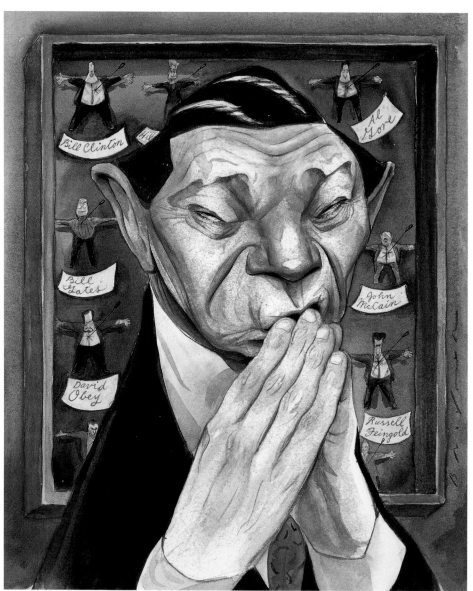

53

54

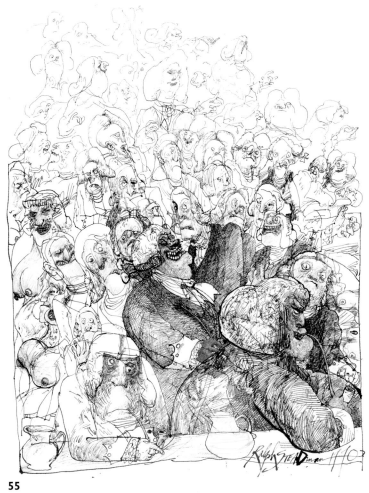

55

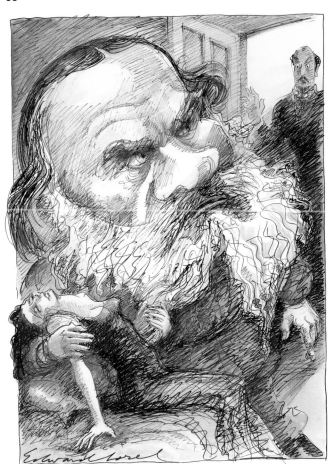

56

57

58

Artist: **Barry Blitt**

Art Director: Caroline Mailhot

Illustration Editor: Chris Curry

Client: The New Yorker

Medium: Watercolor, ink

59

Artist: **Jack Unruh**

Art Director: Cynthia Currie

Client: Kiplingers Personal Finance Magazine

Medium: Pen and brush ink, watercolor
 on board

Size: 14" x 20"

60

Artist: **Jack Unruh**

Art Director: Daniel Bertalotto

Client: The Life Work Company

Medium: Pen and brush ink, watercolor
 on board

Size: 13" x 11"

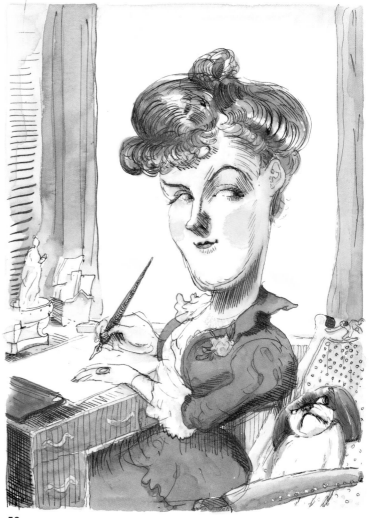

58

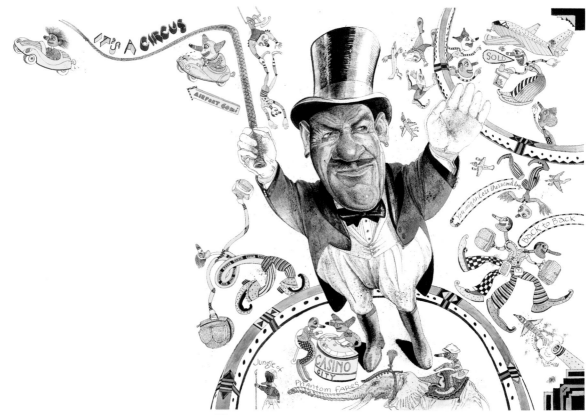

59

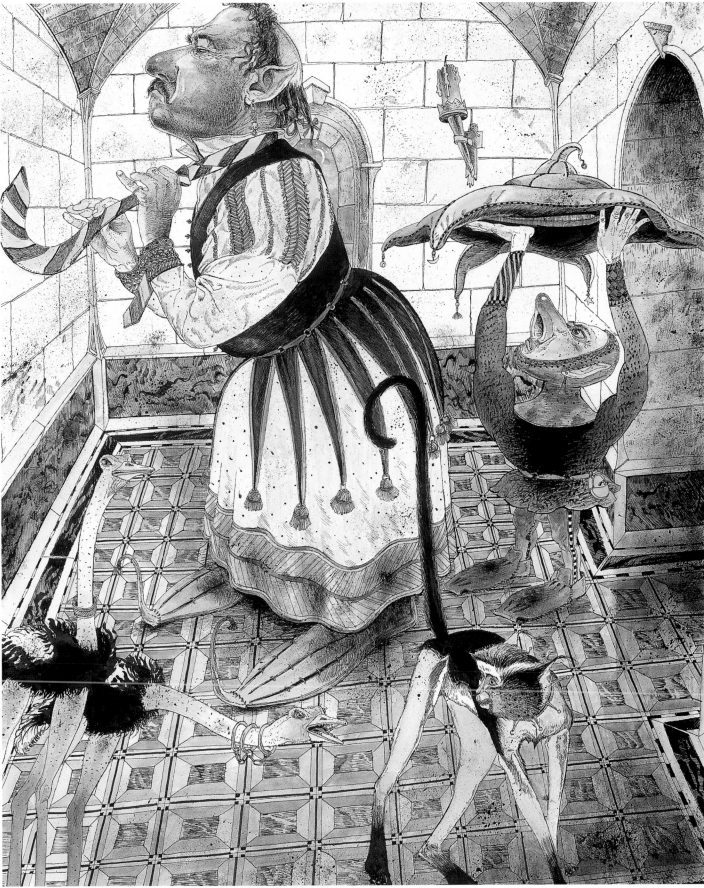

61
Artist: **Steve Brodner**
Illustration Editor: Chris Curry
Client: The New Yorker

62
Artist: **Anita Kunz**
Art Director: Cynthia Hoffman
Client: TIME
Medium: Watercolor on board
Size: 11" x 8"

63
Artist: **James Bennett**
Art Director: Sam Viviano
Client: MAD Magazine
Medium: Oil on board
Size: 15" x 11"

64
Artist: **Daniel Adel**
Art Directors: John Walker
 Geraldine Hessler
Client: Entertainment Weekly
Medium: Oil on linen
Size: 19" x 16"

65
Artist: **Daniel Adel**
Art Director: Kirby Rodriguez
Client: W Magazine
Medium: Oil on canvas
Size: 20" x 16"

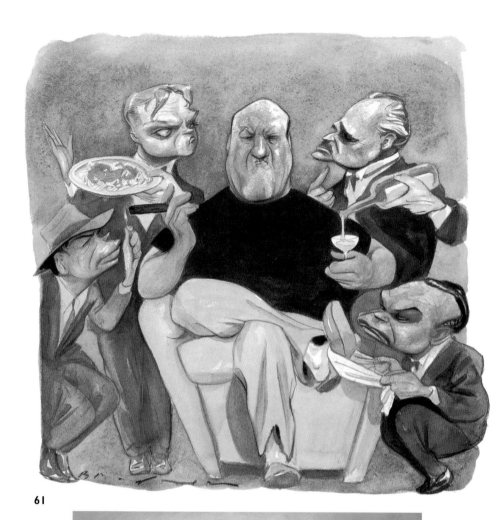

61

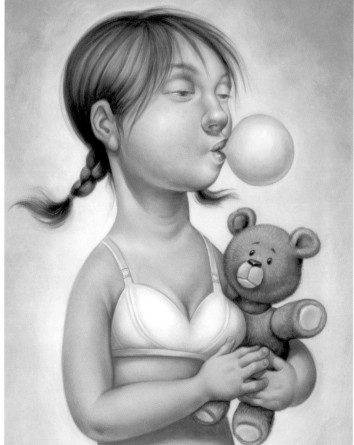

62

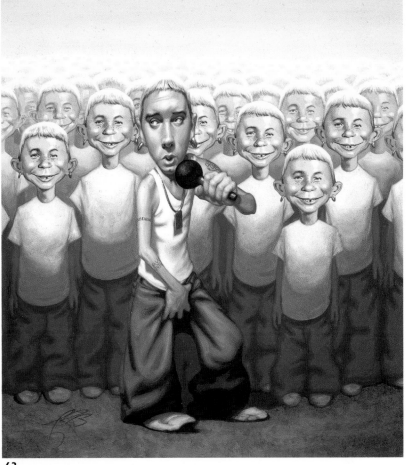

63

64

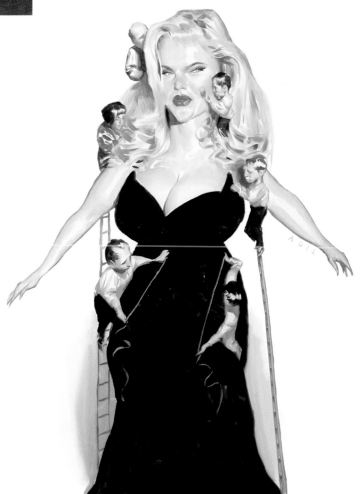

65

66

Artist: **C.F. Payne**

Art Director: Steven Heller

Client: The New York Times Book Review

Size: 14" x 10"

67

Artist: **Roberto Parada**

Art Director: Nick Torello

Client: Penthouse

Medium: Oil on canvas

Size: 19" x 15"

68

Artist: **Roberto Parada**

Art Director: Andrew Nimmo

Client: My Generation

Medium: Oil on canvas

Size: 15" x 11"

69

Artist: **Tom Fluharty**

Art Director: Katherine Rybak Torres

Client: Weekly Standard

Medium: Acrylic on Bristol board

Size: 12" x 9"

70

Artist: **Daniel Adel**

Illustration Editor: Chris Curry

Client: The New Yorker

Medium: Oil on canvas

Size: 20" x 16"

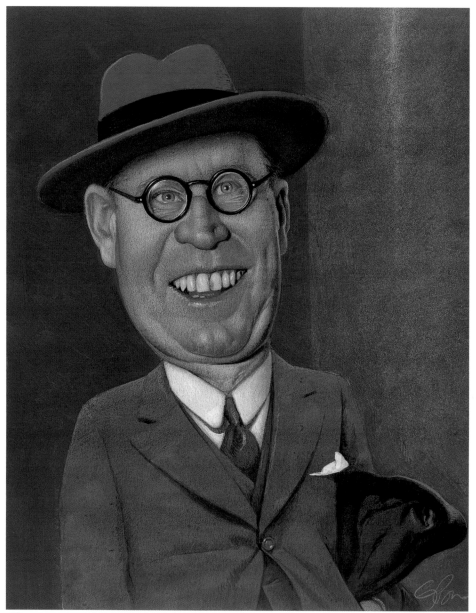

66

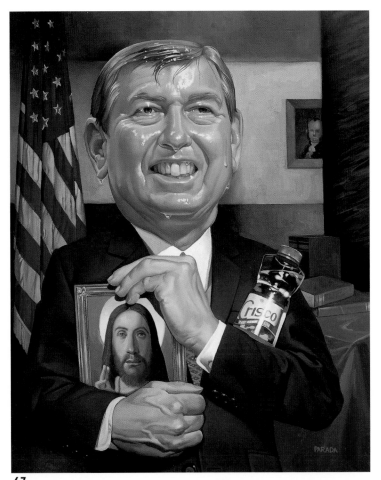

67

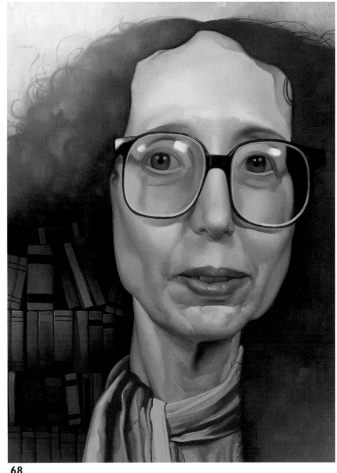

68

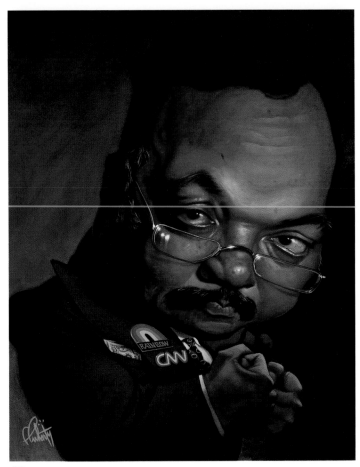

69

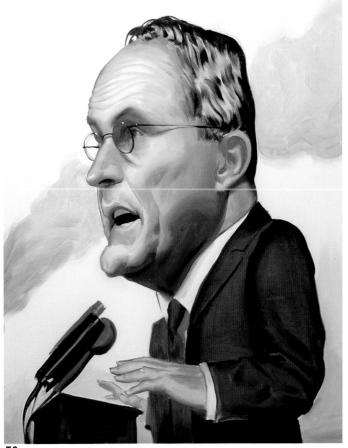

70

71
Artist: **C.F. Payne**
Art Director: Hannu Laakso
Client: Reader's Digest
Size: 13" x 9"

72
Artist: **C.F. Payne**
Art Director: Steven Heller
Client: The New York Times Book Review
Size: 13" x 11"

73
Artist: **John Cuneo**
Art Director: Michele Parrella
Client: New York Magazine
Medium: Pen & ink, watercolor on
 Arches watercolor paper
Size: 10" x 8"

74
Artist: **John Cuneo**
Art Director: Michele Parrella
Client: New York Magazine
Medium: Pen & ink, watercolor on
 Arches watercolor paper
Size: 6" x 4"

75
Artist: **David Hughes**
Art Director: Vicki Nightingale
Client: Reader's Digest
Medium: Mixed on paper

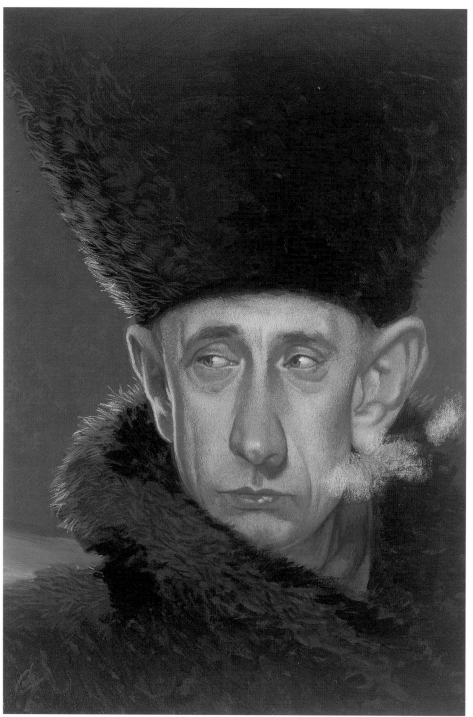

71

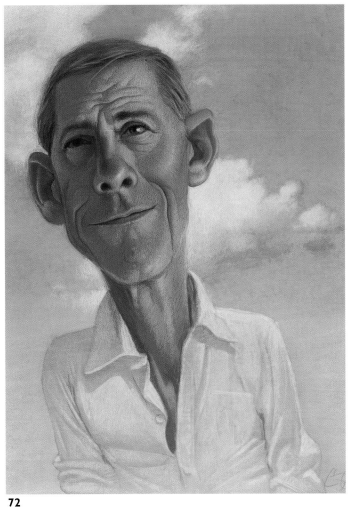

72

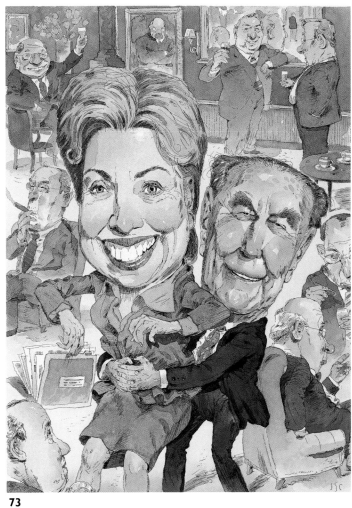

73

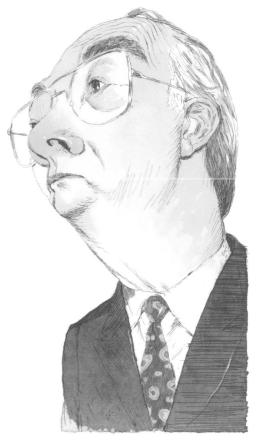

74

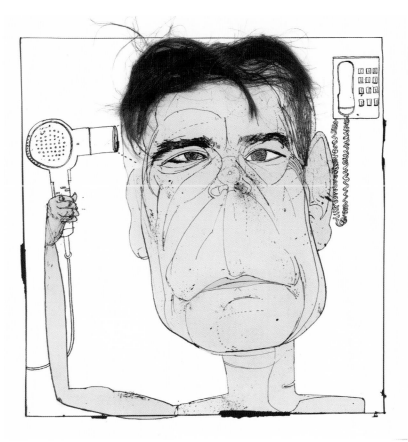

75

76
Artist: **Jody Hewgill**
Art Directors: Sara Osten
 Geraldine Hessler
Client: Entertainment Weekly
Medium: Acrylic on gessoed board
Size: 9" x 7"

77
Artist: **Andrea Ventura**
Art Director: Steven Heller
Client: The New York Times Book Review
Medium: Mixed
Size: 24" x 18"

78
Artist: **Al Hirschfeld**
Illustration Editor: Chris Curry
Client: The New Yorker
Medium: Watercolor, ink

79
Artist: **Esther Pearl Watson**
Art Director: Geraldine Hessler
Client: Entertainment Weekly
Size: 25" x 19"

80
Artist: **Mark Ulriksen**
Illustration Editor: Chris Curry
Client: The New Yorker
Medium: Acrylic

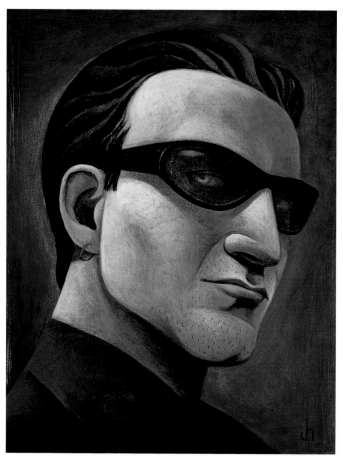

76

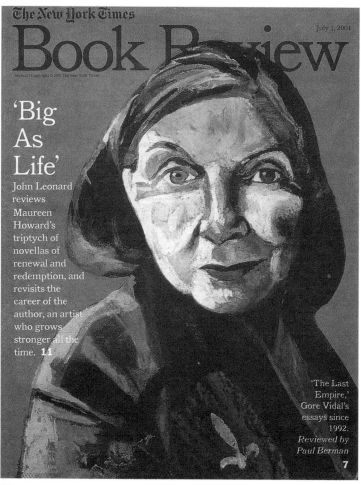

77

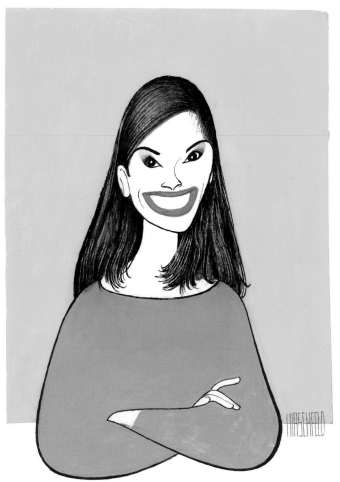

78

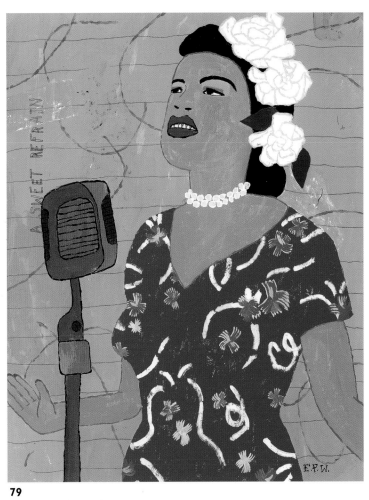

79

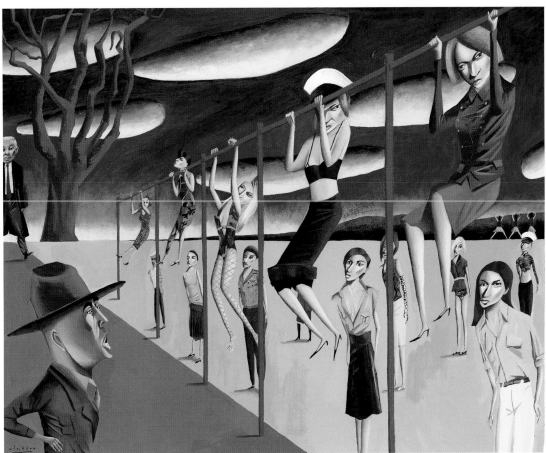

80

81
Artist: **Mark Ulriksen**
Illustration Editor: Chris Curry
Client: The New Yorker
Medium: Acrylic

82
Artist: **Blair Drawson**
Art Director: Susan Meingast
Client: Explore Magazine
Medium: Acrylic on gessoed paper
Size: 15" x 11"

83
Artist: **Marc Burckhardt**
Art Director: Lindsey Sipes
Client: Oxford American
Medium: Acrylic on wood
Size: 15" x 11"

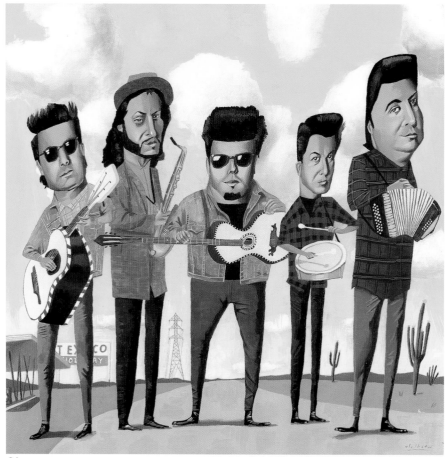

81

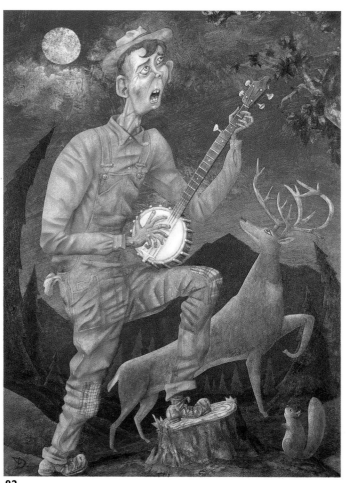

82

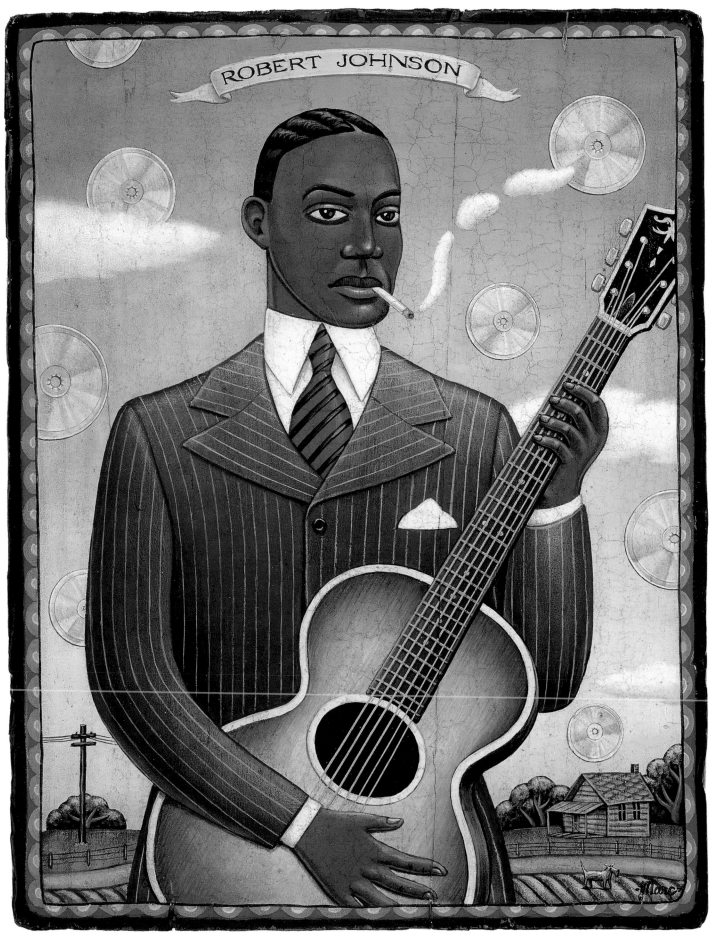

84
Artist: **Fred Stonehouse**
Art Director: Tom Staebler
Client: Playboy

85
Artist: **Christian Clayton**
Art Director: Dean Abatemarco
Client: Reader's Digest
Medium: Mixed on paper
Size: 13" x 13"

86
Artist: **Marc Burckhardt**
Art Director: Mary Workman
Client: Texas Monthly
Medium: Acrylic on wood
Size: 13" x 10"

87
Artist: **Marco Ventura**
Art Directors: Arem K. Duplessis
 Kayoko Suzuki
Client: Gentleman's Quarterly
Medium: Oil on paper
Size: 7" x 6"

88
Artist: **Scott McKowen**
Art Director: Ellen Winkler
Client: The Chronicle of Higher Education
Medium: Scratchboard
Size: 14" x 10"

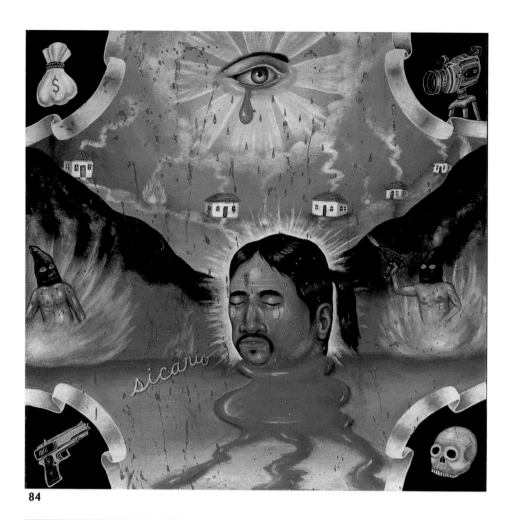

84

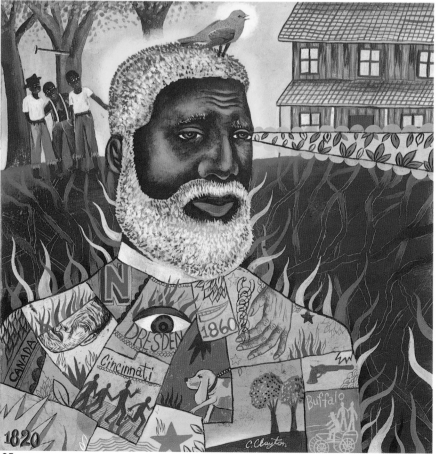

85

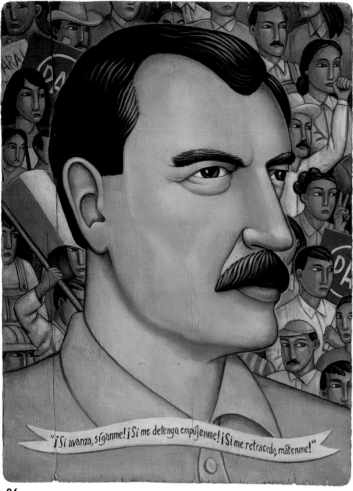

"¡Si avanzo, síganme! ¡Si me detengo, empújenme! ¡Si me retrocedo, mátenme!"

86

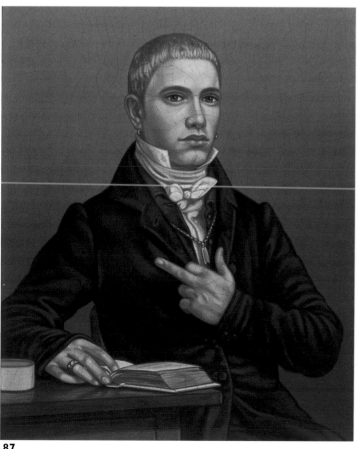

87

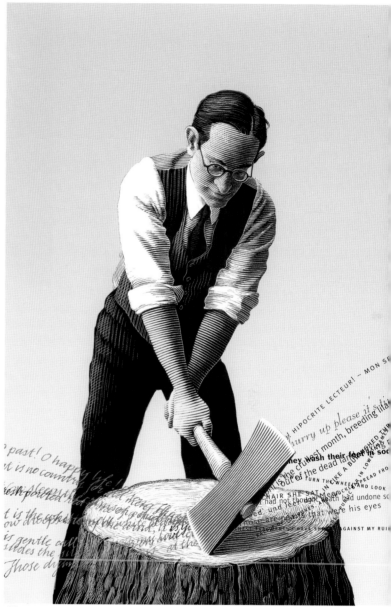

88

89

Artist: **Daniel Bejar**

Art Director: Matthew Lenning

Client: Gentleman's Quarterly

Medium: Two-color monoprint on Rives BFK
paper

Size: 17" × 15"

90

Artist: **Frances Jetter**

Art Director: Edel Rodriguez

Client: TIME

Medium: Sculpey, stocking, linocut, monoprinted
paper collage on paper

Size: 15" × 11"

91

Artist: **Rachel Salomon**

Art Director: Bill Smith

Client: LA Weekly

Medium: Acrylic, ink on board

Size: 12" × 9"

92

Artist: **Brad Holland**

Art Director: Jaimey Easler

Client: Hemispheres Magazine

Medium: Acrylic on board

Size: 14" × 11"

93

Artist: **Gary Kelley**

Art Directors: Geraldine Hessler
Jen Procopio

Client: Entertainment Weekly

Medium: Pastel on paper

Size: 18" × 15"

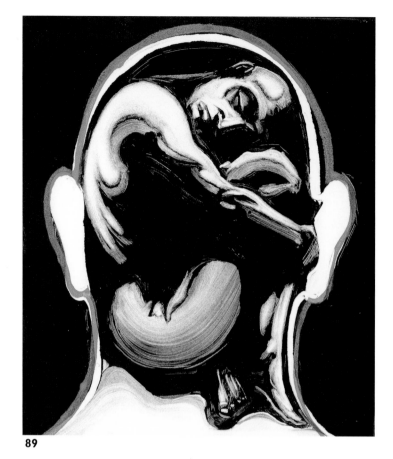

89

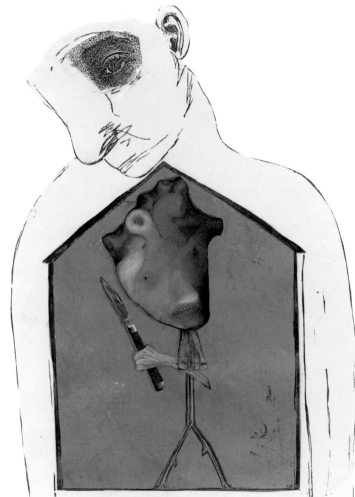

90

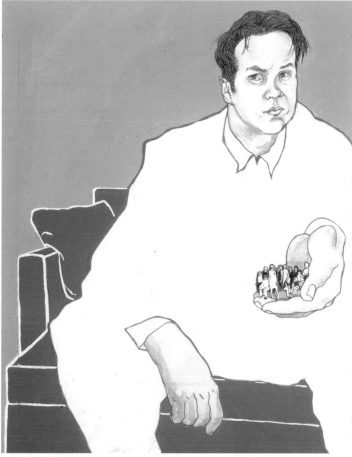

91

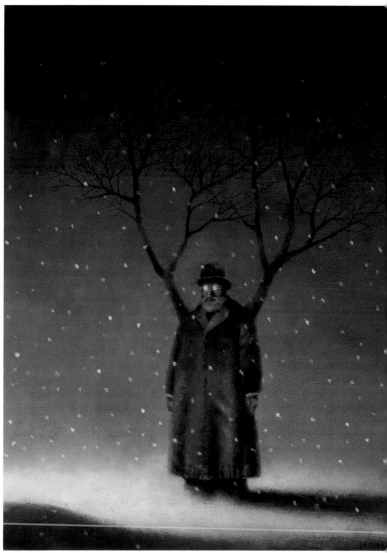

92

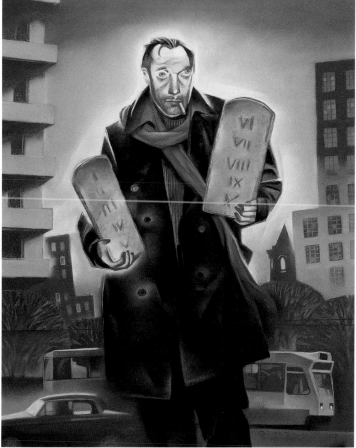

93

94

Artist: **Brad Holland**

Art Director: Shawn Bernadou

Client: Bike Magazine

Medium: Pastel on paper

Size: 11" × 17"

95

Artist: **Brad Holland**

Art Director: Jaimey Easler

Client: Hemispheres Magazine

Medium: Acrylic on board

Size: 14" × 11"

96

Artist: **Robert Neubecker**

Art Director: Jon Houston

Client: The New Republic

Medium: Digital

Size: 10" × 7"

97

Artist: **Douglas Fraser**

Art Director: John Thompson

Client: Cigar Aficionado Magazine

Medium: Alkyd on canvas

Size: 12" × 10"

98

Artist: **Robert Neubecker**

Art Director: Wendy McMillan

Client: Dartmouth Alumni Magazine

Medium: Digital

Size: 9" × 6"

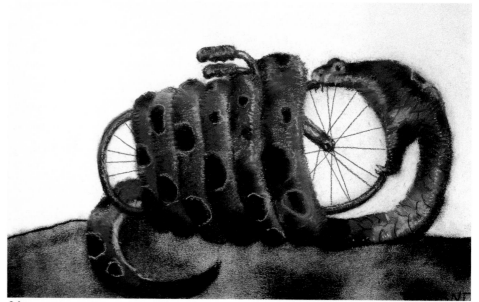

94

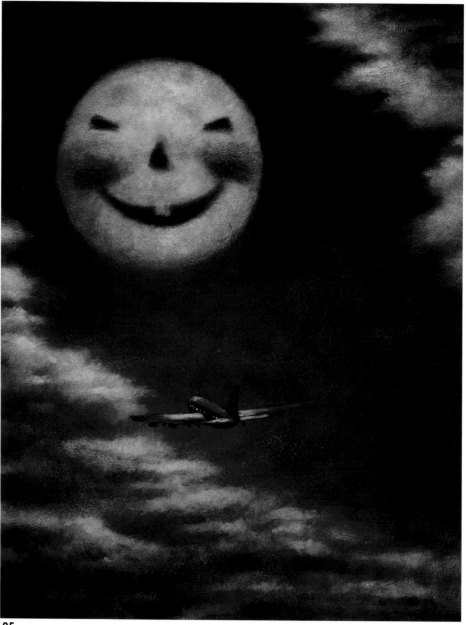

95

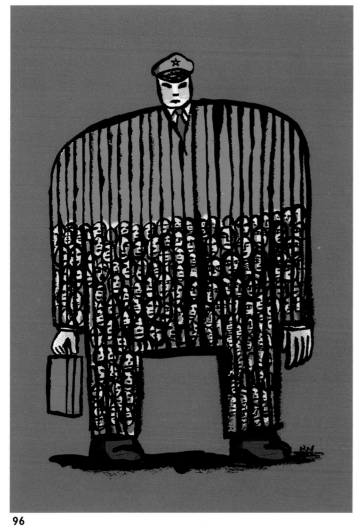

96

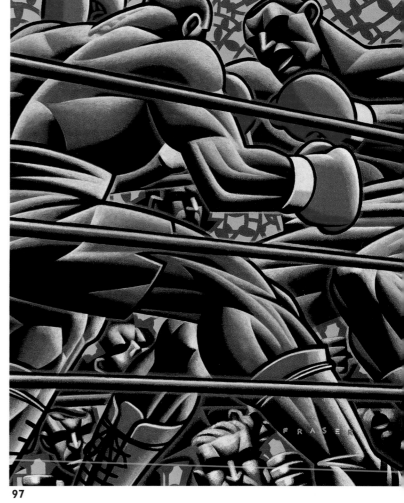

97

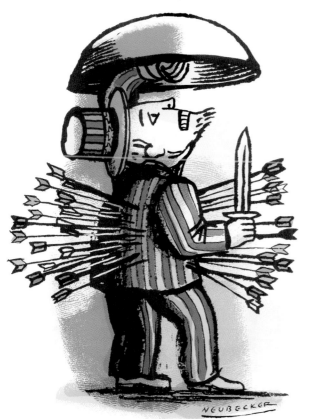

98

99

Artist: **Tim Bower**
Art Director: Stacie Reistetter
Client: The Washington Post
Medium: Mixed
Size: 10" x 8"

100

Artist: **Steven Guarnaccia**
Art Director: Peter Morance
Client: The New York Times
Medium: Pen & ink, watercolor on
 watercolor paper
Size: 15" x 15"

101

Artist: **Jan Descartes**
Art Director: Kathleen McGowan
Client: Nylon Magazine
Medium: Pen & ink, dye, chartpak on
 double-sided mylar
Size: 12" x 18"

102

Artist: **Peter de Sève**
Art Director: Francoise Mouly
Client: The New Yorker
Medium: Watercolor, ink
Size: 14" x 10"

103

Artist: **Greg Clarke**
Art Director: Joe Kimberling
Client: Los Angeles Magazine
Medium: Watercolor on paper
Size: 12" x 9"

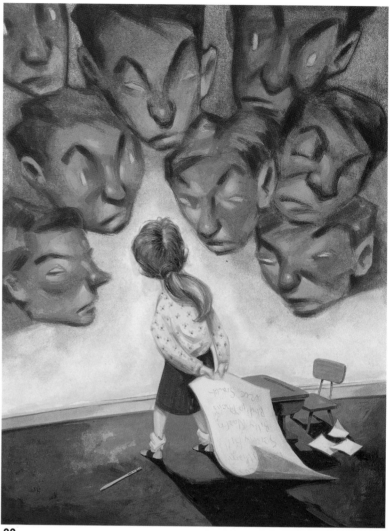

99

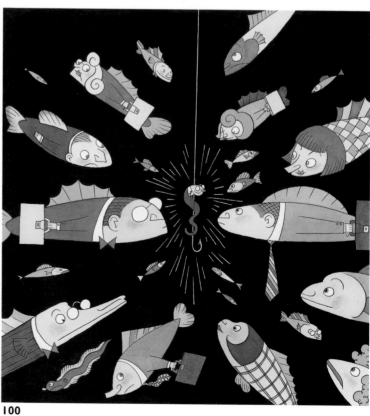

100

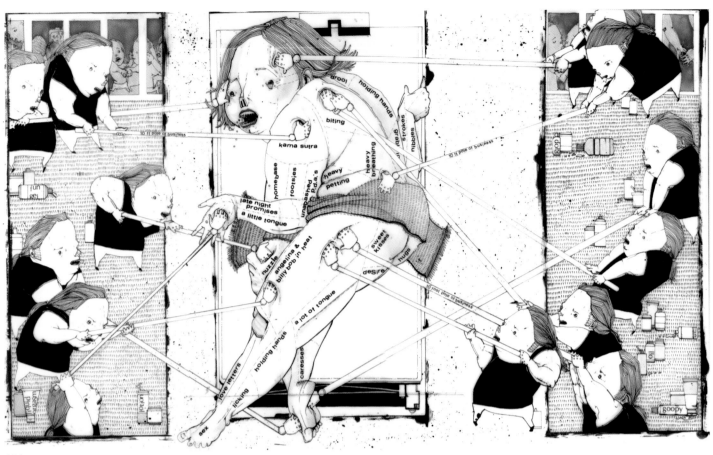

101

102

The LIFE & DEATH of an L.A. GASTRONOME
A Mostly Savory Tale by Greg Clarke

Paul was wealthy, ruggedly handsome, and obsessed with pleasuring his palate.

His prized possession was a signed 8 x 10 glossy of Joachim Splichal.

In Hancock Park, his herb-encrusted bungalow was a sore point with the neighbors.

Paul preferred his women drizzled with a mild Gorgonzola.

He was haunted by a beguiling jambon buerre he had eaten at Scandia back in 1978.

His favorite poet, Robert M. Parker, Jr., moved him to tears.

Each fall, he traveled to Piedmont with his friend Phil to dig for truffles.

Paul's erotic dreams usually involved Penelope Cruz and Bing cherry compote.

The end came swiftly when, forced to choose between the seared skate wing and a barley risotto with braised oxtail, he spontaneously combusted.

103

104
Artist: **Phillipe Weisbecker**
Art Director: Elisa Baur
Client: Santa Barbara Magazine
Medium: Mixed
Size: 6" x 7"

105
Artist: **Craig Frazier**
Art Director: Christine Silver
Client: Business Week
Medium: Digital
Size: 14" x 11"

106
Artist: **Leanne Shapton**
Art Directors: Tom Ackerman
Davia Smith
Client: Talk Magazine
Medium: Watercolor

107
Artist: **Istvan Banyai**
Art Director: Mary Parsons
Client: The Atlantic Monthly
Medium: Digital
Size: 6" x 6"

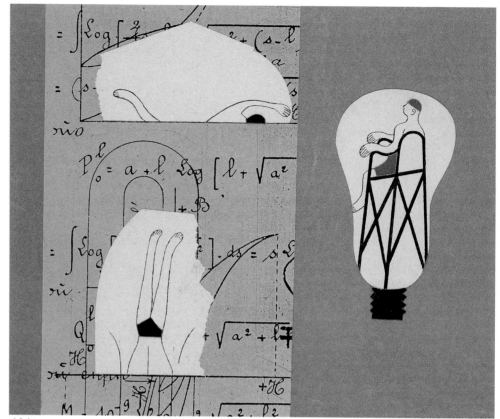

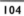
104

105

106

107

108
Artist: **Hanoch Piven**
Art Director: Janet Michaud
Client: TIME
Medium: 3D collage
Size: 12" x 9"

109
Artist: **Hanoch Piven**
Art Directors: Sara Osten
 Geraldine Hessler
Client: Entertainment Weekly
Medium: 3D collage
Size: 21" x 15"

110
Artist: **Hanoch Piven**
Art Director: Kenneth Smith
Client: TIME
Medium: 3D collage
Size: 9" x 7"

111
Artist: **Greg Clarke**
Art Director: Dave Roman
Client: Nikelodeon Magazine
Medium: Watercolor, pastel on paper
Size: 11" x 8"

112
Artist: **Edel Rodriguez**
Art Director: Owen Phillips
Client: The New Yorker
Medium: Pastel, gouache, woodblock printing
 ink on colored paper
Size: 10" x 10"

113
Artist: **Jim Frazier**
Art Director: Robert Mansfield
Client: Forbes
Size: 16" x 10"

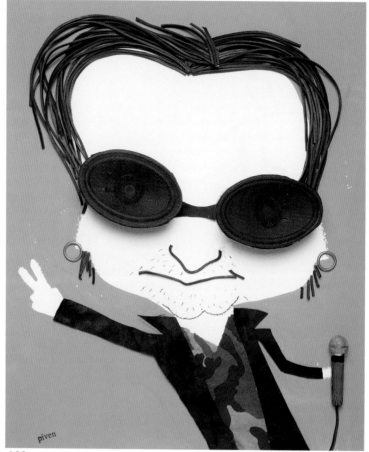

108

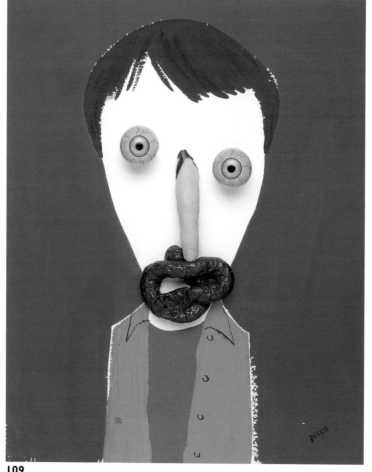

109

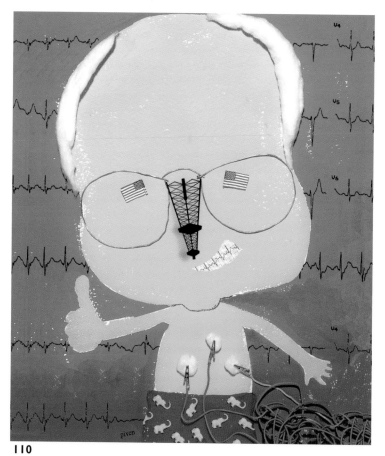

110

111

112

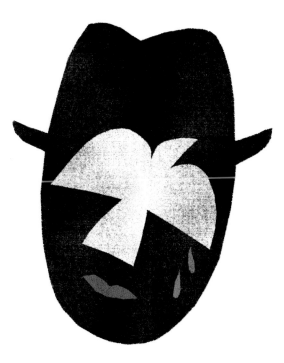

113

114
Artist: **Anita Kunz**
Art Director: Joe Kimberling
Client: Los Angeles Magazine
Medium: Mixed
Size: 14" x 11"

115
Artist: **Etienne Delessert**
Art Director: Gary Kelley
Client: North American Review

116
Artist: **David Johnson**
Art Director: Steven Heller
Client: The New York Times Book Review
Medium: Pen & ink, watercolor
Size: 21" x 15"

117
Artist: **Dugald Stermer**
Art Director: Nancy Harris
Client: The New York Times Magazine
Medium: Cut paper
Size: 14" x 12"

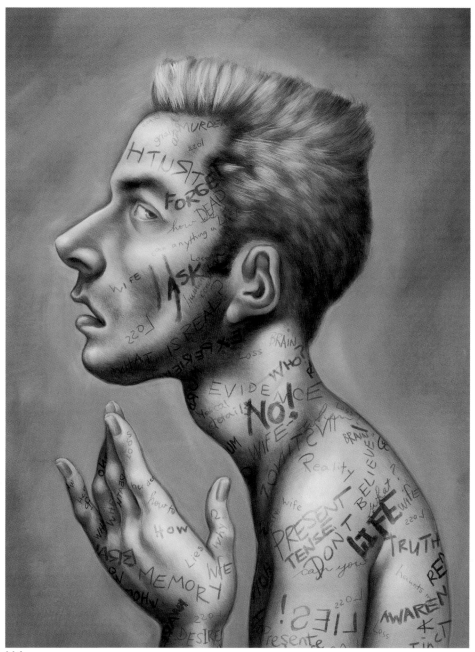

114

115

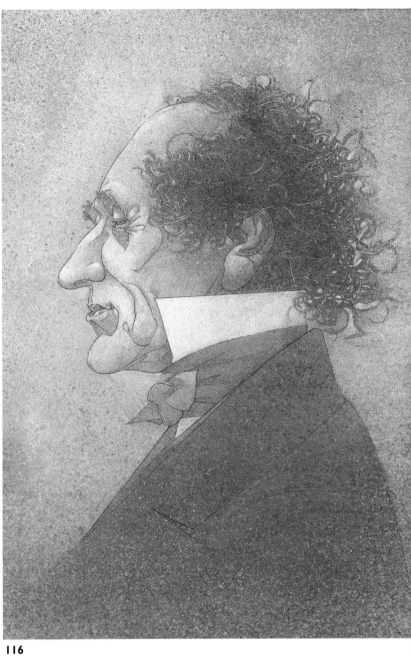

116

117

118
Artist: **Brian Cronin**
Art Director: Carol Macrini
Client: Bloomberg L.P.
Size: 7" x 5"

119
Artist: **Edel Rodriguez**
Art Director: Owen Phillips
Client: The New Yorker
Medium: Pastel, gouache, woodblock printing
ink, collage on Mexican bark paper
Size: 10" x 10"

120
Artist: **Brian Cronin**
Art Director: Janet Michaud
Client: TIME
Size: 10" x 8"

121
Artist: **Melinda Beck**
Art Director: Laura Zavetz
Client: Bloomberg Wealth Manager Magazine
Medium: Pencil, acrylic, collage on paper
Size: 21" x 15"

122
Artist: **Scott Laumann**
Art Director: Ann Decker
Client: Fortune
Medium: Mixed
Size: 11" x 10"

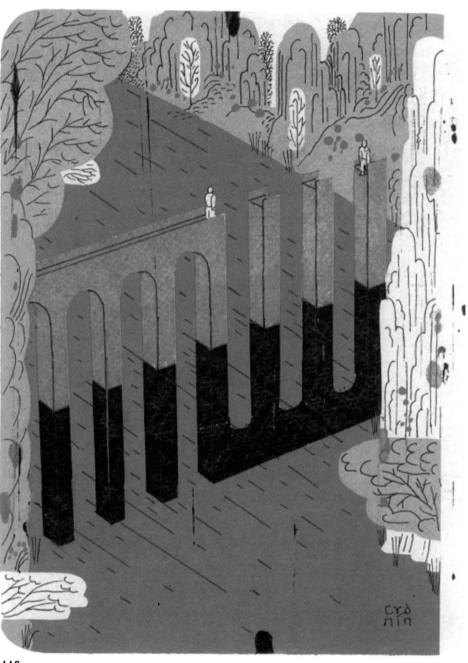

118

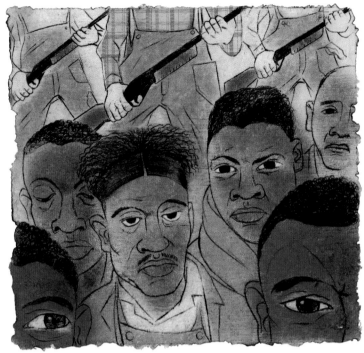

119

120

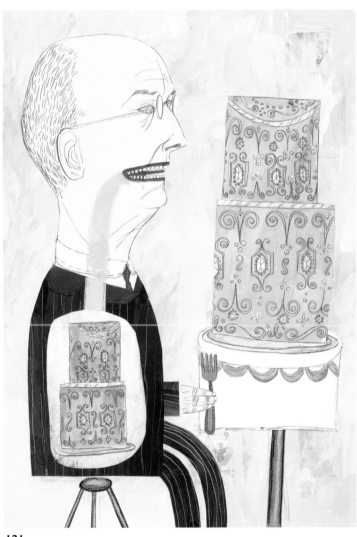

121

122

123
Artist: **Guy Billout**
Art Director: Mary Parsons
Client: The Atlantic Monthly
Medium: Watercolor, airbrush
Size: 9" × 7"

124
Artist: **Guy Billout**
Art Director: Mary Parsons
Client: The Atlantic Monthly
Medium: Watercolor, airbrush
Size: 9" × 7"

125
Artist: **Steve Brodner**
Art Director: Francoise Mouly
Client: The New Yorker
Size: 10" × 8"

126
Artist: **Benoit**
Art Director: Francoise Mouly
Client: The New Yorker
Medium: Oil
Size: 14" × 18"

123

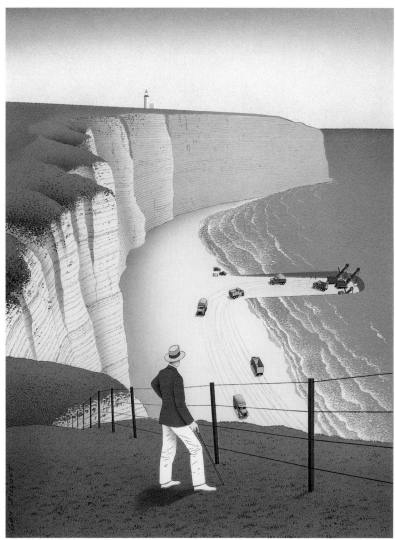

124

125

126

127
Artist: **Tomer Hanuka**
Illustration Editor: Chris Curry
Client: The New Yorker
Medium: Ink, digital
Size: 6" x 7"

128
Artist: **Tomer Hanuka**
Illustration Editor: Chris Curry
Client: The New Yorker
Medium: Ink, digital
Size: 6" x 7"

129
Artist: **Martin Haake**
Art Director: Aimee Bida
Client: Harvard Business Review
Medium: Collage, cut paper on board
Size: 21" x 47"

130
Artist: **Istvan Banyai**
Art Directors: Rina Migliaccio
　　　　　　　Davia Smith
Client: Talk Magazine
Medium: Digital

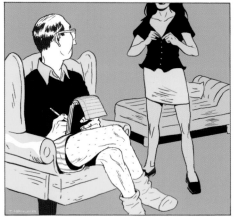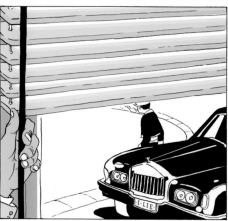

127

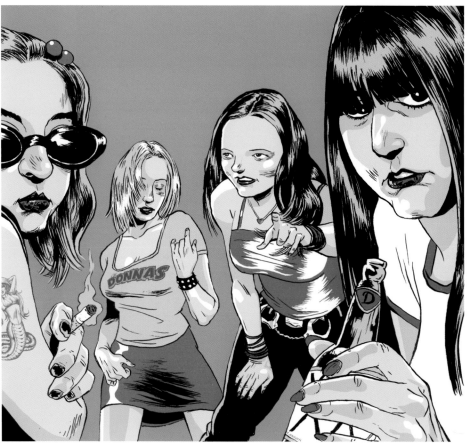

128

129

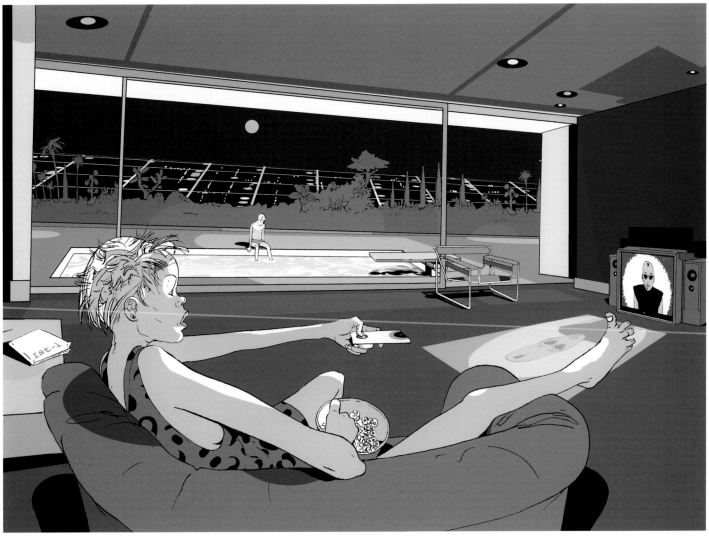

130

131
Artist: **Mark Bischel**
Art Director: Gary Kelley
Client: North American Review
Medium: Charcoal, digital
Size: 10" × 8"

132
Artist: **Brian Cronin**
Art Director: Laura Zavetz
Client: Bloomberg Wealth Manager Magazine
Size: 8" × 6"

133
Artist: **Istvan Banyai**
Art Director: Caroline Mailhot
Illustration Editor: Chris Curry
Client: The New Yorker
Medium: Digital

134
Artist: **Richard Beards**
Art Director: Scott A. Davis
Client: Fortune Small Business Magazine
Medium: Ink
Size: 10" × 16"

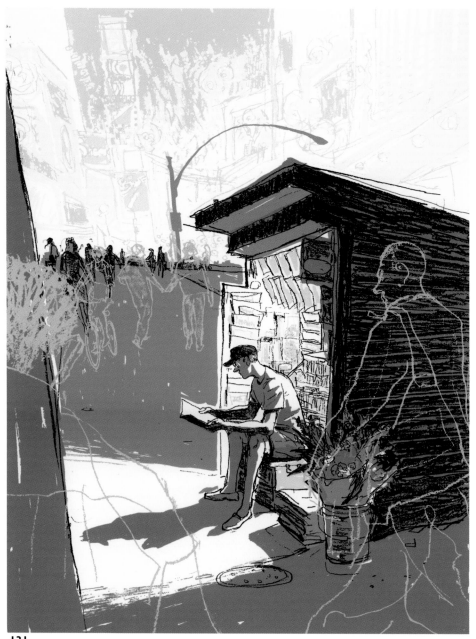

131

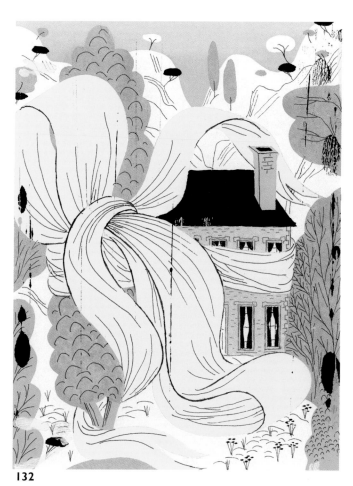

132

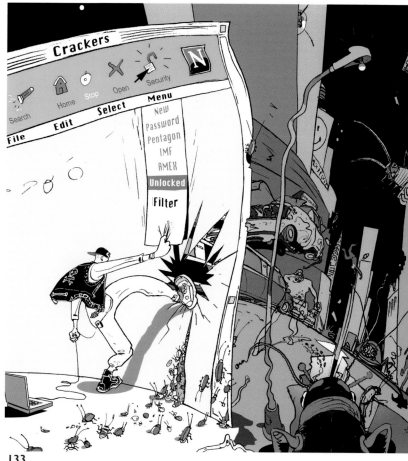

133

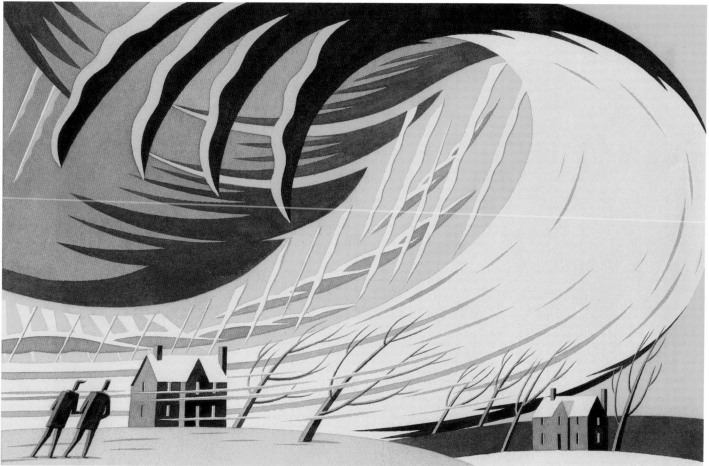

134

135
Artist: **Jeffrey Fisher**
Art Director: Michael Valenti
Client: The New York Times
Medium: Acrylic
Size: 17" x 17"

136
Artist: **Ross MacDonald**
Art Director: Gayle Grin
Client: The National Post
Medium: Watercolor, pencil crayon on paper
Size: 10" x 8"

137
Artist: **Walton Ford**
Illustration Editor: Chris Curry
Client: The New Yorker
Medium: Watercolor

138
Artist: **Guy Billout**
Illustration Editor: Chris Curry
Client: The New Yorker
Medium: Watercolor, airbrush
Size: 8" x 6"

139
Artist: **Tristan Elwell**
Art Director: Michael Tucker
Client: Ackerman McQueen
Medium: Oil, acrylic, colored pencil on
 illustration board
Size: 10" x 8"

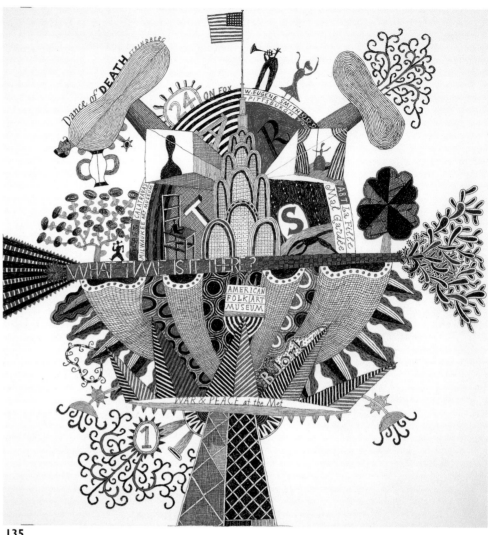

135

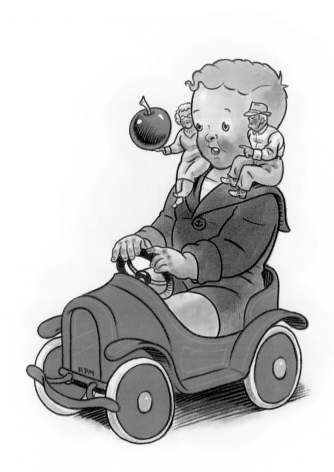

136

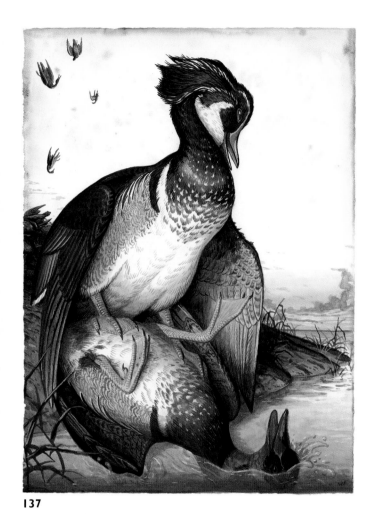

137

138

139

140
Artist: **Robert Andrew Parker**
Art Director: Vicki Nightingale
Client: Reader's Digest

141
Artist: **Christopher Evans**
Art Director: Jeff Osborn
Client: National Geographic Society
Medium: Oil on masonite
Size: 19" x 26"

140

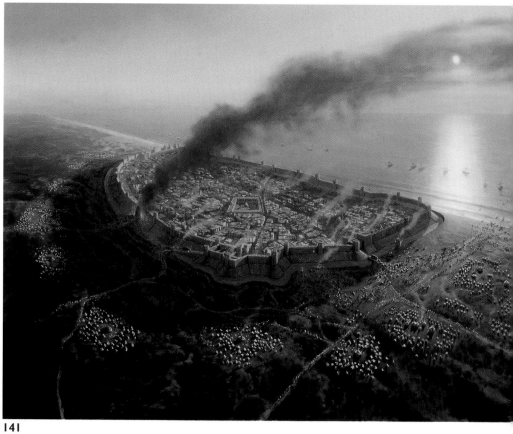

141

BOOK

JURY

Anita Kunz, Chair
Illustrator

Sue Coe
Illustrator

Claire Counihan
Director of Art and Design
Holiday House

Richard Egielski
Illustrator

Rita Marshall
Art director

C.F. Payne
Illustrator

Jonathon Rosen
Graphic designer/animator/
painter/illustrator

Joanie Schwarz
Illustrator

142 GOLD MEDAL
Artist: **Robert Andrew Parker**
Art Director: Alison Donalty
Client: HarperCollins
Medium: Etching with hand colored
aqua-tint on paper
Size: 10" x 8"

Robert Andrew Parker's long and varied career includes creation of the drawings and paintings for the film *Lust for Life*; costumes and sets for the dance company Crow's Nest; sets for an opera at MoMA; awards from Tamarind Lithography Workshop, the Guggenheim, and the National Academy of Design; teaching stints at Skowhegan, SVA, Syracuse, Parsons, RISD, and the Gerit Rietveld Academie, Amsterdam; lectures nationwide; works held in public collections including the Met, the Whitney, MoMA, and Los Angeles County Museum; and held privately by Joseph Hirschorn, his majesty King Gustav XVI of Sweden, his Royal Highness Charles, Her Royal Highness Elizabeth, the Queen Mother, and many others.

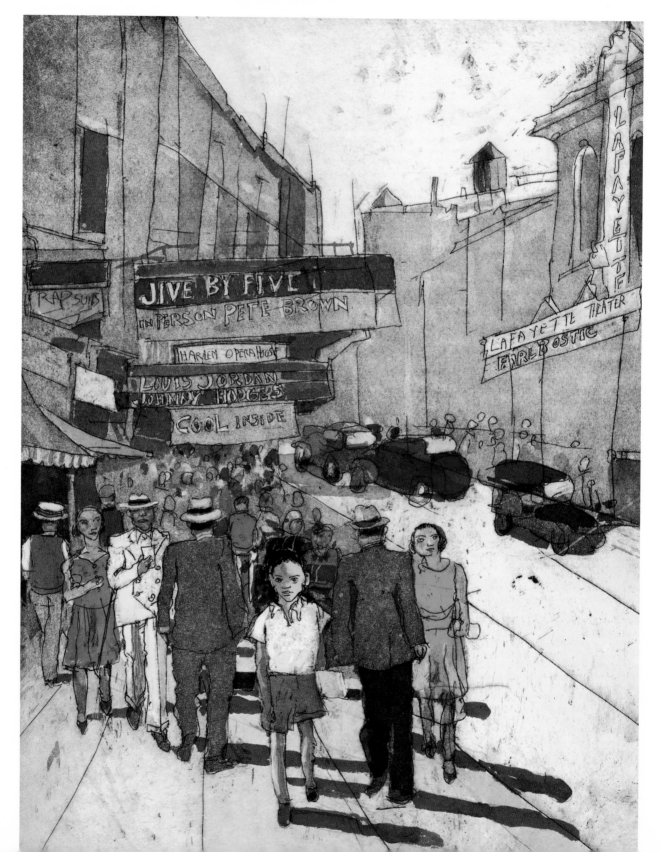

143 GOLD MEDAL
Artist: **David Small**
Art Director: David Saylor
Client: Arthur A. Levine Books
Medium: Charcoal on paper
Size: 14" x 10"

From Detroit, David Small studied at Wayne State University and Yale. He taught printmaking for 14 years during which time he published his first book. He is the author of six of the 32 books he illustrated. *Imogene's Antlers* has been featured for 15 years on the PBS children's program, Reading Rainbow. His wife Sarah Stewart wrote four of Small's picture books. He received the Caldecott Medal for *So You Want to Be President?* published in 2000. In 2001, Small was named distinguished alumni by Wayne State University and recognized by the Michigan legislature for his Caldecott Medal.

BOOK

144 SILVER MEDAL

Artist: **Yan Nascimbene**

Art Director: Jacques Binsztok

Client: Editions du Seuil

Medium: Watercolor, india ink on Arches
cold pressed 140# watercolor paper

Size: 9" × 6"

Half-French, half-Italian, Yan Nascimbene dabbled in photography and filmmaking before becoming an illustrator fifteen years ago. He has illustrated over 300 book covers and 30 books, some of which he wrote. Of his award-winning piece he says, "For years I had fantasized about illustrating Italo Calvino's *Adventures*; my dream came true two years ago, thanks to Esther Calvino's trust and support. Upon our meeting for the release of the book, Mrs. Calvino agreed that I illustrate *Palomar*, a project which I am currently working on."

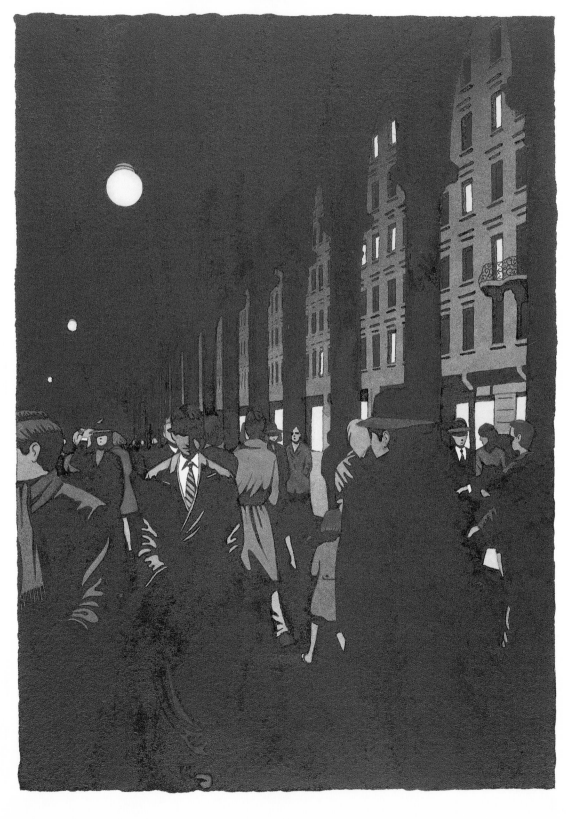

145
Artist: **Etienne Delessert**
Art Director: Rita Marshall
Client: Patrick Cramer Editions
Medium: Watercolor
Size: 11" × 8"

146
Artist: **Frances Jetter**
Art Director: Judie Mills
Client: The Millbrook Press
Medium: Collage including steel wool, string,
monoprinted papers, paint on board
Size: 15" × 10"

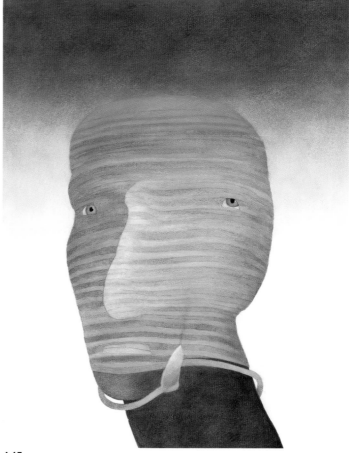

145

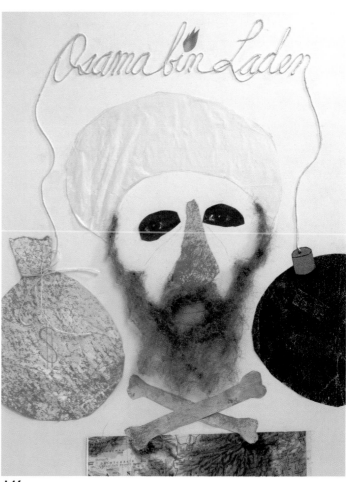

146

147
Artist: **Mark Summers**
Art Director: Steve Snider
Client: St. Martin's Press
Medium: Scratchboard, watercolor
Size: 11" x 8"

148
Artist: **Dave McKean**
Client: NBM Publishing
Medium: Mixed
Size: 11" x 8"

149
Artist: **John Jude Palencar**
Art Director: Irene Gallo
Client: Tor Books
Medium: Acrylic
Size: 14" x 30"

150
Artist: **John Jude Palencar**
Art Director: David Stevenson
Client: Ballantine Books
Medium: Acrylic
Size: 16" x 24"

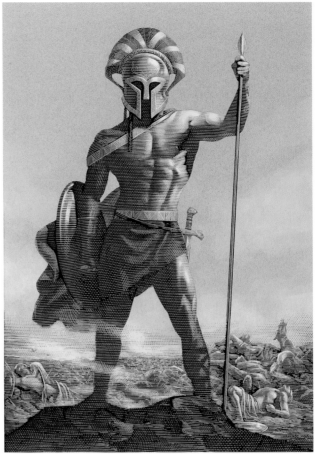

147

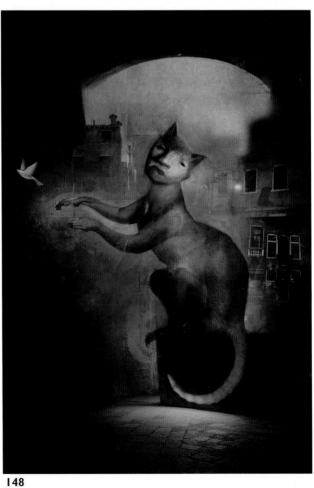

148

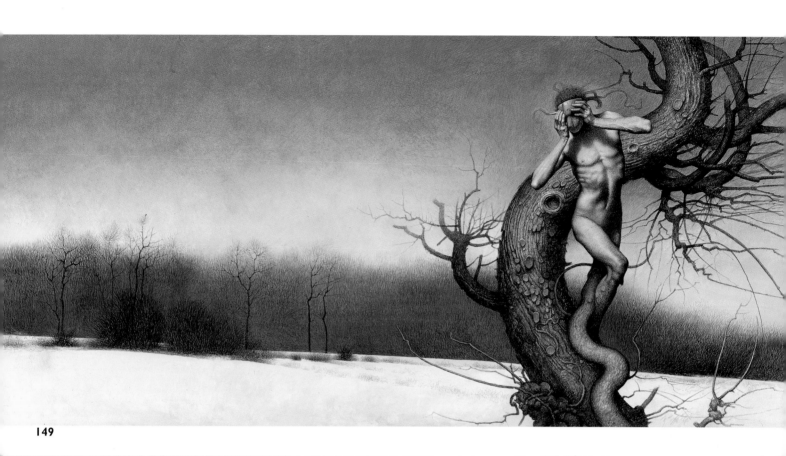

149

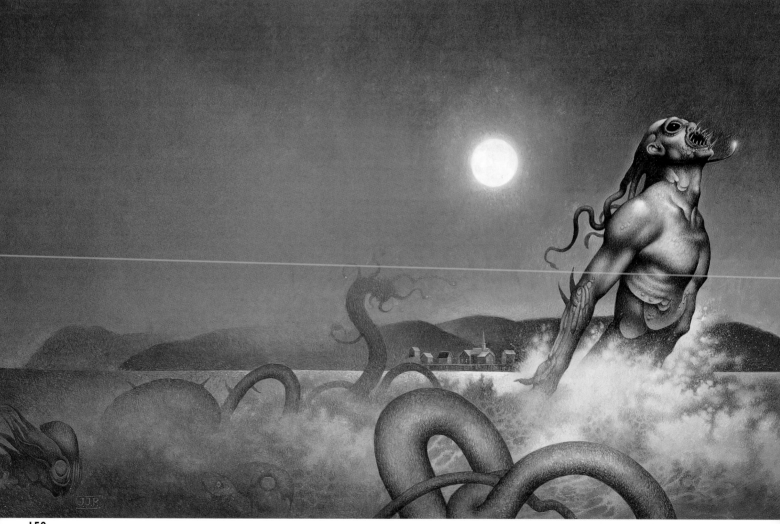

151
Artist: **Polly Becker**
Art Director: Leslie Goldman
Client: Scribner
Medium: Assemblage
Size: 13" x 10"

152
Artist: **Tomer Hanuka**
Publisher: Five O'Clock Shadow
Medium: Ink, digital
Size: 10" x 7"

153
Artist: **Isabel Pin**
Art Director: Michael Neugebauer
Client: Neugebauer Verlag
Medium: Gouache, collage on rice paper
Size: 11" x 17"

154
Artist: **Aljoscha Blau**
Art Director: Brigitte H. Sidjanski
Client: Nord-Sud Verlag
Medium: Gouache, ink on colored
 Japanese paper
Size: 11" x 16"

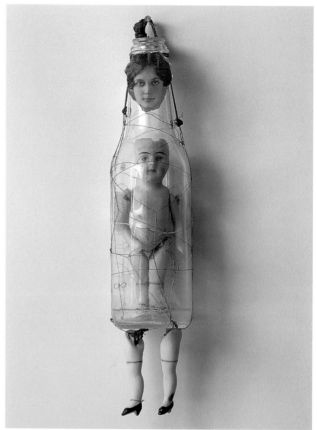

151

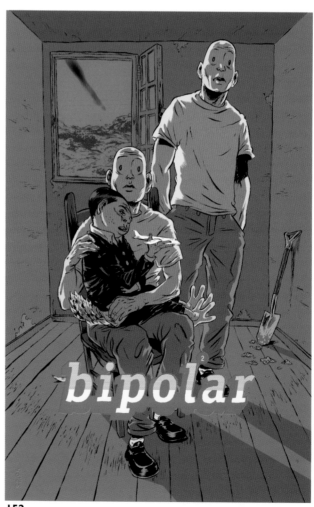

152

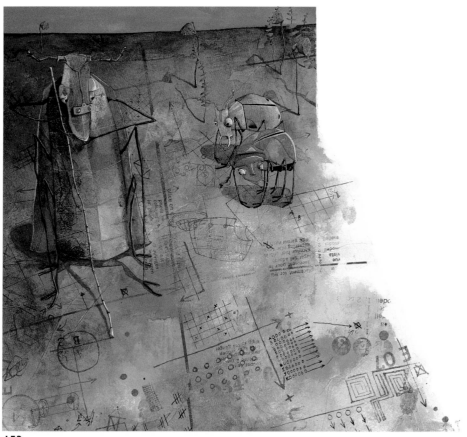

153

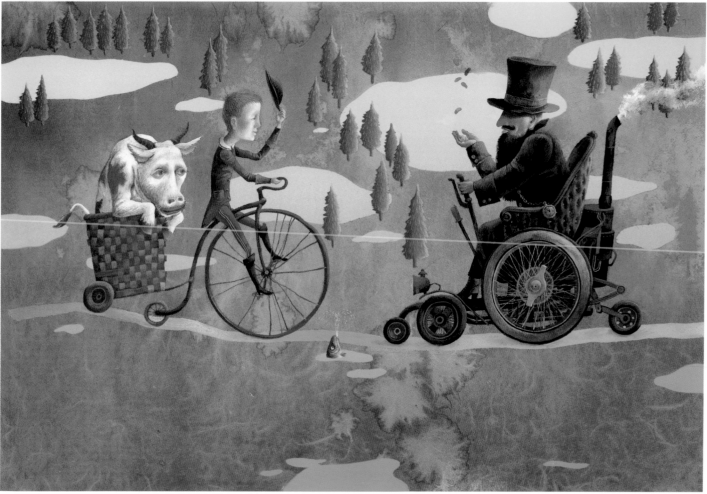

154

155
Artist: **Bill Nelson**
Art Director: Louise Fili
Client: Steerforth Press
Medium: Colored pencil
Size: 7" x 9"

156
Artist: **Dick Krepel**
Art Director: Janice Shay
Client: Savannah College of Art & Design
Medium: Digital, collage
Size: 14" x 12"

157
Artist: **Robert Saunders**
Art Director: Wayne Pope
Client: Creative Arts Book Company
Medium: Acrylic, watercolor on Arches 300 lb.
 watercolor paper
Size: 15" x 16"

158
Artist: **Cathleen Toelke**
Art Director: Richard Aquan
Client: HarperCollins
Medium: Mixed on canvas
Size: 13" x 9"

159
Artist: **Cathleen Toelke**
Art Director: Tom Stvan
Client: Simon & Schuster/Scribner
Medium: Gouache on board
Size: 8" x 8"

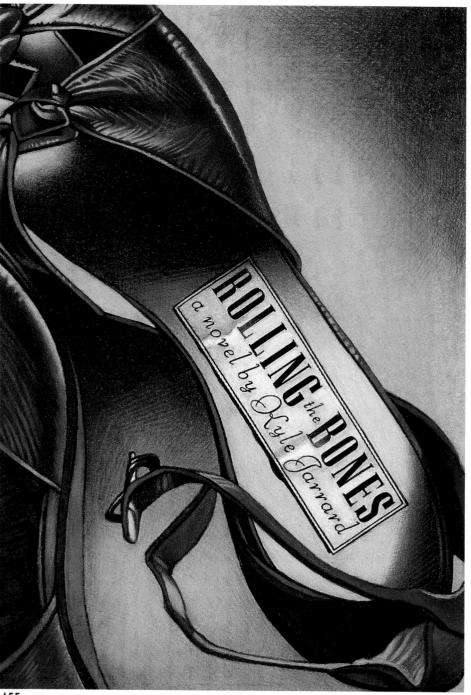

155

156

157

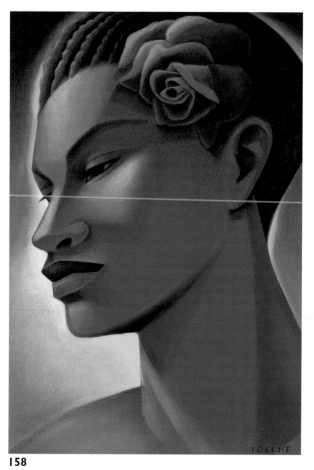

158

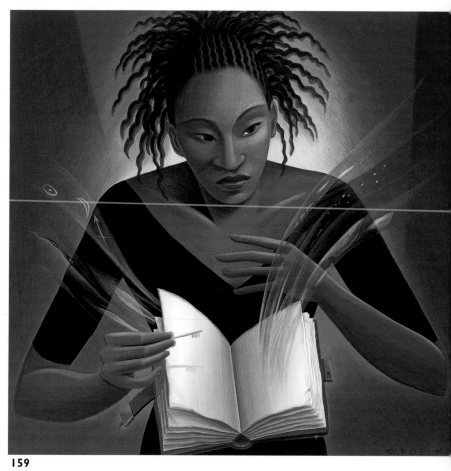

159

BOOK

160
Artist: **Tim O'Brien**
Art Director: Elizabeth Parisi
Client: Scholastic Inc.
Medium: Oil on illustration board
Size: 14" x 10"

161
Artist: **Cathleen Toelke**
Art Director: Nick Krenitsky
Client: HarperCollins
Medium: Gouache on board
Size: 9" x 6"

162
Artist: **Tim O'Brien**
Art Director: Elizabeth Parisi
Client: Scholastic Inc.
Medium: Oil on illustration board
Size: 18" x 12"

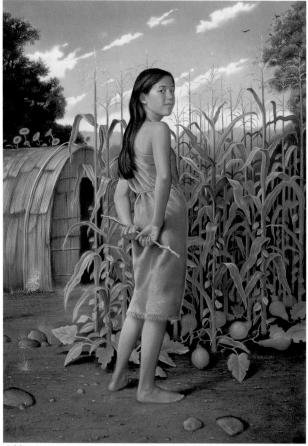

160

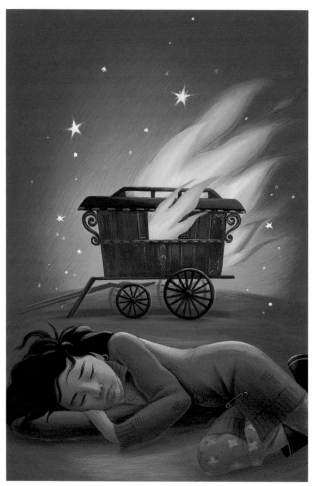

161

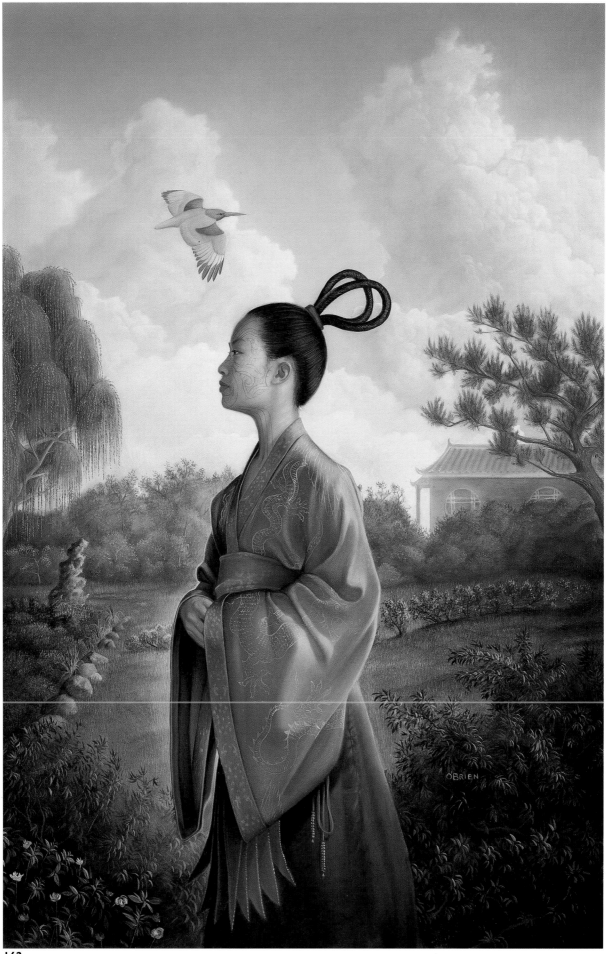

BOOK

163
Artist: **Greg Swearingen**
Art Director: Joyce White
Client: Scholastic Inc.
Medium: Acrylic , colored pencil on board
Size: 12" x 9"

164
Artist: **Masao Gotoh**
Size: 9" x 12"

165
Artists: **Steve Johnson**
 Lou Fancher
Art Director: Lydia Di Moch
Client: Harcourt Brace
Medium: Oil on gessoed Bristol board
Size: 9" x 18"

166
Artist: **Beppe Giacobbe**
Art Director: Matteo Bologna
Client: Rizzoli Books
Medium: Mixed
Size: 7" x 18"

167
Artist: **Leonid Gore**
Art Director: Martha Rago
Client: Henry Holt & Company
Medium: Acrylic, pastel on paper
Size: 12" x 9"

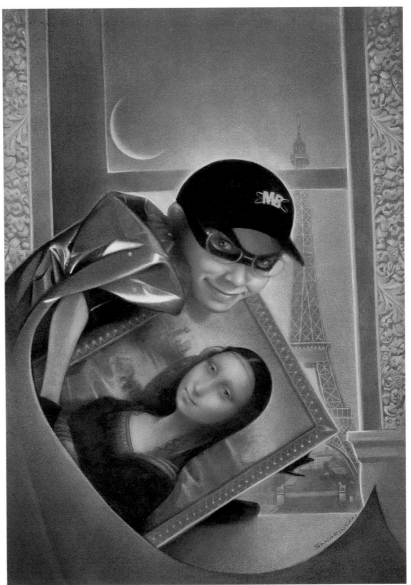

163

164

165

166

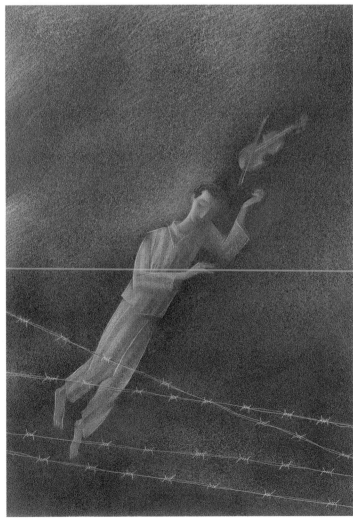

167

168

Artists: **Steve Johnson**
 Lou Fancher
Art Director: Denise Cronin
Client: Starbright
Medium: Oil on gessoed 3 ply Bristol board
Size: 16" x 11"

169

Artist: **Chris Sheban**
Art Director: Rita Marshall
Client: Creative Editions
Medium: Watercolor, pencil
Size: 13" x 17"

170

Artist: **Chris Sheban**
Art Directors: Rita Marshall
 Tom Peterson
Client: Creative Editions
Medium: Watercolor, pencil

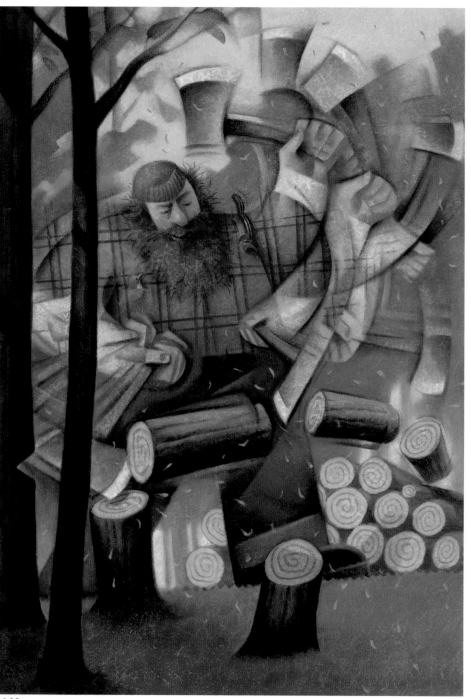

168

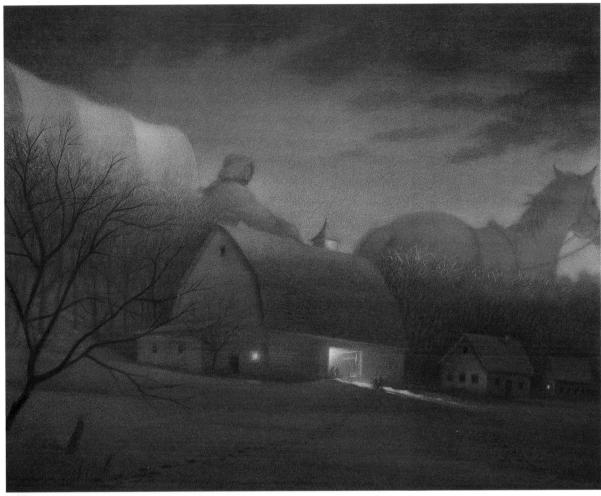

169

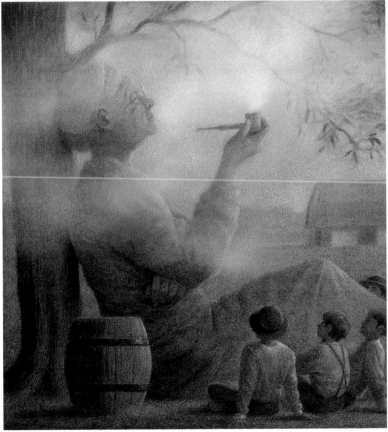

170

BOOK

171
Artist: **Kam Mak**
Art Director: Al Cetta
Client: HarperCollins
Medium: Oil on panel
Size: 10" x 13"

172
Artist: **Lucy Corvino**
Art Director: Lynn Binder
Client: Barnes & Noble Publishing
Medium: Acrylic, colored pencil, pastel
 on pastel paper
Size: 10" x 14"

173
Artist: **Bagram Ibatoulline**
Art Director: Chris Paul
Client: Candlewick Press
Medium: Gouache

174
Artist: **Jerry Pinkney**
Art Directors: Nancy Leo
 Atha Tehon
Client: Phyllis Fogelman Books
Medium: Watercolor, pencil
Size: 14" x 20"

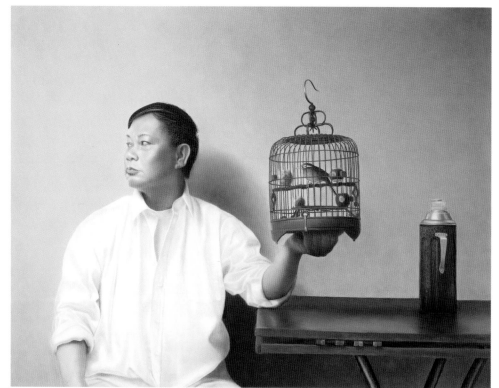

171

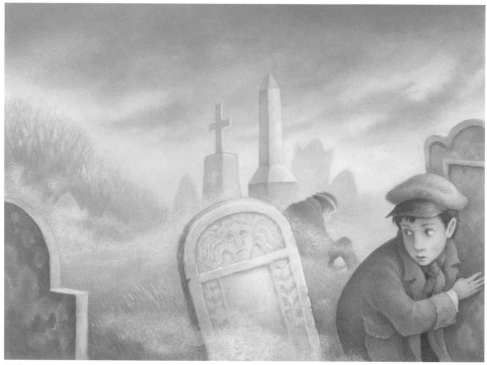

172

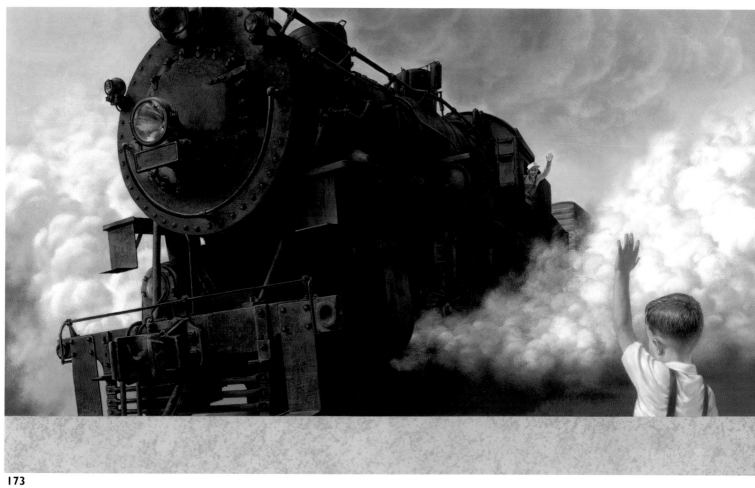

173

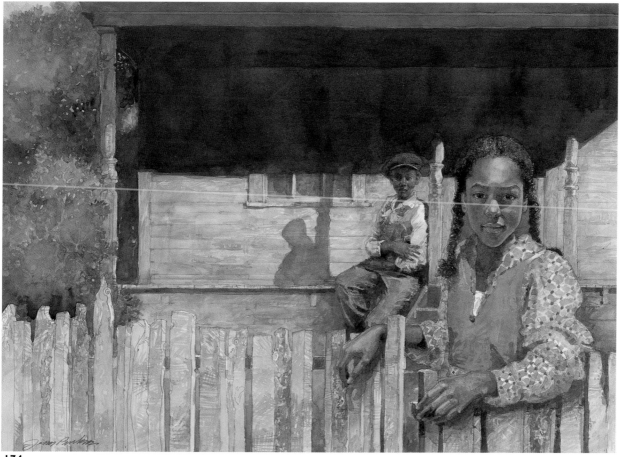

174

175
Artist: **C.F. Payne**
Art Director: Paul Zakris
Client: Simon & Schuster
Medium: Mixed
Size: 16" x 12"

176
Artist: **Mike Benny**
Art Director: Jess Giambroni
Medium: Acrylic
Size: 16" x 11"

177
Artist: **C.F. Payne**
Art Director: Paul Zakris
Client: Simon & Schuster
Medium: Mixed
Size: 15" x 11"

178
Artist: **Gary Kelley**
Client: Hearst Center for the Arts
Medium: Monotype
Size: 14" x 10"

179
Artist: **Kadir Nelson**
Art Director: David Saylor
Client: Scholastic Inc.
Medium: Oil on paper
Size: 11" x 20"

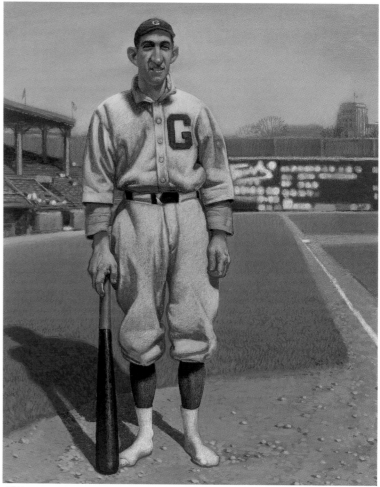

175

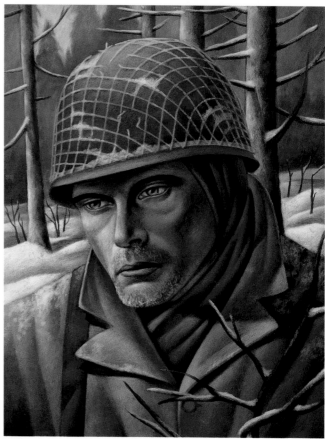

176

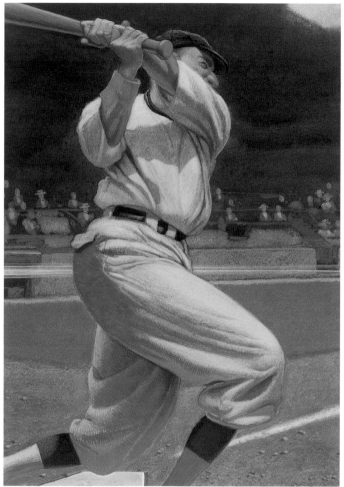

177

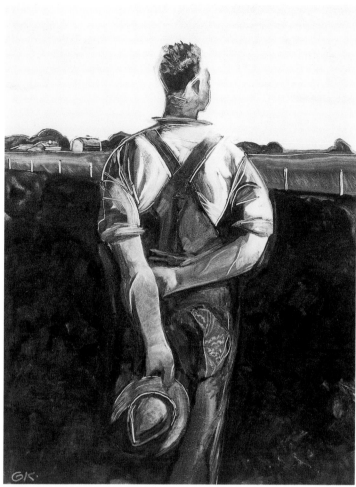

178

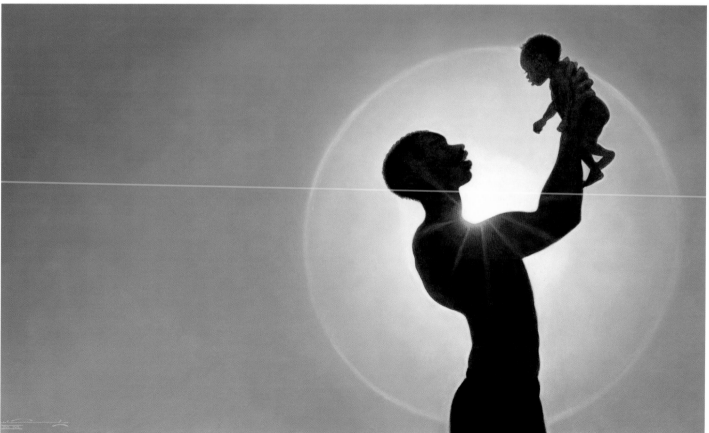

179

180
Artist: **Glenn Harrington**
Art Director: Karen Nelson
Client: Sterling Publishing
Medium: Oil on linen
Size: 17" x 23"

181
Artist: **Gregory Manchess**
Art Director: Francine Kass
Client: Simon & Schuster
Medium: Oil on gessoed board
Size: 15" x 12"

182
Artist: **Warren Chang**
Medium: Oil on canvas
Size: 12" x 16"

183
Artist: **Greg Harlin**
Art Director: Al Cetta
Client: HarperCollins
Medium: Watercolor on watercolor paper
Size: 8" x 21"

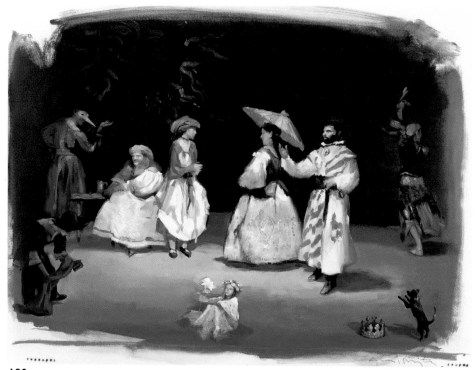

180

181

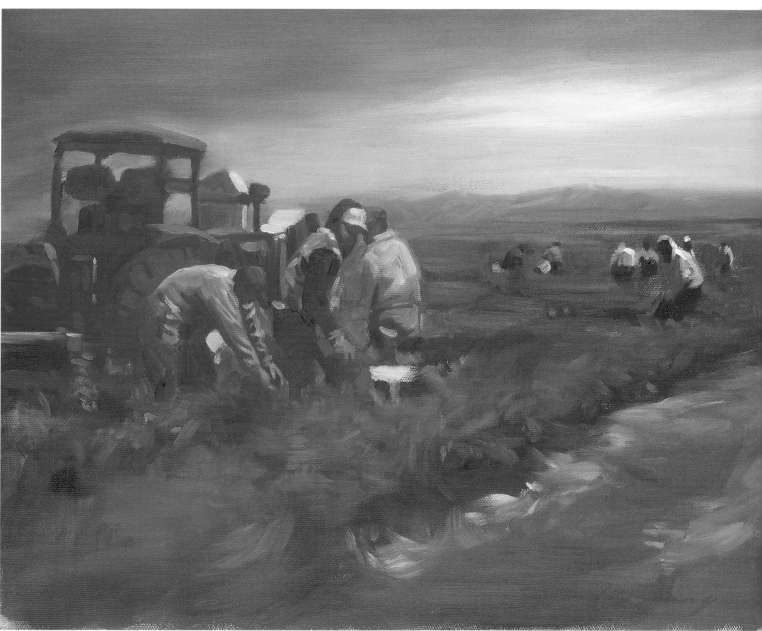

182

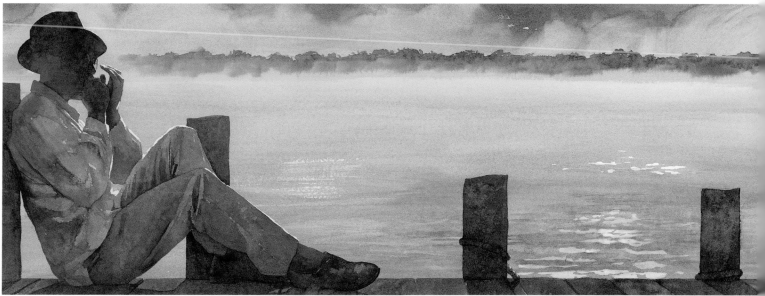

183

184
Artist: **Bernie Fuchs**
Art Directors: Melanie Kroupa
 Jennifer Browne
Client: Farrar, Straus & Giroux
Medium: Oil on canvas
Size: 24" × 20"

185
Artist: **Glenn Harrington**
Art Director: Chris Clark
Client: McDougal Littell
Medium: Oil on linen
Size: 18" × 19"

186
Artist: **Gregory Manchess**
Art Director: Irene Gallo
Client: Tor Books
Medium: Oil on gessoed board
Size: 10" × 17"

187
Artist: **John Thompson**
Art Director: Rita Marshall
Client: Creative Editions
Medium: Acrylic on paper
Size: 8" × 14"

188
Artist: **Robert Ingpen**
Art Director: Amelia Edwards
Client: Candlewick Press/Walker Books
Medium: Watercolor on paper

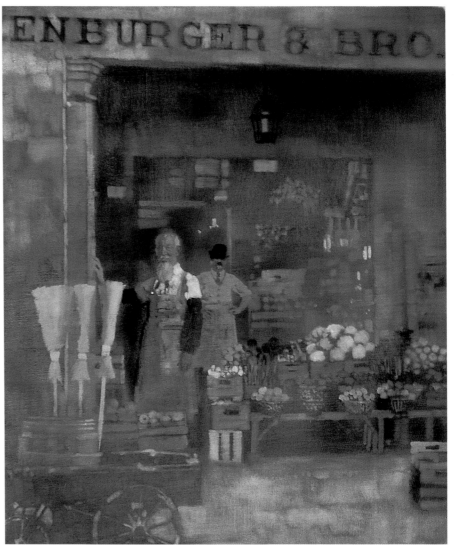

184

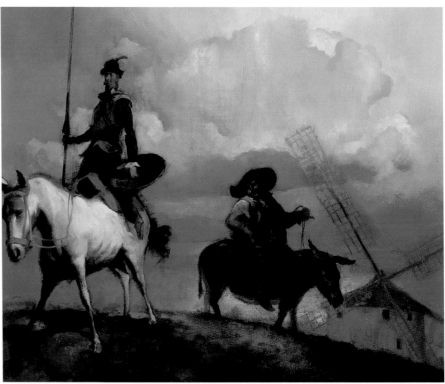

185

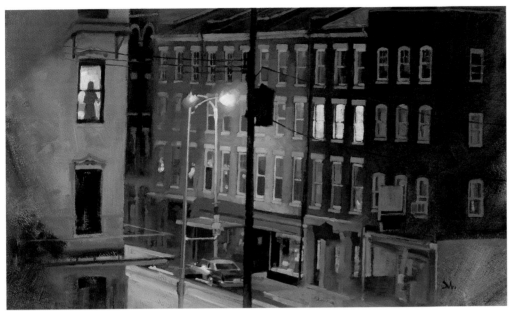

186

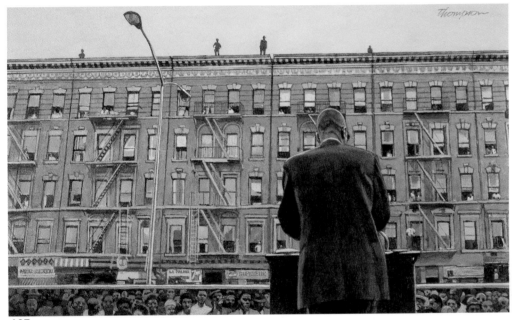

187

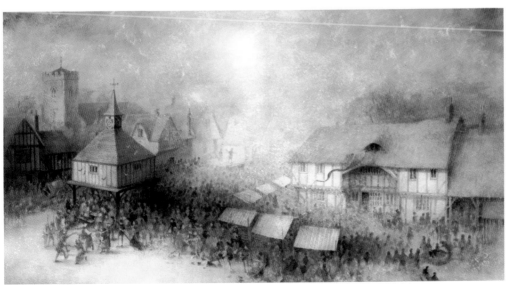

188

189

Artist: **Peter de Sève**

Art Director: Rosanne Serra

Client: Penguin Putnam

Medium: Watercolor, ink

Size: 11" x 7"

190

Artist: **Peter de Sève**

Art Director: Robert Weil

Client: W.W. Norton

Medium: Watercolor, ink

Size: 13" x 9"

191

Artist: **Victor Juhasz**

Art Director: Arnold Goldstein

Client: Rutledge Books

Medium: Pen & ink, watercolor,
 gouache on paper

Size: 20" x 14"

192

Artist: **Victor Juhasz**

Art Director: Arnold Goldstein

Client: Rutledge Books

Medium: Pen & ink, watercolor,
 gouache on paper

Size: 20" x 17"

193

Artist: **Mark Summers**

Art Director: Sonia Scanlin

Client: Yale University Press

Medium: Scratchboard, watercolor

Size: 10" x 10"

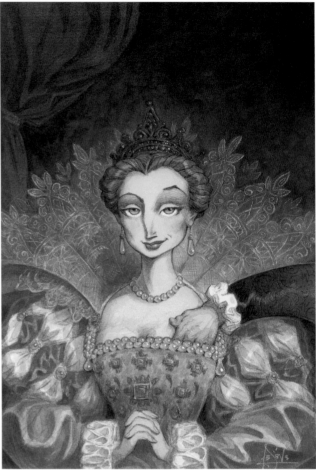

189

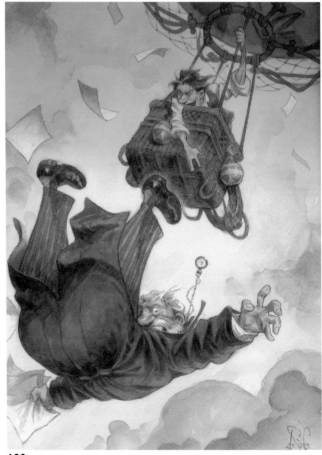

190

191

192

193

194

Artist: **Douglas Smith**

Art Director: Dan Taylor

Client: Regan Books/HarperCollins

Medium: Scratchboard, watercolor

Size: 12" x 8"

195

Artist: **Douglas Smith**

Art Director: Richard Aquan

Client: HarperCollins

Medium: Scratchboard, watercolor

Size: 14" x 10"

196

Artist: **Andrew Davidson**

Art Director: Paul Buckley

Client: Penguin USA

Medium: Wood Engraving on hand-made
　　　　 Japanese paper

Size: 3" x 6"

197

Artist: **Andrew Davidson**

Art Director: Paul Buckley

Client: Penguin USA

Medium: Wood Engraving on hand-made
　　　　 Japanese paper

Size: 3" x 6"

198

Artist: **Andrew Davidson**

Art Director: Paul Buckley

Client: Penguin USA

Medium: Wood Engraving on hand-made
　　　　 Japanese paper

Size: 3" x 7"

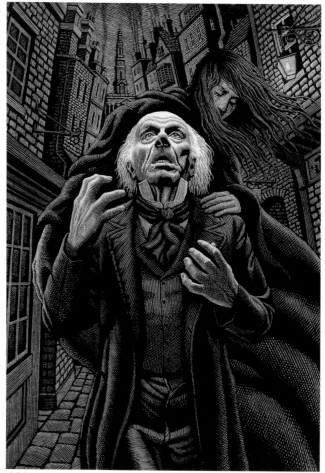

194

195

196

197

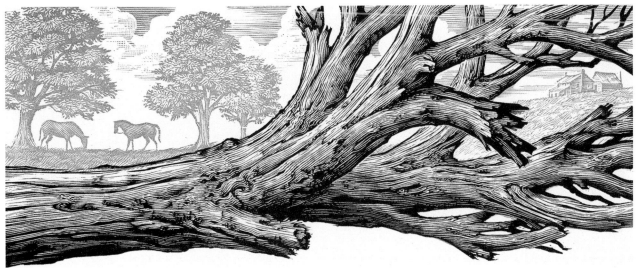

198

199

Artist: **Adam McCauley**

Art Directors: Denise Cronin
Regina Hayes

Client: Viking Children's Books

Medium: Scratchboard, acrylic on
watercolor paper

Size: 7" x 5"

200

Artist: **Jenny Tylden Wright**

Art Director: Paolo Pepe

Client: Pocket Books

Medium: Caran D'Ache colored pencil
on paper

Size: 14" x 9"

201

Artist: **Giselle Potter**

Art Director: Marijka Kostiw

Client: Scholastic Inc.

Size: 9" x 20"

202

Artist: **Patrick Arrasmith**

Art Director: Kristine M. Pettit

Client: Parachute Publishing

Medium: Scratchboard

Size: 9" x 12"

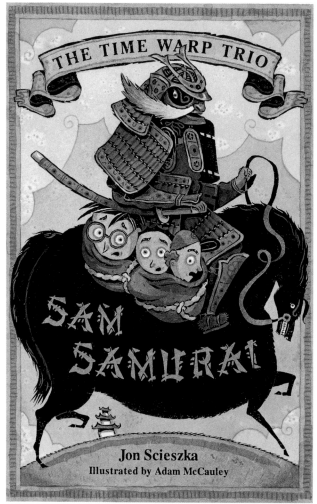

199

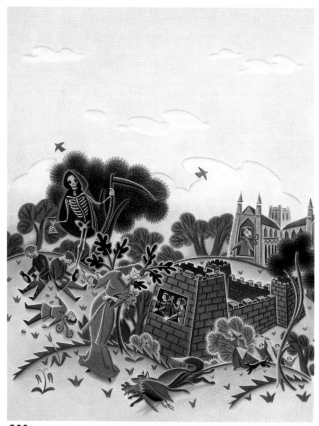

200

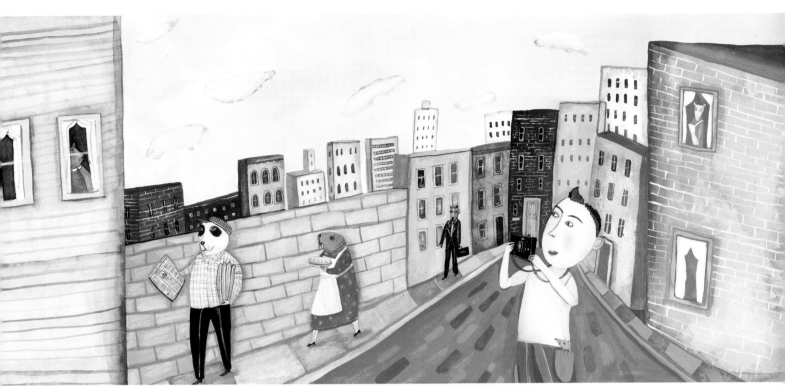

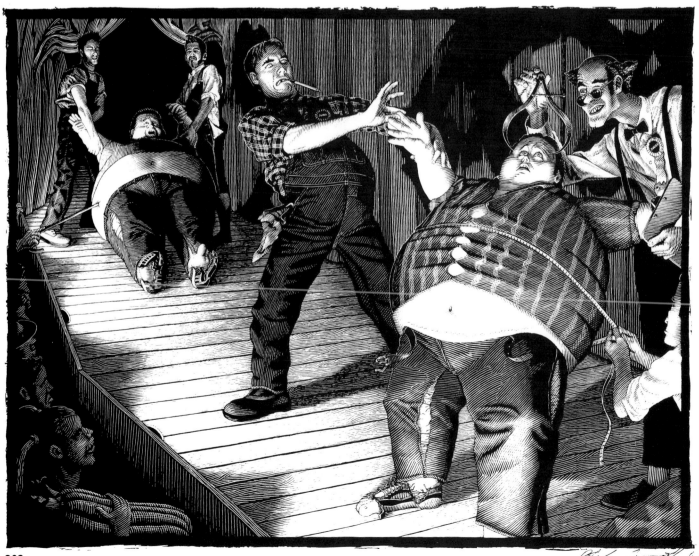

BOOK

203
Artist: **Margaret Hurst**
Client: Laura Geringer Books/HarperCollins
Medium: Hand-sewn, hand silk-screened fabric
Size: 10" x 13"

204
Artist: **Margaret Hurst**
Client: Laura Geringer Books/HarperCollins
Medium: Hand-sewn, hand silk-screened fabric
Size: 10" x 13"

205
Artist: **Rick Sealock**
Art Director: Ken Bessie
Medium: Mixed on mixed papers,
 watercolor paper and cardboard
Size: 19" x 30"

206
Artist: **Rick Sealock**
Art Director: Ken Bessie
Medium: Ink, watercolor, acrylic,
 collage on printmaking paper and
 watercolor paper
Size: 14" x 10"

207
Artist: **Rick Sealock**
Art Director: Ken Bessie
Medium: Ink, watercolor, acrylic, collage on
 watercolor paper
Size: 13" x 10"

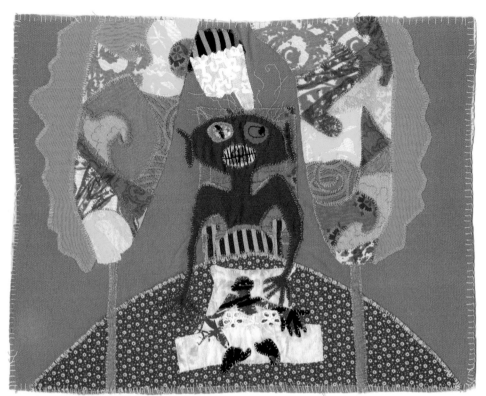

203

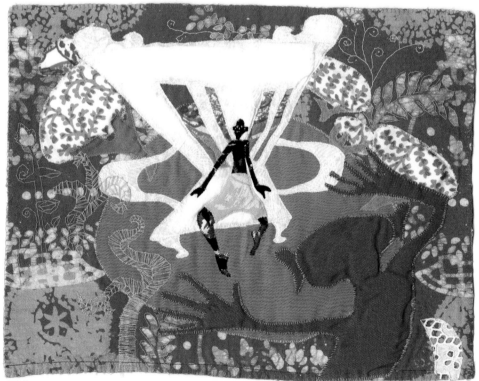

204

205

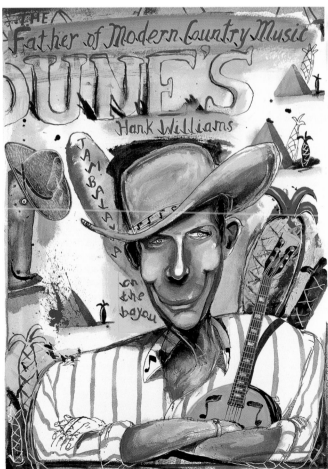

206

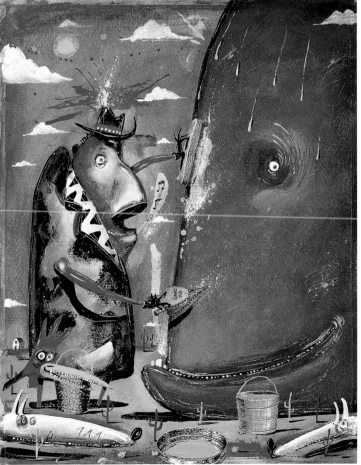

207

208
Artist: **Greg Clarke**
Art Director: Michael Nelson
Client: Simon & Schuster
Medium: Acrylic on paper
Size: 11" x 7"

209
Artist: **Laura Huliska-Beith**
Art Director: Karen Nelson
Client: Sterling Publishing
Medium: Mixed
Size: 13" x 10"

210
Artist: **James Ransome**
Art Director: Claire Counihan
Client: Holiday House
Medium: Acrylic on Strathmore Bristol board
Size: 10" x 14"

211
Artist: **Sasha Rubel**
Client: Stewart, Tabori & Chang
Medium: Oil on canvas
Size: 17" x 23"

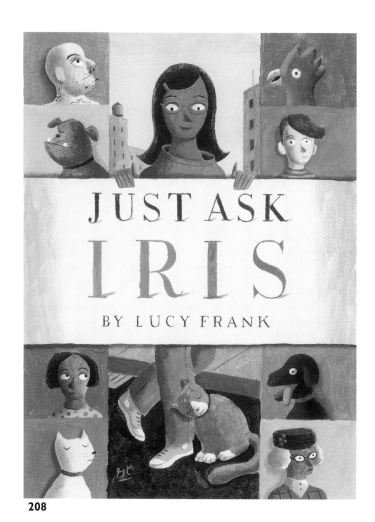

208

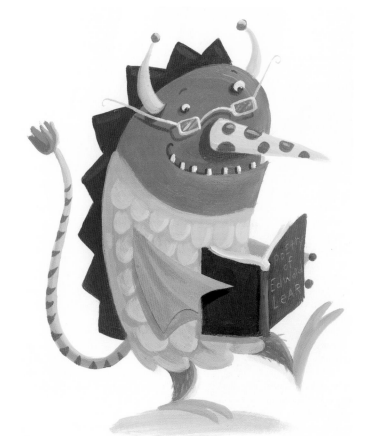

209

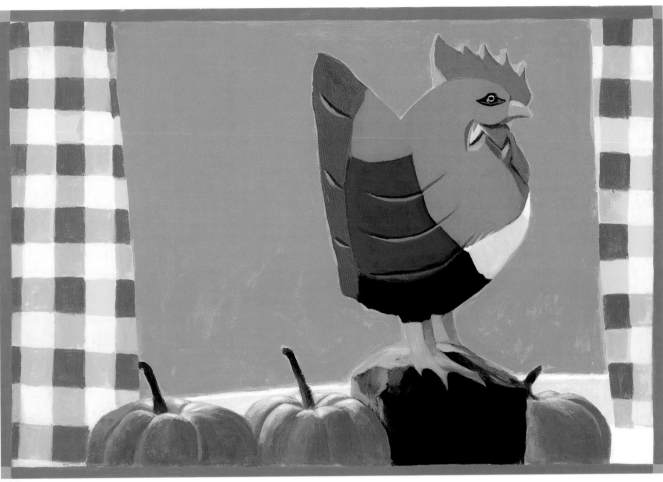

210

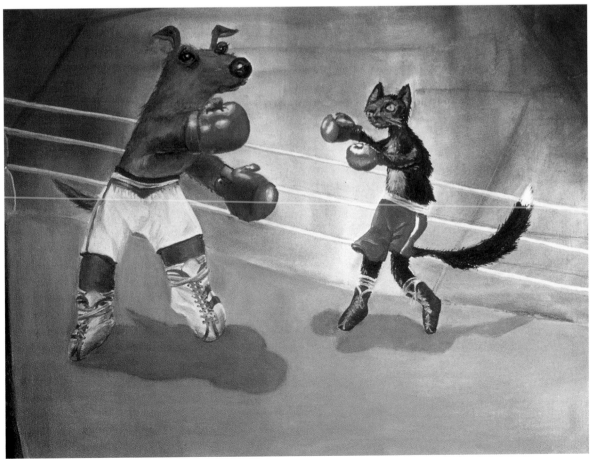

212
Artist: **John H. Howard**
Art Director: Krystyna Skalski
Client: Walker & Company
Medium: Prismacolor pencil on black
Canson paper
Size: 19" x 11"

213
Artist: **Chris Sheban**
Art Director: Atha Tehon
Client: Dial Books for Young Readers
Medium: Pastel
Size: 9" x 8"

214
Artist: **Yan Nascimbene**
Art Director: Jacques Binsztok
Client: Editions du Seuil
Medium: Watercolor, india ink on Arches cold
pressed 140# watercolor paper
Size: 9" x 6"

215
Artist: **Yan Nascimbene**
Art Director: Jacques Binsztok
Client: Editions du Seuil
Medium: Watercolor, india ink on Arches cold
pressed 140# watercolor paper
Size: 9" x 6"

216
Artist: **William Low**
Art Director: Jeanette Larson
Client: Harcourt Brace
Medium: Digital on rag paper
Size: 10" x 17"

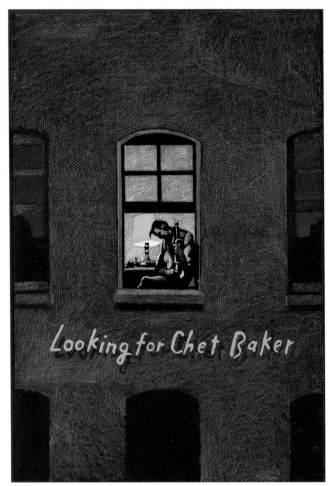

212

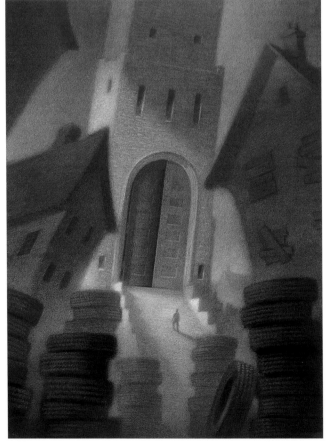

213

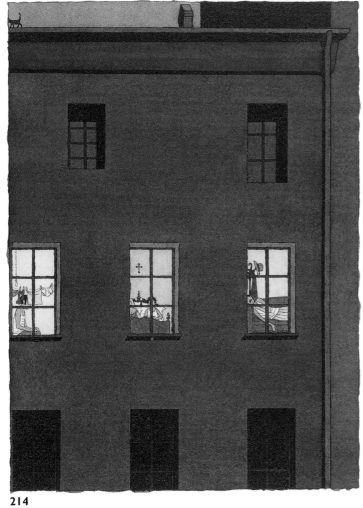

214

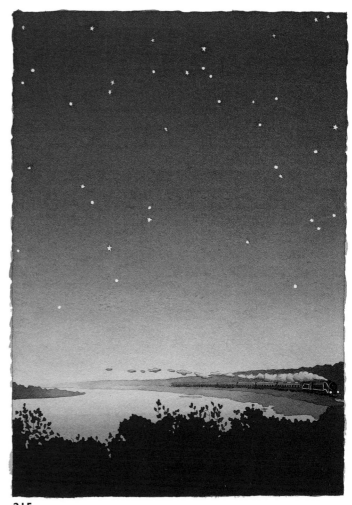

215

216

217
Artist: **Raúl Colón**
Art Director: Matt Adamec
Client: HarperCollins
Medium: Watercolor, colored pencil, litho pencil
Size: 15" × 11"

218
Artist: **Greg Couch**
Art Director: Cecilia Yung
Client: Philomel Books
Medium: Acrylic, colored pencil
Size: 10" × 21"

219
Artist: **Greg Couch**
Art Director: Cecilia Yung
Client: Philomel Books
Medium: Acrylic, colored pencil
Size: 10" × 21"

220
Artist: **Greg Couch**
Art Director: Cecilia Yung
Client: Philomel Books
Medium: Acrylic, colored pencil
Size: 10" × 21"

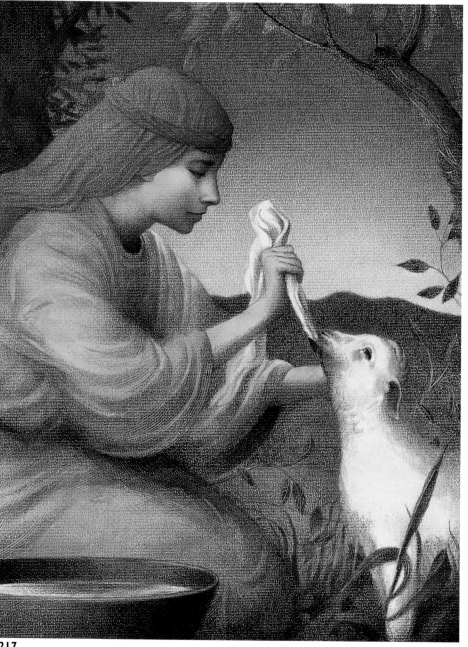

217

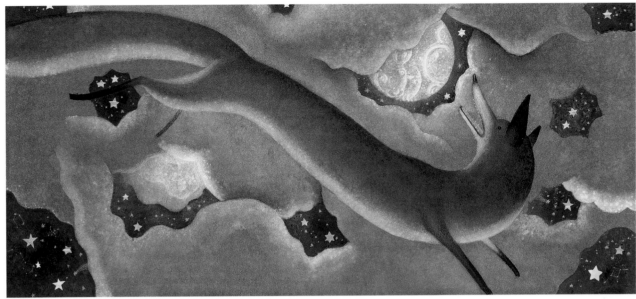

218

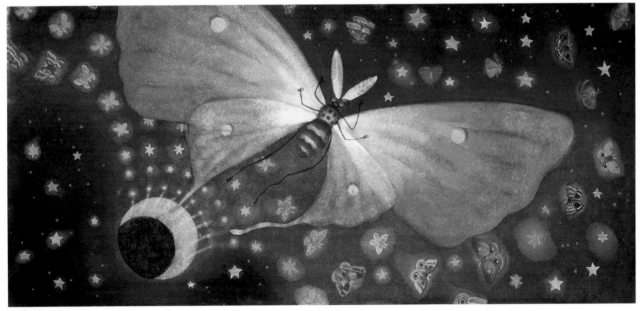

219

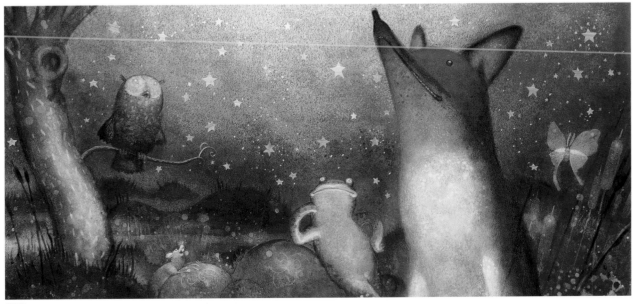

220

BOOK

221
Artist: **Peter Fiore**
Art Director: Yoland LeRoy
Client: Charlesbridge Publishing
Medium: Oil on Strathmore Illustration board
Size: 18" × 13"

222
Artist: **Steve Jenkins**
Art Director: Elynn Cohen
Client: HarperCollins
Medium: Cut paper collage on paper
Size: 9" × 20"

223
Artist: **Etienne Delessert**
Art Director: Rita Marshall
Client: Creative Editions
Medium: Watercolor
Size: 8" × 5"

224
Artist: **Murray Kimber**
Art Director: Kathryn Cole
Client: Stoddart Publishing Company
Medium: Oil, acrylic on canvas
Size: 24" × 18"

225
Artist: **Anita Jeram**
Art Director: Deidre McDermott
Client: Candlewick Press
Medium: Acrylic on canvas textured paper

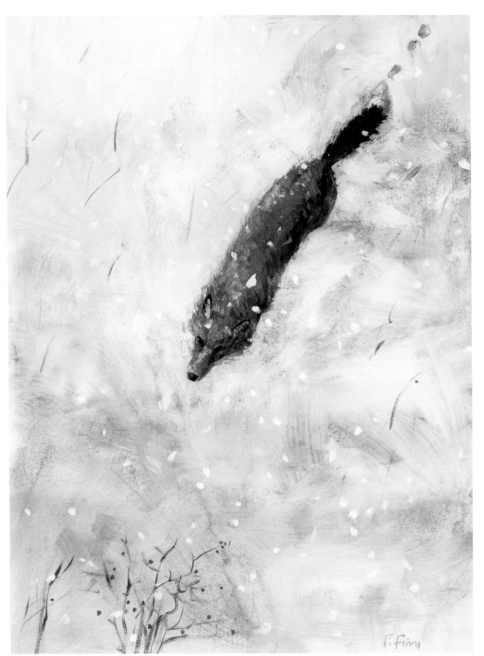

221

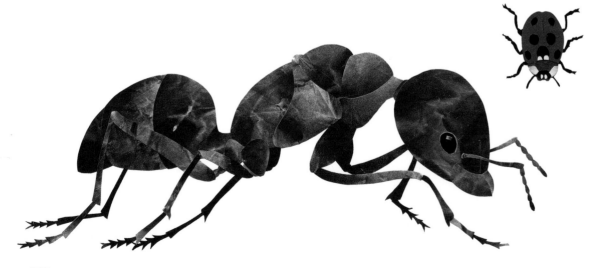

222

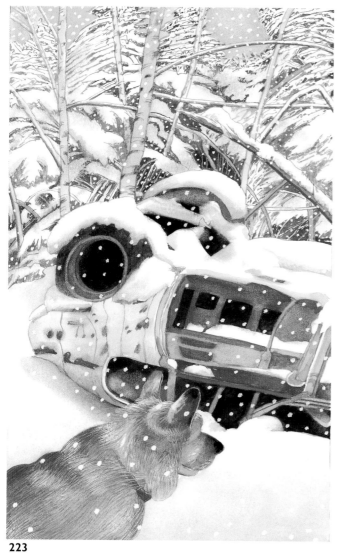

223

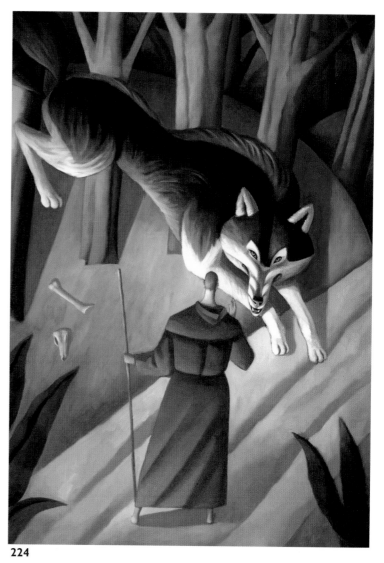

224

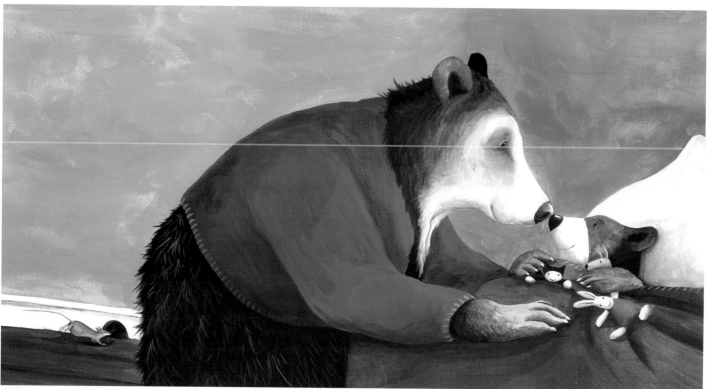

225

BOOK

226
Artist: **Andrea Wesson**
Art Director: Jean Krulis
Client: Marshall Cavendish
Medium: Pen & ink, watercolor on
watercolor paper
Size: 9" x 10"

227
Artist: **Wendy Watson**
Art Directors: Filomena Tuosto
Jane Byers Bierhorst
Client: Farrar, Straus & Giroux
Medium: Ink, watercolor, gouache,
pencil on Lanaquerelle 90 lb. hot press
watercolor paper
Size: 9" x 7"

228
Artist: **Sergio Ruzzier**
Art Director: Francesca Habe
Client: La Vita Felice
Medium: Pen & ink, watercolor on paper
Size: 9" x 11"

229
Artist: **Mary Jane Begin**
Art Director: Ellen Friedman
Client: Sea Star Books
Medium: Acrylic, watercolor on Arches
hot press watercolor paper
Size: 13" x 9"

230
Artist: **Mary Jane Begin**
Art Director: Ellen Friedman
Client: Sea Star Books
Medium: Acrylic, watercolor on Arches
hot press watercolor paper
Size: 13" x 9"

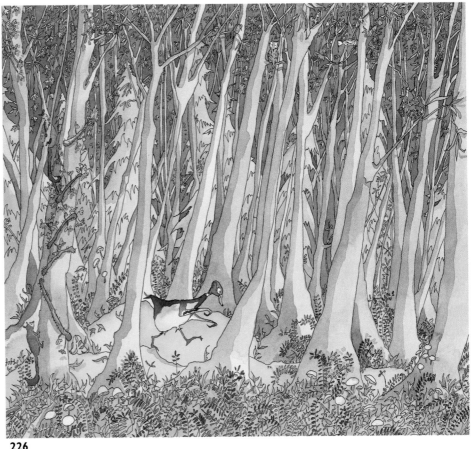

226

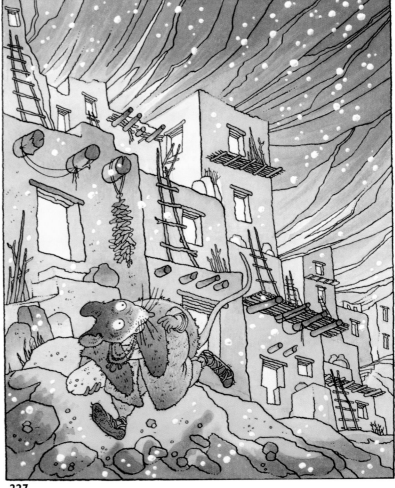

227

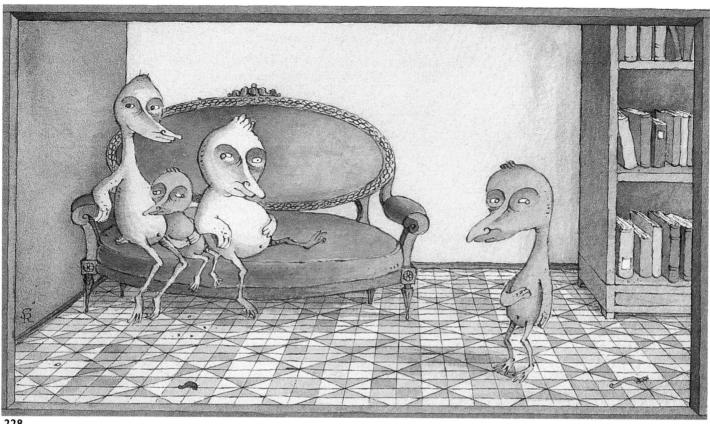

228

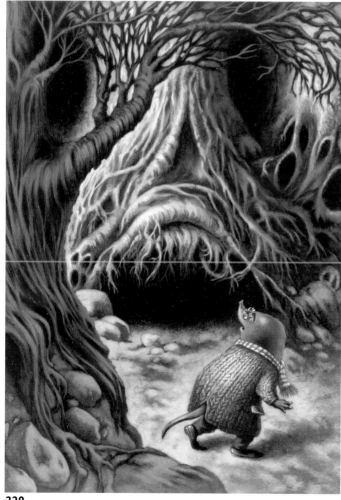

229

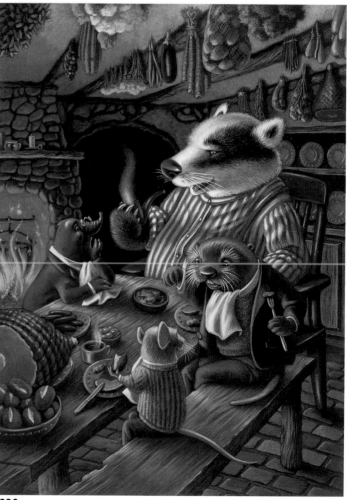

230

232

Artist: **Etienne Delessert**

Art Director: Rita Marshall

Client: Creative Editions

Medium: Watercolor

Size: 9" x 5"

233

Artist: **Jack E. Davis**

Art Director: Judythe Sieck

Client: Harcourt Brace

Medium: Acrylic, colored pencil on
watercolor paper

Size: 13" x 20"

234

Artist: **Leuyen Pham**

Art Director: Jeanette Larson

Client: Harcourt Brace

Medium: Watercolor

Size: 9" x 8"

235

Artist: **Daniel Craig**

Art Director: Jef Wilson

Client: Harcourt Brace

Medium: Acrylic on canvas

Size: 15" x 12"

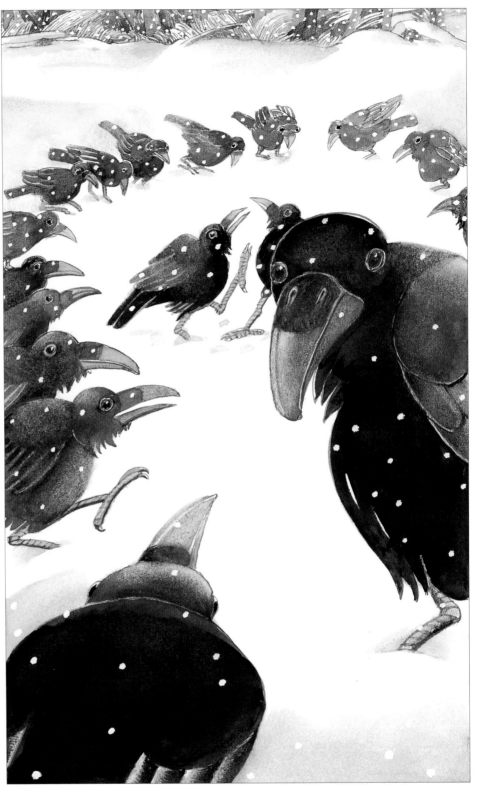

232

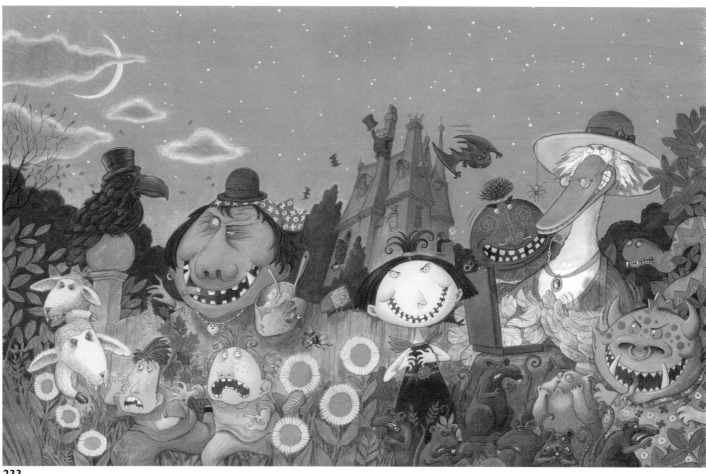

233

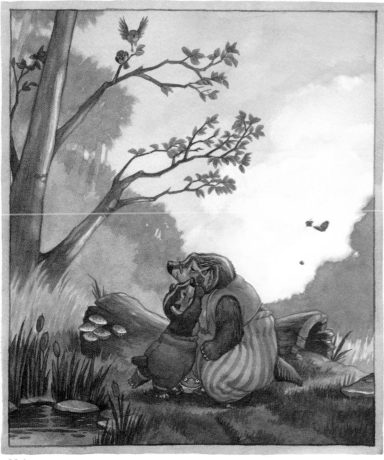

234

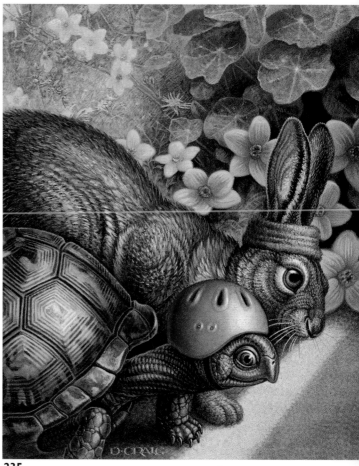

235

236
Artist: **Russell Farrell**
Art Director: Brian Boucher
Client: McGraw-Hill Books
Medium: Acrylic on watercolor board
Size: 5" x 9"

237
Artist: **Wendell Minor**
Art Director: Joann Hill
Client: Clarion Books
Medium: Watercolor on cold press paper
Size: 8" x 17"

238
Artist: **Bill Cigliano**
Art Director: Dawn Beard
Client: Harcourt Brace
Medium: Mixed on Strathmore rag board
Size: 12" x 10"

239
Artist: **Brian Ajhar**
Art Director: David Saylor
Client: Arthur A. Levine Books
Medium: Watercolor, acrylic on
 watercolor paper
Size: 16" x 24"

240
Artist: **Jared Lee**
Art Director: Edith Weinberg
Client: Scholastic Inc.
Medium: Ink, dyes on 5-ply medium
 surface Strathmore
Size: 7" x 15"

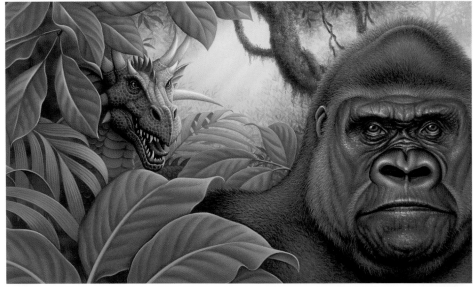

236

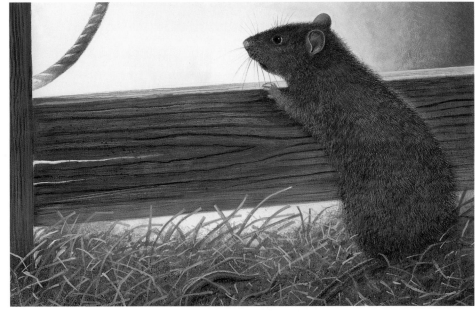

237

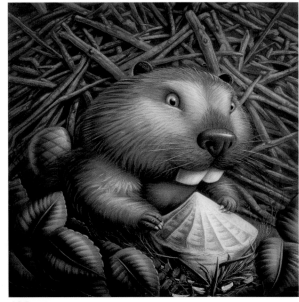

238

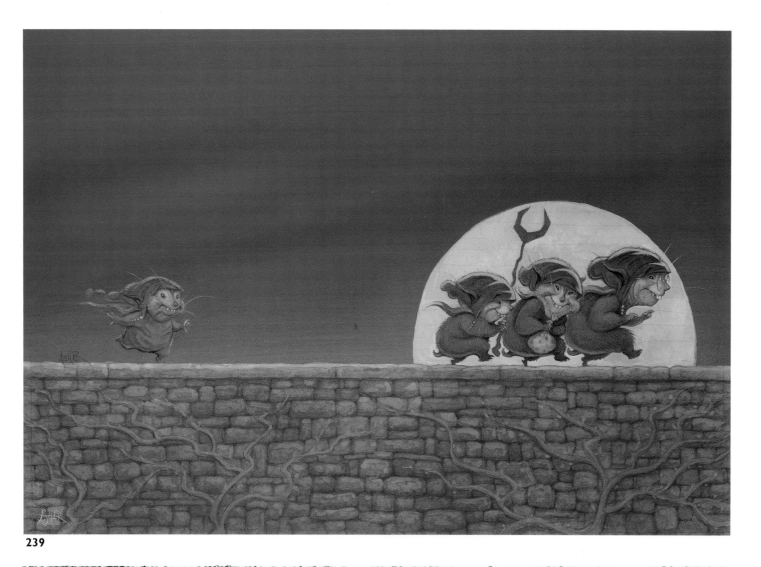

239

240

241
Artist: **William Joyce**
Art Director: Al Cetta
Client: HarperCollins
Medium: Digital
Size: 10" × 20"

242
Artist: **Brian Ajhar**
Art Director: Lily Malcolm
Client: Dial Books for Young Readers
Medium: Watercolor, acrylic on
 watercolor paper
Size: 13" × 18"

241

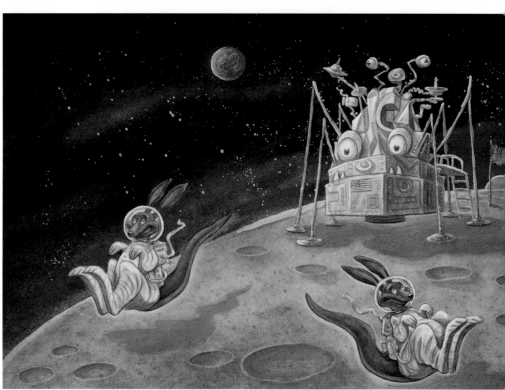

242

ADVERTISING

JURY

Peter de Sève, Chair
Illustrator

Barry Blitt
Illustrator/cartoonist

Paul Buckley
Vice President Art Director
Penguin paperbacks/Viking hardcovers
Penguin Putnam Inc.

Chris Curry
Illustration Editor
The New Yorker

Jordin Isip
Illustrator

Mark McMahon
Illustrator

Elizabeth B. Parisi
Art Director
Scholastic Inc.

Daniel Pelavin
Illustrator

D. J. Stout
Pentagram Design Inc.

ADVERTISING

242 GOLD MEDAL
Artist: **Jason Holley**
Art Director: Gary Williams
Client: Maxygen
Medium: Mixed
Size: 16" x 23"

Maxygen is a firm that can amplify gene mutation and cultivate very specific genes. This, says Holley, is great news for the development of disease killers. Even better, the job was a good deal all around. Gary Williams works at Cahan & Associates, one of an amazing group of designers with a healthy respect for illustration. Jason created 15 works for this annual report, which was meant to have the look of a Darwinian notebook. "The work is acrylic and oils, but my hands are all over it. It gets plenty beat up."

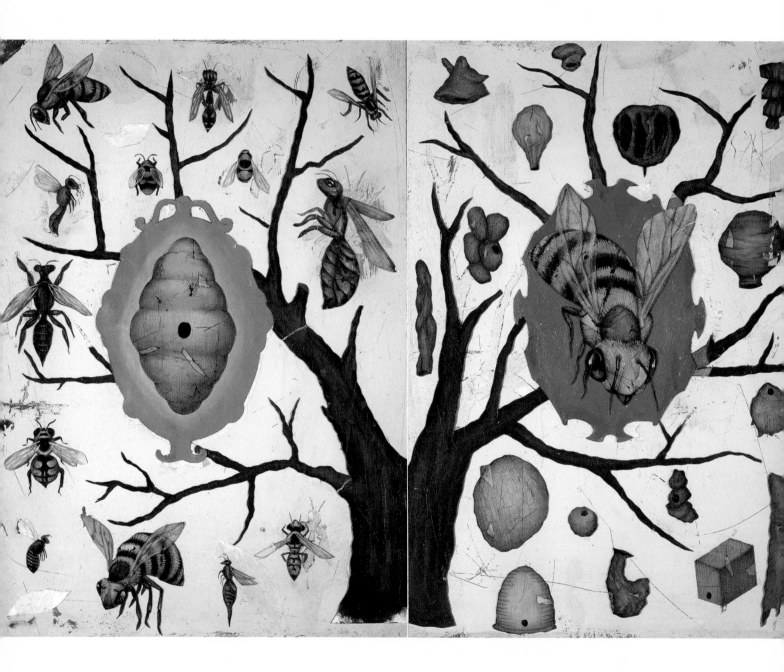

243 SILVER MEDAL
Artist: **Dick Krepel**
Art Director: Brent Watts
Client: Houlihan, Lokey, Howard & Zukin, Inc.
Medium: Digital, mixed
Size: 15" × 12"

Dick Krepel's recent work is radically different from his past work. Selected for the cover of *Illustrators 43*, his work has also been represented in *Communication Arts*, *Step-by-Step Graphics*, *Applied Arts* magazine, the RSVP show, and the on-line site for the Society of Illustrators of Los Angeles. American Illustration 2002 will include Mr. Krepel's work in their "chosen" category, and his work will be included in "Spectrum 9: The Best in Contemporary Fantastic Art."

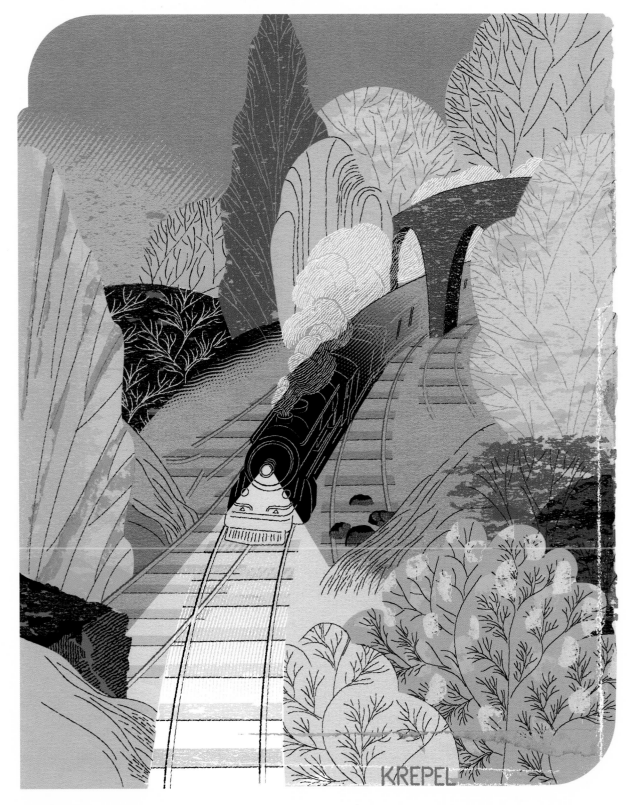

244 SILVER MEDAL
Artist: **David Miller**
Art Director: Lance Ferguson
Client: Flight 001
Medium: Watercolor, pen & ink, collage,
 colored pencil on paper
Size: 24" x 19"

Trained at Parsons School of Design in New York and Paris, David Miller's illustrations reveal a disquieting fantasy world influenced by Eastern European design which nurtured his inspiration during extensive journeys to Prague. Fascinated by Bohemian circus life and the Czech tradition of pantomime theater, children's books, and animation, Miller has imagined a very personal world of hybrid characters with contrasting features and fantastic bodies, surrounded by tapered bestiary images that a child might dream of. Visually striking and frightening, the collages, scribbled sketches, and writings present a subtle and odd sense of humor.

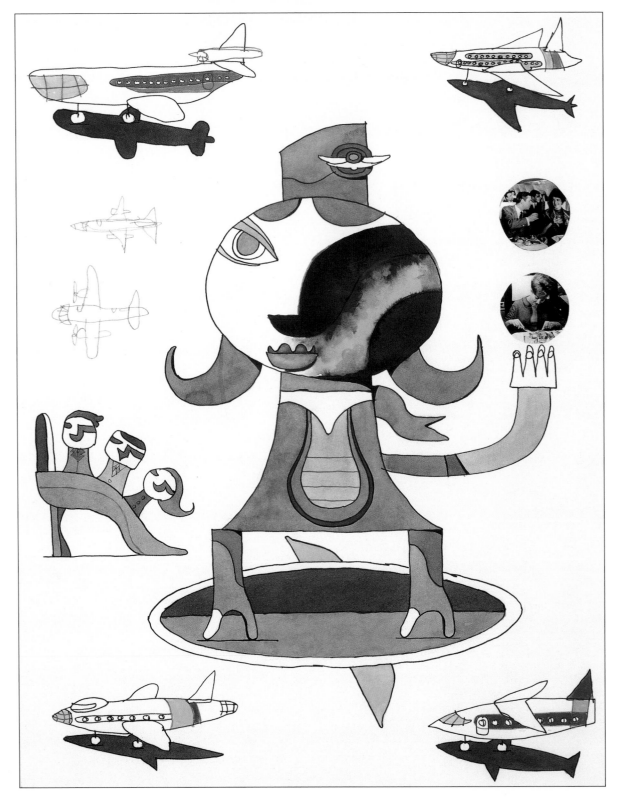

245 SILVER MEDAL
Artist: **Rafal Olbinski**
Client: Kongres Kultury Polskies
Medium: Acrylic on canvas
Size: 30" x 20"

This image was created for the Polish Cultural Congress Festival in Warsaw. The red rose was such a bold visual statement that the image became the symbol for that festival, where the artist also served as design panelist. Olbinski has launched a new career as stage designer following the success of his Don Giovanni in Philadelphia.

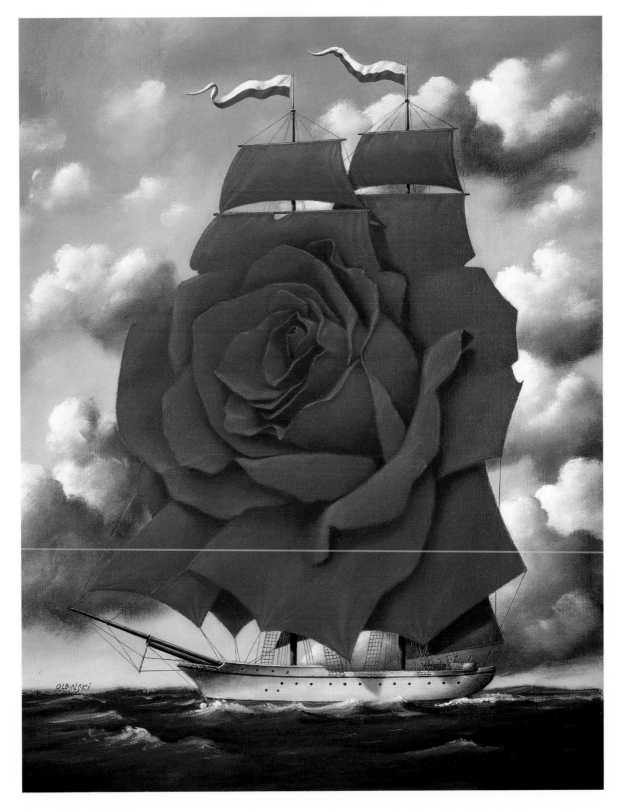

246

Artist: **Linda Fennimore**

Art Director: Linda Prosche

Client: Travel Smith

Medium: Colored pencil on Stonehenge paper

Size: 14" x 11"

247

Artist: **Peter Malone**

Art Director: Susie Heller

Client: Napa Style

Medium: Gouache on paper

Size: 12" x 19"

248

Artist: **Mark Korsak**

Art Director: Hollis King

Client: The Verve Music Group

Medium: Watercolor, colored pencil on
 Strathmore illustration board

Size: 15" x 24"

249

Artist: **Kadir Nelson**

Art Director: Tim Mattimore

Client: Footlocker/And One

Medium: Oil on canvas

Size: 36" x 27"

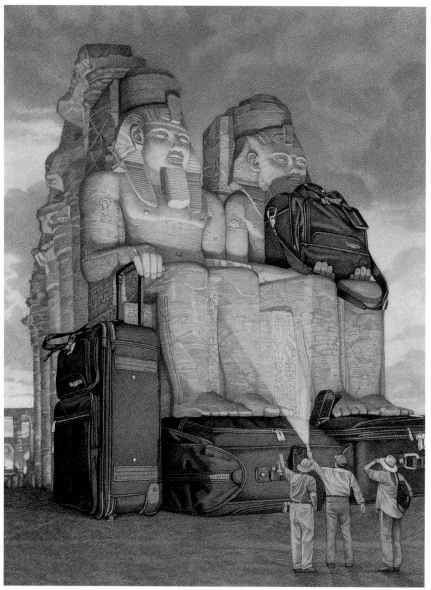

246

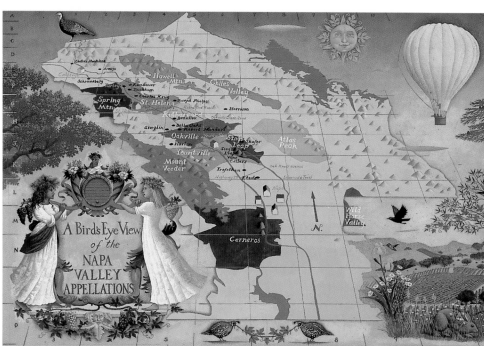

247

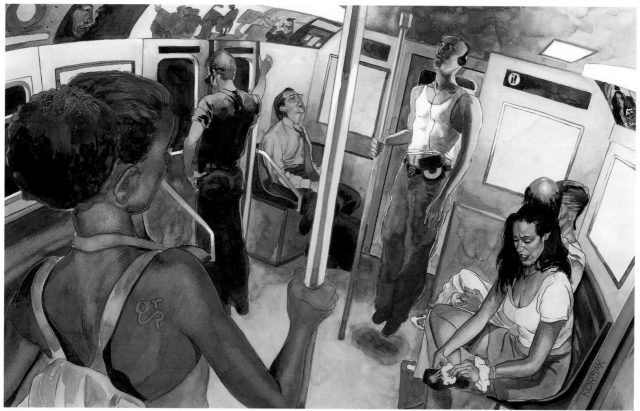

248

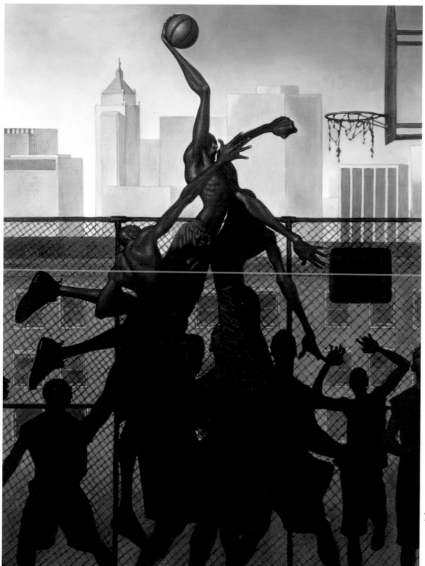

249

250

Artist: **Larry Moore**

Client: Orlando Opera

Medium: Pastel, oil wash on watercolor paper

Size: 20" x 17"

251

Artist: **Rafal Olbinski**

Client: Opera Szczecin

Medium: Acrylic on canvas

Size: 18" x 13"

252

Artist: **James McMullan**

Art Director: Jim Russek

Client: Lincoln Center Theater

Medium: Watercolor, gouache on paper

Size: 10" x 5"

253

Artist: **James McMullan**

Art Director: Jim Russek

Client: Lincoln Center Theater

Medium: Watercolor, gouache on paper

Size: 12" x 6"

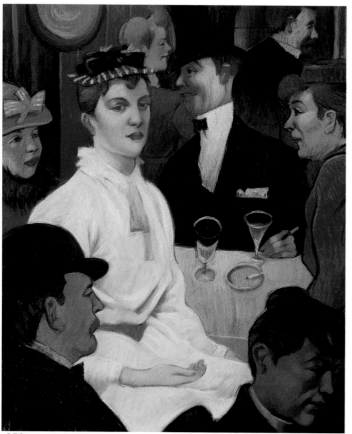

250

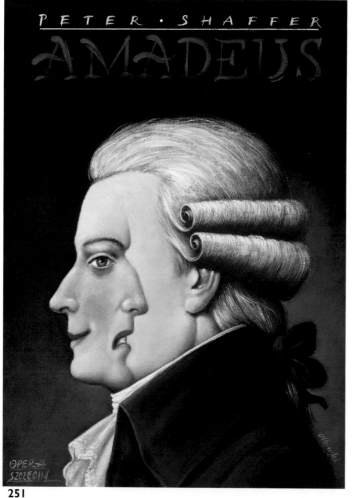

251

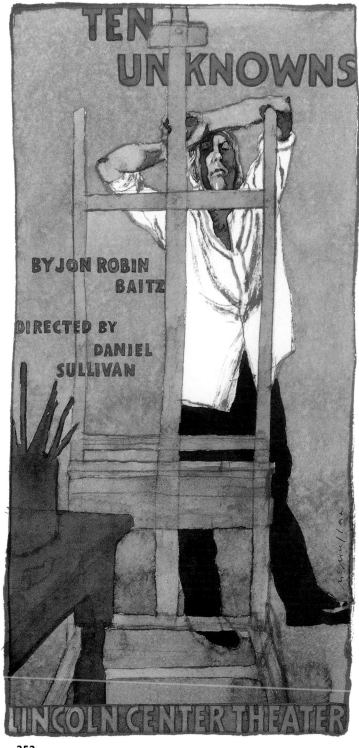

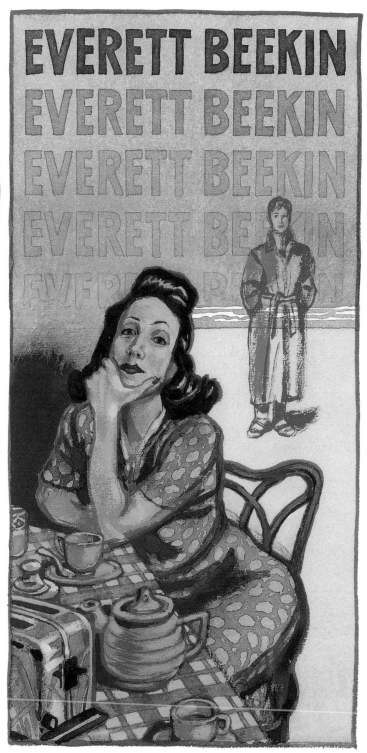

252

253

254
Artist: **Russ Wilson**
Art Directors: Chris Smith
Mike Guiry
Client: Unison Industries
Medium: Pastel on paper
Size: 27" × 22"

255
Artist: **N. Ascencios**
Art Director: Barbara Andrews
Client: McCarter Theatre Center
Medium: Oil on canvas
Size: 22" × 15"

256
Artist: **Sara Tyson**
Art Director: Jane Francis
Client: Pacific Opera Victoria
Medium: Acrylic on board
Size: 13" × 7"

257
Artist: **Scott McKowen**
Client: Roundabout Theatre Company
Medium: Scratchboard
Size: 20" × 14"

254

255

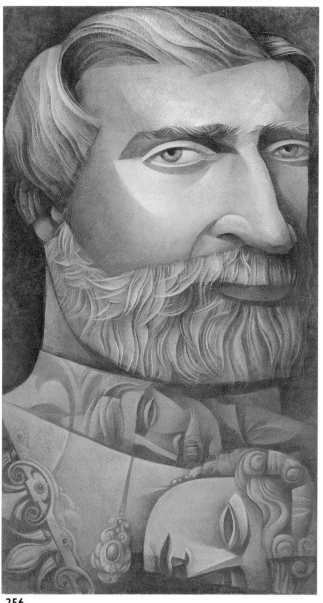

256

258
Artist: **Gary Kelley**
Art Director: Neill Archer Roan
Client: Arena Stage
Medium: Pastel on paper
Size: 23" x 15"

259
Artist: **Laura Smith**
Art Director: Craig Cimmino
Client: Mercedes Benz
Medium: Acrylic on canvas
Size: 18" x 13"

260
Artist: **Laura Smith**
Art Director: Etsuzo Yamakado
Client: JAL Hotels
Medium: Acrylic on canvas
Size: 13" x 9"

261
Artist: **John Mattos**
Art Directors: Judith Ehrlich
　　　　　　Rick Tejada-Flores
Client: Paradigm Productions
Medium: Digital
Size: 28" x 20"

262
Artist: **Jody Hewgill**
Art Directors: Neill Archer Roan
　　　　　　Scott Mires
Client: Arena Stage
Medium: Acrylic on gessoed board

263
Artist: **Jody Hewgill**
Art Directors: Neill Archer Roan
　　　　　　Scott Mires
Client: Arena Stage
Medium: Acrylic on gessoed board
Size: 14" x 8"

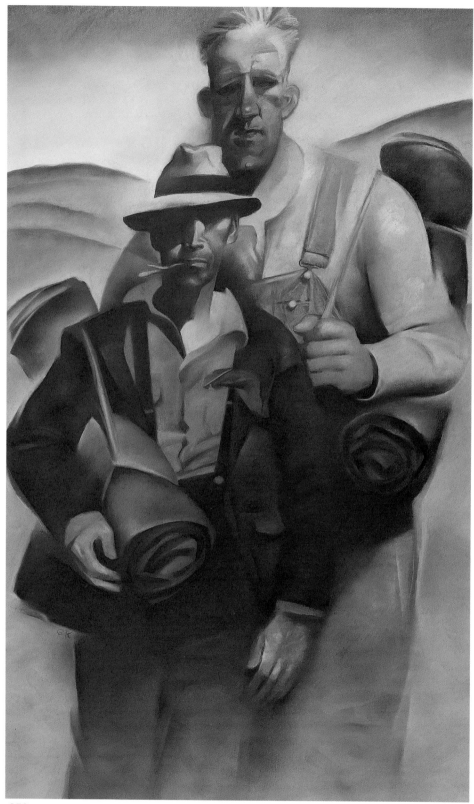

258

259

260

261

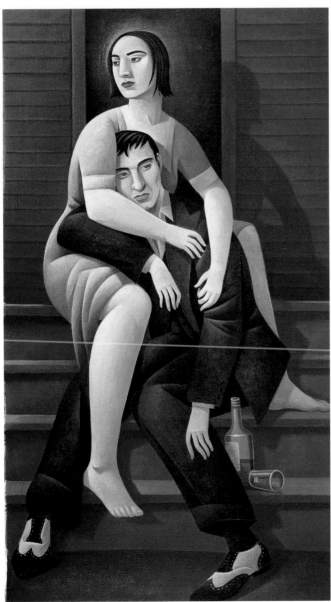

262

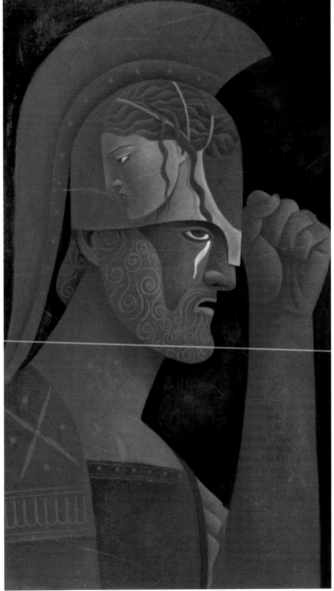

263

ADVERTISING

264
Artist: **Ted Wright**
Art Director: Bill Leissring
Client: Tiger Woods Foundation/Coca-Cola
Medium: Pen & ink, digital, silkscreen on 100%
 Strathmore paper
Size: 36" x 19"

265
Artist: **Kazushige Tateyama**
Client: Art Gallery Zip2
Medium: Colored ink on paper
Size: 18" x 15"

266
Artist: **Dave McKean**
Client: Feral Records
Medium: Mixed
Size: 10" x 8"

267
Artist: **Roxana Villa**
Art Director: Eduardo Cortez
Client: Children's Hospital of Orange County
Medium: Acrylic on board
Size: 8" x 8"

268
Artist: **Ray-Mel Cornelius**
Art Director: Chris Rovillo
Client: Neiman Marcus/Adolphus Hotel,
 Children's Parade
Medium: Acrylic on canvas
Size: 8" x 8"

264

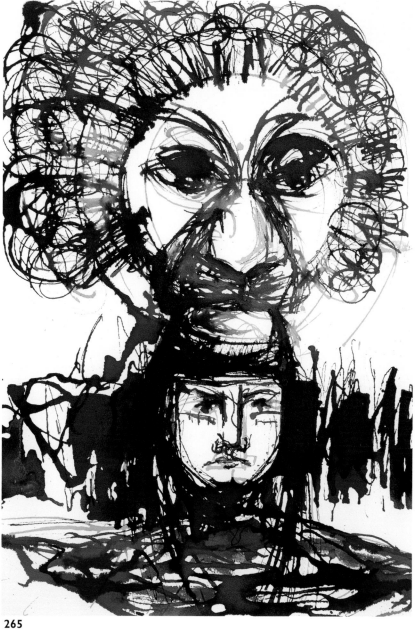

265

266

267

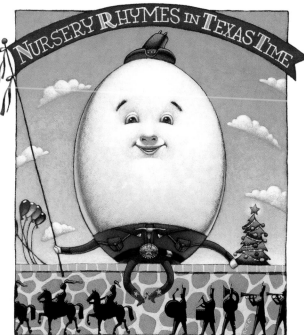

268

269
Artist: **Marti Somers**
Client: Dirty Girl Produce Organic Farm
Medium: Mixed on canvas
Size: 40" x 30"

270
Artist: **Ryan Obermeyer**
Client: Rasputina (RPM Records)
Medium: Digital
Size: 13" x 13"

271
Artist: **Creatink**
Client: Eve's Closet
Medium: Mixed, digital
Size: 14" x 8"

272
Artist: **David Ho**
Art Director: Bionic Jive
Client: Interscope Records
Medium: Digital
Size: 12" x 12"

273
Artist: **Dave McKean**
Client: Front Line Assembly
Medium: Mixed
Size: 14" x 10"

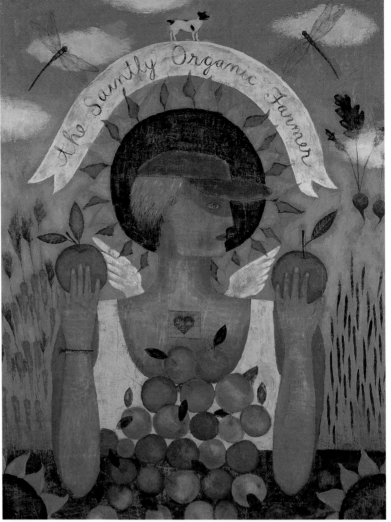

269

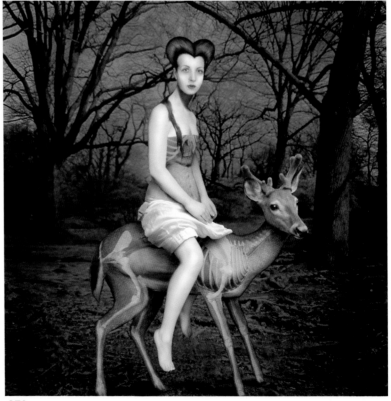

270

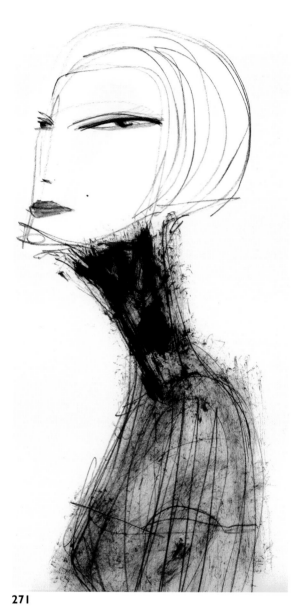

271

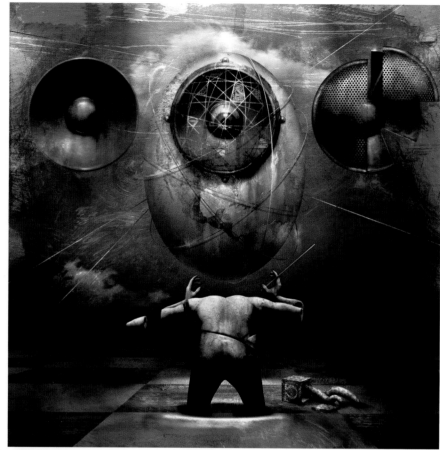

272

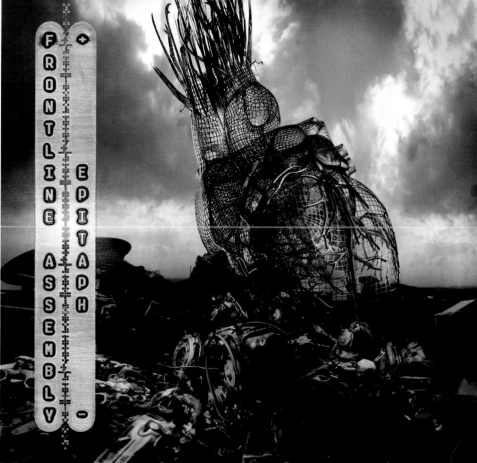

273

274
Artist: **Brad Holland**
Art Director: Roxy Moffitt
Client: Yale School of Drama
Medium: Acrylic on board
Size: 17" x 13"

275
Artist: **Jordin Isip**
Art Director: Micah Valdes
Client: Black Sonny
Medium: Mixed on paper
Size: 23" x 23"

276
Artist: **Mark Andresen**
Art Director: Rudy Vanderlans
Client: Emigre, Inc.
Medium: Pen & ink on paper
Size: 4" x 3"

277
Artist: **Joe Baker**
Art Director: Kelly Bragdon
Client: Pitcairn Scott Gallery
Medium: Oil on masonite
Size: 48" x 48"

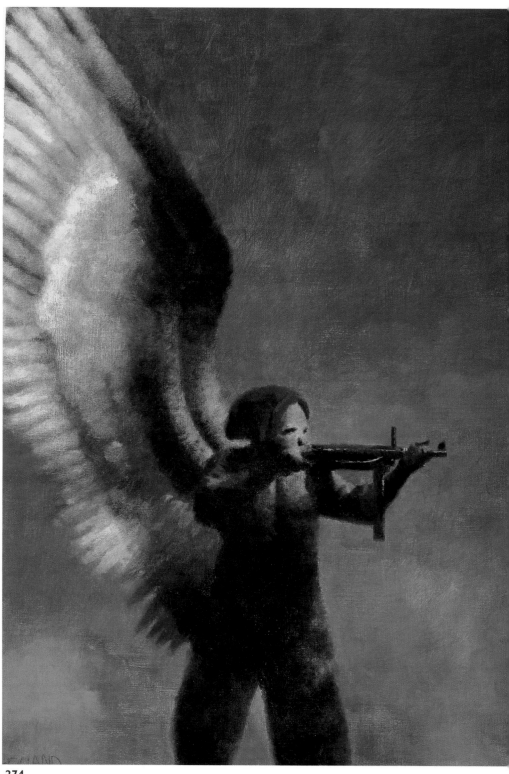

274

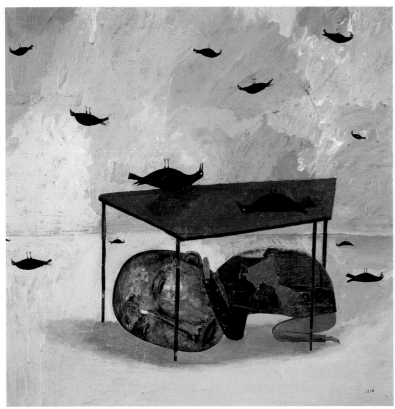

275

276

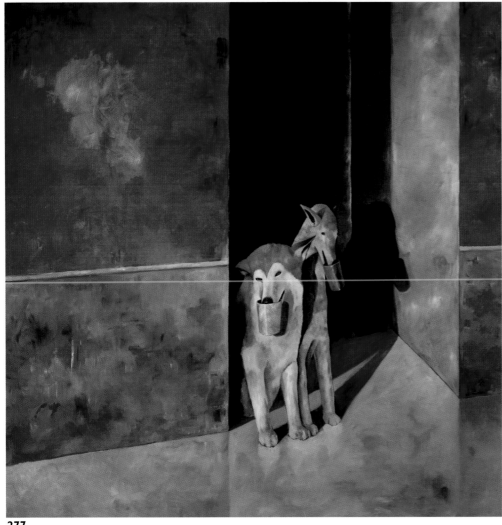

277

ADVERTISING

278
Artist: **Bill Jaynes**
Art Director: Jill Bluming
Client: American Showcase
Medium: Ink, watercolor
Size: 23" × 30"

279
Artist: **Dick Krepel**
Art Director: Brent Watts
Client: Houlihan, Lokey, Howard & Zukin, Inc.
Medium: Digital, mixed
Size: 13" × 12"

280
Artist: **Martijn Heilig**
Art Director: Sharon Box
Client: Popeye's Chicken & Biscuits
Medium: Acrylic on board
Size: 8" × 20"

281
Artist: **Rafael Lopez**
Art Director: Michael Kinsman
Client: Ho Doo Productions
Medium: Acrylic on wood
Size: 13" × 10"

282
Artist: **Larry Moore**
Client: Orlando Opera
Medium: Gouache, charcoal on
 watercolor paper
Size: 20" × 17"

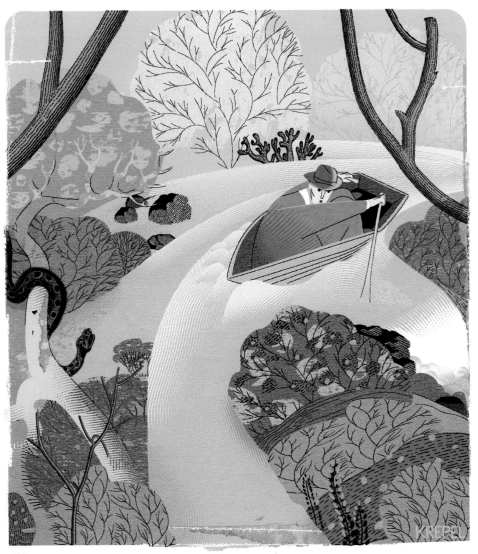

278

279

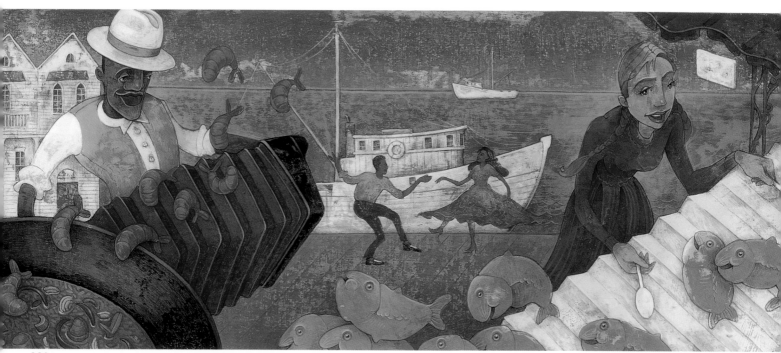

280

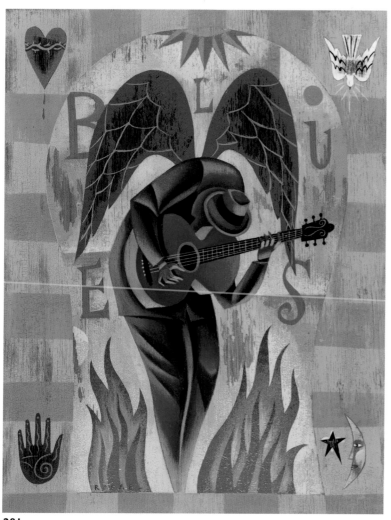

281

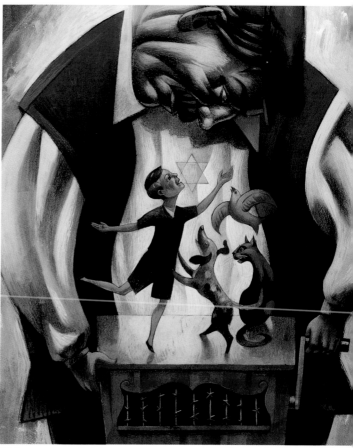

282

ADVERTISING

283
Artist: **Jordin Isip**
Art Director: Micah Valdes
Client: Black Sonny
Medium: Mixed on paper
Size: 47" x 47"

284
Artist: **Whitney Sherman**
Client: Gerald & Cullen Rapp
Medium: Pencil digitally enhanced
 and photocopied on custom-colored
 Strathmore drawing paper
Size: 9" x 9"

285
Artist: **Dick Krepel**
Art Director: Karen Paul
Client: New York City Ballet
Medium: Digital, collage
Size: 16" x 9"

286
Artist: **Jody Hewgill**
Art Directors: Neill Archer Roan
 Scott Mires
Client: Arena Stage
Medium: Acrylic on gessoed board
Size: 16" x 9"

287
Artist: **Dick Krepel**
Art Director: Karen Paul
Client: New York City Ballet
Medium: Digital, mixed
Size: 19" x 14"

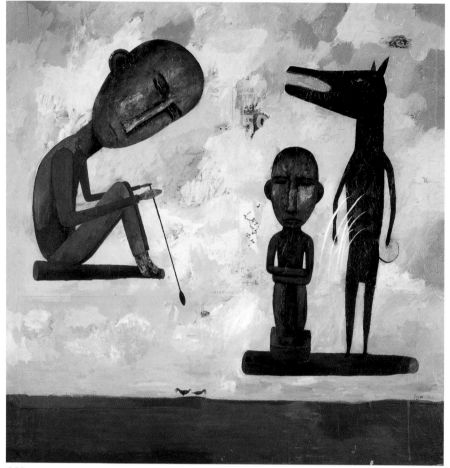

283

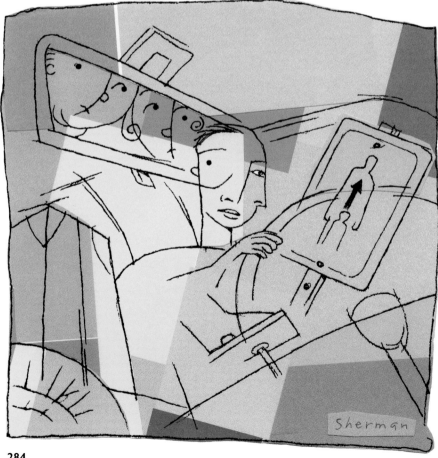

284

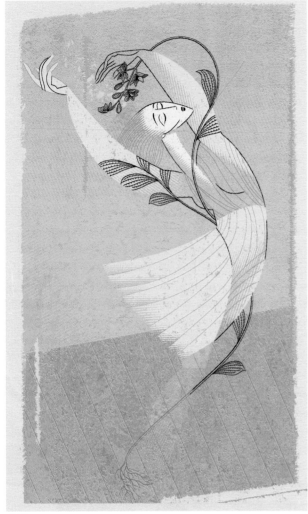

285

286

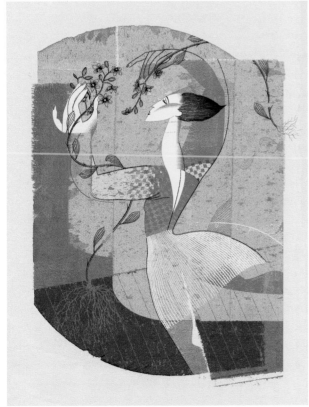

287

288
Artist: **Lasse Skarbovik**
Art Director: Cia Kilander
Client: Fastighetstidningen
Medium: Digital
Size: 12" × 6"

289
Artist: **Rafael Lopez**
Art Director: Michael Kinsman
Client: Ho Doo Productions
Medium: Acrylic on wood
Size: 13" × 10"

290
Artist: **Takashi Akiyama**
Client: Tama Art University
Size: 20" × 14"

291
Artist: **Carlotta**
Art Directors: Saito Yoshihiro
 Masuda Hideaki
Client: Sanwa Bank Limited
Size: 35" × 23"

292
Artist: **Takashi Akiyama**
Client: Tama Art University
Size: 20" × 14"

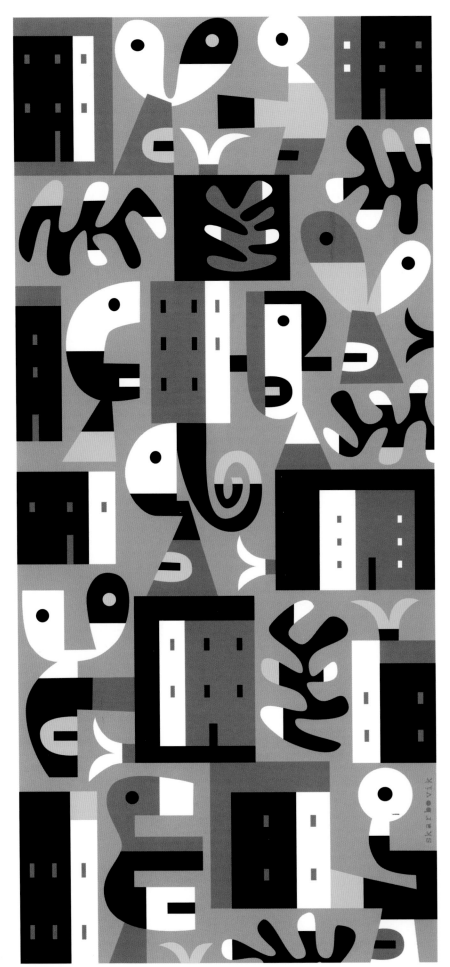

288

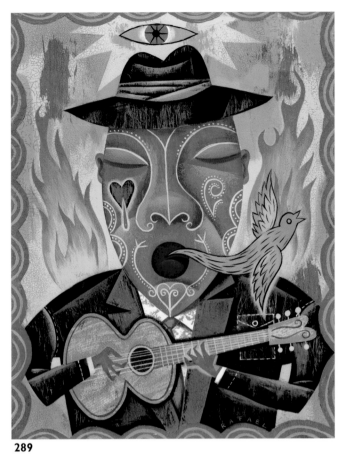

289

290

291

292

293
Artist: **Matt Dreany**
Art Director: Dan Ackerman
Client: Helper Monkey Records
Medium: Digital
Size: 12" × 12"

294
Artist: **Guido Scarabottolo**
Medium: Digital
Size: 15" × 11"

295
Artist: **Sarah Wilkins**
Art Director: Pam Bliss
Client: Plaza Frontenac
Size: 10" × 8"

296
Artist: **Sarah Wilkins**
Art Director: Pam Bliss
Client: Plaza Frontenac
Size: 10" × 8"

297
Artist: **Sarah Wilkins**
Art Director: Pam Bliss
Client: Plaza Frontenac
Size: 10" × 8"

298
Artist: **Robert Arnow**
Art Director: Jon Gordon
Client: New York, New York Hotel & Casino
Medium: Staedtler Mars Graphic 3000
 Duos (Brush marker) on laser
 printer paper, digital
Size: 10" × 8"

293

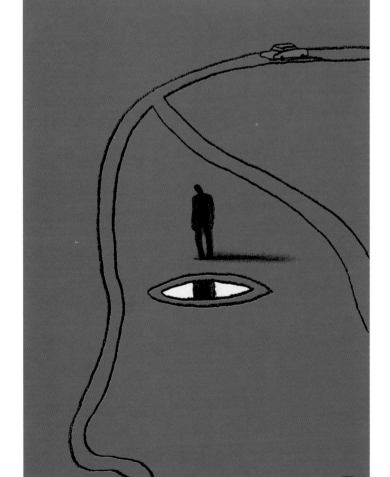

294

295

296

297

298

299

Artist: **Bill Jaynes**

Art Director: Y.H. Kristie Kim

Client: Willie Works

Medium: Ink, watercolor

Size: 22" × 30"

300

Artist: **Jean-Manuel Duvivier**

Client: Kot France

Medium: Pencil, colored paper on paper

Size: 11" × 11"

301

Artist: **Jessie Hartland**

Art Director: Betsy Schwartz

Client: National Association for the
 Fancy Food Trade

Medium: Gouache on paper

Size: 14" × 11"

302

Artist: **Chris Pyle**

Client: Indy Jazz Festival

Medium: Gouache on heavy illustration board

Size: 23" × 15"

303

Artist: **Gary Baseman**

Art Director: Ken Baker

Client: Anheuser Busch

Medium: Acrylic

Size: 17" × 13"

299

300

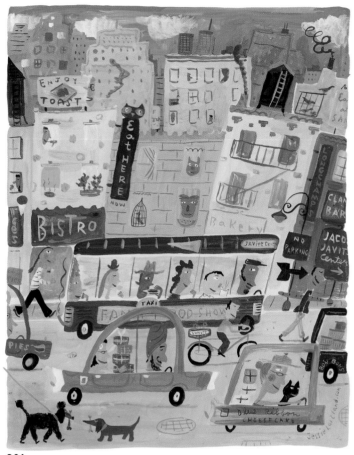

301

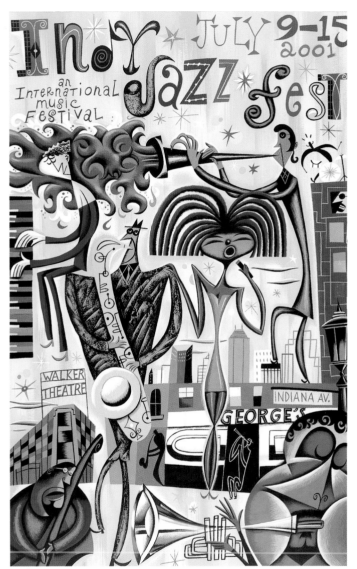

302

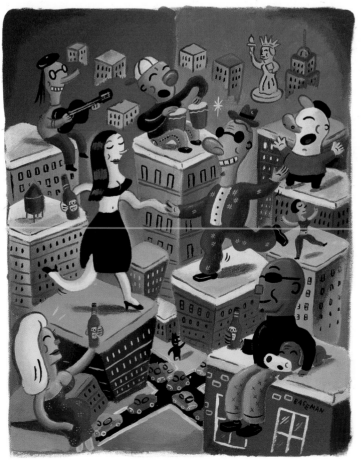

303

304
Artist: **Jason Lynch**
Art Director: Cathy Smith
Client: AIGA of Colorado
Medium: Gouache on Strathmore
 illustration board
Size: 7" × 10"

305
Artist: **John P. Maggard**
Client: Scott Hull Associates
Medium: Digital
Size: 8" × 6"

306
Artist: **Peter de Sève**
Art Director: Drew Hodges
Client: Brooks Atkinson Theatre
Medium: Watercolor, ink
Size: 12" × 9"

307
Artist: **Robert Neubecker**
Client: Pace University's Schaeberle
 Studio Theater
Medium: Digital
Size: 9" × 7"

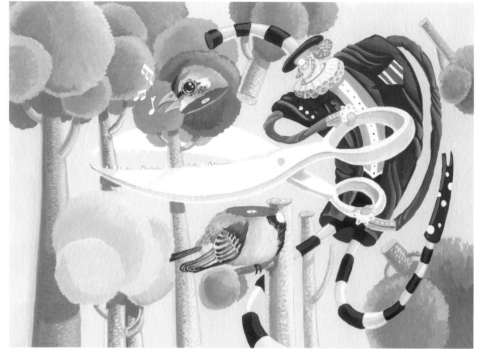

304

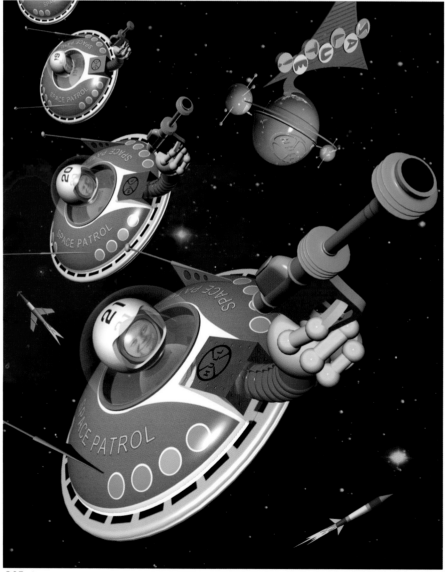

305

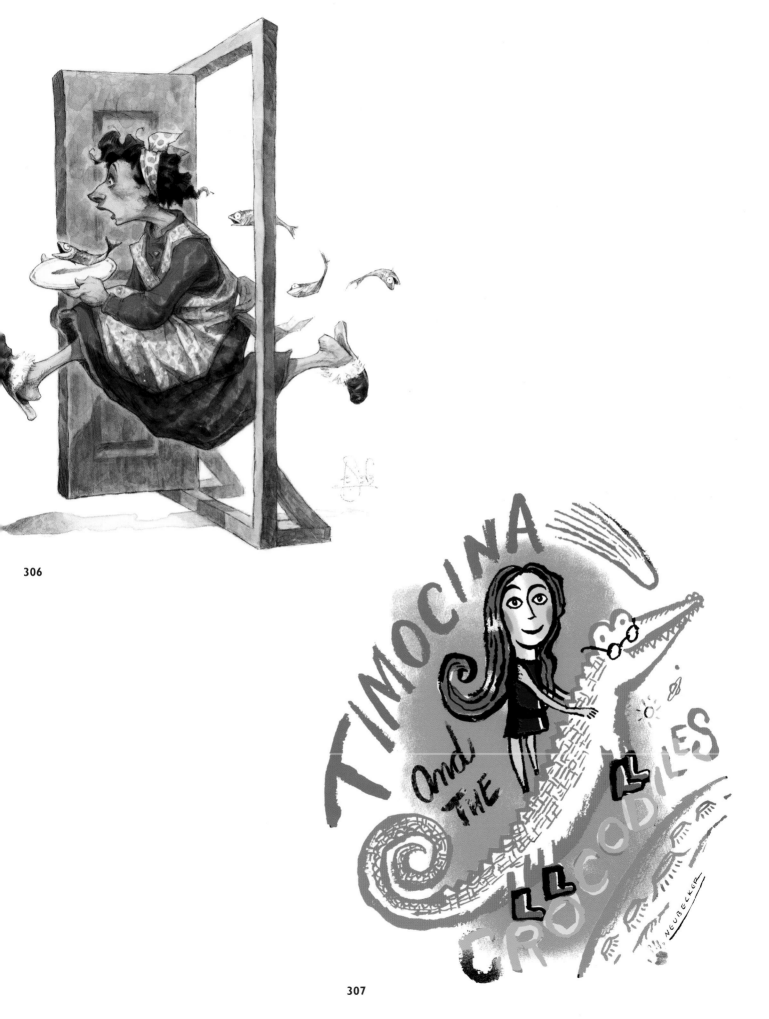

306

307

308

Artist: **Bill Mayer**

Art Director: Joe Moscati

Client: Orkin

Medium: Airbrush, gouache on board

Size: 15" × 12"

309

Artist: **Bill Mayer**

Art Director: Michelle Mar

Client: E Motion, Inc.

Medium: Airbrush, gouache on board

Size: 12" × 18"

310

Artist: **Brian Ajhar**

Art Director: Mario Ruiz

Client: Grizzard

Medium: Watercolor, acrylic on
 watercolor paper

Size: 14" × 21"

311

Artist: **Bill Mayer**

Art Director: Jean Page

Client: Yupo

Medium: Airbrush, gouache on board

Size: 8" × 18"

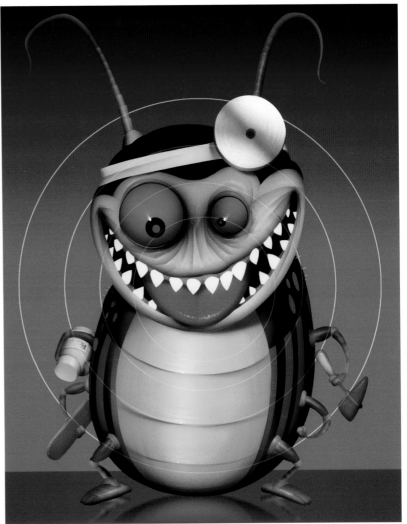

308

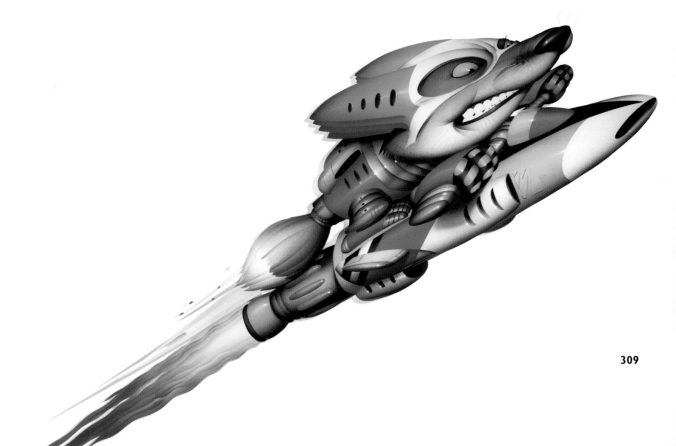

309

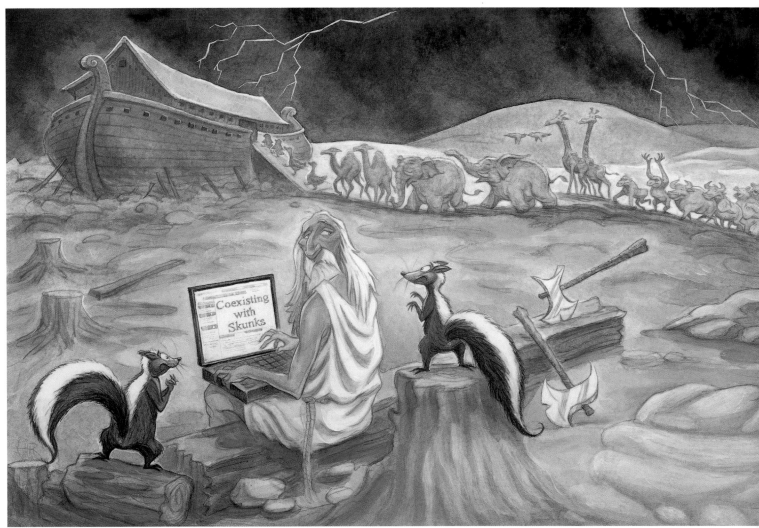

310

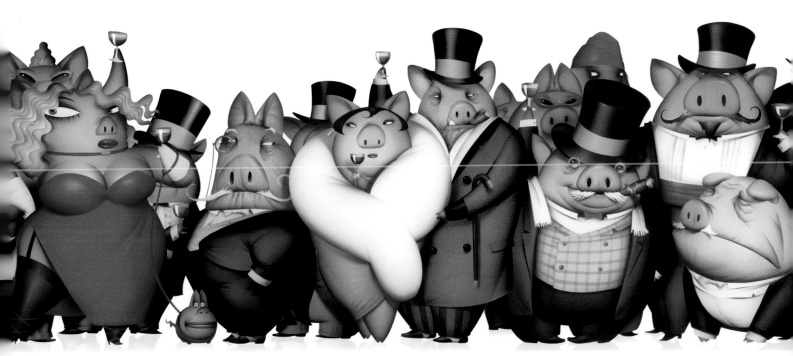

311

312
Artist: **Chris Sheban**
Art Director: Al Shackelford
Client: Land's End
Medium: Watercolor, pencil
Size: 14" x 11"

313
Artist: **Scott McKowen**
Client: Great Lakes Theatre Festival
Medium: Scratchboard
Size: 10" x 9"

314
Artist: **Kazushige Tateyama**
Client: Art Gallery Zip2
Medium: Colored pencil, colored ink on paper
Size: 11" x 11"

315
Artist: **Peter Bollinger**
Art Director: Doug Michels

316
Artist: **Bruce Waldman**
Art Director: Christine Morrison
Client: AEDEN Additions
Medium: Monoprint, pastel on BFK paper
Size: 30" x 40"

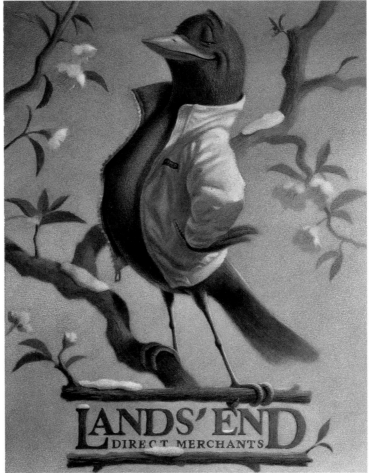

312

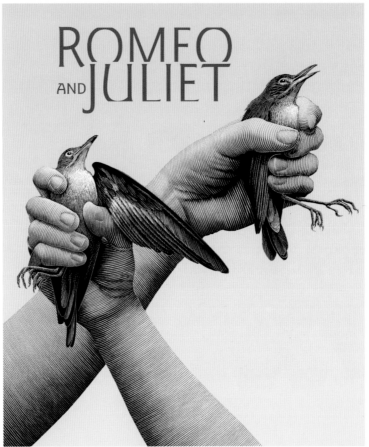

313

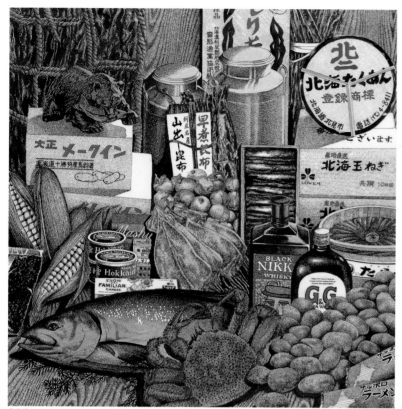

314

315

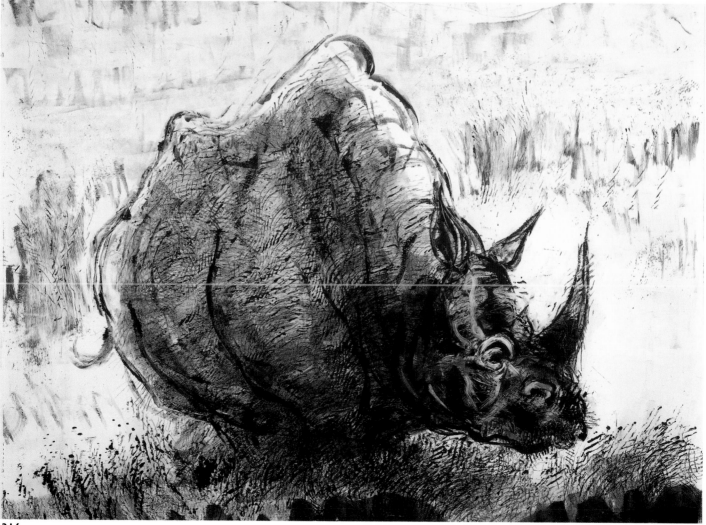

316

317
Artist: **Jason Holley**
Art Director: Gary Williams
Client: Maxygen
Medium: Mixed

318
Artist: **Chris Wormell**
Art Director: Paul Curtin
Client: California Coastal Commission
Medium: Linocut print on paper
Size: 10" x 7"

319
Artist: **Jason Holley**
Art Director: Gary Williams
Client: Maxygen
Medium: Mixed

320
Artist: **Jason Holley**
Art Director: Gary Williams
Client: Maxygen
Medium: Mixed

321
Artist: **Chris Wormell**
Art Director: Paul Curtin
Client: California Coastal Commission
Medium: Linocut print on paper
Size: 10" x 7"

322
Artist: **Chris Wormell**
Art Director: Paul Curtin
Client: California Coastal Commission
Medium: Linocut print on paper
Size: 10" x 7"

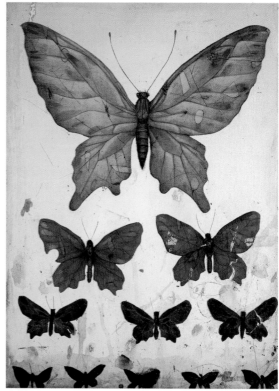

317

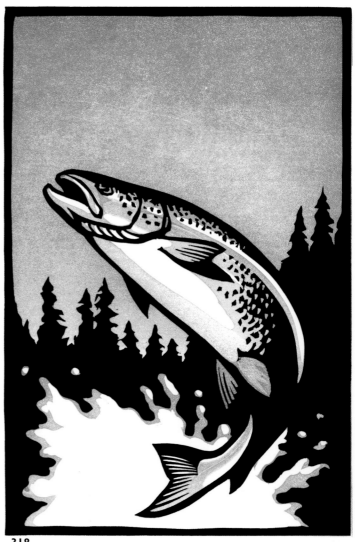

318

319

320

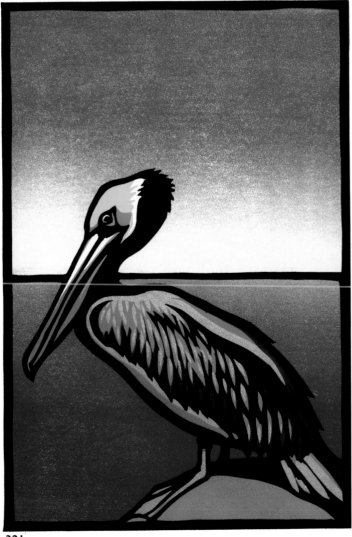

321

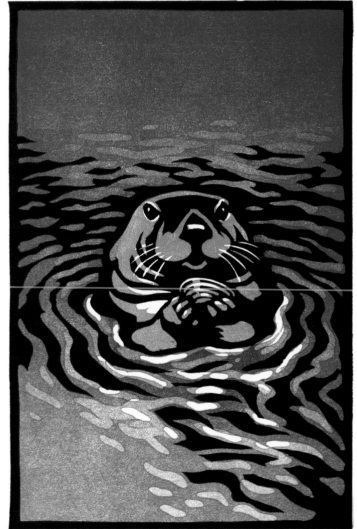

322

323
Artist: **Scott McKowen**
Client: The National Ballet of Canada
Medium: Scratchboard
Size: 16" × 11"

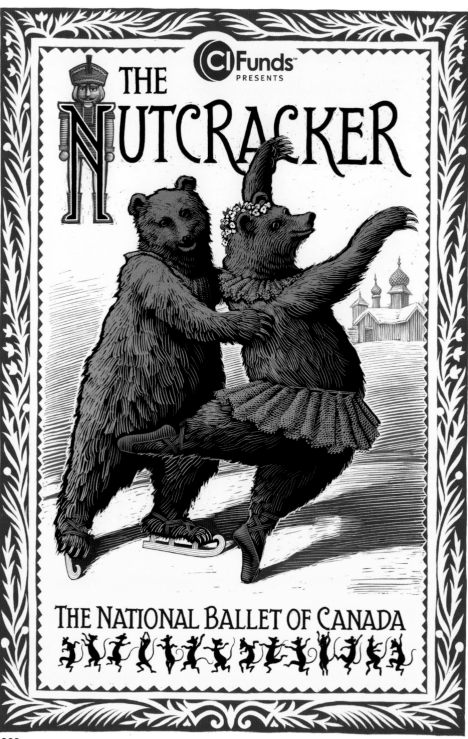

323

INSTITUTIONAL

JURY

Peter de Sève, Chair
Illustrator

Barry Blitt
Illustrator/cartoonist

Paul Buckley
Vice President Art Director
Penguin paperbacks/Viking hardcovers
Penguin Putnam Inc.

Chris Curry
Illustration editor
The New Yorker

Jordin Isip
Illustrator

Mark McMahon
Illustrator

Elizabeth B. Parisi
Art Director
Scholastic Inc.

Daniel Pelavin
Illustrator

D. J. Stout
Pentagram Design Inc.

324 GOLD MEDAL
Artist: **James Bennett**
Art Director: Maureen Dougherty
Client: Ataraxia Studio
Medium: Oil on masonite
Size: 38" × 24"

"I've always been fascinated by the photographs of early twentieth century sporting events. The men were always clad in suits and hats, and the ladies wore dresses and furs. Perhaps that's because I've attended too many events where the fattest guy in the section is a sure bet to be the first with his shirt off. For whatever reason, I am grateful for the opportunity to paint."

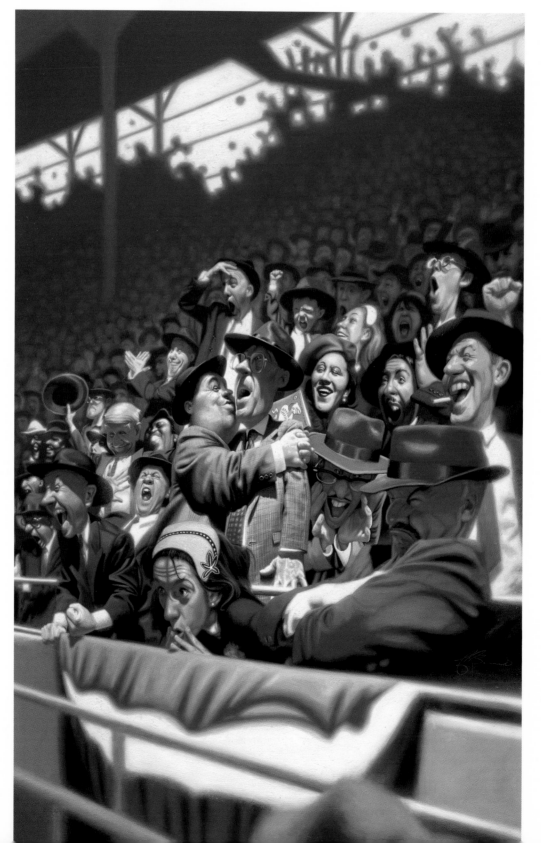

325 GOLD MEDAL
Artist: **Tim Bower**
Art Director: Patrick J.B. Flynn
Client: Society of Illustrators
Medium: Mixed
Size: 16" x 12"

"I spent more time making sketches and gave more attention to this piece than to my usual two-day deadlines," said the artist about the Society of Illustrators 44th Call for Entries poster. He went back to a first sketch to create this tip of the hat to the Society's past traditions, with an added, irreverent spin. "There's no comparing the process here to the fast conceptual business stuff I do."

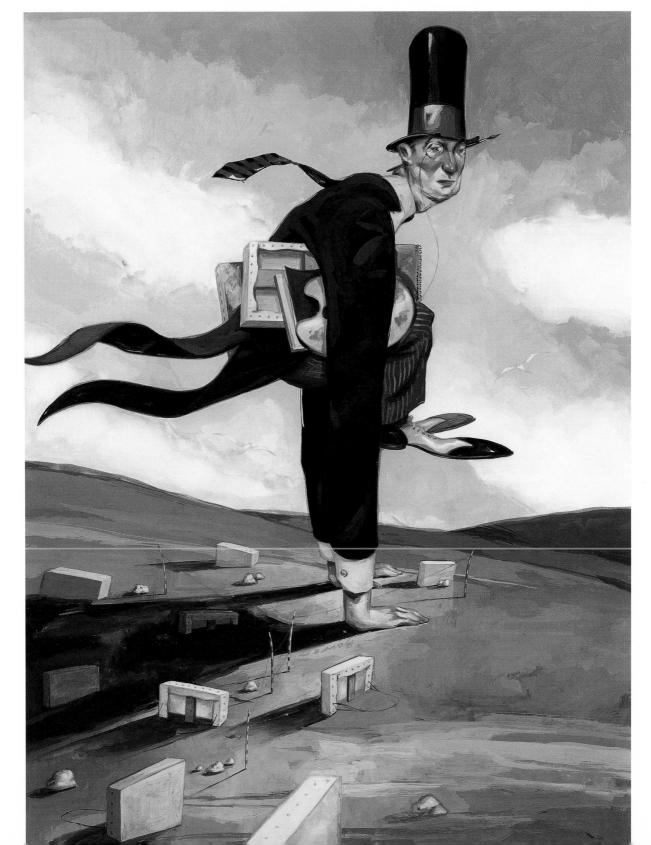

326 GOLD MEDAL
Artist: **Ivan Chermayeff**
Client: Theatre Grottesco
Medium: Mixed media collage on paper
Size: 22" × 15"

Ivan Chermayeff is a past president of the American Institute of Graphic Arts and former vice president of the Yale Arts Association. He was a member of both the Yale Committee on Art and Architecture and the Harvard University of Overseers Committee on Visual and Environmental Studies. A trustee for the Museum of Modern Art for 20 years, he was on the Board of Directors of the International Design Conference in Aspen from 1967 to 1999. A founding partner and principal of Chermayeff & Geismar Inc., Mr. Chermayeff has had his work exhibited worldwide and is a Benjamin Franklin Fellow of the Royal Society of Arts and has served as Andrew Carnegie Visiting Professor of Art at Cooper Union.

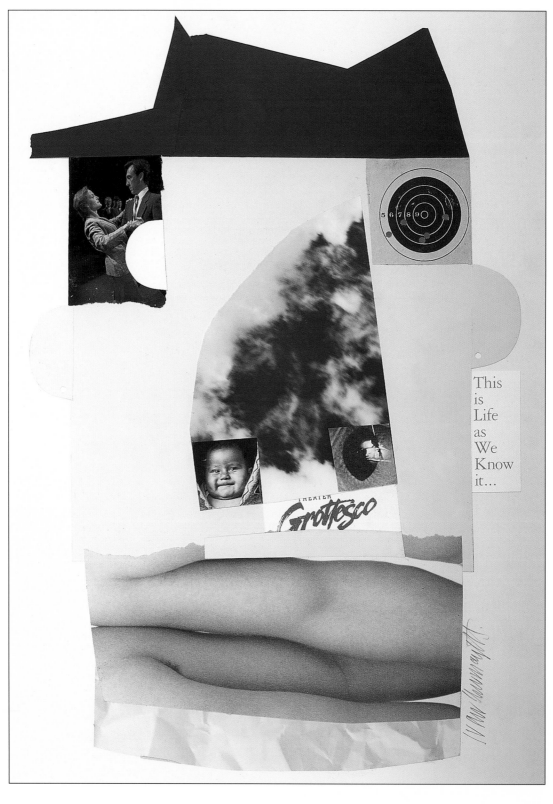

327 SILVER MEDAL
Artist: **Greg Clarke**
Art Director: Rik Besser
Client: Georgia Pacific Paper
Medium: Acrylic on paper
Size: 9" × 24"

"I fled from my former incarnation as harried graphic designer to illustration in the misguided belief that I'd get my life back. I'm now a harried illustrator, but at least the bad jobs are generally over in a matter of days or weeks rather than months or years I spent with unsavory design clients. And not working under somebody, I do have the power to say no. This particular job was one of those trade-off situations: low fee/complete freedom. It was also appealing because I had never worked in this kind of panorama format with a single illustration spanning four panels. I have contributed to *The Atlantic Monthly*, *TIME*, and *Rolling Stone* as well as Compaq, Einstein Bros. Bagels, and Volkswagon."

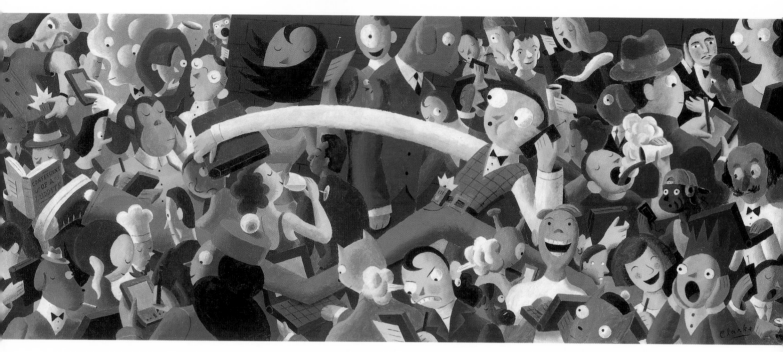

328 SILVER MEDAL
Artist: **David Hollenbach**
Art Director: Mark Gormley
Client: Baseman Printing
Medium: Collage, acrylic on paper
Size: 10" × 10"

"This was a nice job to work on because I could use memories of characters I came in contact with while I was growing up. Whenever I think about this picture, I do get a little homesick."

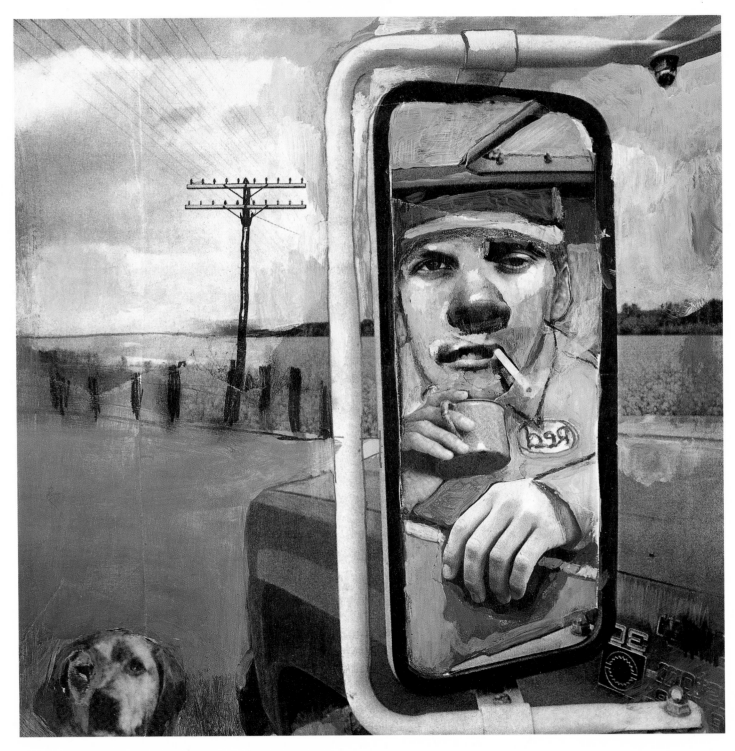

329 SILVER MEDAL
Artist: **Noah Woods**
Art Director: Carol Lasky
Client: Oxfam America
Medium: Mixed
Size: 16" x 13"

"This was one of my all-time favorite projects. The art director, Carol Lasky, brought intelligence and balance, as well as an abundance of very funny e-mails that I'll never forget. It was also a thrill to do this poster for OXFAM, an international organization that works for human rights and global justice. This amazing group tackles big issues and tries to discover better ways of achieving change. I'm blown away by the honor from the Society of Illustrators. Talk about icing on the cake?

330
Artist: **Dave McKean**
Client: Adobe Systems, Inc.
Medium: Mixed
Size: 14" × 8"

331
Artist: **Greg Spalenka**
Art Director: Matt Marsh
Client: National Labor Federation
Medium: Mixed, digital
Size: 7" × 11"

332
Artist: **Brad Holland**
Medium: Acrylic on board
Size: 10" × 11"

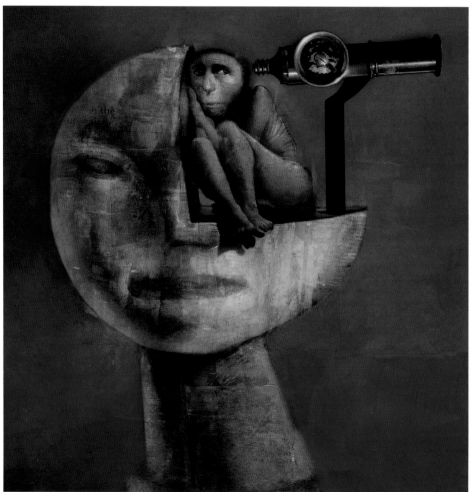

330

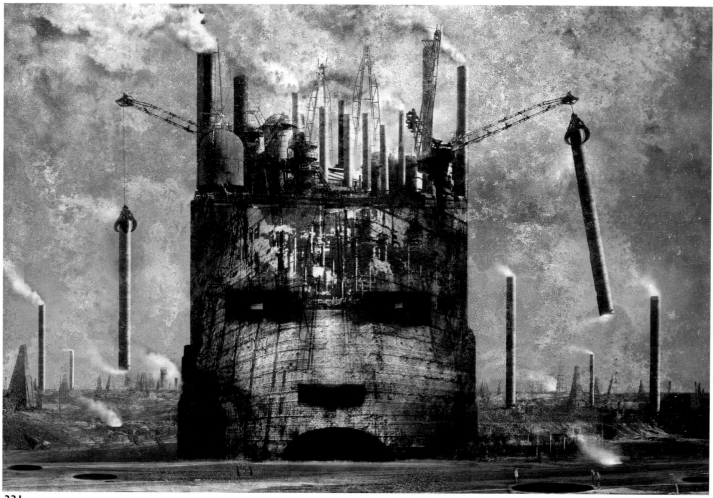

331

332

333
Artist: **Bart Forbes**
Client: Ussery Printing Company
Medium: Oil on canvas
Size: 13" x 19"

334
Artist: **Rafal Olbinski**
Client: Willy Brandt House
Medium: Acrylic on canvas
Size: 30" x 20"

335
Artist: **Bill Cigliano**
Art Director: Shaul Tsemach
Client: Johns Hopkins University
Medium: Oil, gold leaf on gessoed panel
Size: 16" x 12"

336
Artist: **Rafal Olbinski**
Client: Willy Brandt House
Medium: Acrylic on canvas
Size: 30" x 20"

333

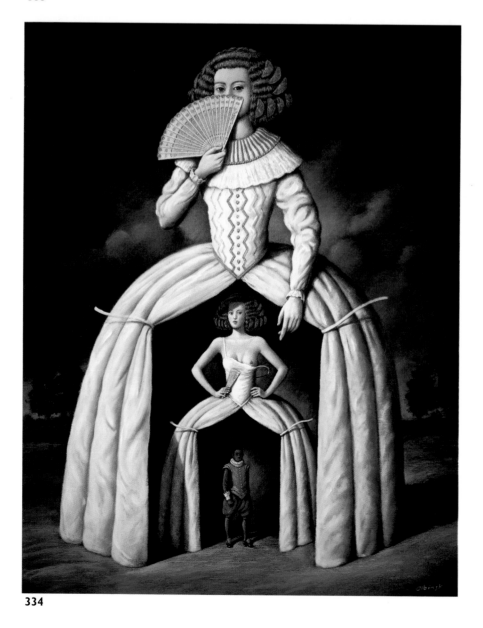

334

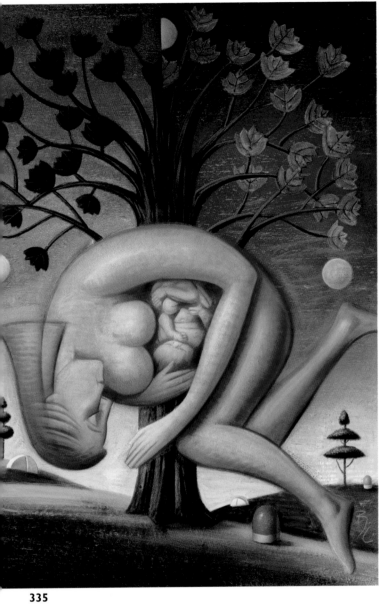

335

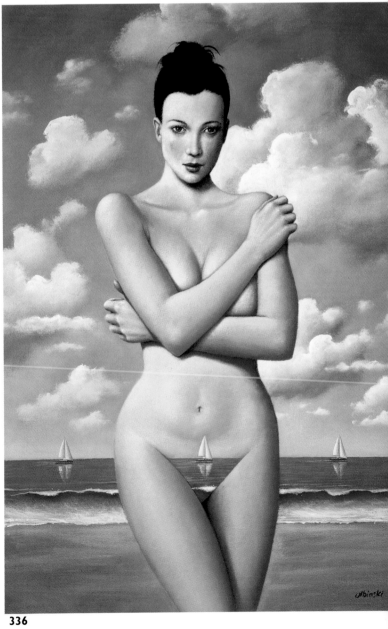

336

337
Artist: **Joseph Daniel Fiedler**
Art Director: Mark Murphy
Client: Murphy Design
Medium: Mixed on wood panel
Size: 48" x 48"

338
Artist: **Greg Swearingen**
Art Director: Steffanie Lorig
Client: AIGA Seattle
Medium: Acrylic , colored pencil on board
Size: 13" x 15"

339
Artist: **Jim Burke**
Client: Dellas Graphics
Medium: Oil on linen
Size: 27" x 20"

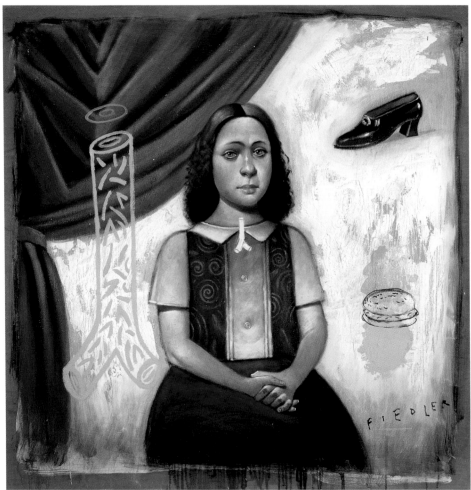

337

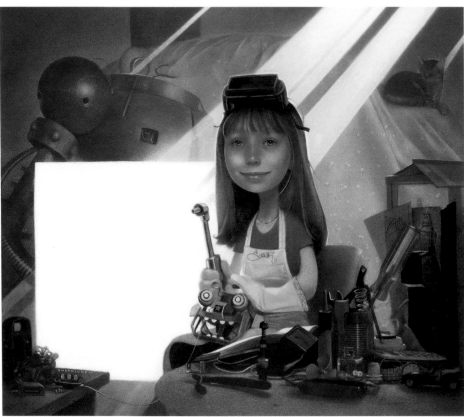

338

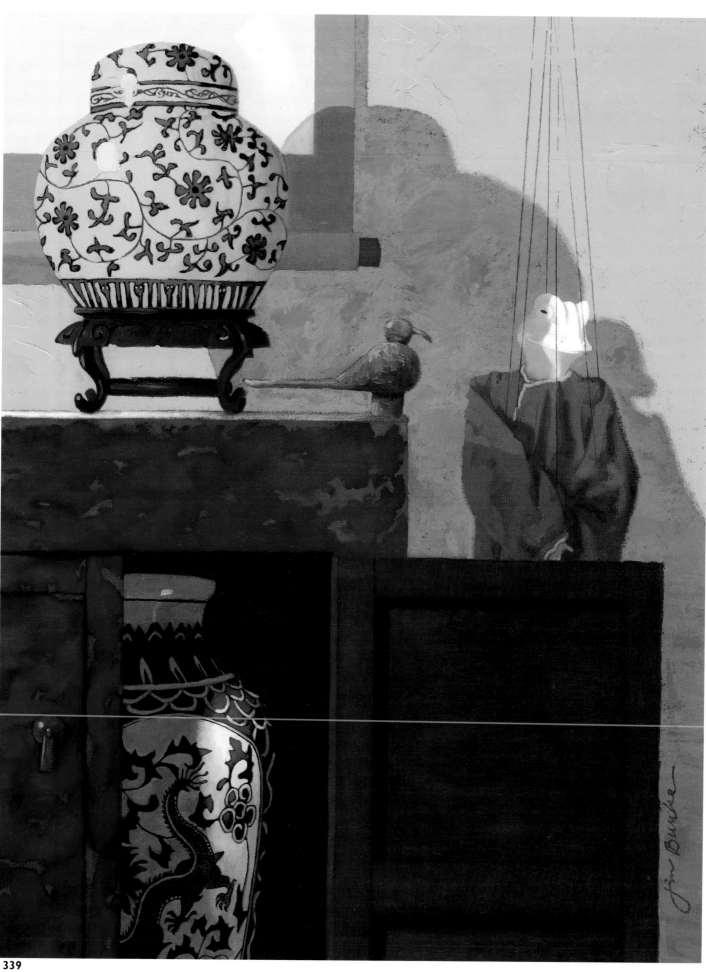

340
Artist: **Lee Ballard**
Art Director: Doug Cunningham
Client: Circle Gallery
Medium: Oil on recycled canvas
Size: 24" × 18"

341
Artist: **Mirko Ilic**
Client: Lelys
Medium: Digital
Size: 19" × 16"

342
Artist: **Kadir Nelson**
Art Director: John McClain
Client: Marvin's Room Recording Studio
Medium: Oil on canvas
Size: 72" × 72"

343
Artist: **Murray Tinkelman**
Client: United States Air Force
Medium: Pen & ink
Size: 14" × 19"

340

341

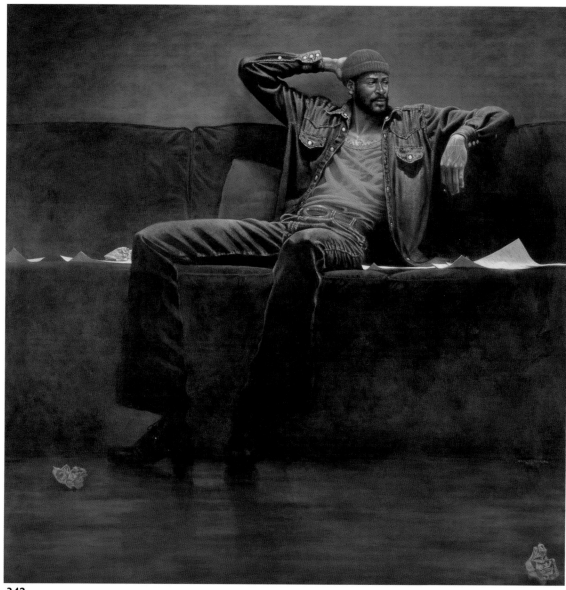

342

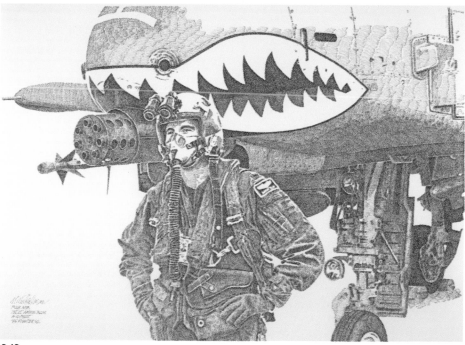

343

344
Artist: **Gil Ashby**
Client: College For Creative Studies
Medium: Pastel on black paper
Size: 27" x 21"

345
Artist: **Mike Benny**
Art Director: Bob Beyn
Client: Seraphein Beyn
Medium: Acrylic
Size: 24" x 17"

346
Artist: **Darren Thompson**
Art Director: Jim Gray
Client: George Washington
 University Magazine Cover
 and Permanent Collection
Medium: Alkyd on canvas
Size: 28" x 22"

347
Artist: **Kadir Nelson**
Art Director: John McClain
Client: Marvin's Room Recording Studio
Medium: Oil on canvas
Size: 48" x 108"

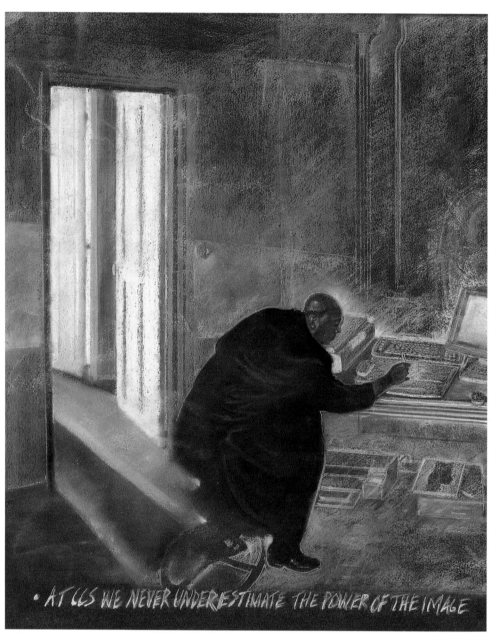

344

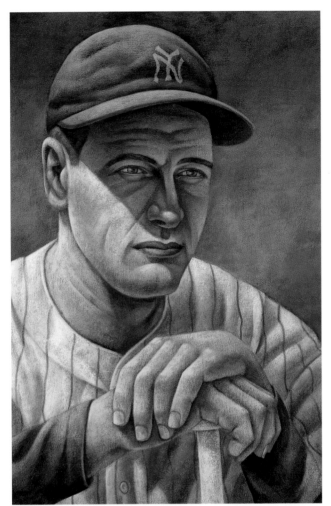

345

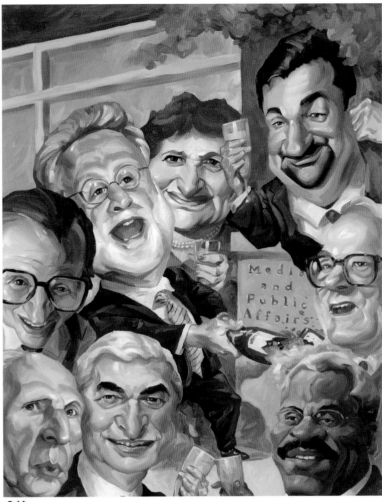

346

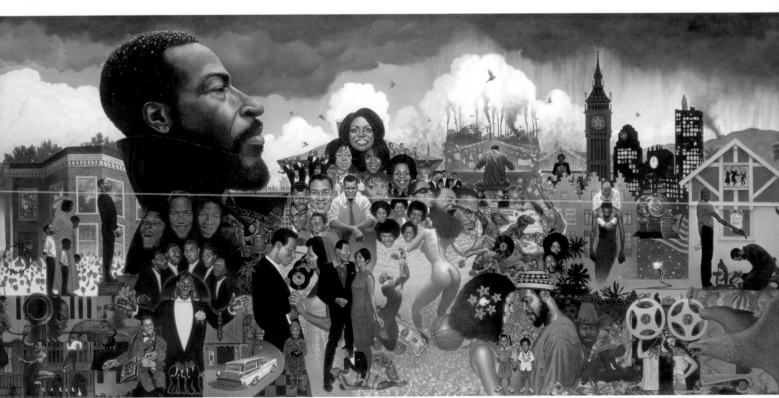

347

INSTITUTIONAL

348
Artist: **Blair Drawson**
Art Director: Bill Grigsby
Client: Gandalf Graphics
Medium: Acrylic
Size: 25" x 18"

349
Artist: **Yucel**
Art Directors: Jean Page
Randy Smith
Client: Yupo Paper Company
Medium: Digital
Size: 10" x 8"

350
Artist: **Robert Neubecker**
Art Director: Ron Stucki
Client: Salt Lake Olympic Committee
Medium: Digital
Size: 16" x 10"

351
Artist: **Hiro Kimura**
Client: Sandwich Graphics
Medium: Digital
Size: 11" x 12"

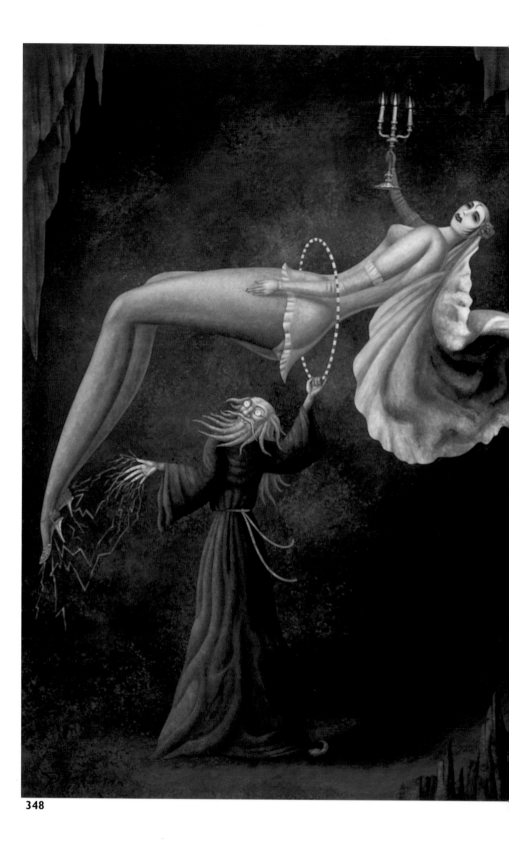

348

349

350

351

352
Artist: **Polly Becker**
Art Director: Chris Chu
Client: Neumier Design
Medium: Assemblage
Size: 11" x 8" x 2"

353
Artist: **Jack Unruh**
Art Director: Gene Mayer
Client: Hartford Financial Services Group, Inc.
Medium: Pen and brush ink, watercolor
 on board
Size: 16" x 25"

354
Artist: **Gary Kelley**
Art Director: Anthon Beeke
Client: Nouveau Salon des Cent
Medium: Oil on canvas
Size: 32" x 22"

355
Artist: **Martin French**
Art Director: Donna Albert
Client: The History Center
Medium: Charcoal, ink, acrylic, digital
Size: 17" x 11"

352

353

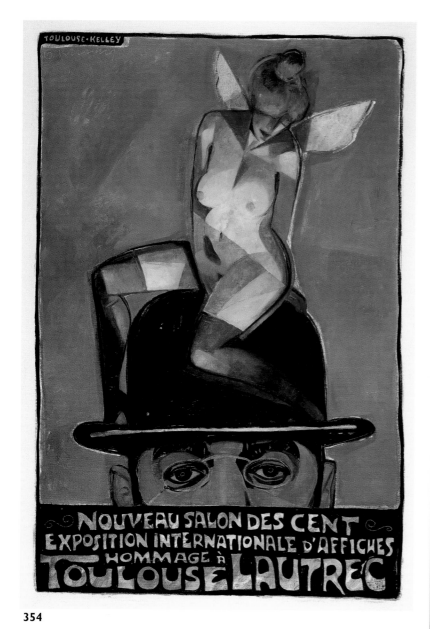

354

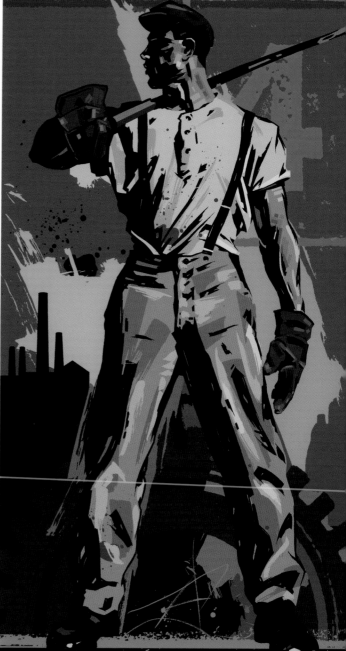

355

356
Artist: **Cathleen Toelke**
Art Director: Marie Christine Lawrence
Client: Keyspan Energy Services, Inc.
Medium: Gouache on board
Size: 8" × 8"

357
Artist: **Whitney Sherman**
Art Director: Glenn Pierce
Client: National Association of
　　　　Independent Schools
Medium: Pencil digitally colored and
　　　　enhanced on Rives BFK paper
Size: 12" × 9"

358
Artist: **Stefano Vitale**
Art Director: Ronn Campisi
Client: Federal Reserve Bank of Boston
Medium: Oil on wood
Size: 13" × 6"

359
Artist: **Linda Helton**
Art Director: John Mulvaney
Client: Young Audiences, Inc.
Medium: Acrylic on paper
Size: 11" × 8"

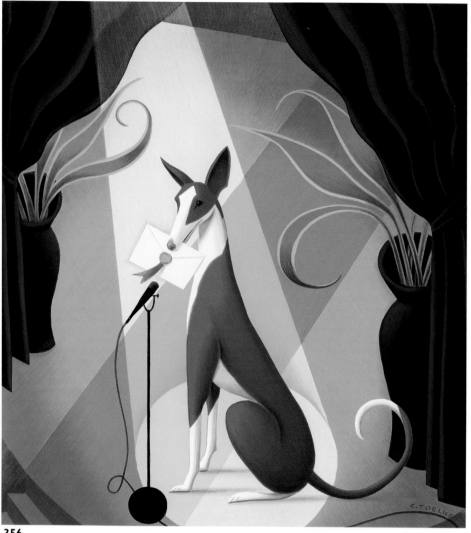

356

357

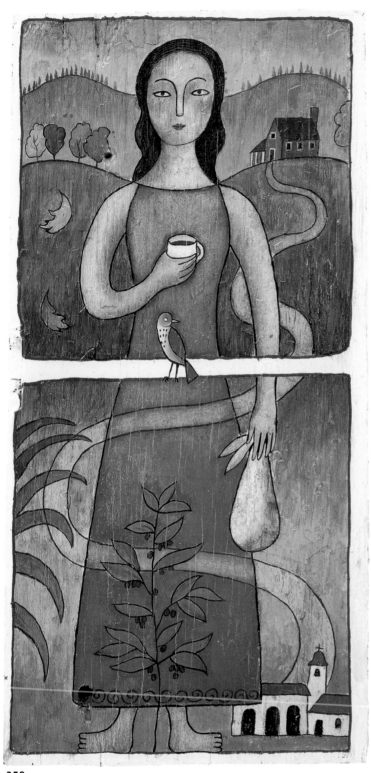

358

359

360
Artist: **Ed Parker**
Art Director: Dawn Astram
Client: The Greenwich Workshop
Medium: Acrylic on gessoed masonite with antiquing glazes & varnish
Size: 28" x 12"

361
Artist: **Ed Parker**
Art Director: Deborah Clark
Client: American Spectator
Medium: Acrylic on gessoed masonite with antiquing glazes & varnish
Size: 6" x 11"

362
Artist: **Marc Burckhardt**
Art Director: Rik Besser
Client: GeorgiaPacific Paper/Domtar
Medium: Acrylic on cold press board
Size: 9" x 24"

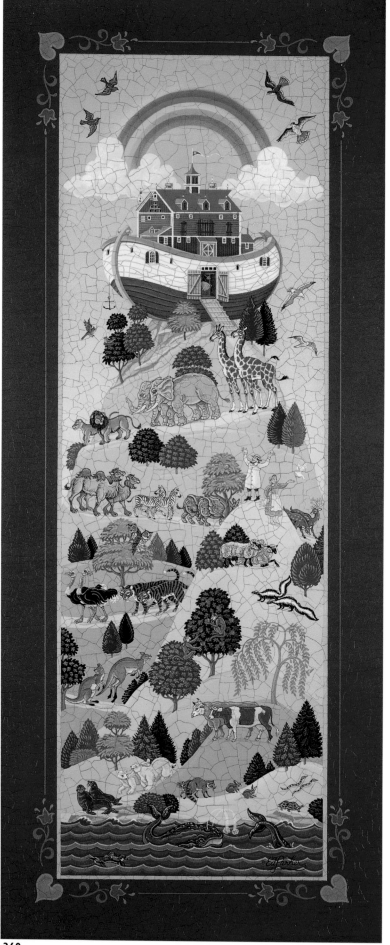

360

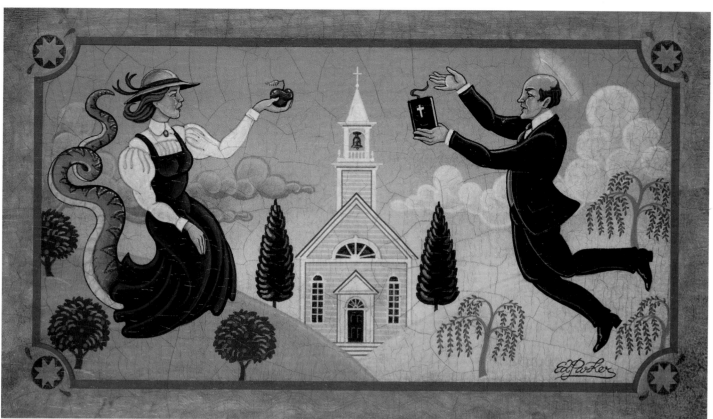

361

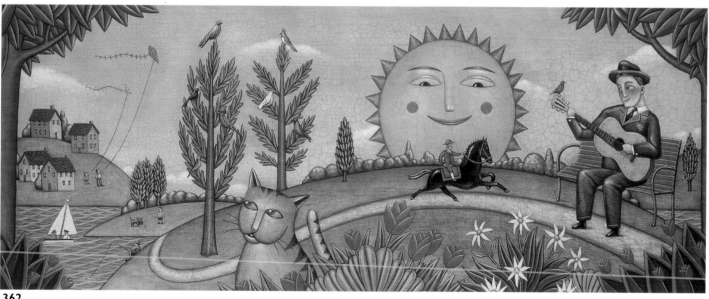

362

INSTITUTIONAL

363
Artist: **Cyril Cabry**
Art Director: Patricia Kowalczyk
Client: Olver Dunlop
Size: 9" × 7"

364
Artist: **Tinou Le Joly Senoville**
Art Director: Patricia Kowalczyk
Client: Olver Dunlop
Size: 11" × 8"

365
Artist: **Robert Neubecker**
Art Director: Ty Cumbie
Client: Lincoln Center
Medium: Digital
Size: 16" × 12"

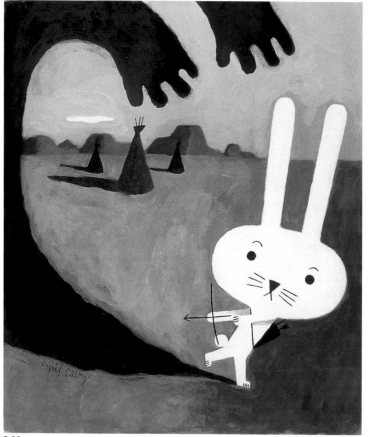

363

364

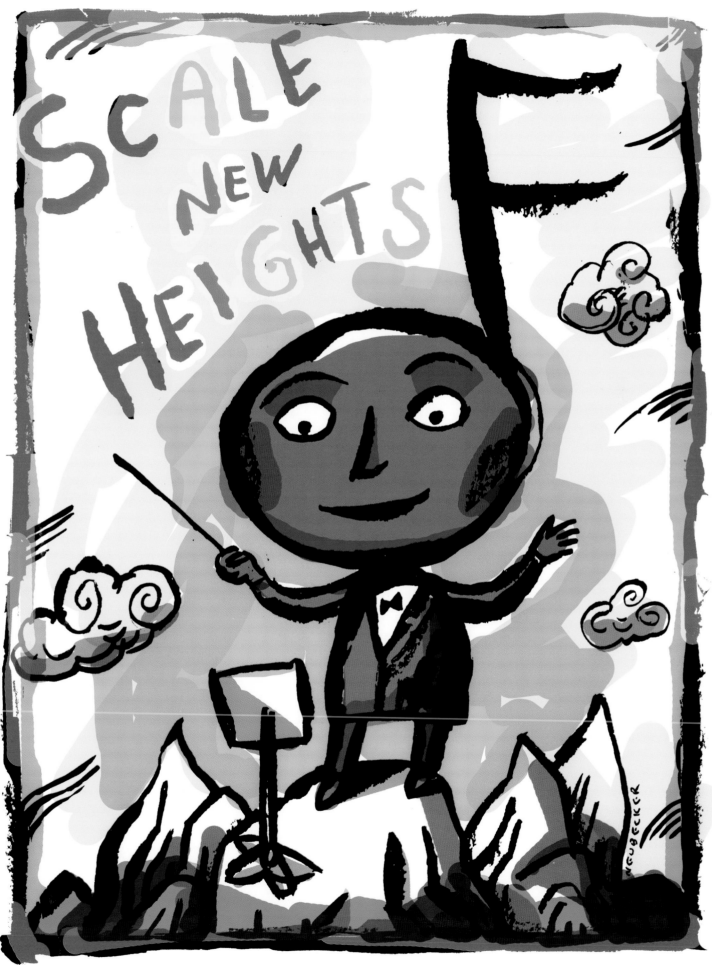

366
Artist: **Nicholas Wilton**
Art Director: JoAnn Sabatino-Falkenstein
Client: Children's Book Council
Medium: Acrylic on board
Size: 12" x 18"

367
Artist: **Bruce Waldman**
Art Director: Christine Morrison
Client: Alysia Duckler Gallery
Medium: Monoprint on BFK paper
Size: 25" x 37"

368
Artist: **Simms Taback**
Art Directors: JoAnn Sabatino-Falkenstein
Paula Wiseman
Client: Children's Book Council
Medium: Pencil, watercolor, gouache,
collage on 140 lb. Arches
hot press paper
Size: 22" x 17"

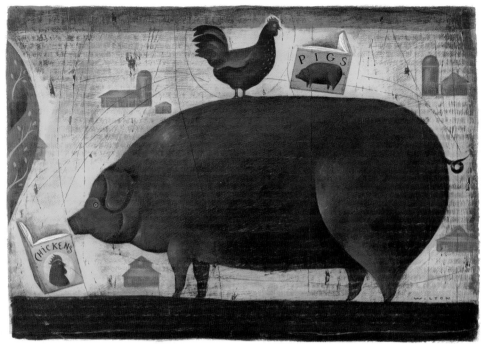

366

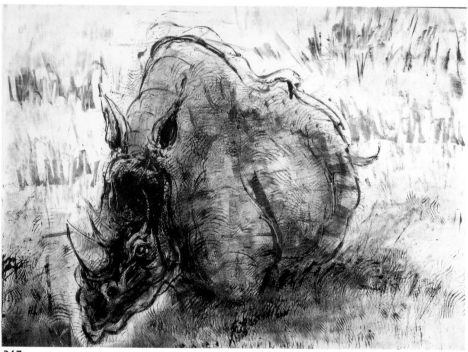

367

369
Artist: **Jack Unruh**
Art Director: Dennis Benoit
Client: Entergy
Medium: Pen and brush ink, watercolor
on board
Size: 9" x 11"

370
Artist: **Jack Unruh**
Art Director: Dennis Benoit
Client: Entergy
Medium: Pen and brush ink, watercolor
on board
Size: 16" x 12"

371
Artist: **Wendell Minor**
Art Director: Derry Noyes
Client: United States Postal Service
Medium: Watercolor on cold press paper
Size: 5" x 9"

372
Artist: **Steve Buchanan**
Art Director: Phil Jordan
Client: United States Postal Service
Medium: Digital

373
Artist: **Grace DeVito**
Art Director: Robert Stein
Client: United Nations Postal Administration
Medium: Oil on panel
Size: 7" x 10"

369

370

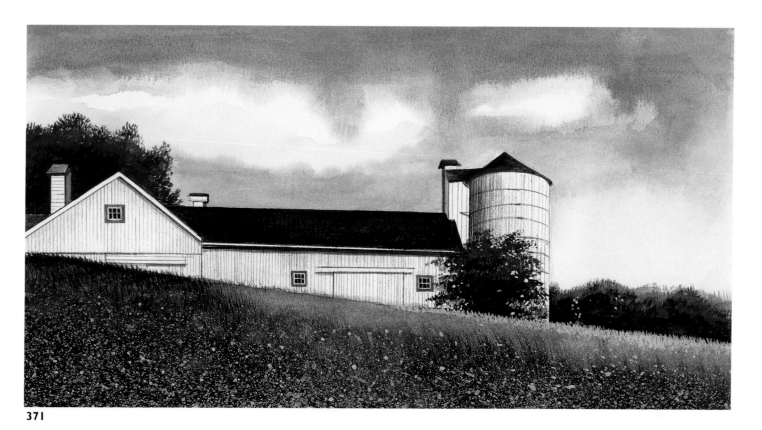

371

372

373

INSTITUTIONAL

374
Artist: **Diren He**
Client: Hallmark Cards
Medium: Mixed on paper
Size: 7" × 6"

375
Artist: **Diren He**
Client: Hallmark Cards
Medium: Mixed on paper
Size: 13" × 9"

376
Artist: **Gregory Montfort Dearth**
Art Director: Tim Bade
Client: Tyson Foods
Medium: Scratchboard, digital coloring
Size: 17" × 14"

374

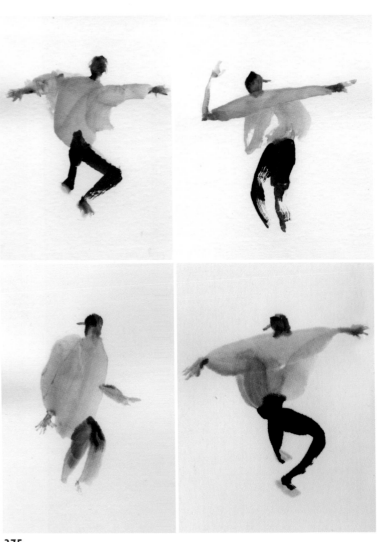

375

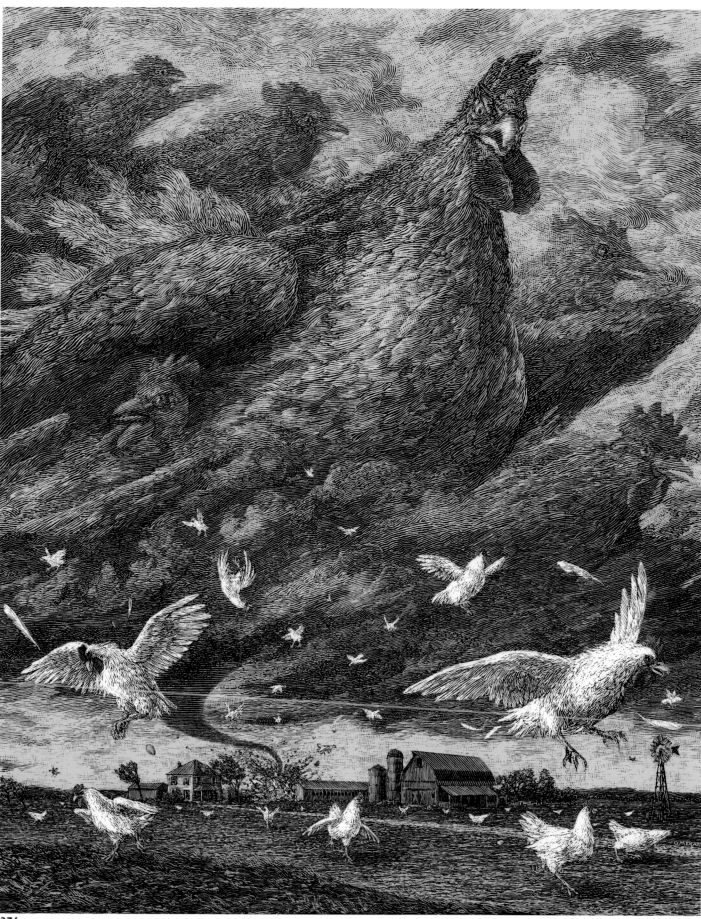

INSTITUTIONAL

377
Artist: **Anja Kroencke**
Art Director: Mark Murphy
Client: Murphy Design
Medium: Mixed, digital
Size: 8" × 8"

378
Artist: **Anja Kroencke**
Art Director: Alain Lachartre
Client: Vue Sur La Ville
Medium: Mixed, digital
Size: 14" × 11"

379
Artist: **Mark McMahon**
Art Director: Don Cooke
Client: Field Museum of Natural History
Medium: Pencil
Size: 30" × 22"

380
Artist: **Guido Scarabottolo**
Client: Galvani and Tremolada
Medium: Digital
Size: 14" × 11"

381
Artist: **Guido Scarabottolo**
Art Director: Mario Vigiak
Client: Mobilclan
Medium: Digital
Size: 10" × 10"

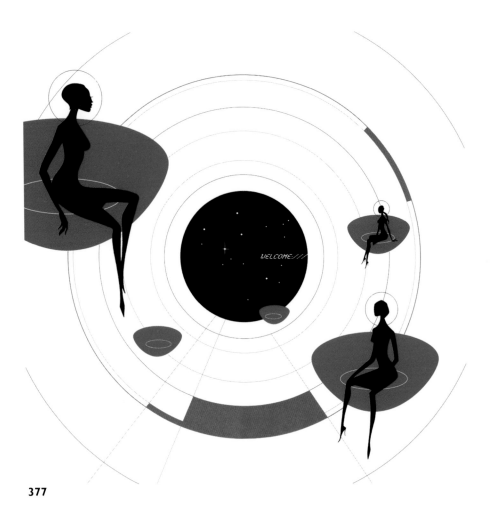

377

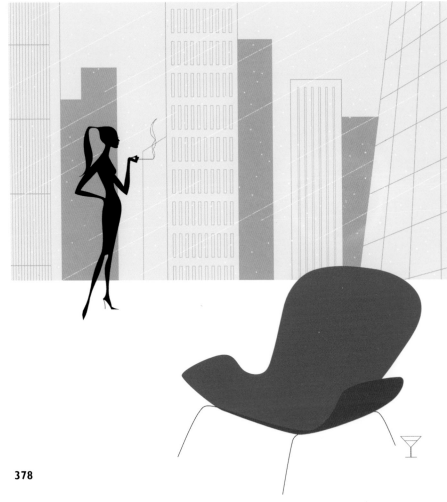

378

379

380

381

382

Artist: **Katherine Mahoney**

Art Director: Anne Yeckley

Client: TIAA Cref

Medium: Hand-tinted papers, pastel,
gouache on Stonehenge bright
white printmaking paper

Size: 12" x 10"

383

Artist: **Phillipe Weisbecker**

Art Director: Sandy Kaufman

Client: Columbia University

Medium: Mixed

Size: 8" x 8"

384

Artist: **Sara Fanelli**

Art Director: Rosemarie Turk

Client: Brookfield Financial Properties

Medium: Mixed

Size: 9" x 4"

385

Artist: **Phillipe Weisbecker**

Art Director: Sandy Kaufman

Client: Columbia University

Medium: Mixed

Size: 8" x 8"

382

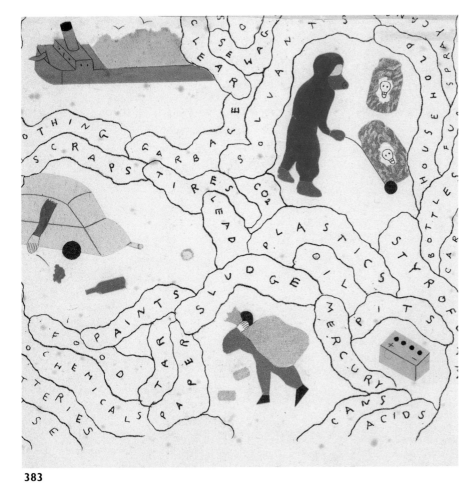

383

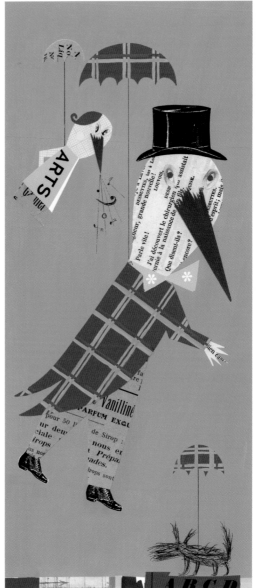

384

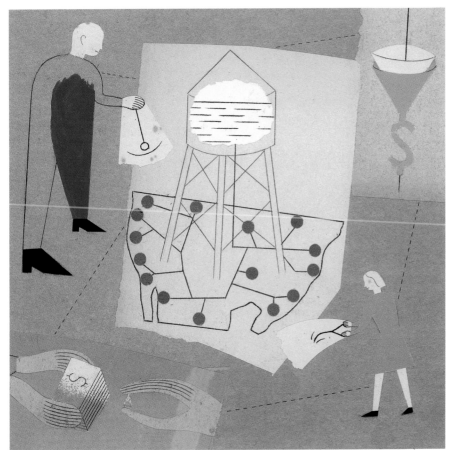

385

386
Artist: **Mark Tellok**
Client: Normand Robert Photographe
Size: 11" x 15"

387
Artist: **Mark von Ulrich**
Art Director: Mike Diehl
Client: Warner Brothers Records
Medium: Digital
Size: 5" x 5"

388
Artist: **Craig Frazier**
Art Directors: Jimmy Locklear
Sook Lim
Client: Netbank, Inc.
Medium: Digital
Size: 14" x 11"

389
Artist: **Craig Frazier**
Art Director: Karen Bronnenkant
Client: Sappi North America
Medium: Digital
Size: 14" x 11"

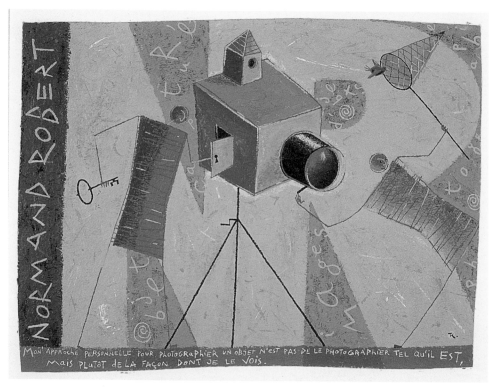

386

387

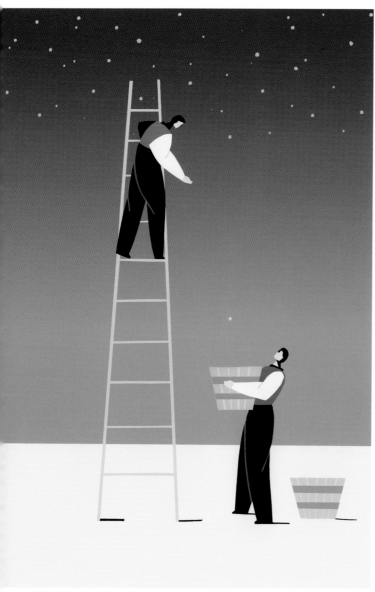

388

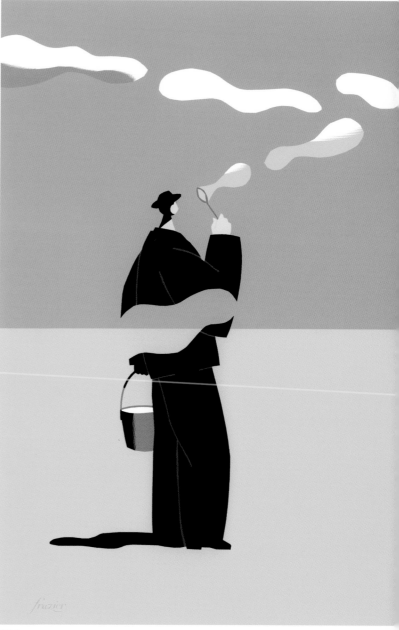

389

390
Artist: **Jeffrey Fisher**
Art Director: Kate Hinrichs
Client: Potlach Corporation/Corporate
 Design Foundation
Medium: Acrylic
Size: 13" × 10"

391
Artist: **Lasse Skarbovik**
Art Director: Paul Hiscock
Client: Adobe System UK
Medium: Digital
Size: 12" × 12"

392
Artist: **Christiane Beauregard**
Client: Association of Illustrators of Quebec
Medium: Digital
Size: 20" × 15"

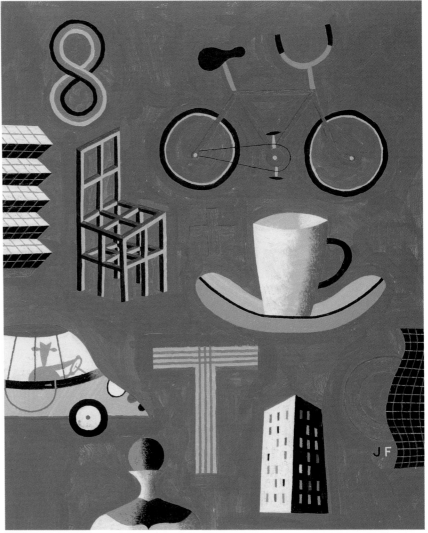

390

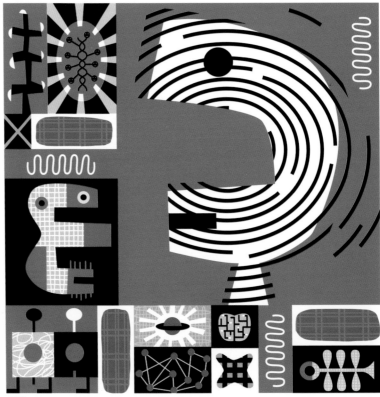

391

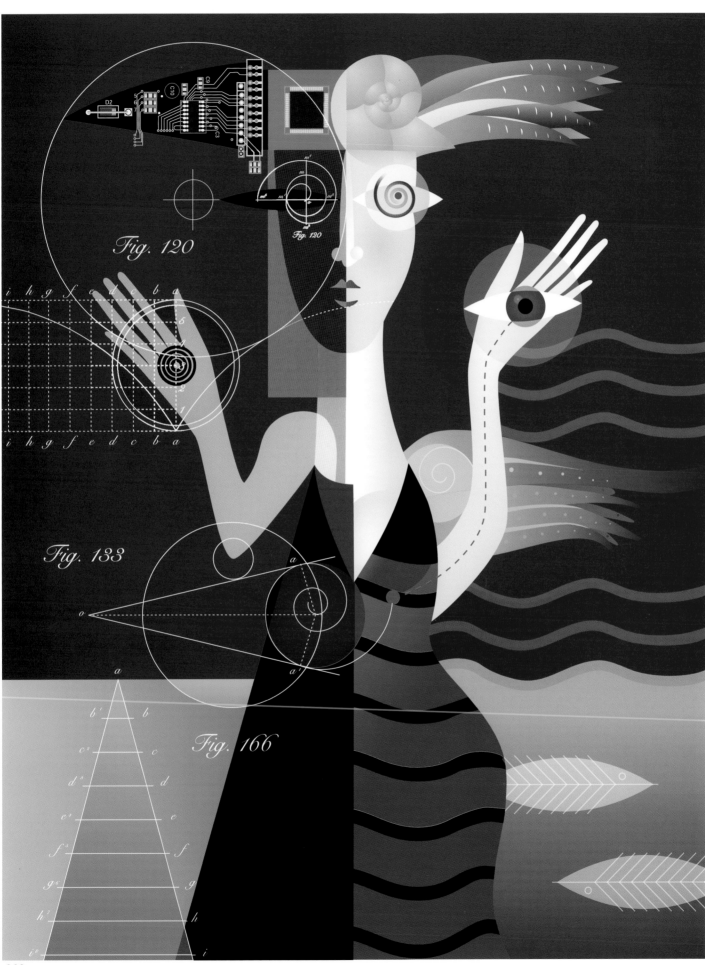

393
Artist: **Gary Baseman**
Art Director: Frank Viva
Client: Opal Sky
Medium: Acrylic
Size: 13" x 11"

394
Artist: **Rich Lillash**
Art Director: Mark Gormley
Client: Baseman Printing
Medium: Cut paper, mixed on paper
Size: 10" x 10"

395
Artist: **Jeffrey Fisher**
Art Director: Mark Schwartz
Client: Fraser Papers
Medium: Acrylic
Size: 12" x 9"

396
Artist: **Jeffrey Fisher**
Art Director: Doug Joseph
Client: Fraser Papers
Medium: Acrylic
Size: 12" x 9"

397
Artist: **Hilla Navok**
Art Director: Ido Shemi
Client: Dinamo Dvash (Electronic Club)
Medium: Pencil, digital on paper
Size: 19" x 27"

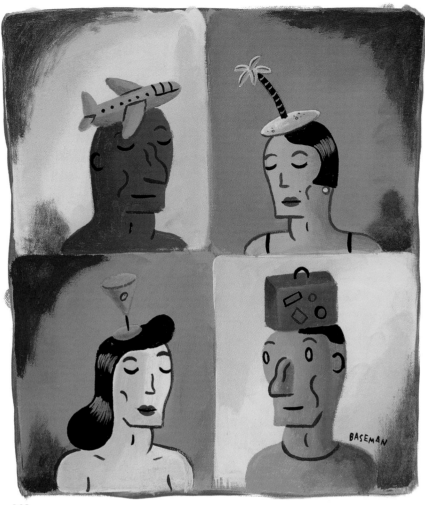

393

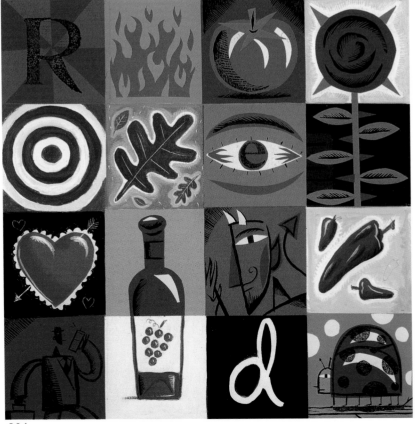

394

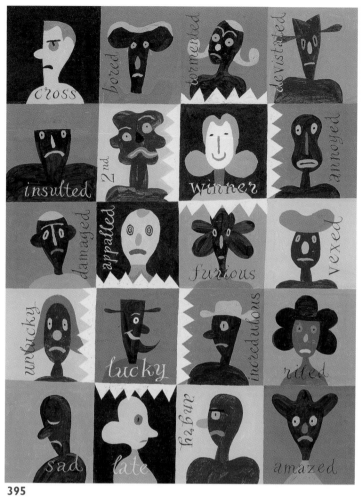

395

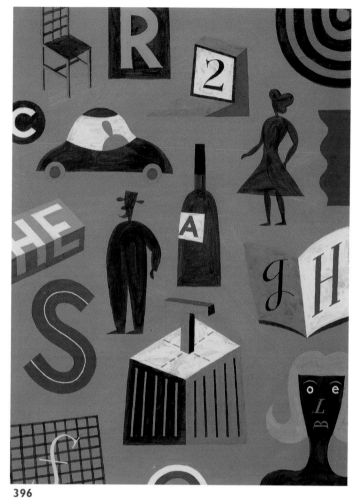

396

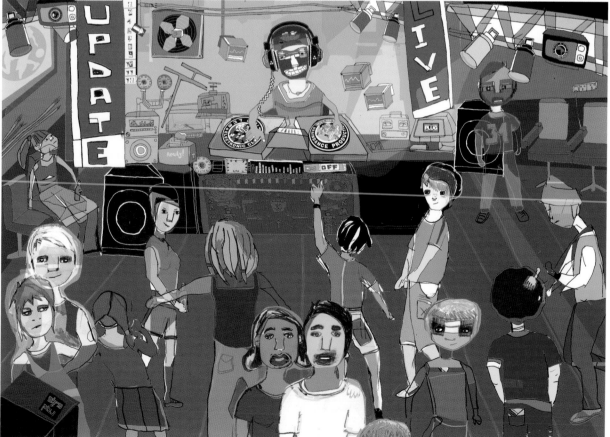

397

398

Artist: **Jessie Hartland**

Art Director: Kelsey Miller

Client: Standard & Poor's Published Image

Medium: Gouache on paper

Size: 12" x 8"

399

Artist: **Chris Pyle**

Art Director: Fred Fehlau

Client: Playboy Jazz Festival

Medium: Gouache, airbrush on Arches
 150 lb. cold press paper

Size: 11" x 9"

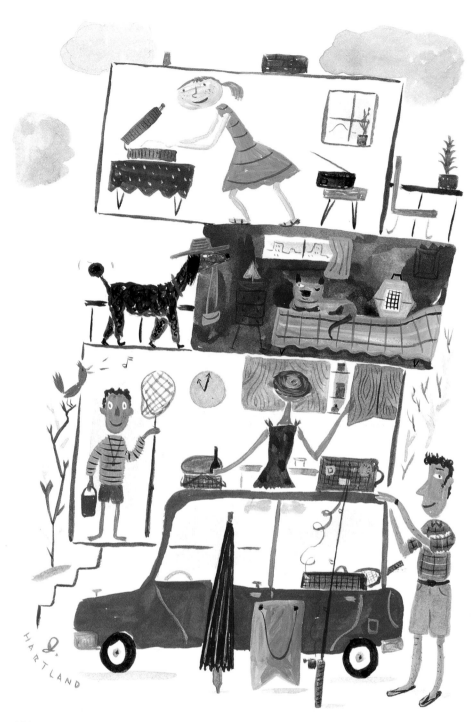

398

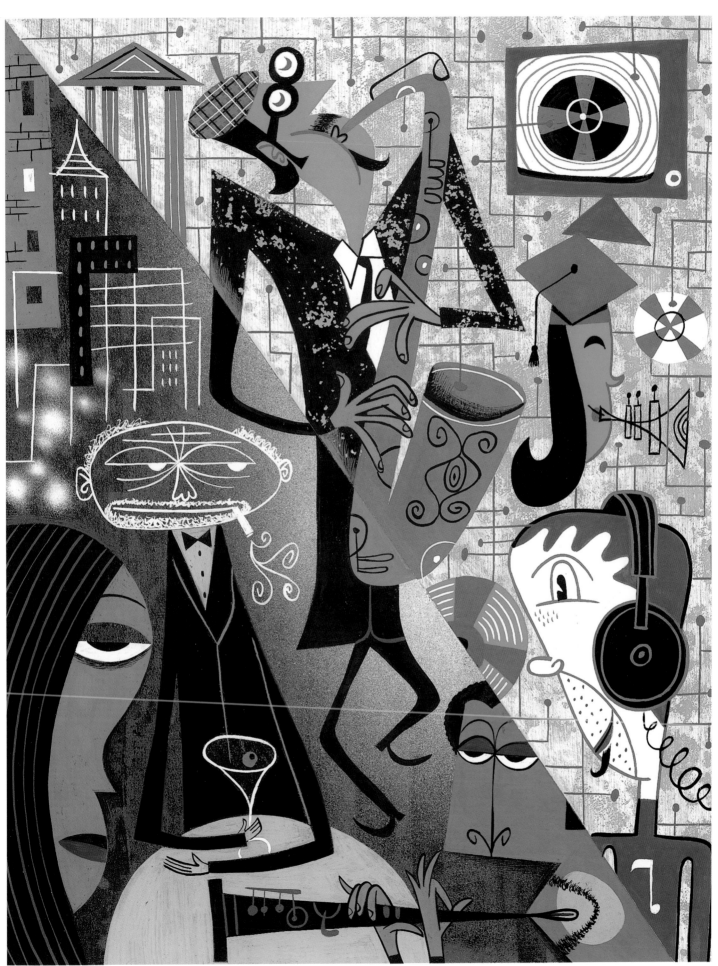

INSTITUTIONAL

400
Artist: **Jim Frazier**
Art Director: Todd Urban
Client: Wells Fargo Business Advisor
Medium: Digital
Size: 10" × 8"

401
Artist: **Marcos Chin**
Art Director: Carolyn Machacek
Client: S.A.P. - Canada Customary
 Advisory Council
Medium: Digital
Size: 10" × 10"

402
Artist: **Jean-Manuel Duvivier**
Art Director: Alain Fallik
Client: European Chemistry
Medium: Acrylic on colored paper
Size: 11" × 8"

403
Artist: **Marcos Chin**
Art Director: Carolyn Machacek
Client: S.A.P. - Canada Customary
 Advisory Council
Medium: Digital
Size: 7" × 11"

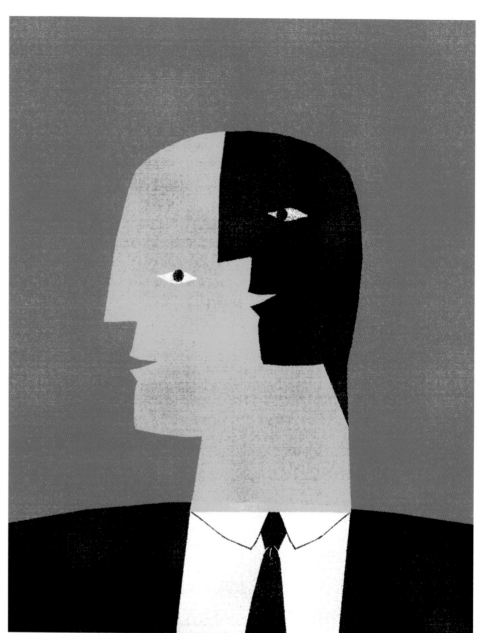

400

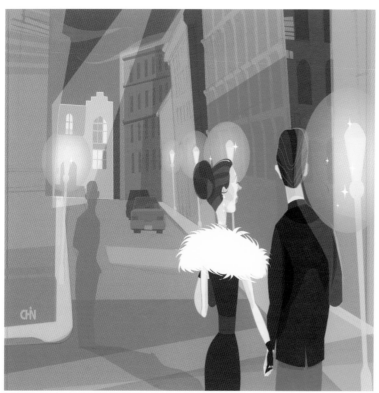

401

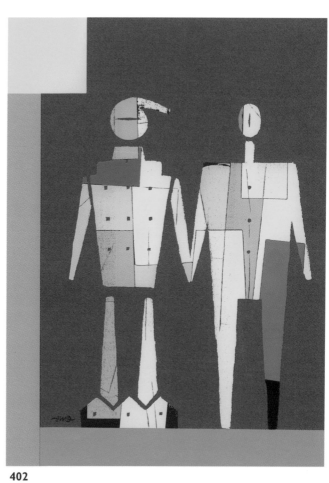

402

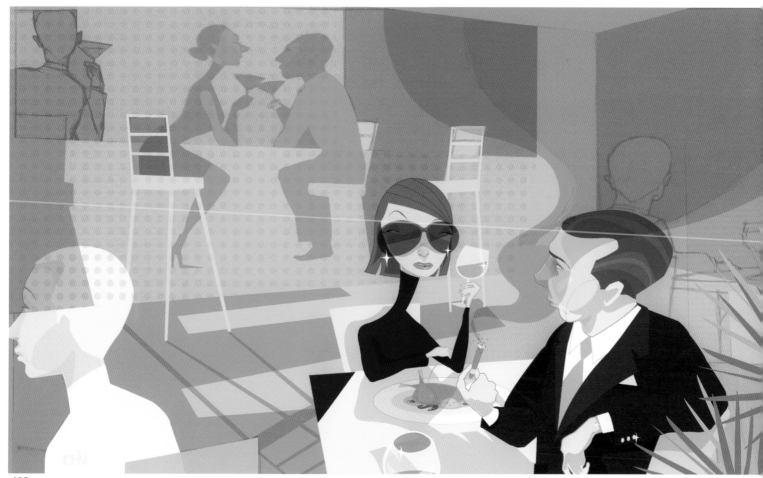

403

404
Artist: **Sara Fanelli**
Art Director: Cecile Hu
Client: AIGA Philadelphia
Medium: Mixed
Size: 9" × 6"

405
Artist: **Phillipe Weisbecker**
Art Director: Sandy Kaufman
Client: Columbia University
Medium: Mixed
Size: 8" × 8"

404

INSTITUTIONAL

406
Artist: **Jonathan Combs**
Art Director: Kirk Stanford
Client: Gravity Design
Medium: Pencil, digital
Size: 17" × 6"

407
Artist: **Mark McMahon**
Art Director: Carolyn McGregor McMahon
Client: Highland House Designs
Medium: Pencil
Size: 30" × 22"

408
Artist: **Kazuhiko Sano**
Art Directors: Hiroki Suzuki
Yoji Suzuki
Client: Galleria Prova
Medium: Mixed
Size: 24" × 35"

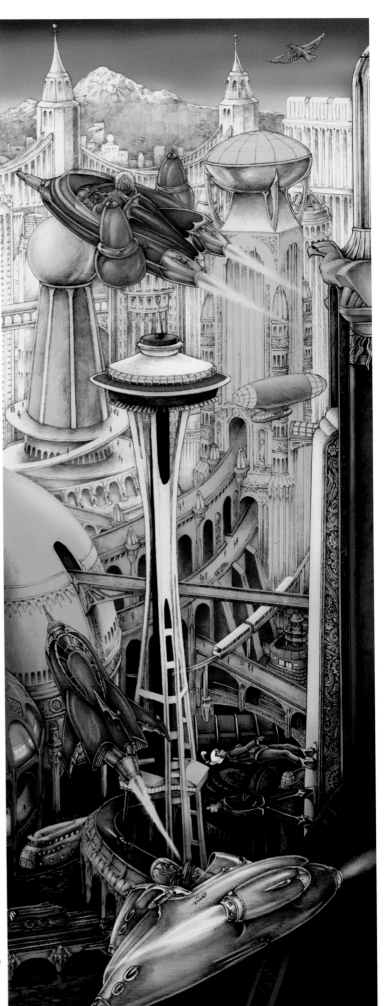

406

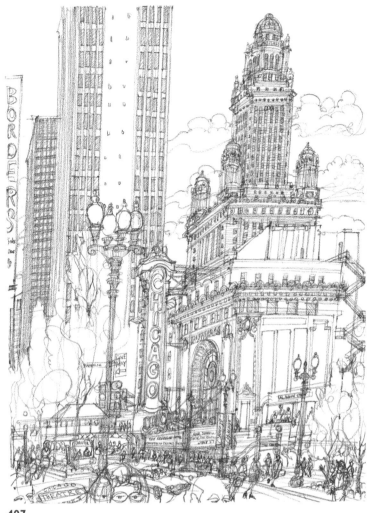

407

408

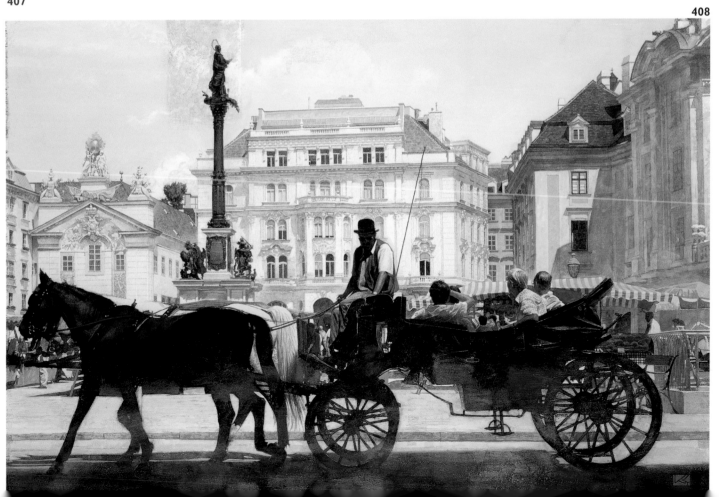

409
Artist: **Whitney Sherman**
Art Director: Meghan Alonso
Client: Loyola College of Maryland
Medium: Pencil digitally colored and
 enhanced on Rives BFK paper
Size: 22" x 16"

410
Artist: **William C. Sturm**
Medium: Oil on linen
Size: 36" x 48"

411
Artist: **Robert Logrippo**
Art Director: Virginia Johnson
Client: Boston University
Medium: Acrylic on masonite
Size: 27" x 21"

409

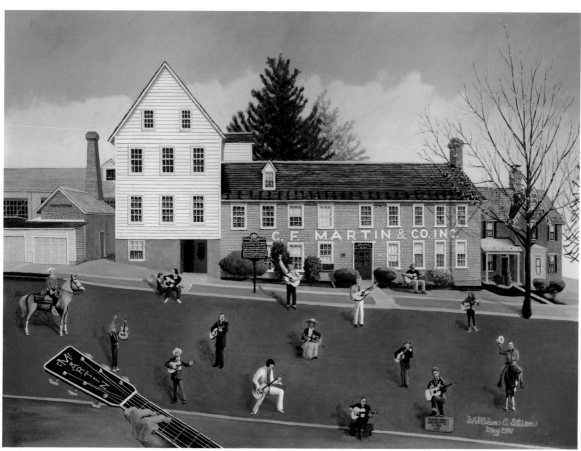

410

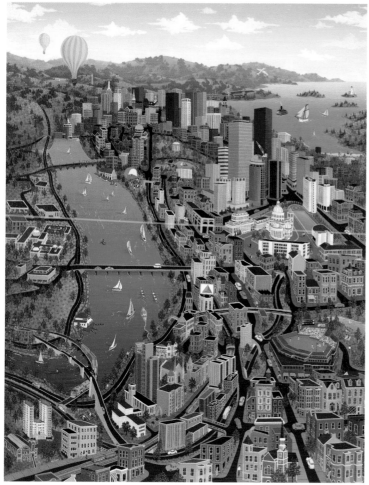

411

412
Artist: **Douglas Fraser**
Art Director: Phil Hollenbeck
Client: Rough Magazine/Dallas Society of
Visual Communications
Medium: Alkyd on canvas
Size: 12" x 9"

413
Artist: **Chris Gall**
Art Director: Charles Gallagher
Client: PTS America
Medium: Scratchboard, digital
Size: 13" x 13"

414
Artist: **Eugene Hoffman**
Art Director: Chris Hill
Client: Southwest Texas State
Medium: Cardboard
Size: 36" x 20"

415
Artist: **Eugene Hoffman**
Client: The Pressworks
Medium: Papier-maché, cardboard
Size: 48" x 38"

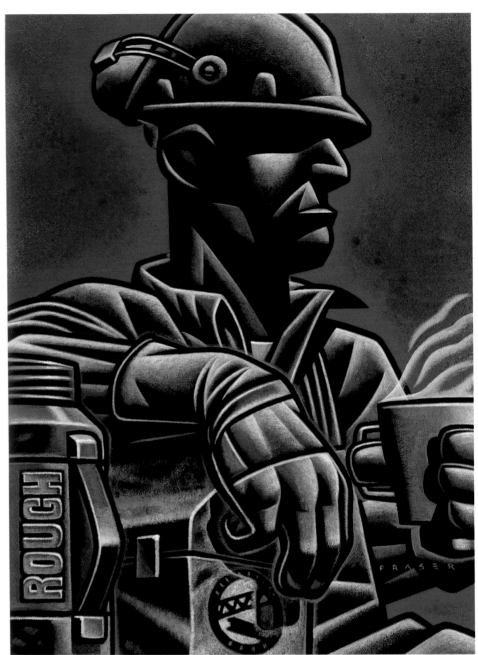

412

413

414

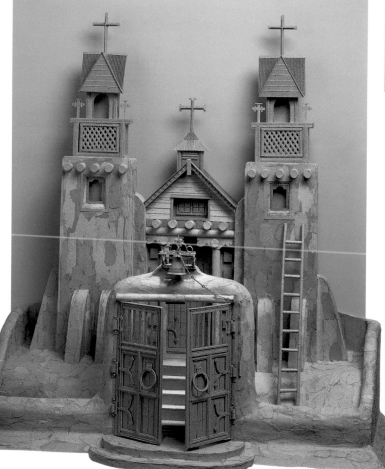

415

416
Artist: **Marc Burckhardt**
Art Director: Mark Murphy
Client: Murphy Design
Medium: Acrylic on wood
Size: 11" × 10"

417
Artist: **Marc Burckhardt**
Art Director: Ruth Eberstein
Client: Serbin Communications
Medium: Acrylic on cold press board
Size: 18" × 13"

418
Artist: **Greg Spalenka**
Art Director: Anthony Padilla
Client: Art Institute of Southern California
Medium: Mixed
Size: 40" × 28"

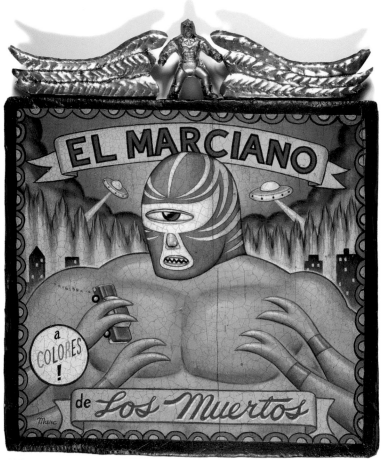

416

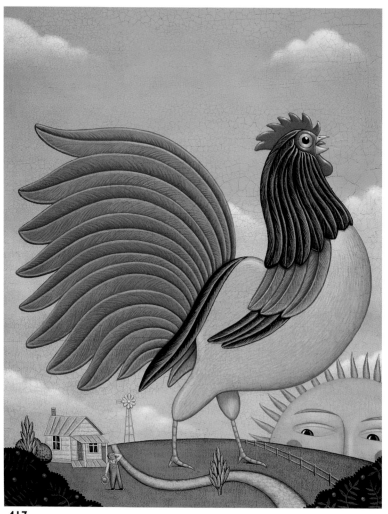

417

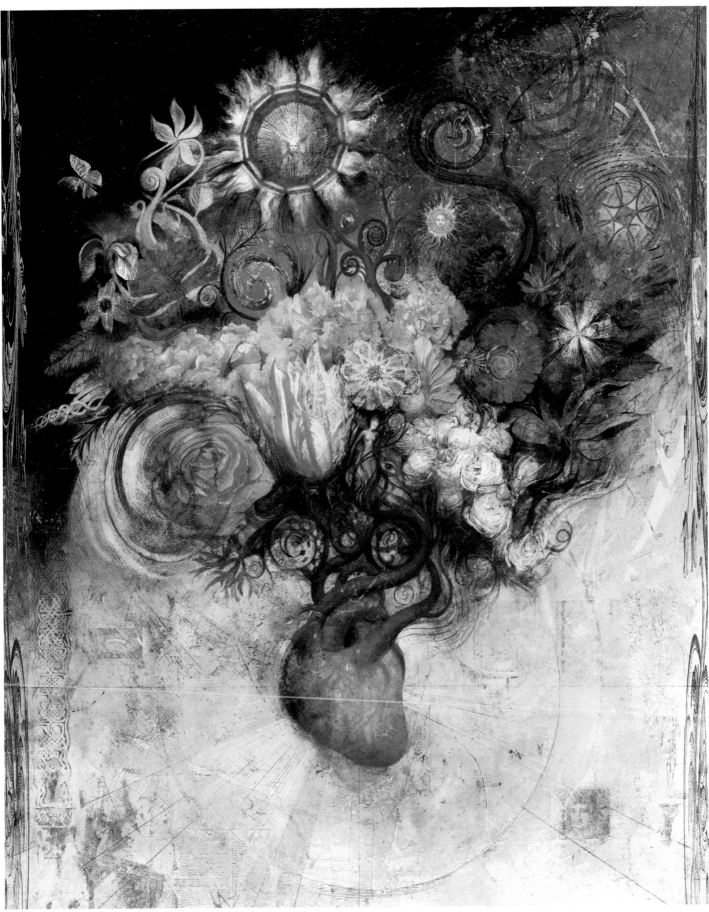

419
Artist: **Gary Baseman**
Art Director: Vicki Fischer
Client: Art Directors Club of Denver
Medium: Acrylic
Size: 21" x 17"

420
Artist: **Gary Baseman**
Art Director: Imin Pao
Client: Hey Song
Medium: Acrylic
Size: 9" x 7"

421
Artist: **Bill Mayer**
Art Director: Dan Dyksen
Client: Russell Design Associates
Medium: Airbrush, gouache on board
Size: 9" x 13"

422
Artist: **Bill Mayer**
Art Director: Jim Burke
Client: Dellas Graphics
Medium: Airbrush, gouache on board
Size: 15" x 12"

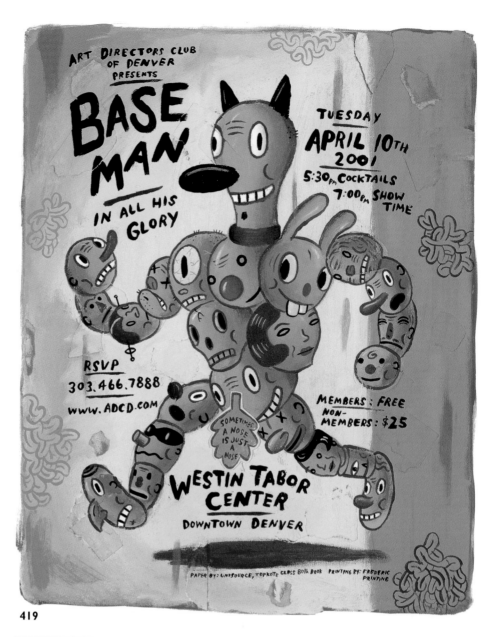

419

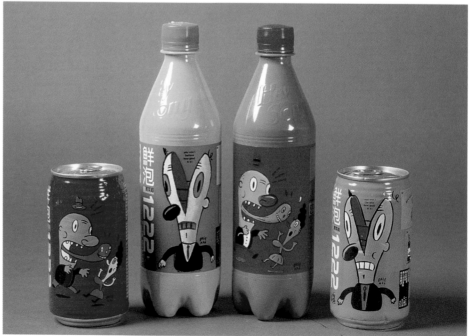

420

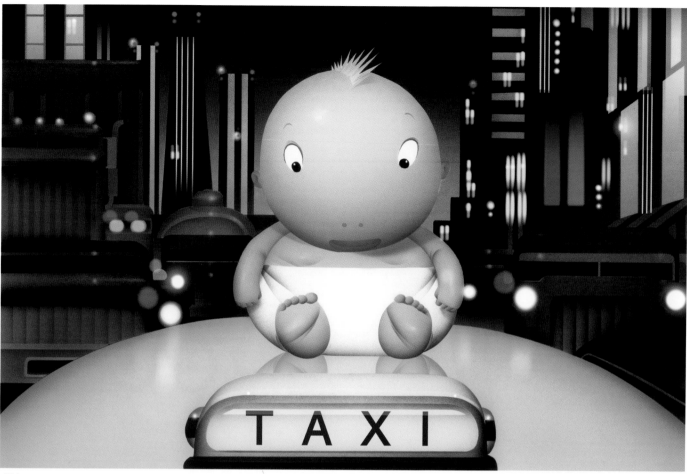

421

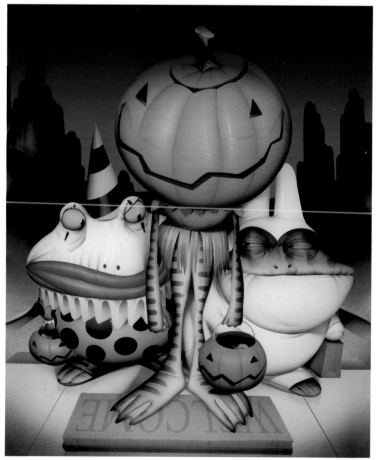

422

423

Artist: **Takashi Akiyama**

Client: Hachioji Festival

Size: 20'' x 14''

424

Artist: **Ramon Olivera**

Art Directors: Karen Dismukes
Joan Orth

Client: Hallmark Cards

Medium: Digital

Size: 6'' x 3''

423

424

UNCOMMISSIONED

JURY

Jim Bennett, Chair
Illustrator

Melinda Beck

John Cuneo
Illustrator

Jessie Hartland
Illustrator

Brad Holland
Illustrator

Gary Kelley
Illustrator

Lynn Pauley
Illustrator

Jim Spanfeller
Illustrator

Dan Yaccarino
Illustrator

425 GOLD MEDAL
Artist: **John H. Howard**
Medium: Acrylic on Arches paper
Size: 15" x 11"

"The pairing of words with images and their resulting logic has always been a puzzle to me, and this piece is another in a long stream of these random couplings. Inspired in part by the endless misery and boredom of the New York Adirondak winter train ride to Montreal, I'd have voted this work a non-contender in the annual illustration olympics. Wrong again, I'm pleased to admit I find myself both amazed and honored by this award."

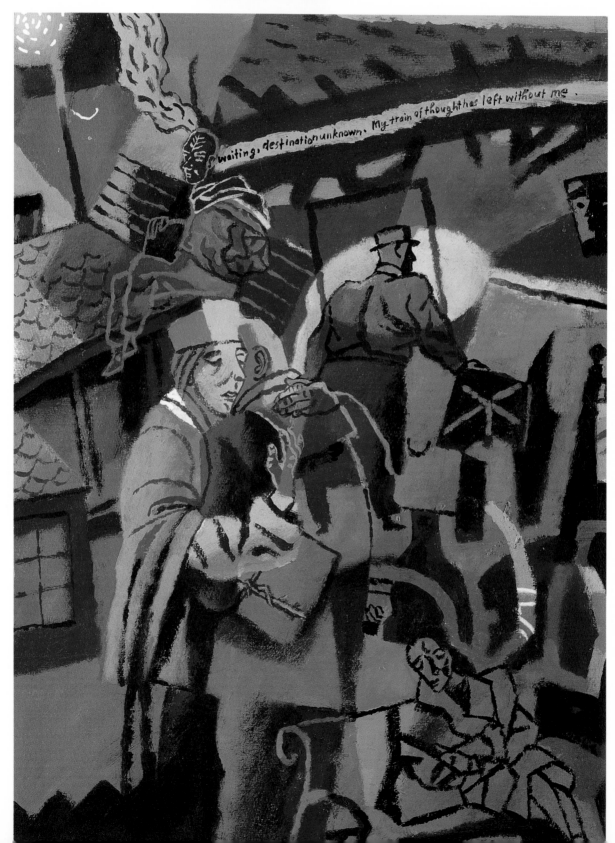

426 SILVER MEDAL
Artist: **Michelle Chang**
Medium: Oil on board
Size: 15" x 9"

"I was born in Seoul, Korea, and grew up here in New York City. My academic background is in design, fine art, and illustration. I was very surprised and honored to have won a silver medal for this piece. It is a portrait of Edward Hopper, the painter. Everyone is familiar with his art, but I was more interested in his personal life. To that end, I chose to put him in a setting reminiscent of his paintings and included a reference alluding to his oftentimes turbulent relationship with his wife."

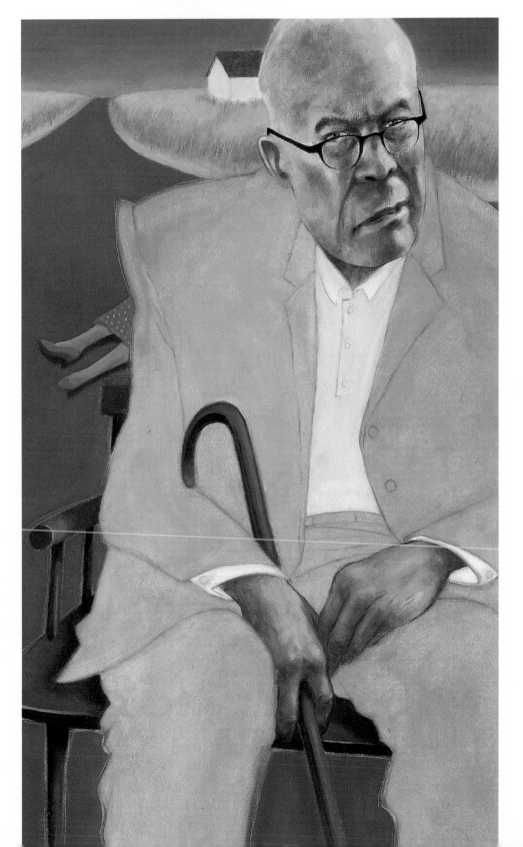

UNCOMMISSIONED

427 SILVER MEDAL
Artist: **Mark Summers**
Medium: Scratchboard, watercolor
Size: 10" × 7"

Mark Summers finds his annual task of creating promotional work both fun and often the most popular. He had some difficulty casting the Mad Hatter after having done so many famous faces. "A generic guy is hard to do." With Tenniel's classic as a base, he pushed the character, action, and texture.

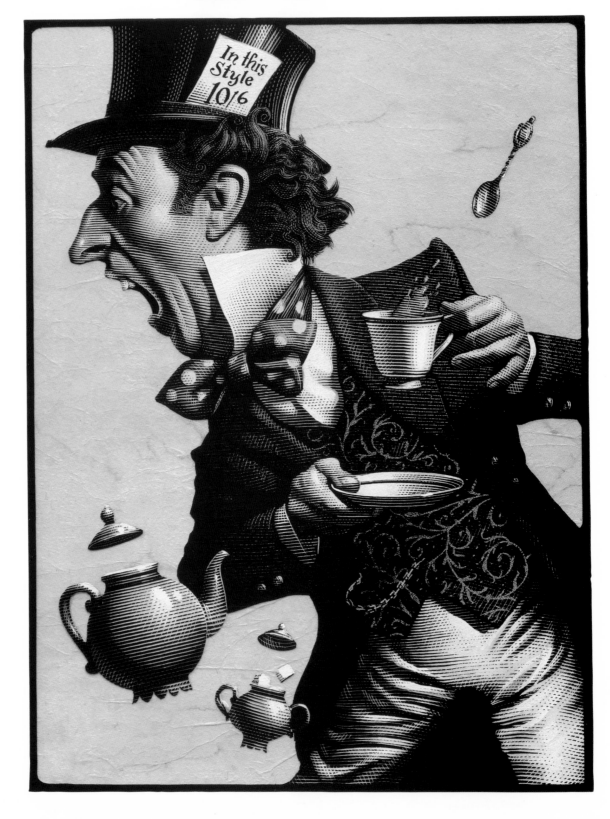

428
Artist: **Francis Livingston**
Medium: Oil on panel
Size: 36" × 48"

429
Artist: **Francis Livingston**
Medium: Oil on panel
Size: 24" × 12"

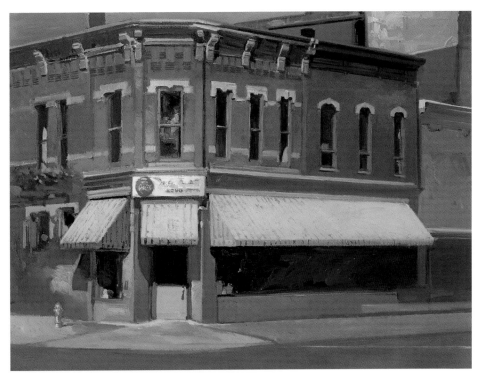

428

429

430
Artist: **Andrea Ventura**
Medium: Mixed
Size: 24" x 18"

431
Artist: **Jerome Lagarrigue**
Medium: Acrylic, collage on masonite
Size: 11" x 14"

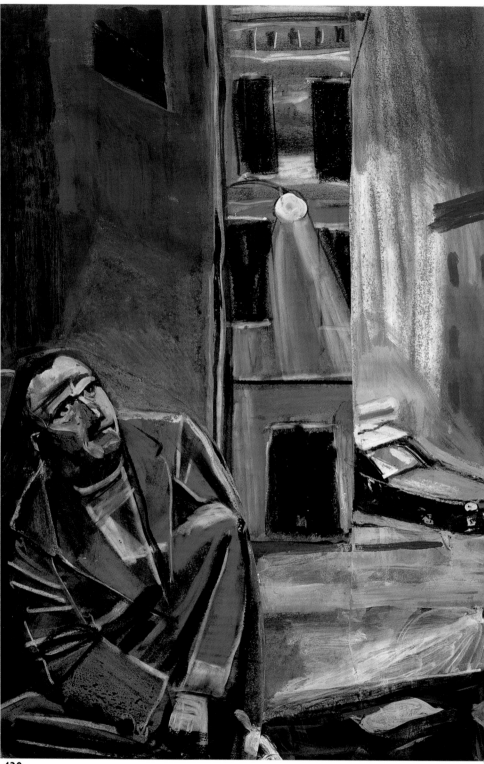

430

431

432
Artist: **Tomas Andreasson**
Medium: Digital
Size: 16" × 12"

433
Artist: **Jason Nobriga**
Medium: Oil on canvas
Size: 36" × 24"

434
Artist: **Jason Nobriga**
Medium: Oil on board
Size: 14" × 11"

432

433

434

435
Artist: **John Collier**
Medium: Oil
Size: 20" × 18"

436
Artist: **John Collier**
Medium: Pastel, watercolor
Size: 20" × 18"

437
Artist: **Morgan Carver**
Medium: Acrylic on birch panel
Size: 33" × 48"

438
Artist: **John Thompson**
Medium: Oil on canvas
Size: 25" × 39"

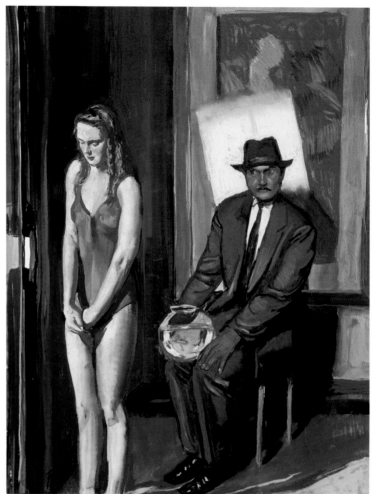

435

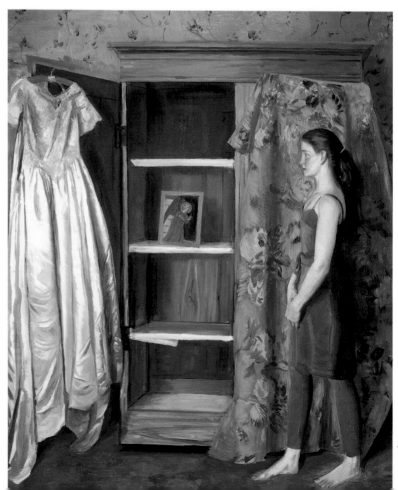

436

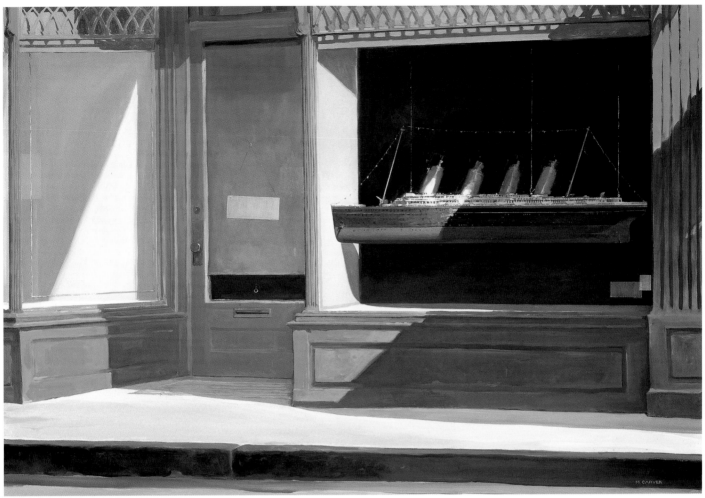

437

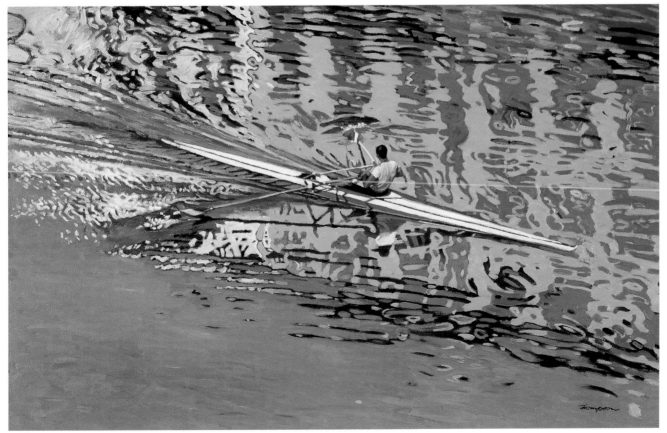

438

439
Artist: **Nicholas Wilton**
Medium: Acrylic on wood
Size: 12" × 12"

440
Artist: **Brett Emanuel**
Medium: Digital on paper
Size: 8" × 7"

441
Artist: **Mark Andresen**
Medium: Pen & ink, watercolor, colored
 pencil, solvents on paper
Size: 11" × 8"

442
Artist: **Alan Dingman**
Medium: Alkyd on Strathmore paper
Size: 12" × 8"

443
Artist: **Dick Krepel**
Medium: Digital, collage
Size: 14" × 12"

439

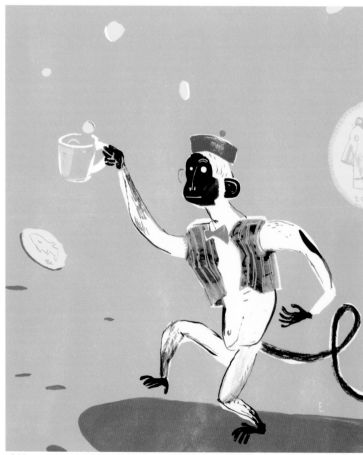

440

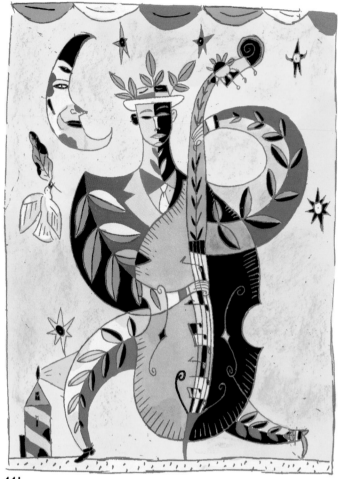

441

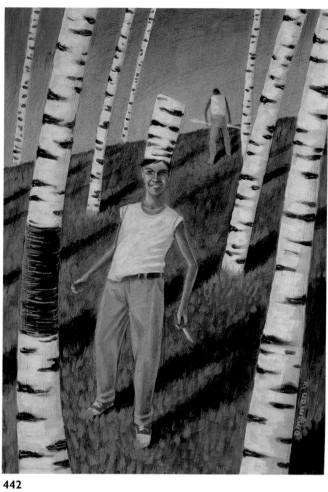

442

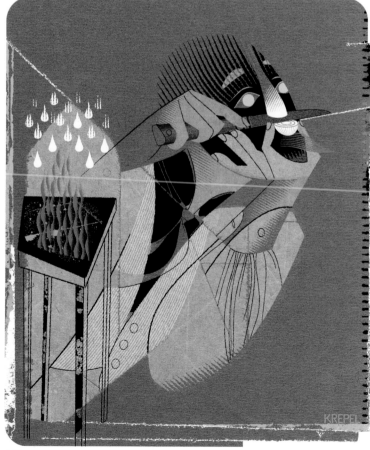

443

444

Artist: **Greg Spalenka**

Medium: Mixed, digital

Size: 10" x 8"

445

Artist: **Donna M. Grethen**

Medium: Oil pastel, pencil on brown
Kraft paper

Size: 7" x 8"

446

Artist: **Joan Hall**

Medium: Mixed, assemblage on wood

Size: 18" x 9" x 2"

447

Artist: **Donna M. Grethen**

Medium: Gouache, pencil, collage on
scratchboard

Size: 9" x 6"

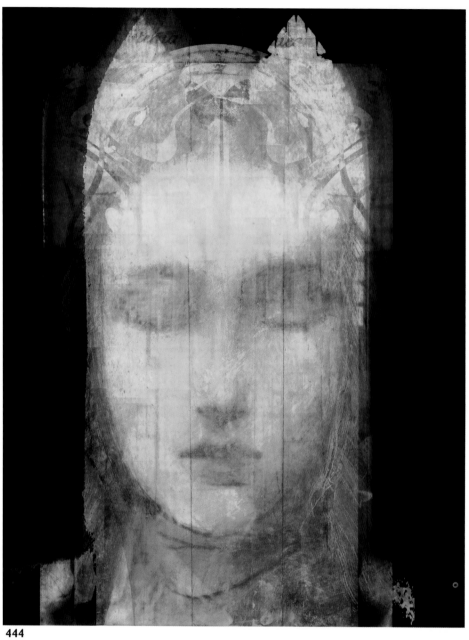

444

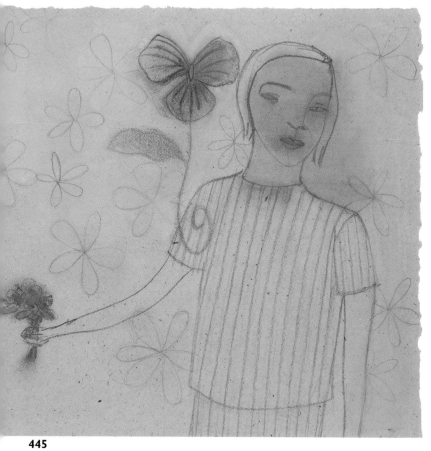

445

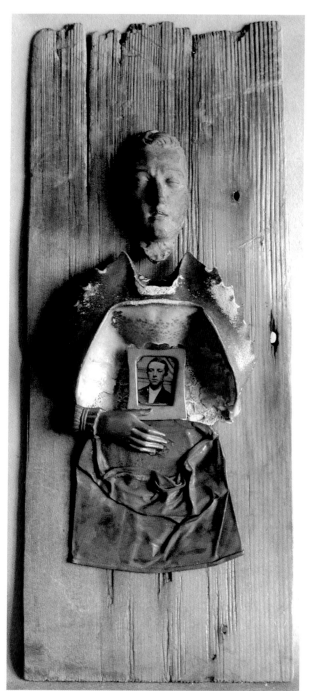

446

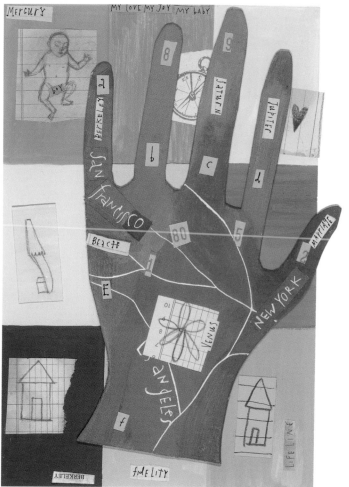

447

448
Artist: **David Bowers**
Medium: Oil on gessoed masonite
Size: 15" × 12"

449
Artist: **Steven Adler**
Medium: Oil on masonite
Size: 26" × 24"

450
Artist: **David Brinley**
Medium: Acrylic on masonite
Size: 24" × 16"

451
Artist: **John Thompson**
Medium: Oil on canvas
Size: 36" × 36"

452
Artist: **Melanie Eberhardt**
Medium: Pen & ink on Bristol board
Size: 11" × 11"

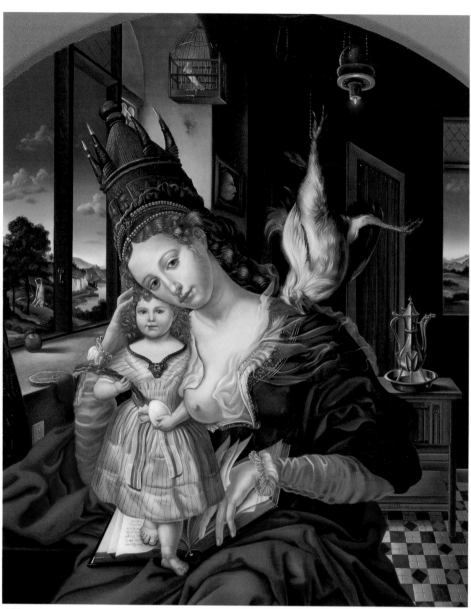

448

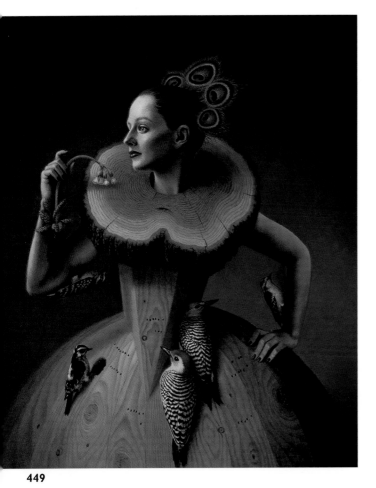

449

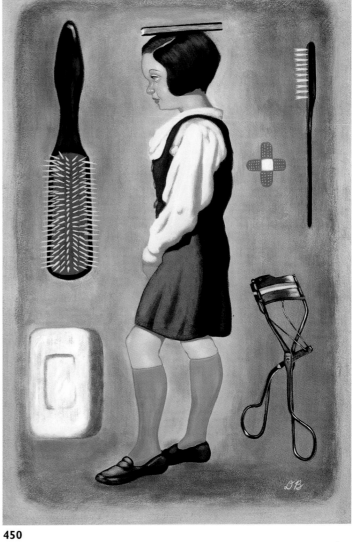

450

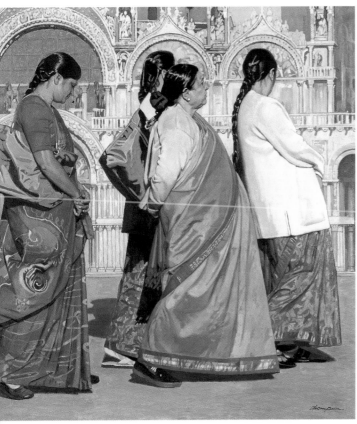

451

452

UNCOMMISSIONED

453
Artist: **Michelle Chang**
Medium: Oil on board
Size: 14" x 11"

454
Artist: **Lisa Adams**
Medium: Acrylic, gouache, collage, rubber stamp
Size: 10" x 9"

455
Artist: **Brad Yeo**
Medium: Acrylic on canvas
Size: 20" x 10"

456
Artist: **Lisa Adams**
Medium: Acrylic, gouache, collage
Size: 8" x 7"

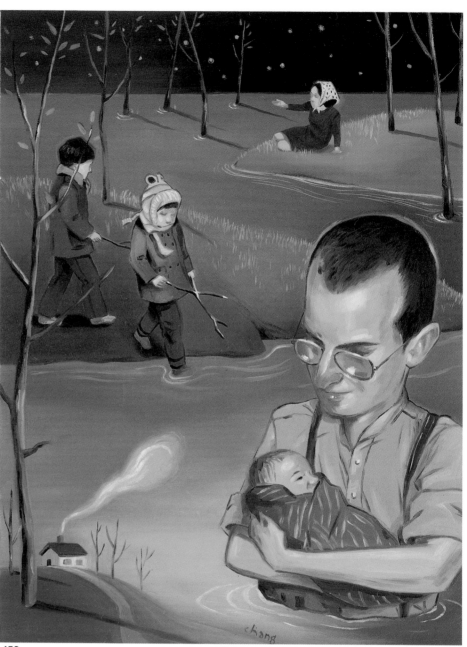

453

454

455

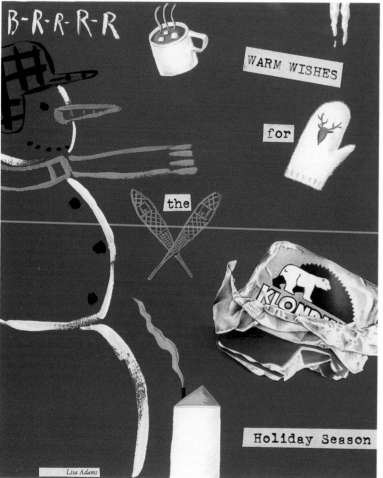

456

457

Artist: **Gina Triplett**

Medium: Acrylic, ink on board

Size: 9" x 7"

458

Artist: **Derek Voldemars Stukuls**

Medium: Oil-based ink, letterpress on paper

Size: 4" x 6"

459

Artist: **Polly Becker**

Medium: Assemblage

Size: 4" x 7"

460

Artist: **Paquebot**

Medium: Digital

Size: 8" x 11"

457

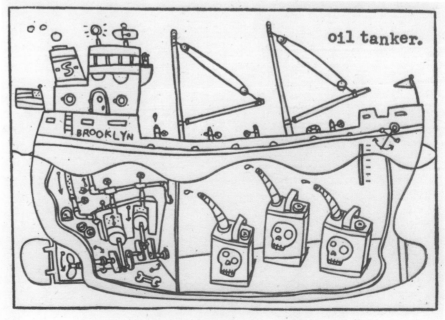

458

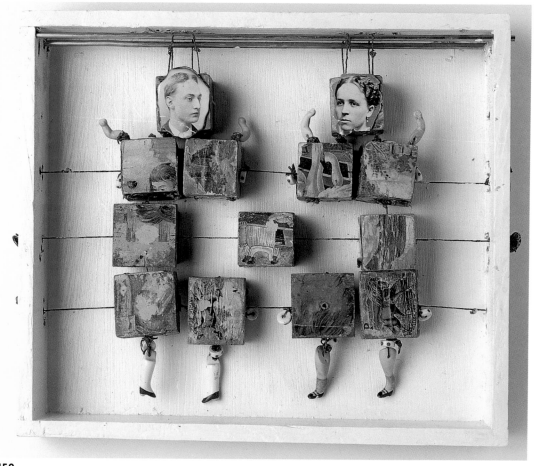

459

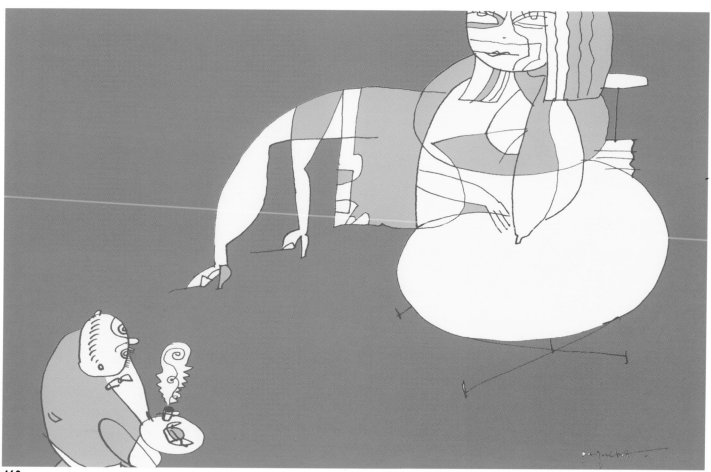

460

461
Artist: **Creatink**
Medium: Mixed, digital
Size: 12" × 9"

462
Artist: **Mike McConnell**
Medium: Pen & ink, digital
Size: 7" × 6"

463
Artist: **James Bennett**
Medium: Oil on board
Size: 12" × 10"

464
Artist: **James Bennett**
Medium: Oil
Size: 13" × 10"

465
Artist: **Gary Kelley**
Medium: Pastel on paper
Size: 19" × 28"

461

462

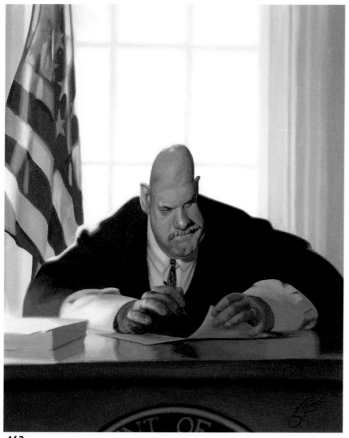

463

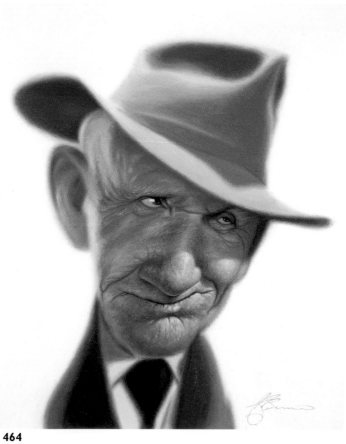

464

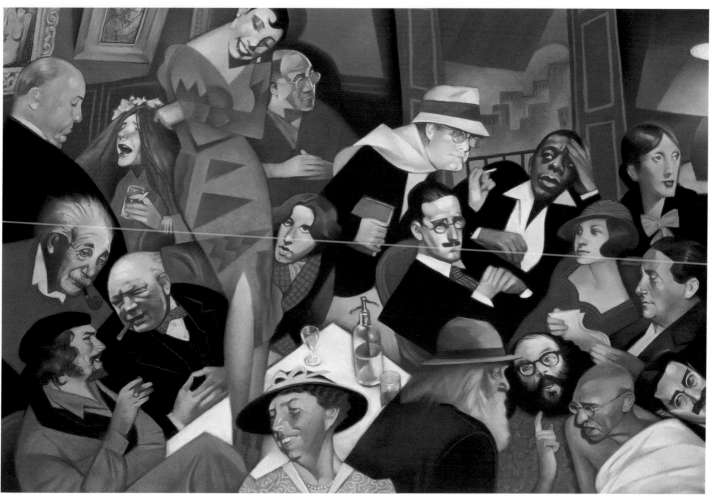

465

UNCOMMISSIONED

466
Artist: **Richard Farrell**
Medium: Oil on board
Size: 23" x 17"

467
Artist: **Melissa J. Gibson**
Medium: Oil, watercolor, acrylic,
cut paper on board
Size: 12" x 9"

468
Artist: **Sterling Hundley**
Medium: Conté, pen & ink, pastel, tar on
Bainbridge illustration board #80
Size: 20" x 15"

469
Artist: **Cindy Eun Young Kim**
Medium: Acrylic, ink, collage on Strathmore
500 Bristol paper
Size: 12" x 22"

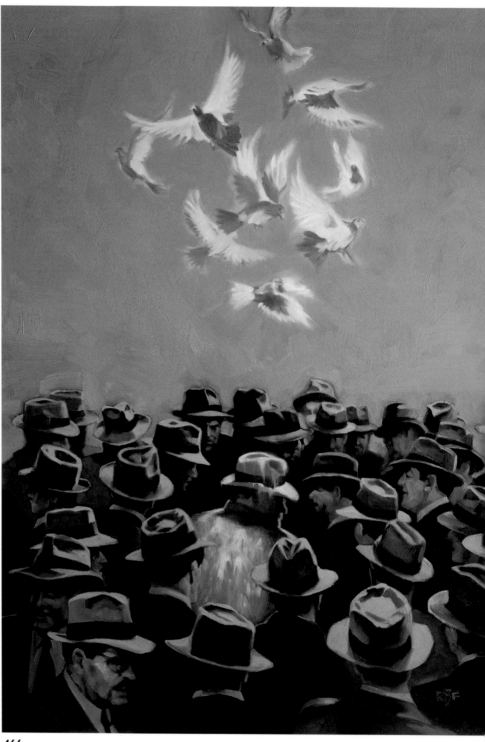

466

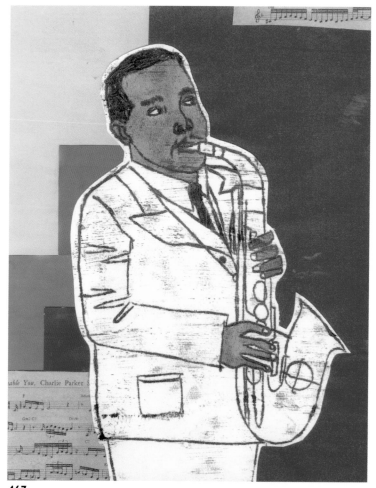

467

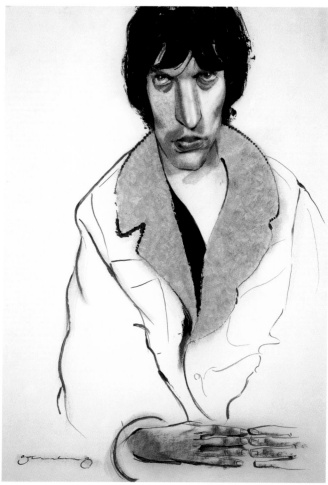

468

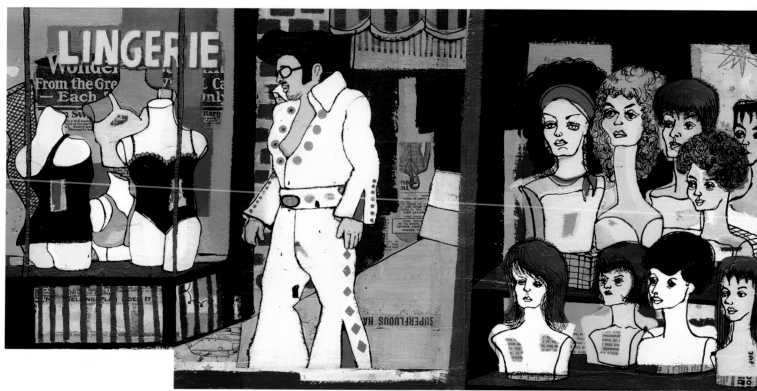

469

470
Artist: **Daniel Zakroczemski**
Medium: Digital
Size: 10" x 8"

471
Artist: **Marie Lessard**
Medium: Relief print with chine collé
Size: 15" x 10"

472
Artist: **Alan Dingman**
Medium: Alkyd on Strathmore paper
Size: 11" x 8"

473
Artist: **Elvis Swift**
Medium: Ink on paper
Size: 4" x 2"

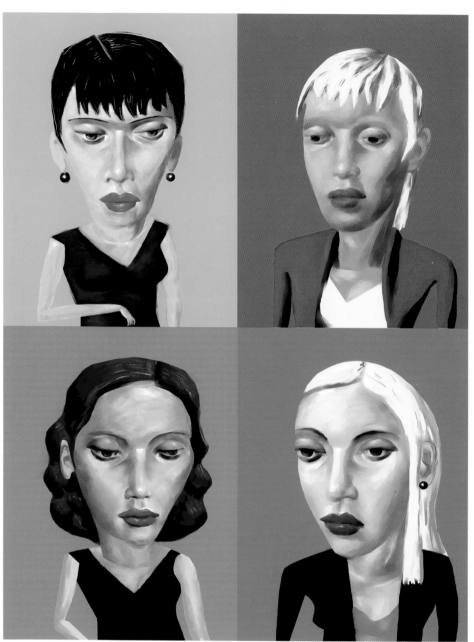

470

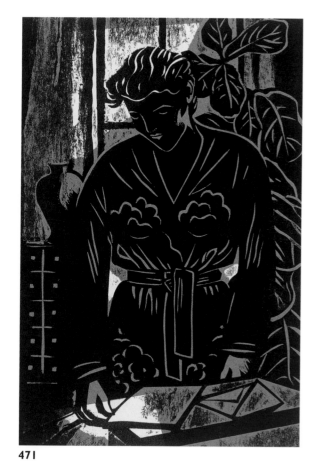

471

472

473

UNCOMMISSIONED

474
Artist: **Harvey Chan**
Medium: Digital
Size: 10" × 5"

475
Artist: **Harvey Chan**
Medium: Digital
Size: 10" × 5"

476
Artist: **Jim Frazier**
Medium: Digital
Size: 9" × 7"

477
Artist: **Jim Frazier**
Medium: Digital
Size: 9" × 7"

474

475

476

478
Artist: **Craig Frazier**
Medium: Digital
Size: 14" x 11"

479
Artist: **Jim Frazier**
Medium: Digital
Size: 9" x 7"

480
Artist: **Marcin Baranski**
Medium: Gouache on paper
Size: 16" x 11"

481
Artist: **Laura Smith**
Medium: Acrylic on canvas
Size: 19" x 14"

478

479

480

481

482
Artist: **Jack Black**
Medium: Gouache, digital
Size: 15" x 11"

483
Artist: **Jack Black**
Medium: Gouache, digital
Size: 14" x 15"

484
Artist: **John H. Howard**
Medium: Acrylic on Arches paper
Size: 15" x 11"

485
Artist: **John H. Howard**
Medium: Acrylic on Arches paper
Size: 29" x 21"

486
Artist: **John H. Howard**
Medium: Acrylic on Arches paper
Size: 30" x 22"

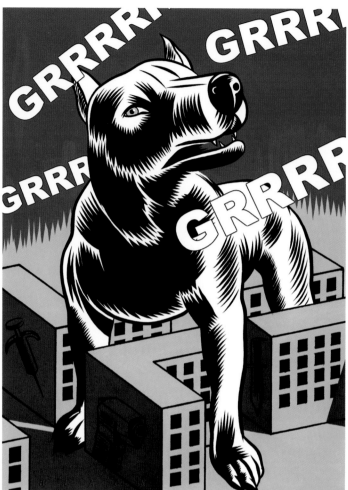

482

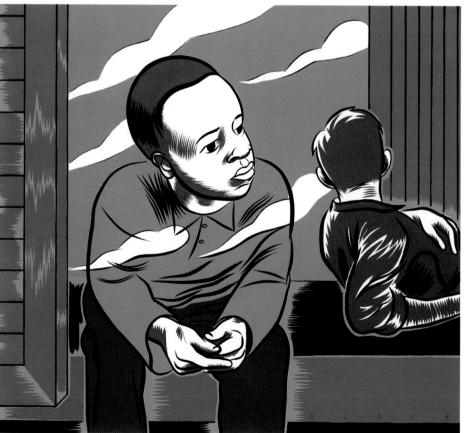

483

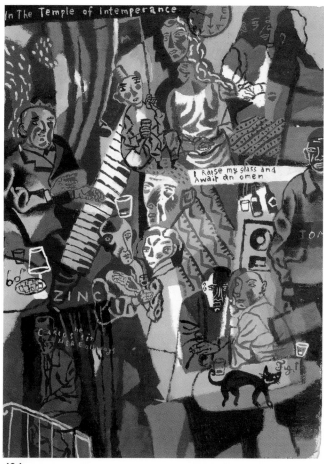

484

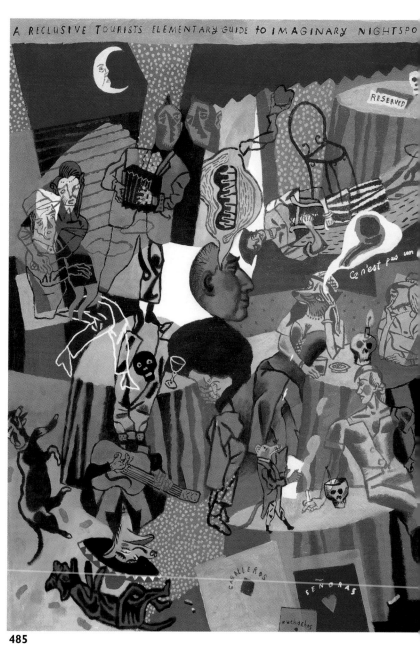

485

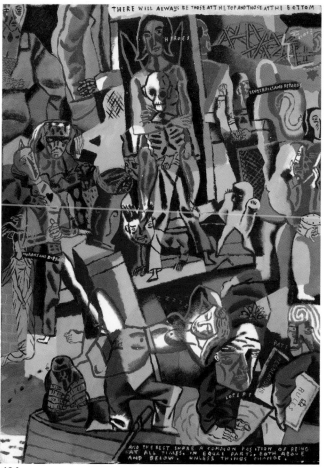

486

487
Artist: **Paul Cox**
Medium: Watercolor
Size: 24" × 18"

488
Artist: **Larry Moore**
Medium: Pastel on sanded paper
Size: 8" × 7"

489
Artist: **Richard Hull**
Medium: Acrylic
Size: 18" × 24"

490
Artist: **Richard Hull**
Medium: Acrylic
Size: 19" × 14"

491
Artist: **Carlo Cosentino**
Medium: Oil on canvas
Size: 48" × 36"

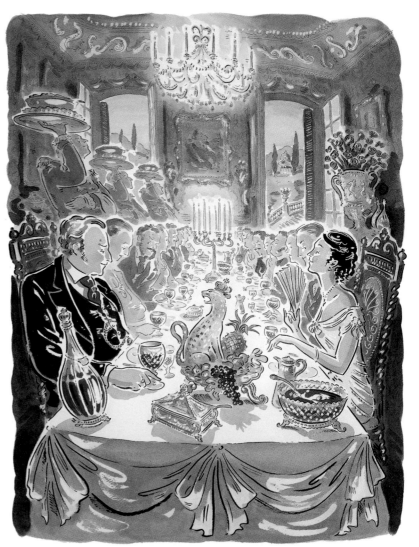

487

488

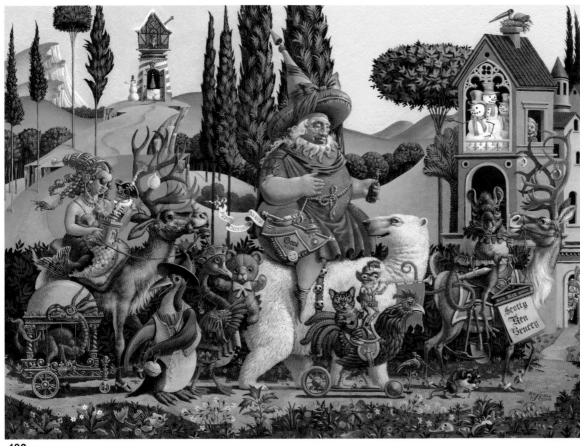

489

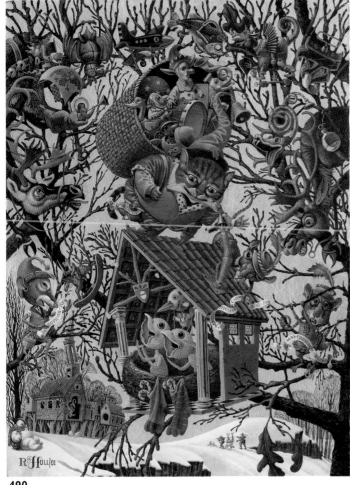

490

491

STUDENT SCHOLARSHIP COMPETITION

The Society of Illustrators fulfills its educational mission through its museum exhibitions, library, archives, permanent collection and, most proudly, through the Student Scholarship Competition.

The following pages present a sampling of the 101 works selected from over 5,000 entries submitted by college level students nationwide. The selections were made by a prestigious jury of professional illustrators.

Tim O'Brien chairs this program, and major financial support is given by Hallmark Corporate Foundation of Kansas City, Missouri. This year, along with donations from corporations, bequests, and an annual auction of member-donated works, the Society awarded over $70,000 to the students and their institutions.

David Passalacqua was selected as Distinguished Educator in the Arts, an honor now recognized by all as affirmation of an influential career in the classroom.

As you will see, the talent is there. If it is coupled with determination, these students will move ahead in this annual to join the selected professionals. Let's see.

HALLMARK CORPORATE FOUNDATION

HALLMARK FOUNDATION MATCHING GRANTS

The Hallmark Corporate Foundation of Kansas City, Missouri, is again this year supplying matching grants representing 50% of the students' awards in the Society's Student Scholarship Competition. Grants, restricted to the Illustration Departments, are awarded to the following institutions:

8,500	Art Center College of Design
4,000	Rhode Island School of Design
2,000	Ringling School of Art & Design
1,500	Maryland Institute, College of Art
1,500	Columbus College of Art & Design
1,000	School of Visual Arts
750	Academy of Art College
750	Parsons School of Design
500	University of Kansas

SCHOLARSHIP COMMITTEE AND JURY

COMMITTEE

Tim O'Brien, Chairman
Lisa Cyr
Tim Bower
Lauren Uram
Dave Flaherty

JURY

Zachary Baldus, *illustrator*
Jorge Colombo, *illustrator*
Greg Couch, *illustrator*
Susan Crawford, *illustrator*
Matthew Dicke, *illustrator*
Ingo Fast, *illustrator*
Yvetta Fedorova, *illustrator*
Robert Field, *illustrator*
Frank Frisari, *illustrator*
Max Grafe, *illustrator*
Tomer Hanuka, *illustrator*
Steve Hill, *illustrator*

David Kassan, *illustrator*
Hiroshi Kimura, *illustrator*
Campbell Laird, *illustrator*
Bryan Leister, *illustrator*
Dave Lesh, *illustrator*
Barbara Lipp, *illustrator*
Brian Rea, *illustrator*
Jennifer Roth, *art director*
Claudia Karabaik Sargent, *illustrator*
Philip Straub, *illustrator*
Beata Szpura, *illustrator*
John Twingley, *illustrator*
Ellen Weinstein, *illustrator*

STUDENT
SCHOLARSHIP
COMPETITION

DAVID PASSALACQUA

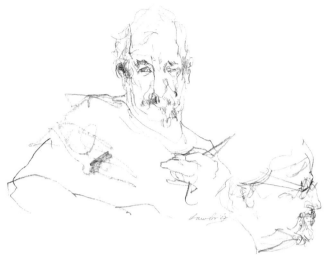

A reading of Dave's résumé clearly reveals his very impressive qualifications as an artist and designer.

It is important to note that he continues to be creative and active as well as having a strong interest in learning and mastering new developing technologies.

Dave has been teaching on the Parsons illustration faculty for more than 20 years. His teaching remains vital and the "tools" students use in his course are current, varied and extensive. The digital camera and computer have become central tools in several of his courses. This openness to new media keeps him current and ahead of his students and most certainly, the peers in his age group.

Dave's course evaluations reflect, year after year, just how much the students value his courses. His warmth and vitality combine to create an environment within his classes that promote active student participation. He encourages diverse points of view and is concerned with each individual's progress and development. Dave is an instructor who enjoys teaching; his courses radiate his enthusiasm.

He is in close contact with a large majority of his former students. His impact on these professionals touches every possible aspect of illustration; for example, the Disney Studios and animation, the film industry, magazine and book publishing and the world of advertising.

Dave's students have been and will continue to be major contributors within the business of illustration.

On September 11th he was in the school teaching his class. As we all viewed in horror the WTC burning, he gave an assessment of how he saw the unfolding situation. Dave is a former military man. Because of his army experience he was a very calming influence on all of our students and teachers who were on our floor. He knew how to handle the situation. After we saw that everyone was OK, he conferred with me about the safety of our students. He then went down to "Ground Zero" to photograph the chaos. The resulting images will be included in a book he is preparing: "NYC Landmark Buildings and Bridges." Dave has the capacity to recognize an opportunity in the midst of disaster.

Not only are his images to be found within the context of illustration, he is always creating new paths, new ways to expand areas of work. This is an inspiration to his students. They see their own future and know it's possible to enjoy and experience the exhilaration of an active and creative life. Dave's teaching and advising effectiveness have been, and are, outstanding.

Barbara Nessim
Chairperson, Illustration
Parsons School of Design

Matt Leines
Robert Brinkerhoff,
Instructor
Rhode Island School
of Design
$5,000 The Starr
Foundation Award
RSVP Publication Award

Rachel Cox
Warren Linn, Instructor
Maryland Institute,
College of Art
$3,000 Jellybean
Photographics Award

Jeff Soto
Christian Clayton, Instructor
Art Center College of Design
$3,000 Albert Dorne Award
"Call For Entries" Poster Award

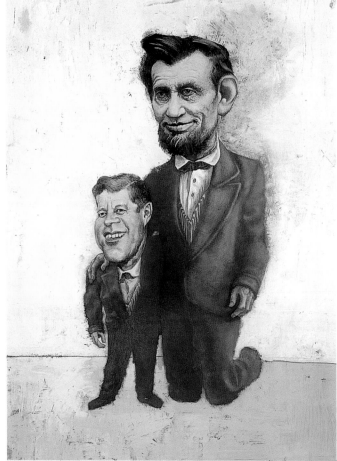

Paul Tepper
Joe Kovach, Instructor
Columbus College of Art & Design
$3,000 Robert H. Blattner Award

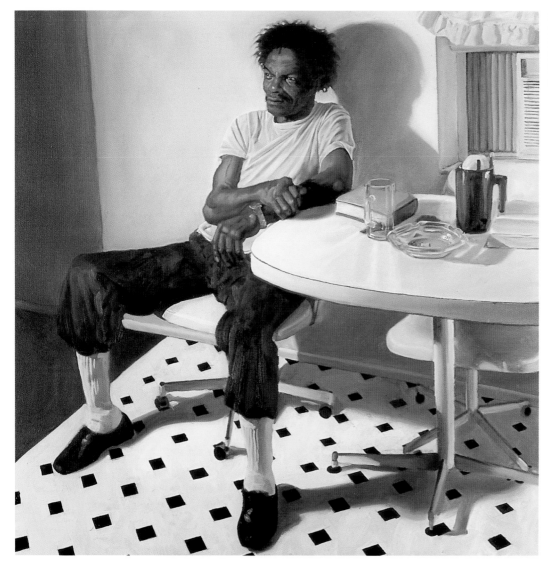

Markus Faust
Joe Thiel, Instructor
Ringling School of Art & Design
$2,000 Award in Memory of
Meg Wohlberg
Illustration Academy Award

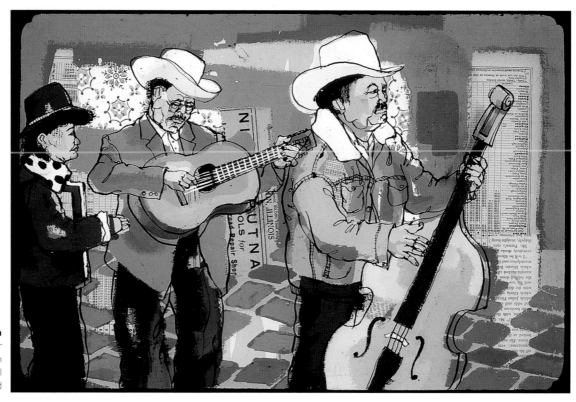

Cindy Eunyoung Kim
Jim Heimann, Instructor
Art Center College of Design
$2,000 The Norman Rockwell
Museum at Stockbridge Award

Leila Lee
Christian Clayton,
Instructor
Art Center College
of Design
$2,000 The Greenwich
Workshop Award
Illustration Academy
Award

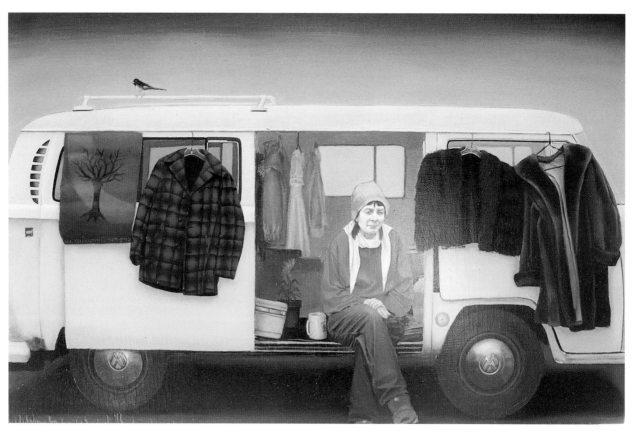

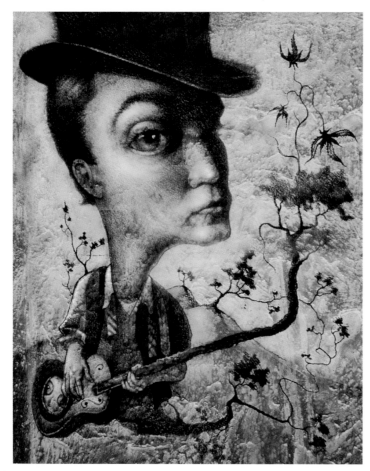

Ben Nettles
Shawn Barber, Instructor
Ringling School of Art & Design
$2,000 Albert Dorne Award

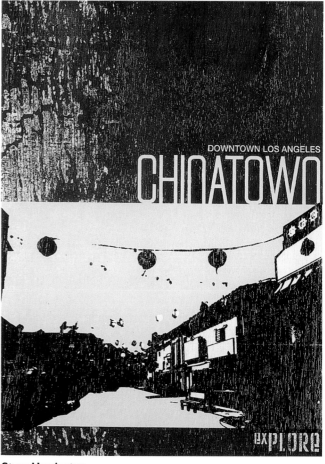

Steve Harrington
Tony Zepeda, Instructor
Art Center College of Design
$2,000 Award in Memory of Helen Wohlberg

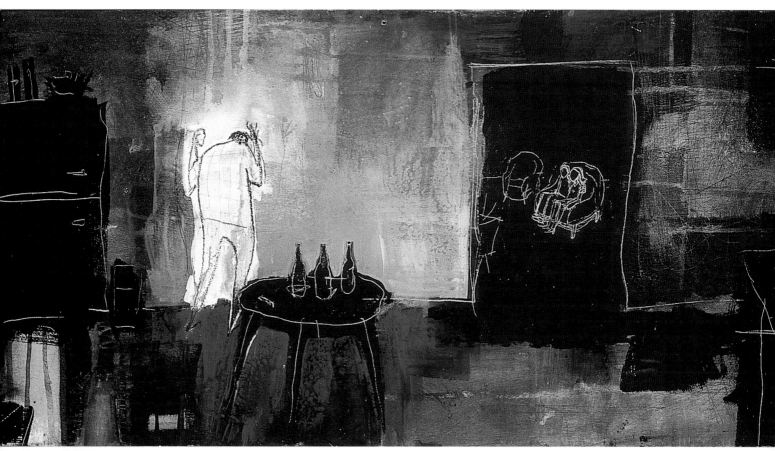

Souther Salazar
Jason Holley, Instructor
Art Center College of Design
$2,000 Award in Memory of Herman Lambert

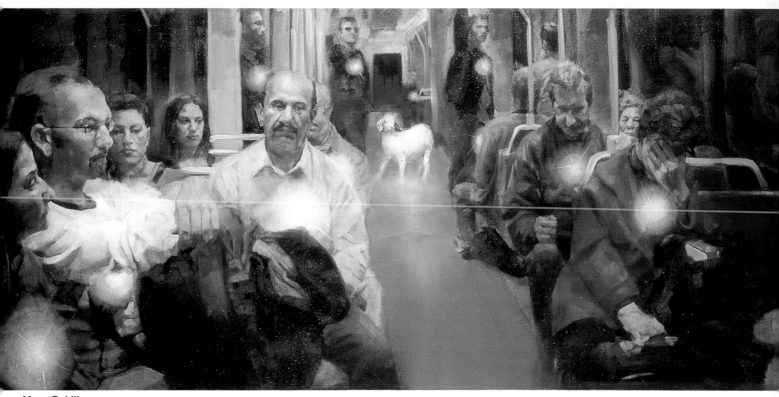

Maya Gohill
William Maughan, Instructor
Academy of Art College
$1,500 Award in Memory of Alan Goffman

Julia Rothman
Robert Brinkerhoff, Instructor
Rhode Island School of Design
$1,000 The Norma Pimsler Award

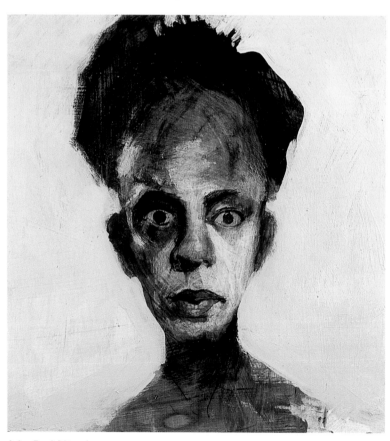

John Paul Altamira
David Mocarski, Instructor
Art Center College of Design
$1,500 Kirchoff/Wohlberg Award
in Memory of Frances Means

Brian O.B. Solinsky
Marvin Mattelson/Steve Assel, Instructors
School of Visual Arts
$2,000 Jellybean Photographics Award

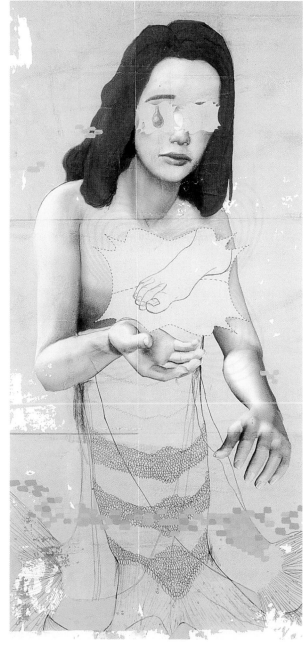

Levon Jihanian
Robert Clayton, Instructor
Art Center College of Design
$1,000 Award in Memory of
Harry Rosenbaum

Justin Wood
Jason Holley, Instructor
Art Center College of Design
$1,500 Kirchoff/Wohlberg Award in
Memory of Helen Wohlberg Lambert

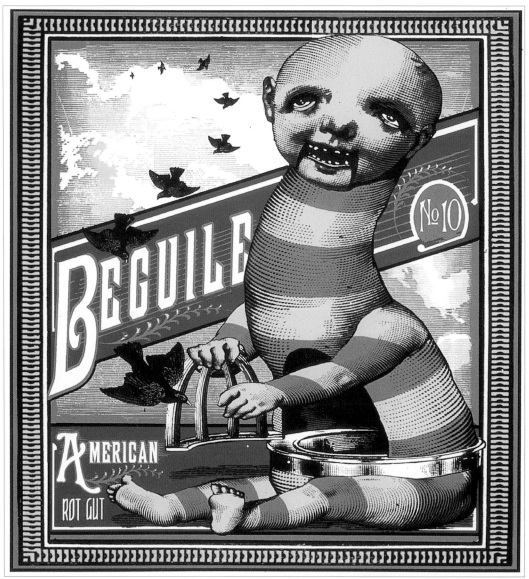

A. J. Finlayson
Les Kanturek, Instructor
Parsons School of Design
$1,500 Jellybean Photographics Award

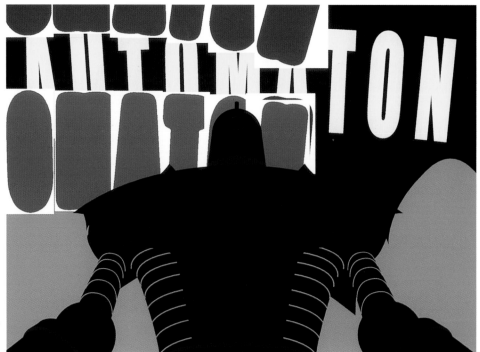

Matt Moore
Nick Jainschigg, Instructor
Rhode Island School of Design
$1,000 Dick Blick Art Materials Award

Oksana A. Badrak
David Mocarski, Instructor
Art Center College of Design
$1,000 Award in Honor of David
Passalacqua

Ann Smith
Robert Brinkerhoff, Instructor
Rhode Island School of Design
$1,000 Dick Blick Art Materials Award

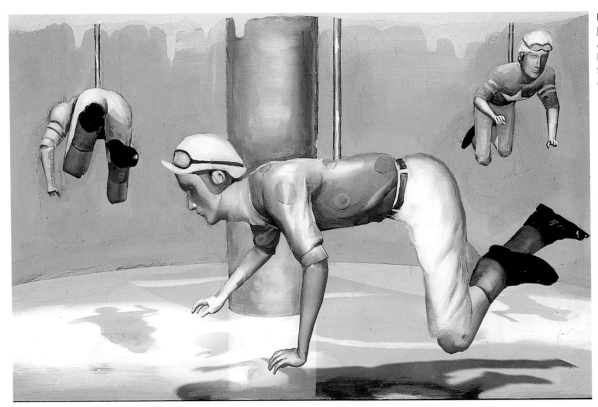

Erik Sandberg
Jeff Smith, Instructor
Art Center College of
Design
$1,000 The Illustration
Conference Award

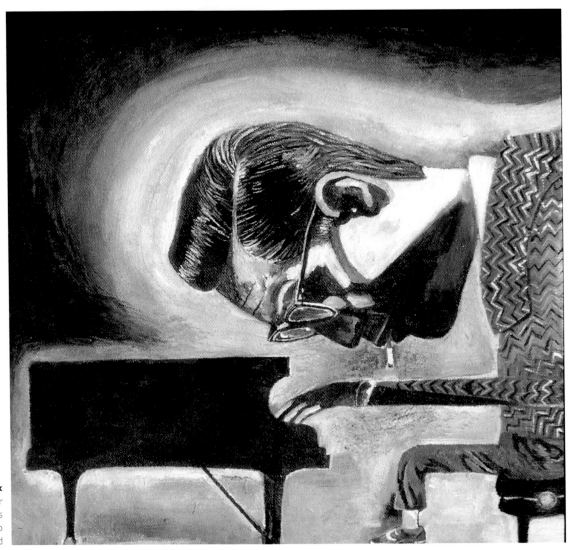

A. J. Halbrook
Barry Fitzgerald, Instructor
University of Kansas
$1,000 Illustrators Partnership
of America Award

Michael Loreti
Larry Kresek, Instructor
Rocky Mountain College of Art & Design

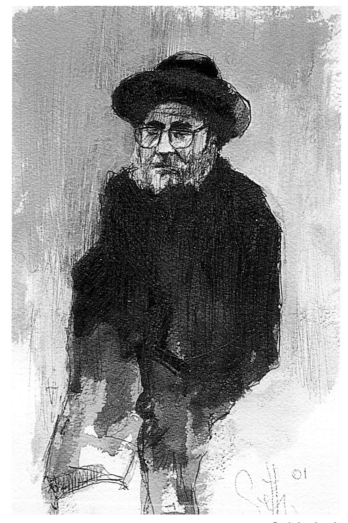

Seth Lockard
Robert Olson, Instructor
Pikes Peak Community College

Mike Naples
Rich Kryczka, Instructor
American Academy of Art

Victoria Perno
Earl Bradley Lewis, Instructor
University of the Arts

Kris Chau
Ken Rignall, Instructor
California College of Arts & Crafts

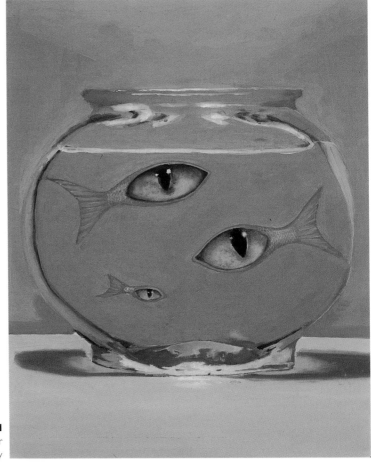

Nathaniel E. Gold
Kam Mak, Instructor
Fashion Institute of Technology

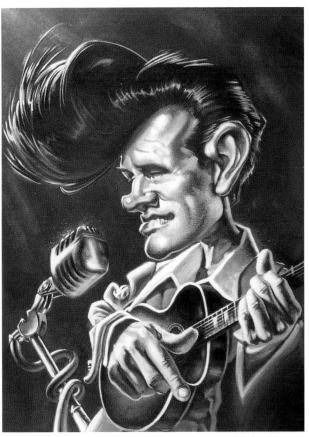

Michael Lovell
Gil Ashby, Instructor
College For Creative Studies

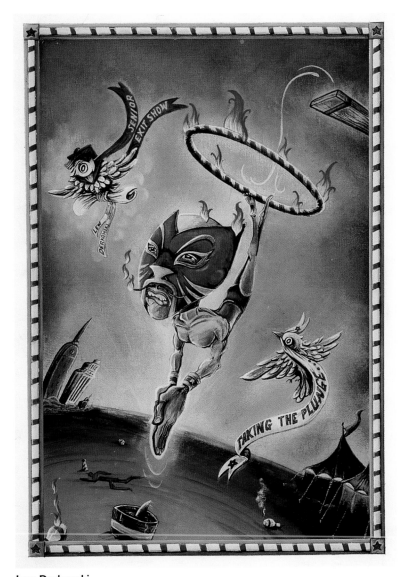

Lew Derkowski
Marc Burckhardt, Instructor
Southwest Texas State University

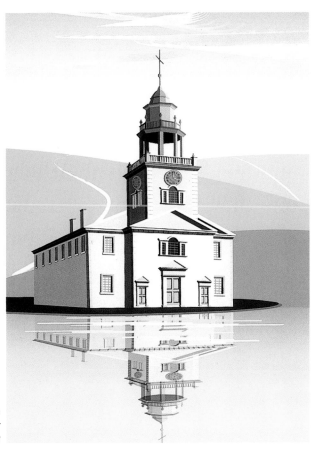

Hueng Min
Dennis Dittrich, Instructor
New Jersey City University

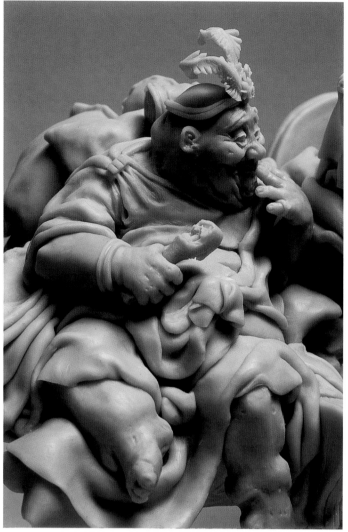

Scott W. Hahn
Mike Hodges, Instructor
Ringling School of Art & Design

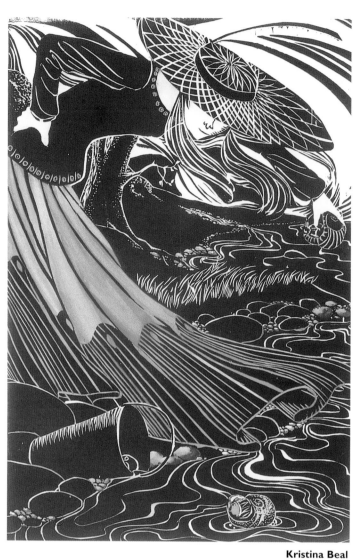

Kristina Beal
Kate Gorman, Instructor
Columbus College of Art & Design

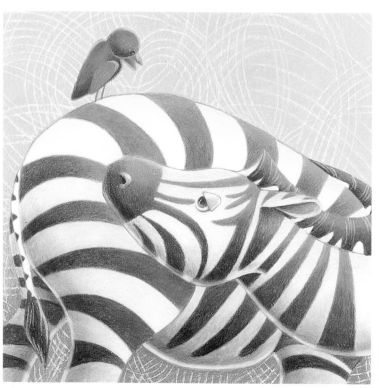

Brittin Asbury
Barry Fitzgerald, Instructor
University of Kansas

INDEX

ARTISTS

Adams, Lisa, 454, 456
40 Harrison St.
New York, NY 10013
212-385-8189
lisadams@aol.com

Adel, Daniel, 64, 65, 70
56 West 22nd St. 8th Fl.
New York, NY 10010
212-989-6114
www.danieladel.com

Adler, Steven, 449
130 Fodderstack Rd.
Washington, VA 22747
540-675-2355
800-789-9389
stevenkenny@earthlink.net

Ajhar, Brian, 233, 242, 310
P.O. Box 521
333 Lower Seese Hill Rd. RD#1
Canadensis, PA 18325
570-595-3782
brian@ajhar.com

Akiyama, Takashi, 290, 292, 423
3-14-35 Shimo-Ochiai
Shinjuku-ku
Tokyo, 161-0033
JAPAN
81-3-3565-4316
akiyama@t3.rim.or.jp

Andreasson, Tomas, 423
310 East 85th St. #3B
New York, NY 10028
212-774-1891
tomas@graphicpunch.com

Andresen, Mark, 276, 441
6417 Gladys St.
Metairie, LA 70003
504-888-1644
andresenm@aol.com

Arnow, Robert, 298
370 4th Ave.
San Francisco, CA 94118
415-752-2240
www.robarnow.com

Arrasmith, Patrick, 202
309 6th St. #3
Brooklyn, NY 11215
718-499-4101
www.patrickarrasmith.com

Ascencios, N., 255
382 Jefferson St.
Brooklyn, NY 11237
718-386-1240
ascencios@hotmail.com

Ashby, Gil, 344
20100 Sorrento
Detroit, MI 48235
313-861-5906
gashby@ccscad.edu

Baker, Joe, 277
555 Asylum St. #102
Hartford, CT 06105
800-484-2282 x1956
www.joebaker.net

Ballard, Lee, 340
514 Galland St.
Petallma, CA 94952
707-775-4723
lee@nillo.com

Banyai, Istvan, 107, 130, 133
666 Greenwich St. #420
New York, NY 10014
212-627-2953
istvan@rcn.com

Baranski, Marcin, 480
c/o The Artworks
70 Rosaline Rd.
London, SW6 7QT
ENGLAND
(0) 207-610-1801
www.theartworksinc.com

Baseman, Gary, 30, 303, 393, 419, 420
257 South Lucerne Blvd.
Los Angeles, CA 90004
323-934-5567
basemanart@earthlink.net

Beards, Richard, 134
89 Ave. Gambetti
Paris, 75020
FRANCE
331-4636-5174

Beauregard, Christiane, 392
2324 Sainte-Cunegonde
Montreal, Quebec H3J 2W3
CANADA
514-935-6794
c.beauregard@videotron.ca

Beck, Melinda, 121
536 5th St. #2
Brooklyn, NY 11215
718-499-0985
www.melindabeck.com

Becker, Polly, 151, 352, 459
258 Shawmut Ave. #5
Boston, MA 02118
617-426-8284
pollybecker@yahoo.com

Begin, Mary Jane, 229, 230
3 Hidden St.
Providence, RI 02906
401-421-2344
mjbegin@earthlink.net

Bejar, Daniel, 89
P.O. Box 903
Vails Gate, NY 12584
845-565-7604
dabejar@hotmail.com

Bennett, James, 48, 63, 324, 463, 464
5821 Durham Rd.
Pipersville, PA 18947
215-766-2134
jamesbennettart@home.com
represented by Richard Solomon
212-223-9545

Benny, Mike, 176, 345
11703 Uplands Ridge Dr.
Austin, TX 78738
512-263-5490
mbenny@austin.rr.com

Benoit, 126
c/o Riley Illustration
155 West 15th St. #4C
New York , NY 10011
212-989-8770

Billout, Guy, 123, 124, 138,
380 Rector Pl. #4M
New York, NY 10280
212-431-6350

Bischel, Mark, 131
228 East 85th St. #10D
New York, NY 10028
212-717-9811
mlbischele@yahoo.com

Black, Jack, 482, 483
295 St. John's Pl. #3G
Brooklyn, NY 11238
718-783-8994

Blau, Aljoscha, 154
Grindelallee 149
Hamburg, 20146
GERMANY
49-40-41497781
blau.ali@gmx.net

Blitt, Barry, 35, 58
176 Riverside Ave.
Riverside, CT 06878
203-698-2983
barryblitt@aol.com

Bloch, Serge, 27
c/o Marlena Agency
145 Witherspoon St.
Princeton, NJ 08542
609-252-9405
www.marlenaagency.com

Bollinger, Peter, 315
c/o Shannon Associates
333 West 57th St. #810
New York, NY 10019
212-333-2551
simon@shannonassociates.com

Bower, Tim, 39, 40, 99, 325
61 Pearl St. #306
Brooklyn, NY 11201
718-834-8974

Bowers, David, 448
206 Arrowhead Lane
Eighty-Four, PA 15330
724-942-3274
www.dmbowers.com

Brinley, David, 450
122 West Mill Station Dr.
Newark, DE 19711
302-731-9485
www.davidbrinley.com

Brodner, Steve, 17, 53, 61, 125
120 Cabrini Blvd. #116
New York, NY 10033
212-942-7139
www.stevebrodner.com

Buchanan, Steve, 372
317 Colebrook Rd.
Winsted, CT 06098-2225
860-379-5668
steve@stevebuchanan.com

Burckhardt, Marc, 83, 86, 362, 416, 417
112 West 41st St.
Austin, TX 78751
512-458-1690
marc@marcart.net

Burke, Jim, 339
140 Guernsey St. #2L
Brooklyn, NY 11222
718-383-7621
jimburkeart@aol.com

Cabry, Cyril, 363
c/o Marlena Agency
145 Witherspoon St.
Princeton, NJ 08542
609-252-9405
www.marlenaagency.com

Carlotta, 291
c/o KPDP Carole Glass
1 Rue Du Louvres
Paris, 75001
FRANCE
33-1-42-61-50-11

Carver, Morgan, 437
2421 South Santa Fe Ave. #20
Los Angeles, CA 90058
323-588-9940

Chan, Harvey, 474, 475
2 Clinton Pl.
Toronto, Ontario M6G 1J9
CANADA
416-533-6658
harveychan@on.aibn.com

Chang, Michelle, 426, 453
36 3rd St. #4L
Brooklyn, NY 11231
718-797-4427
www.theispot.com/artist/mchang

Chang, Warren, 182
3645 Middle Two Rock Rd.
Petaluma, CA 94952
707-766-7510
www.warrenchang.com

Chermayeff, Ivan, 326
15 East 26th St. 12th Fl.
New York, NY 10010
212-532-4499
ic@cgnyc.com

Chin, Marcos, 20, 401, 403
c/o Anna Goodson Management
514-983-9020
www.agoodson.com

Chwast, Seymour, 15
18 East 16th St. 7th Fl.
New York, NY 10003
212-255-6456
seymour_chwast@pushpininc.com

Cigliano, Bill, 238, 335
1525 West Glenlake Ave.
Chicago, IL 60660
773-973-0062
billcigliano@billcigliano.com

Clarke, Greg, 21, 103, 111, 208, 327
c/o Artworks USA, Inc.
455 West 23rd St. #8D
New York, NY 10011
212-366-1893
sally@theartworksinc.com

Clayton, Christian, 85
3235 San Fernando Rd.
Bldg. #1 Unit E
Los Angeles, CA 90065
323-478-0800

Collier, John, 435, 436
2500 Creek Cove
Plano, TX 75074
972-424-5791
jcoll28626@home.com
represented by Richard Solomon
212-223-9545

Colón, Raúl, 217
43-C Heritage Dr.
New City, NY 10956
845-639-1505

Combs, Jonathan, 406
18430 SE 279th Pl.
Covington, WA 98042
253-631-4822
acecombs@aol.com

Cornelius, Ray-Mel, 268
1526 Elmwood Blvd.
Dallas, TX 75224
214-946-9405
rmbc@earthlink.net

Corvino, Lucy, 172
111 Brookfield Ave.
Nutley, NJ 07110
973-667-1036
www.mypaintbrush.com

Cosentino, Carlo, 491
573 Cherrier St.
Ile. Bizard, Quebec H9E 1J7
CANADA
514-620-8912
www.carlocosentino.com

Couch, Greg, 218, 219, 220
47 2nd Ave.
Nyack, NY 10960
843-358-9353
gcrsesc@earthlink.net

Cox, Paul, 487
Twytten House
Wilmington
East Sussex, BN265SN
ENGLAND
44-132-387-1264
represented by Richard Solomon
212-223-9545

Craig, Daniel, 235
118 East 26th St. #302
Minneapolis, MN 55404
612-871-4539
dan@portogo.net

Creatink, 271, 461
270 5th St. #1H
Brooklyn, NY 11215
718-832-7720
y@creatink.com

Cronin, Brian, 19, 118, 120, 132
59 West 12th St. #8H
New York, NY 10011
212-727-9539
www.briancronin.com

Cuneo, John, 73, 74
18 Elting Lane
Bearsville, NY 12409
845-679-7973

Dalrymple, Farel, 1
P.O. Box 2045
New York, NY 10009
347-661-7467
farelkahn@yahoo.com

Davidson, Andrew, 196, 197, 198
Moors Cottage, Swells Hill, Burleigh
Stroud
Gloucestershire, 9L5 2SP
ENGLAND
44-1453-884650

Davis, Jack E., 239
1336 14th St.
Port Townsend, WA 98368
360-344-4365
www.hkportfolio.com

de Sève, Peter, 54, 102, 189, 190, 306
25 Park Pl.
Brooklyn, NY 11217
718-398-8099
deseve@earthlink.net

Dearth, Gregory Montfort, 376
4041 Beal Rd.
Franklin, OH 45005
937-746-5970
gmdearth@gemair.com

Delessert, Etienne, 115, 145, 223, 232
P.O. Box 1689
Lakeville, CT 06039
860-435-0061

Descartes, Jan, 101
45-04 30th Ave. 2nd Fl.
Astoria, NY 11103
917-887-1460
jandescartes@hotmail.com

DeVito, Grace, 373
27 Burwood Ave.
Stamford, CT 06902
203-975-7447
gracepaints@aol.com

Dicke, Matt, 4
173 Lafayette St. #401
New York, NY 10013
212-431-0594
www.mattdicke.com

Dingman, Alan, 442, 472
c/o Levy Creative Management
300 East 46th St. #8E
New York, NY 10017
212-687-6463
www.levycreative.com

Drawson, Blair, 82, 348
14 Leuty Ave.
Toronto, Ontario M4E 2R3
CANADA
416-693-7774

Dreany, Matt, 293
20-27 120th St.
College Point, NY 11356
718-939-9557
matt@margaritagirl.com

DuBois, Gerard, 16, 41, 42, 43
c/o Marlena Agency
145 Witherspoon St.
Princeton, NJ 08542
609-252-9405
www.marlenaagency.com

Duvivier, Jean-Manuel, 300, 402
31 Rue de Venise
Brussels, 1050
BELGIUM
00-322-648-05-12
jmduvivier@skynet.be

Eberhardt, Melanie, 452
740 Charles Cox Dr.
Canton, GA 30115
770-345-7999
www.meportfolio.com

Elwell, Tristan, 139
197 Main St.
Cold Spring, NY 10516
845-265-5207

Emanuel, Brett, 440
1212 West 8th St.
Kansas City, MO 64101
913-485-7490
eman@kc.rr.com

Enos, Randall, 51
402 North Park Ave.
Easton, CT 06612
203-445-8376
renos@optonline.net

Evans, Christopher, 141
48 South Clinton Ave.
Bay Shore, NY 11706
631-969-1704
cevansart.com/~tcevans

Fancher, Lou, 165, 168
440 Sheridan Ave. South
Minneapolis, MN 55405
612-377-8728

Fanelli, Sara, 384, 404
c/o Riley Illustration
155 West 15th St. #4C
New York, NY 10011
212-989-8770
teresa@rileyillustration.com

Farrell, Richard, 466
4642 North Frace St.
Tacoma, WA 98407
253-752-8814
www.rbfarrell.com

Farrell, Russell, 236
136 Mercer Ave.
Woodbury Heights, NJ 08097
856-848-9236

Fennimore, Linda, 246
808 West End Ave. #801
New York, NY 10025
212-866-0279

Fiedler, Joseph Daniel, 337
154 Vista Del Valle
Ranchos De Taos, NM 87557
505-737-5498
fiedler@scaryjoey.com

Fiore, Peter, 221
1168 Delaware Dr.
Matamoras, PA 18336
570-491-2610
www.peterfiore.com

Fisher, Jeffrey, 135, 390, 395, 396
c/o Riley Illustration
155 West 15th St. #4C
New York, NY 10011
212-989-8770
teresa@rileyillustration.com

Fluharty, Tom, 69
2704 180th St. East
Prior Lake, MN 55372
952-226-2646
www.levycreative.com

Forbes, Bart, 333
5510 Nakoma Dr.
Dallas, TX 75209
214-357-8077
www.bartforbes.com

Ford, Walton, 137
26 East Hill Rd.
Southfield, MA 01259
413-528-4496

Fraser, Douglas, 22, 97, 412
1161 Camrose Crescent
Victoria, BC V8P 1M9
CANADA
250-385-4881
doug@fraserart.com

Frazier, Craig, 14, 105, 388, 389, 478
90 Throckmorton Ave. #28
Mill Valley, CA 94941-1926
415-389-1475
www.craigfrazier.com

Frazier, Jim, 113, 400, 476, 477, 479
221 Lakeridge Dr.
Dallas, TX 75218
214-340-9972

French, Martin, 355
69425 Deer Ridge Rd.
Sisters, OR 97759
541-549-4969
martino@teleport.com

Fuchs, Bernie, 184
3 Tanglewood Lane
Westport, CT 06880
203-227-4644
alhf99@aol.com

Gall, Chris, 413
4421 North Camino del Santo
Tucson, AZ 85718
520-299-4454
chris@chrisgall.com

Giacobbe, Beppe, 166
c/o Morgan Gaynin Inc.
194 3rd Ave. 3rd Fl.
New York, NY 10003
212-475-0440
www.morgangaynin.com

Gibson, Melissa J., 467
226 Spruce St.
Emmaus, PA 18049
610-966-4098
tomthumb5@aol.com

Goodrich, Carter, 25
3021 Silver Lea Terrace
Los Angeles, CA 90039
323-644-8909

Gore, Leonid, 167
1429 Dahill Rd. Apt. A
Brooklyn, NY 11204
718-627-4952
www.hkportfolio.com

Gotoh, Masao, 164
3-15-8 Simoochiai Sinjukuku
Tokyo, 161-0033
JAPAN
81-3-3953-7085
mgotoh@ma5.justnet.ne.jp

Grethen, Donna M., 445, 447
2312 Roosevelt Ave.
Berkeley, CA 94703
510-644-0596

Guarnaccia, Steven, 24, 32, 100
31 Fairfield St.
Montclair, NJ 07042
973-746-9785
sguarnaccia@hotmail.com

Haake, Martin, 129
c/o Lindgren & Smith
250 West 57th St. #521
New York, NY 10107
212-397-7330
mail@martinhaake.de

Hale, Phil, 33
25A Vyner St.
London, E29DG
ENGLAND
44-208-981-1214
melegrau@zoom.co.uk

Hall, Joan, 446
155 Bank St. #H954
New York, NY 10014
212-243-6059
jhcollage@aol.com

Hanuka, Tomer, 127, 128, 152
449 Grand St. #2L
Brooklyn, NY 11211
718-963-3383
www.thanuka.com

Harlin, Greg, 183
19 Pinewood St.
Annapolis, MD 21401
410-266-6550
gregharlin@toad.net

Harrington, Glenn, 180, 185
329 Twin Lear Rd.
Pipersville, PA 18947
610-294-8104

Hartland, Jessie, 301, 398
165 William St.
New York, NY 10038
212-233-1413
www.jessiehartland.com

He, Diren, 374, 375
12725 West 116th St.
Overland Park, KS 66210
913-345-2359
direnh@yahoo.com

Heilig, Martijn, 280
1331 Amherst Ave. #6
Los Angeles, CA 90025
310-442-1098
mrheilig@aol.com

Helton, Linda, 359
7000 Meadow Lake
Dallas, TX 75214
214-319-7877

Hewgill, Jody, 76, 262, 263, 286
260 Brunswick Ave.
Toronto, Ontario M5S 2M7
CANADA
416-924-4200
www.jodyhewgill.com

Hinds, Gareth, 6
617-625-6468
gareth@thecomic.com

Hirschfeld, Al, 78
c/o Margo Feiden Gallery
699 Madison Ave.
New York, NY 10021
212-677-5330

Ho, David, 272
3586 Dickenson Common
Fremont, CA 94538
510-656-2468
www.davidho.com

Hoey, Peter and Maria, 23
1534 Waller St.
San Francisco, CA 94117
415-431-1069
hoeyart@earthlink.net

Hoffman, Eugene, 414, 415
521 Mt. Harvard Rd.
Livermore, CO 80536
970-416-9854

Holland, Brad, 92, 94, 95, 274, 332
96 Greene St.
New York, NY 10012
212-226-3675
brad-holland@erols.com

Hollenbach, David, 328
c/o Frank Sturges
142 West Winter St.
Delaware, OH 43015
740-369-9702
www.sturgesreps.com

Holley, Jason, 242, 317, 319, 320
391 West Grandview Ave.
Sierra Madre, CA 91024
626-836-7700

Howard, John H., 212, 425, 484, 485, 486
115 West 23rd St. #43A
New York, NY 10011
212-989-4600
www.newborngroup.com

Hughes, David, 75
c/o Gerald & Cullen Rapp, Inc.
108 east 35th St. 1st Fl.
New York, NY 10016
212-889-3337

Huliska-Beith, Laura, 209
443 Greenway Terrace
Kansas City, MO 64113
816-333-6647
www.hkportfolio.com

Hull, Richard, 489, 490
73 West 1435 South
Orem, UT 84058
801-223-0147
hullr@byugate.byu.edu

Hundley, Sterling, 47, 468
1 North 5th St. #403
Ricmond, VA 23219
804-644-2034
www.sterlinghundley.com

Hurst, Margaret, 203, 204
531 East 78th St. #1E
New York, NY 10021
212-988-6952

Ibatoulline, Bagram, 173
282 Barrow St.
Jersey City, NJ 07302
201-332-5889

Ilic, Mirko, 45, 341
207 East 32nd St.
New York, NY 10016
212-481-9737

Ingpen, Robert, 188
29 Parker St.
Anglesea, Victoria 3230
AUSTRALIA
0061-35263-3699

Isip, Jordin, 275, 283
536 5th St. #2
Brooklyn, NY 11215
718-499-0985
www.jordinisip.com

Jarrie, Martin, 44
c/o Marlena Agency
145 Witherspoon St.
Princeton, NJ 08542
609-252-9405
www.marlenaagency.com

Jaynes, Bill, 278, 299
2818 Knoxville Ave.
Long Beach, CA 90815
562-420-7209
www.billjaynes.com

Jenkins, Steve, 222
1627 5th St.
Boulder, CO 80302
303-939-9748

Jeram, Anita, 225
Mullaghdubh House
27 Gobbins Path
Island Magee, Larne BT 40 3SP
NORTH IRELAND
44-2893-373933

Jetter, Frances, 90, 146
2211 Broadway #3KN
New York, NY 10024
212-580-3720
www.fjetter.net

Johnson, David, 116
P.O. Box 82
New Caanan, CT 06840
203-966-3269
davidaj@iopener.net
represented by Richard Solomon
212-223-9545

Johnson, Steve, 165, 168
440 Sheridan Ave. South
Minneapolis, MN 55405
612-377-8728

Joyce, William, 241
3302 Centenary Blvd.
Shreveport, LA 71104
318-869-0180
wjoyce@williamjoyce.com

Juhasz, Victor, 191, 192
576 Westminster Ave.
Elizabeth, NJ 07208
908-351-4227
victorjuhasz@att.net

Kelley, Gary, 93, 178, 258, 354, 465
226 1/2 Main St.
Cedar Falls, IA 50613
319-277-2330
represented by Richard Solomon
212-223-9545

Kim, Cindy Eun Young, 469
149 South Los Robles St. #315
Pasadena, CA 91101
626-584-5862
cindykim71@yahoo.com

Kimber, Murray, 224
817 Baker St.
Nelson, BC V1L 4J8
CANADA
250-352-6722
kimber_mex@hotmail.com
represented by Richard Solomon
212-223-9545

Kimura, Hiro, 351
237 Windsor Pl.
Brooklyn, NY 11215
718-788-9866
hiro@hirostudio.com

Korsak, Mark, 248
53 West 19th St. #16
New York, NY 10011
212-741-1673
mckorsak@aol.com

Krepel, Dick, 156, 243, 279, 285, 287, 443
869 Warnell Dr.
Richmond Hill, GA 31324
912-727-3368
rkrepel@coastalnow.net

Kroencke, Anja, 377, 378
129 Grand St. #2
New York, NY 10013
212-343-0341
missanja@earthlink.net

Kunz, Anita, 56, 62, 114
218 Ontario St.
Toronto, Ontario M5A 2V5
CANADA
416-364-3846
www.anitakunz.com

Kuper, Peter, 26, 31
235 West 102nd St. #11J
New York, NY 10025
212-932-1722
kuperart@aol.com

Lagarrigue, Jerome, 431
503 Atlantic Ave. #5R
Brooklyn, NY 11217
718-596-2791
jeromelagarrigue@aol.com

Laumann, Scott, 50, 122
108 East 35th St.
New York, NY 10016
212-889-3337
www.scottlaumann.com

Lee, Jae, 7, 8, 9
150 West 56th St. #3306
New York, NY 10016
212-265-2345
jaelee@aol.com

Lee, Jared, 240
2942 Hamilton Rd.
Lebanon, OH 45036
513-932-2154
jaredlee@go-concepts.com

Lessard, Marie, 471
4641 Hutchison
Montreal, Quebec H2V 4A2
CANADA
514-272-5696
www.marielessard.com

Levine, Laura, 11
444 Broome St.
New York, NY 10013
212-431-4787
LauraL6000@aol.com

Lillash, Rich, 394
c/o Frank Sturges
142 West Winter St.
Delaware, OH 43015
740-369-9702
www.sturgesreps.com

Lim, Daniel, 29
5357 Lemon Grove Ave. #8
Los Angeles, CA 90038
323-461-9663
ytcc@hotmail.com

Livingston, Francis, 428, 429
110 Elderberry Lane
Bellevue, ID 83313
208-788-1978

Logrippo, Robert, 411
106 Brydon Ct.
Simpsonville, SC 29680
864-963-7878

Lopez, Rafael, 281, 289
843 10th Ave. Suite C
San Diego, CA 92101
619-237-8061
www.rafaellopez.com

Low, William, 216
144 Soundview Rd.
Huntington, NY 11743
631-421-5859
www.williamlow.com

Lynch, Jason, 304
1200 South Oneida St. #13-205
Denver, CO 80224
720-291-2836
jsnlynch@aol.com

MacDonald, Ross, 46, 136
56 Castle Meadow Rd.
Newtown, CT 06470
203-270-6438
brightwork@earthlink.net

Maggard, John P., 305
102 Marian Lane
Terrace Park, OH 45174
513-248-1550
jpmagg3@fuse.net

Mahoney, Katherine, 382
60 Hurd Rd.
Belmont, MA 02478
617-868-7877
kmahoney17@earthlink.net

Mak, Kam, 171
369 Sackett St.
Brooklyn, NY 11231
718-624-6173
kammak@mac.com

Malone, Peter, 247
c/o The Artworks
70 Rosaline Rd.
London, SW6 7QT
ENGLAND
(0) 207-610-1801
www.theartworksinc.com

Manchess, Gregory, 181, 186
13358 SW Gallop Ct.
Beaverton, OR 97008
503-590-5447
represented by Richard Solomon
212-223-9545

Mattos, John, 261
1546 Grant
San Francisco, CA 94133
415-397-2138

Mayer, Bill, 308, 309, 311, 421, 422
240 Forkner Dr.
Decatur, GA 30030
404-378-0686
bill@thebillmayer.com

McCauley, Adam, 199
1081 Treat Ave.
San Francisco, CA 94110
415-826-5668
adam@atomicalley.com

McConnell, Mike, 462
6 Seven Springs Ct.
Phoenix, MD 21131-1542
410-527-0055
mike@wetinc.com

McKean, Dave, 13, 148, 266, 273, 330
c/o Allen Spiegel Fine Arts
221 Lobos Ave.
Pacific Grove, CA 93950
831-372-4672
asfa@redshift.com

McKowen, Scott, 88, 257, 313, 323
428 Downie St.
Stratford, Ontario N5A 1X7
CANADA
519-271-3049
mckowen@sympatico.ca

McMahon, Mark, 379, 407
321 South Ridge Rd.
Lake Forest, IL 60045
847-295-2604
www.mcmahonartgallery.com

McMullan, James, 49, 252, 253
207 East 32nd St.
New York, NY 10016
212-689-5527
mcmullanstudio@aol.com

Miller, David, 244
195 Chrystie St. #803C
New York, NY 10002
212-477-4576
inkomil@yahoo.com

Minor, Wendell, 237, 371
P.O. Box 1135
15 Old North Rd.
Washington, CT 06793
860-868-9101
www.minorart.com

Moeller, Christopher, 10
210 Parkside Ave.
Pittsburgh, PA 15228
412-531-3629
www.cmoeller.com

Moore, Larry, 250, 282, 488
2440 Roxbury Rd.
Winter Park, FL 32789
407-222-8585
www.larrymooreillustration.com

Nascimbene, Yan, 144, 214, 215
235 East 7th St.
Davis, CA 95616
530-756-7076
www.yannascimbene.com

Navok, Hilla, 397
17 Kisufim St.
Tel-Aviv, 69355
ISRAEL
972-054-818227
go_hilla@hotmail.com

Nelson, Bill, 155
P.O. Box 579
Manteo, NC 27954
252-473-6181
represented by Richard Solomon
212-223-9545

Nelson, Kadir, 179, 249, 342, 347
P.O. Box 19067
San Diego, CA 92159
619-463-0619
www.kadirnelson.com

Neubecker, Robert, 96, 98, 307, 350, 365
505 East 3rd Ave.
Salt Lake City, UT 84103
801-531-6999
www.neubecker.com

Nobriga, Jason, 433, 434
94-217 Lumiaina Pl. #A102
Waipahu, HI 96797
808-381-9913
www.jasonnobriga.com

O'Brien, Tim, 36 , 160, 162
310 Marlborough Rd.
Brooklyn, NY 11226
718-282-2821
tonka1964@aol.com

Obermeyer, Ryan, 270
250 West 19th St. #4M
New York, NY 10011
212-741-6854
www.ryanobermeyer.com

Olbinski, Rafal, 245, 251, 334, 336
142 East 35th St.
New York, NY 10016
212-532-4328

Olivera, Ramon, 424
4836 West 76th St.
Prairie Village, KS 66208
913-381-8241
www.ramonolivera.com

Palencar, John Jude, 149, 150
6768 Middlebrook Blvd.
Middleburg Heights, OH 44130
216-676-8839
jjp33@core.com

Paquebot, 460
Flat 2, 40 Tisbury Rd.
Hove
East Sussex, BN3 3BA
ENGLAND
44-1273-771539
www.satoshi-illustration.com

Parada, Roberto, 52, 67, 68
c/o Levy Creative Management
300 East 46th St. #4G
New York, NY 10017
212-687-6463
www.levycreative.com

Parker, Ed, 360, 361
9 Carlisle St.
Andover, MA 01810
978-475-2659
edparkerstudio@mediaone.net

Parker, Robert Andrew, 140, 142
P.O. Box 114
22 River Rd.
West Cornwall, CT 06796
860-672-0152

Pauley, Lynn, 18
41 Union Square #814
New York, NY 10003
212-924-0881
pauleylynn331@hotmail.com

Payne, C.F., 37, 66, 71, 72, 175, 177
3600 Sherbrooke Dr.
Cincinnati, OH 45241
513-769-1172
represented by Richard Solomon
212-223-9545

Pham, Leuyen, 234
789 East California Blvd.
Pasadena, CA 91106
626-744-0646

Pin, Isabel, 153
Grindelallee 149
Hamburg, 20146
GERMANY
49-40-41-49-7781
isabel.p@gmx.net

Pinkney, Jerry, 174
41 Furnace Dock Rd.
Croton-on-Hudson, NY 10520
914-271-5238

Piven, Hanoch, 108, 109, 110
c/o Artworks USA, Inc.
455 West 23rd St. #8D
New York, NY 10011
212-366-1893
sally@theartworksinc.com

Potter, Giselle, 201
9 Sawdust Ave.
Kingston, NY 12401
856-658-3986

Pyle, Chris, 302, 399
35 North Wallace Ave.
Indianapolis, IN 46201
317-357-6015
cpyleart@aol.com

Pyle, Kevin C., 2
112 Maolis Ave.
Bloomfield, NJ 07003
973-680-1952
boatfire@erols.com

Ransome, James, 210
71 Hooker Ave.
Poughkeepsie, NY 12601
845-473-8281
www.jamesransome.com

Rodriguez, Edel, 34, 112, 119
16 Ridgewood Ave.
P.O. Box 102
Mt. Tabor, NJ 07878
973-983-7776
edelrodriguez@aol.com

Rubel, Sasha, 211
3421 North Marshfield
Chicago, IL 60657
773-525-3075
www.sasharubel.com

Ruzzier, Sergio, 228
346 Leonard St. #3
Brooklyn, NY 11211
718-383-1915
www.ruzzier.com

Salomon, Rachel, 91
1938 Mill Rd. Apt. C
South Pasadena, CA 91030
626-222-0780

Sano, Kazuhiko, 408
105 Stadium Ave.
Mill Valley, CA 94941
415-381-6377
kazusano@worldnet.att.net

Saunders, Robert, 157
45 Bartlett Crescent
Brookline, MA 02446
617-566-4464
rob@robertsaunders.com

Scarabottolo, Guido, 294, 380, 381
c/o Morgan Gaynin Inc.
194 3rd Ave. 3rd Fl.
New York, NY 10003
212-475-0440
www.morgangaynin.com

Sealock, Rick, 205, 206, 207
391 Regal Park NE
Calgary, Alberta T2E 0S6
CANADA
403-276-5428
www.ricksealock.com

Senoville, Tinou Le Joly, 364
c/o Marlena Agency
145 Witherspoon St.
Princeton, NJ 08542
609-252-9405
www.marlenaagency.com

Shapton, Leanne, 106
158 Argyle St.
Upper Toronto, Ontario M6J 1P3
CANADA
416-383-2358
shapton@saturdaynight.ca

Sheban, Chris, 169, 170, 213, 312
1856 Walters Ave.
Northbrook, IL 60062
847-412-9707

Sherman, Whitney, 284, 357, 409
5101 Whiteford Ave.
Baltimore, MD 21212
410-435-2095
ws@whitneysherman.com

Sienkiewicz, Bill, 5
93 Weed Ave. #4
Stamford, CT 06902
203-327-5189

Skarbovik, Lasse, 288, 391
Stora Nygatan 44
Stockholm, 111 27
SWEDEN
46-8-22-2433
www.stockholmillustration.com

Small, David, 143
25626 Simpson Rd.
Mendon,, MI 49072
616-496-7491

Smith, Douglas, 194, 195
34 Erie Ave.
Newton, MA 02461
617-558-3256
represented by Richard Solomon
212-223-9545

Smith, Laura, 259, 260, 481
6545 Cahuenga Terrace
Hollywood, CA 90068
323-467-1700
www.laurasmithart.com

Somers, Marti, 269
12 Trillium Lane
San Carlos, CA 94070
650-593-2738
www.martisomers.com

Sorel, Edward, 57
156 Franklin St.
New York, NY 10013
212-966-3949

Spalenka, Greg, 331, 418, 444
P.O. Box 884
Woodland Hills, CA 91365
818-992-5828
greg@spalenka.com

Stamaty, Mark Alan, 12
12 East 86th St. #1226
New York, NY 10028
212-396-0744
markstamaty@earthlink.net

Steadman, Ralph, 55
Old Loose Ct.
Loose Valley
Maidstone,
ENGLAND
44-162-274-5070
yfe80@dial.piper.com

Stermer, Dugald, 117
600 The Embarcadero
San Francisco, CA 91407
415-777-0110
www.dugaldstermer.com

Stonehouse, Fred, 84
8327 West Rogers St.
West Allis, WI 53219
414-327-7098

Stukuls, Derek Voldemars, 458
117 Sterling Pl. #16
Brooklyn, NY 11217
718-622-6609
stukuls@panix.com

Sturm, William C., 410
Box 175 Route 46
Budd Lake, NJ 07828
800-334-0345
www.sturmsart.com

Summers, Mark, 147, 193, 427
12 Milverton Close
Waterdown, Ontario L0R 2H3
CANADA
905-689-6219
represented by Richard Solomon
212-223-9545

Swearington, Greg, 163, 338
1955 NW Hoyt #G5
Portland, OR 97209
503-449-8998
gregswearingen@yahoo.com

Swift, Elvis, 473
756 8th Ave. South
Naples, FL 31402
941-403-9002
www.joaniebrep.com

Taback, Simms, 368
98 Hickory Rd.
Willow, NY 12495
845-688-2605

Tateyama, Kazushige, 265, 314
4-6. 20-702 Imafuku-minami
Jyoto-ku
Osaka, 536-0003
JAPAN
81-6-6933-2286
kazushige.tateyama@ata.co.jp

Tellok, Mark, 386
4361 de Bullion #101
Montreal, Quebec H2W 2G2
CANADA
514-288-6918
mail@marktellok.com

Thiel, Joe, 28
742 40th St.
Sarasota, FL 34234
941-355-1757
publisher@longwindpub.com

Thompson, Darren, 346
212 West 10th St. #B465
Indianapolis, IN 46204
317-972-4969
www.darrent.com

Thompson, John, 187, 438, 451
109 Euclid Terrace
Syracuse, NY 13210
315-426-0123
www.johnthompson-artist.com

Tinkelman, Murray, 343
75 Lakeview Ave. West
Cortlandt Manor, NY 10567
914-737-5960

Toelke, Cathleen, 158, 159, 161, 356
P.O. Box 487
Rhinebeck, NY 12572
845-876-8776
www.cathleentoelke.com

Triplett, Gina, 457
c/o Frank Sturges
142 West Winter St.
Delaware, OH 43015
740-369-9702
www.sturgesreps.com

Tyson, Sara, 256
12 Spring Lane
RR #2
Parry Sound, Ontario P2A 2W8
CANADA
705-378-0893
styson@vianet.on.ca

Ulriksen, Mark, 38, 80, 81
841 Shrader St.
San Francisco, CA 94117
415-387-0170
ulriksen@sirius.com

Unruh, Jack, 59, 60, 353, 369, 370
8138 Santa Clara Dr.
Dallas, TX 75218
214-327-6211
www.jackunruh.com

Ventura, Andrea, 77, 430
346 Leonard St. #2
Brooklyn, NY 11211
718-349-3131
andreaventura@earthlink.net
represented by Richard Solomon
212-223-9545

Ventura, Marco, 87
c/o Artworks USA, Inc.
455 West 23rd St. #8D
New York, NY 10011
212-366-1893
sally@theartworksinc.com

Villa, Roxana, 267
P.O. Box 884
Woodland Hills, CA 91365
818-992-0490
www.roxanavilla.com

Villarrubia, Jose, 5, 7, 8, 9
701 Cathedral St. #61
Baltimore, MD 21201
410-685-4890

Vitale, Stefano, 358
49 Sandy Hill Rd.
Oyster Bay, NY 11771
516-922-7130
stefanovitale@aol.com

von Ulrich, Mark, 387
c/o Riley Illustration
155 West 15th St. #4C
New York, NY 10011
212-989-8770
teresa@rileyillustration.com

Waldman, Bruce, 316, 367
18 Westbrook Rd.
Westfield, NJ 07090
908-232-2840
swgraphics@comcast.net

Watson, Esther Pearl, 79
1772 Route 21
Valatie, NY 12184
518-392-9263

Watson, Wendy, 227
73 Oak St. #100
Brattleboro, VT 05301
802-251-1060
wwatson@together.net

Weisbecker, Phillipe, 104, 383, 385, 405
c/o Riley Illustration
155 West 15th St. #4C
New York, NY 10011
212-989-8770
teresa@rileyillustration.com

Wesson, Andrea, 226
c/o Kirchoff/Wohlberg
866 United Nations Plaza #525
New York, NY 10017
212-644-2020
lford@kirchoffwohlberg.com

Wilkins, Sarah, 295, 296, 297
c/o Riley Illustration
155 West 15th St. #4C
New York, NY 10011
212-989-8770
teresa@rileyillustration.com

Wilson, Russ, 254
2215 South 3rd St. #201-C
Jacksonville Beach, FL 32250
904-249-0060
www.russwilson.com

Wilton, Nicholas, 366, 439
220 Alta Ave.
P.O. Box 292
Lagunitas, CA 94938
415-488-4710
nick@zocolo.com

Woods, Noah, 329
927 Westbourne Dr.
Los Angeles, CA 90069
310-659-0259
www.theispot.com/artist/woods

Wormell, Chris, 318, 321, 322
c/o The Artworks
70 Rosaline Rd.
London, SW6 7QT
ENGLAND
(0) 207-610-1801
www.theartworksinc.com

Wright, Jenny Tylden, 200
c/o Alan Lynch Artists' Rep.
11 Kings Ridge Rd.
Long Valley, NJ 07853
908-813-8718

Wright, Ted, 264
4237 Hansard Lane
Hillsboro, MO 63050
636-797-4264
www.tedwright.com

Yeo, Brad, 455
602 8th Ave. NE
Calgary, Alberta T2E 0R6
CANADA
403-237-5553
www.bradyeo.com

Yucel, 349
270 5th St. #1H
Brooklyn, NY 11215
718-832-0665
yucel@rcn.com

Zakroczemski, Daniel, 470
168 Olean St.
East Aurora, NY 14052
716-849-4168

Zezelj, Daniel, 3
512 NW 44th St.
Seattle, WA 98107
206-782-9070

ART DIRECTORS

Abatemarco, Dean, 85
Ackerman, Tom, 106
Adamec, Matt, 217
Albert, Donna, 355
Alonso, Meghan, 409
Anderson, Gail, 45, 49, 50, 51, 53
Andrews, Barbara, 255
Aquan, Richard, 158, 195
Astram, Dawn, 360
Bade, Tim, 376
Baker, Ken, 303
Baldwin, Tim, 17
Baur, Elisa, 104
Bean, Mary Ann, 27
Beard, Dawn, 238
Beauchamp, Monte, 11, 21, 22, 23, 24, 31
Beeke, Anthon, 354
Benoit, Dennis, 369, 370
Bernadou, Shawn, 94
Bertalotto, Daniel, 60
Besser, Rik, 327, 362
Bessie, Ken, 205, 206, 207
Beyn, Bob, 345
Bida, Aimee, 129
Bierhorst, Jane Byers, 227
Binder, Lynn, 172
Binsztok, Jacques, 144, 214, 215
Bliss, Pam, 295, 296, 297
Bluming, Jill, 278
Bologna, Matteo, 166
Boucher, Brian, 236
Box, Sharon, 280
Bragdon, Kelly, 277
Brockway, Annie, 10
Bronnenkant, Karen, 389
Browne, Jennifer, 184
Buckley, Paul, 196, 197, 198
Burke, Jim, 422
Campisi, Ronn, 358
Cetta, Al, 171, 183, 241
Chu, Chris, 352
Cimmino, Craig, 259
Clark, Chris, 185
Clark, Deborah, 361
Cohen, Elynn, 222
Cole, Kathryn, 224
Cooke, Don, 379
Cortez, Eduardo, 267
Counihan, Claire, 210
Cronin, Denise, 168, 199
Cumbie, Ty, 365
Cunningham, Doug, 340
Currie, Cynthia, 59
Curry, Chris, 38, 41, 55, 57, 58, 61, 70, 78, 80, 81, 127, 128, 133, 137, 138
Curtin, Paul, 318, 321, 322
Dakesian, Nanci, 7, 8, 9

Davis, Scott A., 134
Decker, Ann, 122
Di Moch, Lydia, 165
Diehl, Mike, 387
Dismukes, Karen, 424
Donalty, Alison, 142
Dougherty, Maureen, 324
Duplessis, Arem K., 87
Dyksen, Dan, 421
Easler, Jaimey, 44, 92, 95
Eberstein, Ruth, 417
Edwards, Amelia, 188
Ehrlich, Judith, 261
Fallik, Alain, 402
Fehlau, Fred, 399
Ferguson, Lance, 244
Fili, Louise, 155
Fischer, Vicki, 419
Flynn, Patrick J.B., 325
Fournel, Jocelyne, 43
Francis, Jane, 256
Friedman, Ellen, 229, 230
Frouman, Malcolm, 14
Gallagher, Charles, 413
Gallo, Irene, 149, 186
Giambroni, Jess, 176
Goldman, Leslie, 151
Goldstein, Arnold, 191, 192
Golon, Marti, 52
Gordon, Jon, 298
Gormley, Mark, 328, 394
Gray, Jim, 346
Grigsby, Bill, 348
Grin, Gayle, 46, 136
Gross, Alex, 29
Gury, Mike, 254
Habe, Francesca, 228
Hayes, Regina, 199
Harris, Nancy, 117
Heller, Steven, 37, 66, 72, 77, 116
Heller, Susie, 247
Hessler, Geraldine, 39, 64, 76, 79, 93, 109
Hideaki, Masuda, 291
Hill, Chris, 414
Hill, Joann, 237
Hinrichs, Kate, 390
Hiscock, Paul, 391
Hodges, Drew, 306
Hoffman, Cynthia, 62
Hollenbeck, Phil, 412
Houston, Jon, 96
Hu, Cecile, 404
Jive, Bionic, 272
Johnson, Virginia, 411
Jordan, Phil, 372
Joseph, Doug, 396
Kass, Francine, 181
Kaufman, Sandy, 383, 385, 405

Kelley, Gary, 115, 131
Keyes, Richard, 29
Kilander, Cia, 288
Kim, Y.H. Kristie, 299
Kimberling, Joe, 103, 114
King, Hollis, 248
Kinsman, Michael, 281, 289
Kostiw, Marijka, 201
Kowalczyk, Patricia, 363, 364
Krenitsky, Nick, 161
Kroupa, Melanie, 184
Krulis, Jean, 226
Laakso, Hannu, 42, 71
Lachartre, Alain, 378
Larson, Jeanette, 216, 234
Lasky, Carol, 329
Lawrence, Marie Christine, 356
Lawton, Michael, 35
Leissring, Bill, 264
Lenning, Matthew, 12, 89
Leo, Nancy, 174
LeRoy, Yoland, 221
Lim, Sook, 388
Locklear, Jimmy, 388
Loria, Leonard, 48
Lorig, Steffanie, 338
Machacek, Carolyn, 401, 403
Macrini, Carol, 118
Mailhot, Caroline, 38, 41, 55, 57, 58
Malcolm, Lily, 242
Mansfield, Robert, 113
Mar, Michelle, 309
Marsh, Matt, 331
Marshall, Rita, 145, 169, 170, 187, 223, 232
Marts, Mike, 5
Mattimore, Tim, 249
Mayer, Gene, 353
McClain, John, 342, 347
McCudden, Coleen, 16
McDermott, Deidre, 225
McGowan, Kathleen, 101
McMahon, Carolyn McGregor, 407
McMillan, Wendy, 98
Meingast, Susan, 82
Michaud, Janet, 108, 120
Michels, Doug, 315
Migliaccio, Rina, 130
Miller, Kelsey, 398
Mills, Judie, 146
Mires, Scott, 262, 263, 286
Moffitt, Roxy, 274
Moore, Stuart, 7, 8, 9
Morance, Peter, 100
Morrison, Christine, 316, 317
Moscati, Joe, 308
Mouly, Francoise, 54, 56, 102, 125, 126
Mulvaney, John, 359
Murphy, Mark, 337, 377, 416

Nelson, Dave, 48
Nelson, Karen, 180, 209
Nelson, Michael, 208
Neugebauer, Michael, 153
Nightingale, Vicki, 75, 140
Nimmo, Andrew, 68
Noyes, Derry, 371
Oliveros, Chris, 32
Orth, Joan, 424
Osborn, Jeff, 141
Osten, Sara, 76, 109
Padilla, Anthony, 418
Page, Jean, 311, 349
Pao, Imin, 420
Parisi, Elizabeth, 160, 162
Parrella, Michele, 73, 74
Parsons, Mary, 25, 36, 107, 123, 124
Paul, Chris, 173
Paul, Karen, 285, 287
Pepe, Paolo, 200
Peterson, Tom, 170
Pettit, Kristine M., 202
Phillips, Owen, 34, 112, 119
Picon, Michael, 40
Pierce, Glenn, 357
Pope, Kerig, 33, 84
Pope, Wayne, 157
Prange, Oliver, 15
Procopio, Jen, 93
Prosche, Linda, 246
Rago, Martha, 167
Raitch, Mike, 5
Ramos, Steve, 19
Raspler, Dan, 10
Reistetter, Stacie, 99
Roan, Neill Archer, 258, 262, 263, 286
Rodriguez, Edel, 90
Rodriguez, Kirby, 65
Roman, Dave, 111
Rovillo, Chris, 268
Rufiange, Carole, 20
Ruiz, Mario, 310
Russek, Jim, 252, 253
Sabatino-Falkenstein, Jo Ann, 366, 368
Saylor, David, 143, 179, 233
Scanlin, Sonia, 193
Schwartz, Betsy, 301
Schwartz, Mark, 395
Serra, Rosanne, 189
Shackelford, Al, 312
Shay, Janice, 156
Shemi, Ido, 397
Sidjanski, Brigitte H., 154
Sieck, Judythe, 239
Silver, Christine, 105
Sipes, Lindsey, 83
Skalski, Krystyna, 212
Smith, Bill, 91

Smith, Cathy, 304
Smith, Chris, 254
Smith, Davia, 106, 130
Smith, Kenneth, 110
Smith, Randy, 349
Snider, Steve, 147
Staebler, Tom, 33, 84
Stanford, Kirk, 406
Stein, Robert, 373
Stevenson, David, 150
Stucki, Ron, 350
Stvan, Tom, 159
Suzuki, Hiroki, 408
Suzuki, Kayoko, 87
Suzuki, Yoji, 408
Taylor, Dan, 194
Tehon, Atha, 174, 213
Tejada-Flores, Rick, 261
Thompson, John, 97
Torello, Nick, 67
Torres, Katherine Rybak, 69
Tsemach, Shaul, 335
Tucker, Michael, 139
Tuosto, Filomena, 227
Turk, Rosemarie, 384
Urban, Todd, 400
Valdes, Micah, 275, 283
Valenti, Michael, 135
Vanderlans, Rudy, 276
Vigiak, Mario, 381
Viva, Frank, 393
Viviano, Sam, 63
Walker, John, 64
Ward, Jon, 28
Warnock, Brett, 26
Watts, Brent, 243, 279
Weil, Robert, 190
Weinberg, Edith, 240
White, Joyce, 163
Williams, Gary, 242, 317, 319, 320
Wilson, Jef, 235
Winkler, Ellen, 88
Wiseman, Paula, 368
Woodward, Fred, 47
Workman, Mary, 86
Yamakado, Etsuzo, 260
Yeckley, Anne, 382
Yoshihiro, Saito, 291
Yung, Cecilia, 218, 219, 220
Zakris, Paul, 175, 177
Zavetz, Laura, 121, 132

CLIENTS

Ackerman McQueen, 139
Adobe System UK, 391
Adobe Systems, Inc., 330
AEDEN Additions, 316
AIGA of Colorado, 304
AIGA Philadelphia, 404
AIGA Seattle, 338
ALDO, 20
Allen Spiegel Fine Arts/
 Kent Williams Publishing, 13
Alysia Duckler Gallery, 367
American Showcase, 278
American Spectator, 361
Anheuser Busch, 303
Arena Stage, 258, 262, 263, 286
Art Directors Club of Denver, 419
Art Gallery Zip2, 265, 314
Art Institute of Southern California, 418
Arthur A. Levine Books, 143, 233
Association of Illustrators of Quebec, 392
Ataraxia Studio, 324
Autonomedia, 2
Ballantine Books, 150
Barnes & Noble Publishing, 172
Baseman Printing, 328, 394
Bike Magazine, 94
Blab! Magazine, 11, 22, 23, 24, 31
Black Sonny, 275, 283
Bloomberg L.P., 118
Bloomberg Wealth Manager
 Magazine, 121, 132
Boston University, 411
Brookfield Financial Properties, 384
Brooks Atkinson Theatre, 306
Business Week, 14, 105
California Coastal Commission,
 318, 321, 322
Candlewick Press, 173, 225
Candlewick Press/Walker Books, 188
Charlesbridge Publishing, 221
Children's Book Council, 366, 368
Children's Hospital of Orange County, 267
Cigar Aficionado Magazine, 97
Circle Gallery, 340
Clandestino Publications, 3
Clarion Books, 237
College For Creative Studies, 344
Columbia University, 383, 385, 405
Creative Arts Book Company, 157
Creative Editions, 169, 170, 187, 223, 232
Cryptic Press, 1
Dartmouth Alumni Magazine, 98
DC Comics, 10
Dean & DeLuca, 18
Dellas Graphics, 339, 422
Dial Books for Young Readers,
 174, 213, 242

Dinamo Dvash (Electronic Club), 397
Dirty Girl Produce Organic Farm, 269
Disney/ABC Television, 30
Drawn & Quarterly, 32
E Motion, Inc., 309
Editions du Seuil, 144, 214, 215
Emigre, Inc., 276
Entergy, 369, 370
Entertainment Weekly, 39, 64, 76, 79, 93, 109
European Chemistry, 402
Eve's Closet, 271
Explore Magazine, 82
Fantagraphics Books, 21
Farrar Straus & Giroux, 184, 227
Fastighetstidningen, 288
Federal Reserve Bank of Boston, 358
Feral Records, 266
Field Museum of Natural History, 379
Five O'Clock Shadow, 152
Flight 1, 244
Footlocker/And One, 249
Forbes, 19, 113
Fortune, 122
Fortune Small Business Magazine, 134
Fraser Papers, 395, 396
Front Line Assembly, 273
Galleria Prova, 408
Galvani and Tremolada, 380
Gandalf Graphics, 348
Gentleman's Quarterly, 12, 87, 89
George Washington University Magazine Cover and Permanent Collection, 346
Georgia Pacific Paper, 327
Georgia-Pacific Paper/Domtar, 362
Gerald & Cullen Rapp, 284
Gravity Design, 406
Great Lakes Theatre Festival, 313
Grizzard, 310
Hachioji Festival, 423
Hallmark Cards, 374, 375, 424
Harcourt Brace, 165, 216, 234, 235, 238, 239
Hard Left Press, 4
HarperCollins, 142, 158, 161, 171, 195, 183, 217, 222, 241
Hartford Financial Services Group, Inc., 353
Harvard Business Review, 129
Hearst Center for the Arts, 178
Helper Monkey Records, 293
Hemispheres Magazine, 44, 92, 95
Henry Holt & Company, 167
Hey Song, 420
Highland House Designs, 407
Ho Doo Productions, 281, 289
Holiday House, 210
Houlihan, Lokey, Howard & Zukin, Inc., 243, 279
Iceland Air, 27

Indy Jazz Festival, 302
Interscope Records, 272
JAL Hotels, 260
Johns Hopkins University, 335
Keyspan Energy Services, Inc., 356
Kiplingers Personal Finance Magazine, 59
Kongres Kultury Polskies, 245
Kot France, 300
L'Actualité, 43
La Vita Felice, 228
LA Weekly, 91
Land's End, 312
Laura Geringer Books/HarperCollins, 203, 204
Lelys, 341
Lincoln Center, 252, 253, 365
Long Wind Publishing, 28
Los Angeles Magazine, 103, 114
Loyola College of Maryland, 409
MAD Magazine, 63
Marshall Cavendish, 226
Marvel Comics, 8
Marvel Enterprises, Inc., 5, 7, 9
Marvin's Room Recording Studio, 342, 347
Maxygen, 317, 319, 320, 242
McCarter Theatre Center, 255
McDougal Littell, 185
McGraw-Hill Books, 236
Men's Journal, 35
Mercedes Benz, 259
Mobilclan, 381
Murphy Design, 337, 377, 416
My Generation, 68
Napa Style, 247
National Association for the Fancy Food Trade, 301
National Association of Independent Schools, 357
National Geographic Society, 141
National Labor Federation, 331
NBM Publishing, 148
Neugebauer Verlag, 153
Neumier Design, 352
New York City Ballet, 285, 287
New York Magazine, 40, 73, 74
New York, New York Hotel & Casino, 298
Nikelodeon Magazine, 111
Nord-Sud Verlag, 154
Normand Robert Photographe, 386
North American Review, 115, 131
Nouveau Salon des Cent, 354
Nylon Magazine, 101
Olver Dunlop, 363, 364
Opal Sky, 393
Opera Szczecin, 251
Orkin, 308

Orlando Opera, 250, 282
Oxfam America, 329
Oxford American, 83
Pace University's Schaeberle Studio Theater, 307
Pacific Opera Victoria, 256
Parachute Publishing, 202
Paradigm Productions, 261
Patrick Cramer Editions, 145
Penguin Putnam, 189, 196, 197, 198
Penthouse, 67
Personlich Magazine, 15
Philadelphia Magazine, 17
Philomel Books, 218, 219, 220
Phyllis Fogelman Books, 174
Pitcairn Scott Gallery, 277
Playboy, 33, 84
Playboy Jazz Festival, 399
Plaza Frontenac, 295, 296, 297
Pocket Books, 200
Popeye's Chicken & Biscuits, 280
Potlach Corporation/Corporate Design Foundation, 390
PTS America, 413
Rasputina (RPM Records), 270
Reader's Digest, 42, 71, 75, 85, 140
Regan Books/HarperCollins, 194
Rizzoli Books, 166
Rolling Stone, 45, 47, 49, 50, 51, 53
Rough Magazine/Dallas Society of Visual Communications, 412
Roundabout Theatre Company, 257
Russell Design Associates, 421
Rutledge Books, 191, 192
S.A.P. - Canada Customary Advisory Council, 401, 403
Salt Lake Olympic Committee, 350
Sandwich Graphics, 351
Santa Barbara Magazine, 104
Sanwa Bank Limited, 291
Sappi North America, 389
Savannah College of Art & Design, 156
Scholastic, Inc., 160, 162, 163, 179, 240
Scott Hull Associates, 305
Scribner, 151
Sea Star Books, 229, 230
Selling Power, 16
Seraphein Beyn, 345
Serbin Communications, 417
Simon & Schuster, 175, 177, 181, 208
Simon & Schuster/Scribner, 159
Society of Illustrators, 325
Southwest Texas State, 414
St. Martin's Press, 147
Standard & Poor's Published Image, 398
Starbright, 168
Steerforth Press, 155
Sterling Publishing, 180, 209
Stewart, Tabori & Chang, 211

Stoddart Publishing Company, 224
Talk Magazine, 106, 130
Tama Art University, 290, 292
Texas Monthly, 86
The Atlantic Monthly, 25, 36, 107, 123, 124,
The Chronicle of Higher Education, 88
The Greenwich Workshop, 360
The History Center, 355
The Life Work Company, 60
The Millbrook Press, 146
The National Ballet of Canada, 323
The National Post, 46, 136
The New Republic, 96
The New York Times, 100, 135
The New York Times Book Review, 37, 66, 72, 77, 116
The New York Times Magazine, 117
The New Yorker, 34, 38, 41, 54, 55, 56, 57, 58, 61, 70, 78, 80, 81, 102, 112, 119, 125, 126, 127, 128, 133, 137, 138
The Pressworks, 415
The Verve Music Group, 248
The Washington Post, 99
Theatre Grottesco, 326
thecomic.com, 6
TIAA Cref, 382
Tiger Woods Foundation/Coca-Cola, 264
TIME, 52, 62, 90, 108, 110, 120
Top Shelf Productions, 26
Tor Books, 149, 186
Travel Smith, 246
Tyson Foods, 376
Unison Industries, 254
United Nations Postal Administration, 373
United States Air Force, 343
United States Postal Service, 371, 372
Ussery Printing Company, 333
Viking Children's Books, 199
Vue Sur La Ville, 378
W Magazine, 65
W.W. Norton, 190
Walker & Company, 212
Warner Brothers Records, 387
Weekly Standard, 69
Wells Fargo Business Advisor, 400
Willie Works, 299
Willy Brandt House, 334, 336
Yale School of Drama, 274
Yale University Press, 193
Yankee Magazine, 48
Young Audiences, Inc., 359
Yupo Paper Company, 311, 349

PROFESSIONAL
STATEMENTS

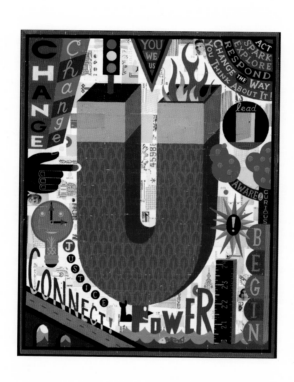

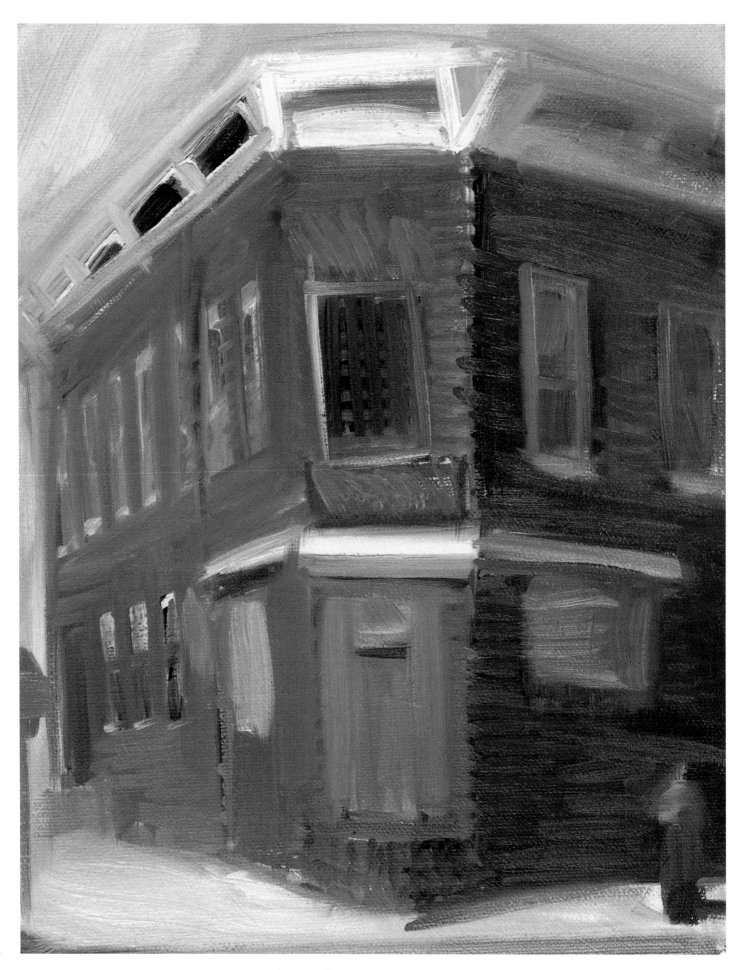

email: epfowler@attglobal.net

ERIC FOWLER
PH 609 695-4305 FAX 609 466-1994

MARK ENGLISH

THE BOOK by Jill Bossert

160 full color images of illustrations and paintings
covering 37 years as an illustrator and painter.

 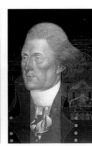

the illustration academy

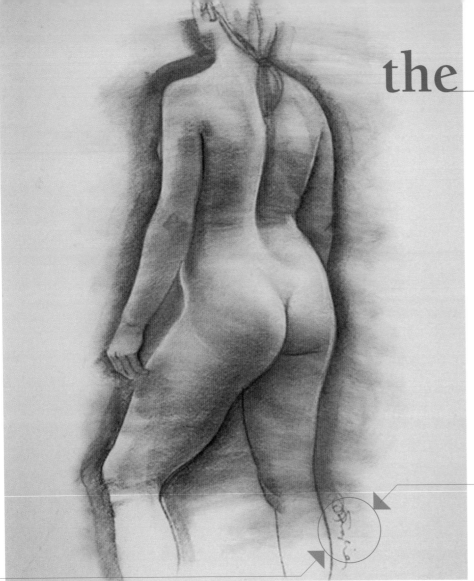

mark english ■
john collier
john english
bart forbes

gary kelley **c.f. payne**
sterling hundley **greg spalenka**
anita kunz **jack unruh**
fred otnes **brent watkinson**

summer 2003

the illustration academy offers art students and professionals the opportunity to study with some of the most successful and exciting illustrators working today. See the art and talk to the artists who set the pace in the field. Improve your work, your work habits, and your portfolio.

the illustration academy offers a one-week, and two three-week intensive workshops to be held in the summer of 2003 at Virginia Commonwealth University in Richmond, Virginia. Room and board are available, up to fifteen hours of college credit offered.

for information write to: Virginia Commonwealth University
Attn: The Illustration Academy
325 North Harrison Street
P.O. Box 842519
Richmond, Virginia 23284-2519
fax 804 828 6930

now @VCU

phone 804 828 1709

www.illustrationacademy.com

Wendell Minor illustrates a new edition of THE RED BADGE OF COURAGE for Scribner Illustrated Classics!

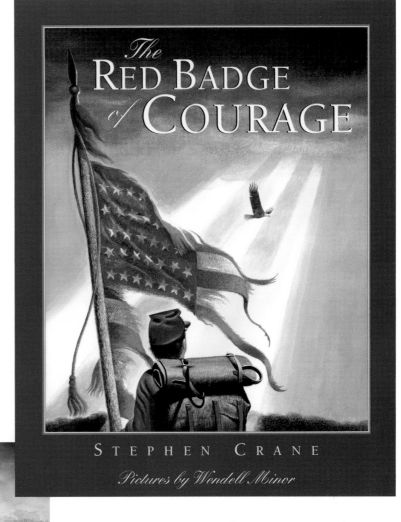

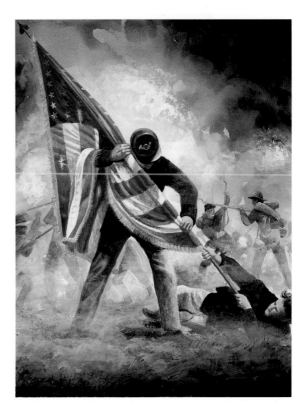

Visit minorart.com

Kirchoff

illustration by Nicole Rutten

Wohlberg

Artists Representatives
since 1930

866 United Nations Plaza New York, New York 10017
Phone: 212-644-2020 Fax: 212-223-4387
www.kirchoffwohlberg.com

Picturebook is a proud sponsor of The Original Art Show

The Society of Illustrator's celebration and exhibition
of the wonderful world of children's illustration for books.

"Picturebook is the first source we turn to when looking for illustrators."

Phoebe Yeh, Executive Editor of Children's Books
HarperCollins Publishing

See what else the world of children's illustration holds.

Visit us on the web at www.picture-book.com
2080 valleydale road, suite 15, birmingham, al 35244
(888) 490-0100 • (205) 403-9882 • fax: (205) 403-9162

illustrationOnLine

the *i* spot·showcase™

the *illustration* internet site

Portfolios

See up-to-the-minute work, available 24/7 and only a click away.

Stock Illustrations

Find thousands of quality images available for immediate electronic delivery.

Virtual Gallery

Add your favorite illustrators' originals to your personal art collection.

www.the *i* spot.com

e-mail service@theispot.com toll-free 888.834.7768

dale stephanos

www.dalestephanos.com

508-543-2500

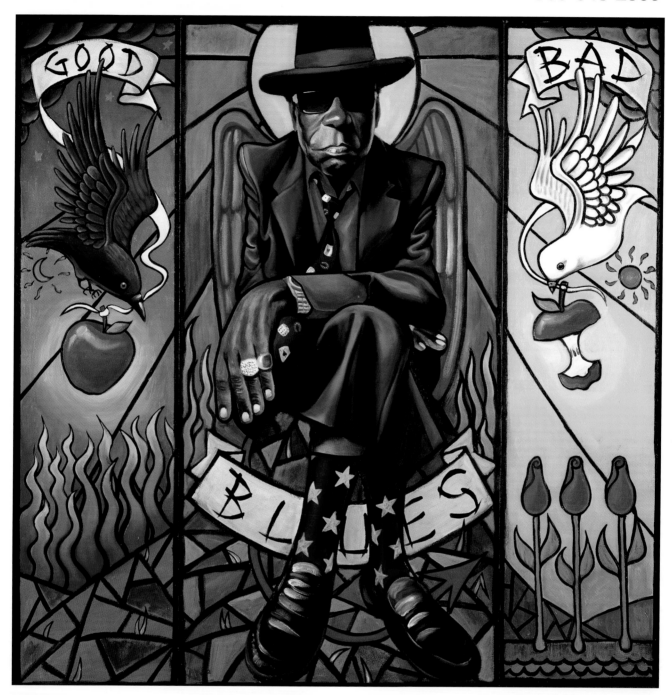

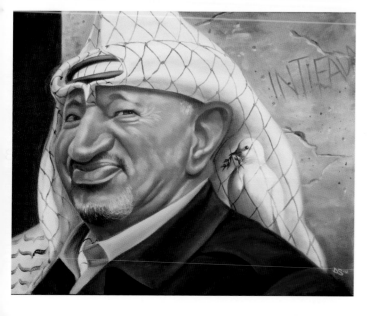

Great illustrators represent Gerald & Cullen Rapp

Beth Adams

Philip Anderson

N. Ascencios

Daniel Baxter

Stuart Briers

Jonathan Carlson

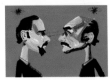
R. Gregory Christie

Jack Davis

Robert de Michiell

The Dynamic Duo

Randall Enos

Leo Espinosa

Phil Foster

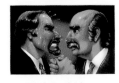
Mark Fredrickson

Chris Gall

Eliza Gran

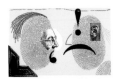
Gene Greif

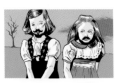
Tomer Hanuka

Peter Horjus

David Hughes

Celia Johnson

Douglas Jones

James Kaczman

J.D. King

Laszlo Kubinyi

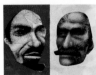
Scott Laumann

Davy Liu

PJ Loughran

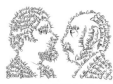
Bernard Maisner

Hal Mayforth

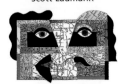
David McLimans

Aaron Meshon

James O'Brien

John Pirman

Marc Rosenthal

Alison Seiffer

Seth

Whitney Sherman

James Steinberg

Drew Struzan

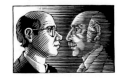
Elizabeth Traynor

Anders Wenngren

Michael Witte

Noah Woods

Brad Yeo

And **Gerald & Cullen Rapp** has represented great illustrators since 1944

108 East 35th Street, New York, NY 10016 | Phone 212 889 3337 | Fax 212 889 3341 | www.theispot.com/rep/rapp

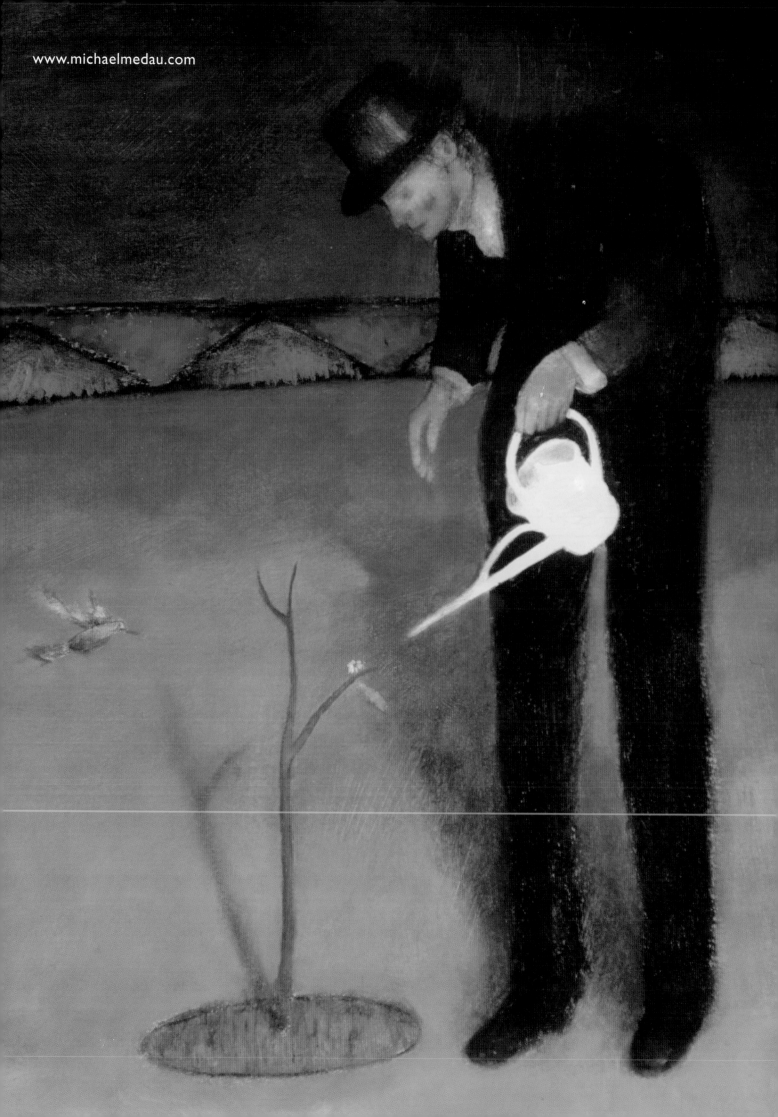

the*i*spot·showcase™

*The only illustration licensing agency
endorsed by The Graphic Artists Guild.*

THEISPOT-SHOWCASE

has long been acknowledged as the premier illustration Internet site. With six plus years of experience, the work of nearly 1,000 top artists, and superior technical capability, it is the industry's website of choice for quality illustration. The recent integration of e-commerce into Theispot-Showcase site has further streamlined the process of finding and obtaining the perfect illustration online, all in a matter of minutes. In further support of the industry, 21% of the new licensing site's profits will be given to the Guild to continue its groundbreaking work.

THE GRAPHIC ARTISTS GUILD

has been a major force in gaining and maintaining the rights of creative professionals for over 30 years. Today, with nearly 2,000 illustrator members, the Guild works on behalf of far more illustrators than any other organization. Its membership boasts an even greater number of designers. By taking an active role in shaping the policy of this comprehensive, state-of-the-art licensing solution, the Guild will ensure that illustrators benefit not only through sales, but through profit sharing and positive industry action.

www.the*i*spot.com/stock

Portraits

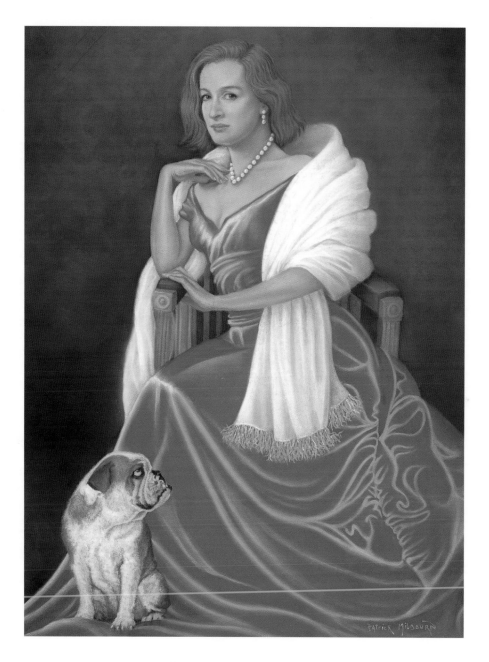

Patrick Milbourn
327 West 22nd Street
New York, NY 10011
212-989-4594

www.patrickmilbourn.com

Charlotte Noruzi

Shannon Associates 212.333.2551

SOCIETY
ACTIVITIES

THE DAVID P. USHER/GREENWICH WORKSHOP
MEMORIAL AWARD

☖

MARK SUMMERS

The selection was made from all of the works exhibited in the 44th Annual.
The jury included: Past Medalists Dan Adel and Hiro Kimura, Exhibition Chair Joe Ciardiello
and representing The Greenwich Workshop, Peter Landa.
A cash prize and subsequent print edition accompanies the award.

Greenwich Workshop

SI OO
our own show

"Our Own Show" presents annually the Stevan Dohanos Award as the Best in Show in this open, unjuried exhibition.

AWARDS JURY
Rudy Gutierrez
Betsy Lewin
Richard Clark
Christopher Short
Angelo Perrone

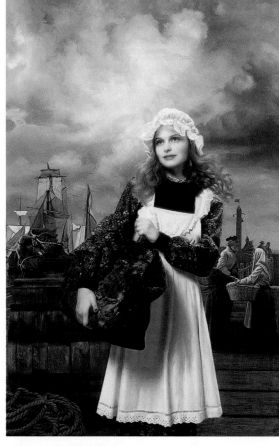

AWARD OF MERIT
Heide Oberheide

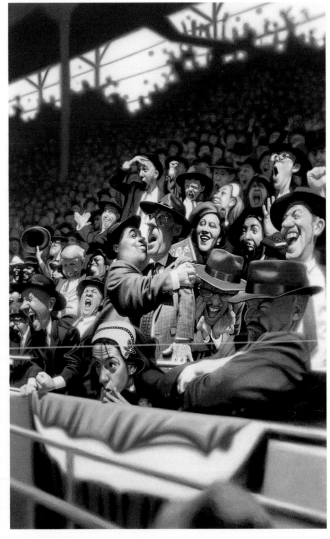

STEVAN DOHANOS AWARD
James Bennett

AWARD OF MERIT
William Low

SOCIETY OF ILLUSTRATORS MUSEUM SHOP

Founded on February 1, 1901, the Society of Illustrators has been the center for the study of illustration for the past 101 years.

"The Illustrator in America". 458 pages spanning 1860–2000 continues to be a favorite.

The Museum Shop is an extension of the Society's role as the center for illustration in America today. For further information or quantity discounts, contact the Society at
• TEL: (212) 838-2560 • FAX: (212) 838-2561
• E-MAIL: si1901@aol.com • WEB SITE www.societyillustrators.org

ILLUSTRATORS 44
324 pp. Cover by Noah Woods.
Contains 481 works of art.
Included are Hall of Fame biographies and the Hamilton King interview. Our most recent annual, the most contemporary illustration.
$49.95

NEW!

ILLUSTRATORS ANNUAL BOOKS

These catalogs are based on our annual juried exhibitions, divided into four major categories in American Illustration: Editorial, Book, Advertising, and Institutional. Some are available in a limited supply only.

In addition, a limited number of out-of-print collector's editions of the Illustrators Annuals that are not listed below (1959 to Illustrators 35) are available as is.

Contact the Society for details...

ILLUSTRATORS 43
$40.00

ILLUSTRATORS 42
$40.00

ILLUSTRATORS 41
$35.00

ILLUSTRATORS 40
$30.00

ILLUSTRATORS 38
$25.00

ILLUSTRATORS 37
$20.00

SOCIETY OF ILLUSTRATORS • 128 East 63rd Street • New York, NY 10021-7303
www.societyillustrators.org EMail: si1901@aol.com

THE ILLUSTRATOR IN AMERICA 1860 - 2000

NEW EXPANDED EDITION!

BY WALT REED
EDITED BY ROGER REED

First published in 1964, this is the third edition of *The Illustrator in America*. It now goes back in time to the Civil War when artist reporters made on-the-spot pictures of the military action for publication by newspapers and periodicals of the day.

Following the improvements in printing and the attractions of better reproductions, the turn of the century brought a "Golden Age of Illustration" spearheaded by Howard Pyle, Edwin Austin Abbey, A.B. Frost and others, who brought it to a high art. Illustrators were celebrities along with the authors whose works they pictured.

This history of 140 years of illustration is brought up to the millennium year of 2000 when the new computer-generated techniques and digital printing is creating another revolution in this evolving, dynamic art form.

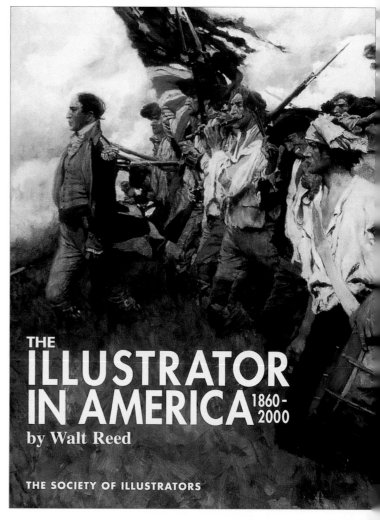

THE **ILLUSTRATOR IN AMERICA** 1860-2000 by Walt Reed

THE SOCIETY OF ILLUSTRATORS

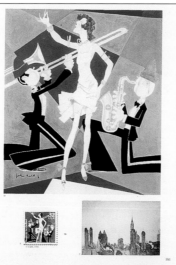

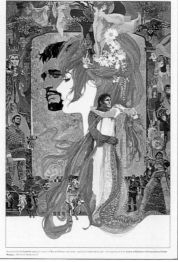

As before, the pictures and biographies of the outstanding artists of each decade are presented along with the historical context of each ten-year period. A time-line chart presents the various influences of styles, schools, and "isms" within this diverse and vital field that has made such an important contribution to America's art.

Included are the works of over 650 artists, their biographies, examples of their signatures and their best works. Among the artists are Winslow Homer, Thomas Moran, Charles Dana Gibson, Frederic Remington, William Glackens, Maxfield Parrish, N.C. Wyeth, James Montgomery Flagg, J.C. and F.X. Leyendecker, Jessie Wilcox Smith, John Held Jr., Norman Rockwell, Dean Cornwell, John Falter, Harold von Schmidt, Stevan Dohanos, Robert Fawcett, Austin Briggs, Al Parker, Bernie Fuchs, Bob Peak, Brad Holland, Milton Glaser, Richard Amsel, Gary Kelley, Leo and Diane Dillon, and Chris Van Allsberg.

COVER ILLUSTRATION:
"The Nation Makers" by Howard Pyle
Collection of the Brandywine River Museum

458 PAGES, FULL COLOR, HARDBOUND.
$49.95

Fred Otnes

Guy Billout

Chris Spollen

PRO-ILLUSTRATION
by Jill Bossert

A How-to Series
$24.00 EACH. SET OF TWO $40.00

Joan Hall

VOLUME ONE
EDITORIAL ILLUSTRATION

The Society of Illustrators has simulated an editorial assignment for a Sunday magazine supplement surveying the topic of "Love." Topics assigned to the illustrators include: Erotic Love, First Love, Weddings, Sensual Love, Computer Love, Adultery and Divorce. The stages of execution. from initial sketch to finish, are shown in a series of photographs and accompanying text. It's a unique, behind-the-scenes look at each illustrator's studio and the secrets of their individual styles. Professional techniques demonstrated include oil, acrylic, collage, computer, etching, trompe l'oeil, dyes and airbrush.

EDITORIAL
Marshall Arisman, Guy Billout, Alan E. Cober, Elaine Duillo, Joan Hall, Wilson McLean, Barbara Nessim, Tim O'Brien, Mel Odom

VOLUME TWO
ADVERTISING ILLUSTRATION

This is an advertising campaign for a fictitious manufacturer of timepieces. The overall concept is "Time" and nine of the very best illustrators put their talents to solving the problem. The stages of execution, from initial phone call to finish, are described in photographs and text. You'll understand the demonstration of the techniques used to create a final piece of art. Professional techniques demonstrated include oil, acrylic, mixed media collage, computer, three-dimension and airbrush.

ADVERTISING
N. Ascencios, Mark Borow, Robert M. Cunningham, Teresa Fasolino, Mark Hess, Hiro Kimura, Rafal Olbinski, Fred Otnes, Chris Spollen

FAMOUS AMERICAN ILLUSTRATORS
by Arpi Ermoyan

THE HALL OF FAME

Every year since the inception of the Hall of Fame in 1958, the Society of Illustrators bestows its highest honor upon those artists recognized for their distinguished achievement in the art of illustration. The 87 recipients of the Hall of Fame Award represented in this book are the foremost illustrators of the last two centuries.

FAMOUS AMERICAN ILLUSTRATORS, a full-color, 224 page volume, is a veritable "Who's Who" of American illustration. The artists are presented in the order in which they were elected to the Hall of Fame. Included are short biographical sketches and major examples of each artist's work. Their range of styles is all-encompassing, their viewpoints varied, their palettes imaginative. The changing patterns of life in America are vividly recorded as seen through the eyes of these men and women—the greatest illustrators of the 19th and 20th Centuries. **11 1-2 x 12 inches. $34.95**

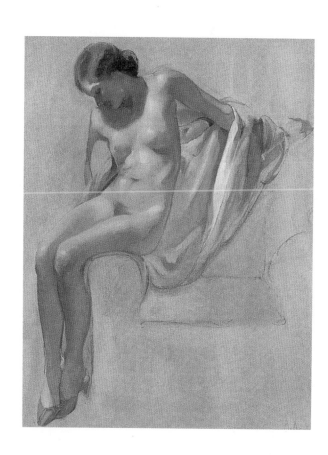

BOOKS & CATALOGS

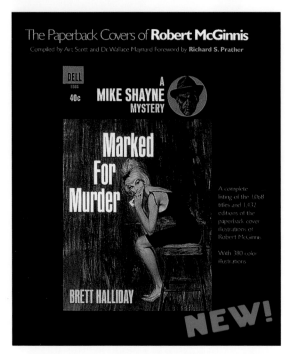

THE PAPERBACK COVERS OF ROBERT McGINNIS
Robert McGinnis is best known for his astonishing career as a paperback cover artist. Over 250 covers are reproduced in this book, along with examples of original art, model photos, and preliminary sketches.
144 pages, color, hardbound.
$39.95

WENDELL MINOR: ART FOR THE WRITTEN WORD
Wendell Minor's extraordinary body of jacket art includes a commentary on the relationship between a book's cover and what is inside.
154 pages, color, paperback.
$29.95

SIGHT & INSIGHT - THE ART OF BURTON SILVERMAN
From the exhibition held at the Butler Institute of American Art in Youngstown, Ohio and the Brigham Young Museum in Provo, UT, 1999. This book is a collection of the past 25 years of work by this universally respected painter, illustrator and teacher.
157 pages, color, hardbound.
$39.95

DEAN CORNWELL DEAN OF ILLUSTRATORS
The reissue of Pat Broder's 1978 biography, which has been long out of print. Cornwell was the prolific master draftsmen and consumate visual storyteller. Introductions by Norman Rockwell and Walt Reed.
240 pages, color, hardbound.
$70.00

JOHN LA GATTA - AN ARTIST'S LIFE
Hall of Fame illustrator John La Gatta lived a life as glamorous as the elegant men and gorgeous women he depicted during the twenties and thirties for magazines and advertisers. A biography and lavish portfolio of his work reveals one of the Golden Age's most famous artists.
168 pages, color, hardbound. **$39.95**
168 pages, color, paperback. **$29.95**

THE J.C. LEYENDECKER COLLECTION
Considered the unheralded King of American Illustration, Leyendecker shaped the look of the modern magazine during a career that stretched over fifty years. This book offers reproductions photographed directly from the original works—many of which have never before been published.
47 pages, color, paperback.
$19.95

THE BUSINESS LIBRARY

$18.95

$19.95

$34.95

$29.95

APPAREL

SI CAPS
Blue or Red with SI logo and name embroidered in white. Adjustable, one size fits all **$15.**

White shirt with the Society logo.
L, XL, XXL **$15.**

9TH ANNUAL EXHIBITION "CALL" T-SHIRT
age of the tattooed face by Anita Kunz.
0% cotton. Heavyweight pocket T.
ly XL, XXL **$15.**

38TH ANNUAL EXHIBITION "CALL" T-SHIRT
Image of a frog on a palette by Jack Unruh.
Frog on front pocket.
100% cotton. Heavyweight pocket T.
Only XL, XXL **$15.**

NAVY BLUE MICROFIBER NYLON CAP
SI logo and name embroidered in white. Floppy style cap. Feels broken in before its even worn. Adjustable, one size fits all.
$20.

SWEATSHIRTS
Blue with white lettering of multiple logos or grey with large red SI.
Blue L, XL, XXL **$20.**
Gray L, XL **$20.**

40TH ANNUAL EXHIBITION "CALL" T-SHIRT
Image of "The Messenger" by Leo and Diane Dillon.
100% cotton. Heavyweight pocket T.
Only L, XXL **$15.**

GIFT ITEMS

SI LAPEL PINS
Actual Size
$6.00

The Society's famous Red and Black logo, designed by Bradbury Thompson, is featured on many items.

SI TOTE BAGS
Heavyweight, white canvas bags are 14" high with the two-color logo **$15.00**

SI PATCH
White with blue lettering and piping - 4" wide
$4.00

SI CERAMIC COFFEE MUGS
Heavyweight 14 oz. mugs feature the Society's logo or original illustrations from the Permanent Collection.
1. John Held, Jr.'s "Flapper";
2. Norman Rockwell's "Dover Coach";
3. J. C. Leyendecker's "Easter";
4. Charles Dana Gibson's "Gibson Girl"
5. SI Logo
$6.00 each

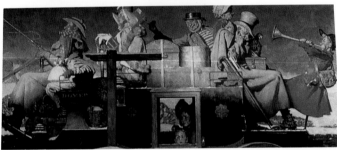

SI NOTE CARDS
Norman Rockwell greeting cards, 3-7/8" x 8-5/8", inside blank, great for all occasions.
Includes 100% rag envelopes

10 CARDS	**- $10.00**
20 CARDS	**- $18.00**
50 CARDS	**- $35.00**
100 CARDS	**- $60.00**

ORDER FORM

Mail: The Museum Shop, Society of Illustrators, 128 East 63rd Street, New York, NY 10021-7303
Phone: 1-800-SI-MUSEUM (1-800-746-8738) Fax: 1-212-838-2561 EMail: si1901@aol.com

44

NAME _____

COMPANY _____

STREET _____
(No P.O. Box numbers please)

CITY _____

STATE _____ ZIP _____

PHONE () _____

Enclosed is my check for $ _____
Make checks payable to SOCIETY OF ILLUSTRATORS

Please charge my credit card:

☐ **American Express** ☐ **Master Card** ☐ **Visa**

CARD NUMBER _____

SIGNATURE _____ EXPIRATION DATE _____
*please note if name appearing on the card is different than the mailing name.

Ship via FEDEX Economy and charge my account _____

QTY	DESCRIPTION	SIZE	COLOR	PRICE	TOTAL
# of items ordered					

Total price of item(s) ordered	
TAX (NYS Residents add 8 1/4%)	
UPS Shipping per order	7.00
or	
Foreign Shipping via Surface per order	20.00
or	
Foreign Shipping via Air per order	CONTACT OFFICE
	FX
TOTAL DUE	

VISIT US ONLINE AT www.societyillustrators.org/museum_shop